Flash 3D
Animation, Interactivity, and Games

Flash 3D
Animation, Interactivity, and Games

Jim Ver Hague

Chris Jackson

Amsterdam • Boston • Heidelberg • London • New York
Oxford • Paris • San Diego • San Francisco • Singapore
Sydney • Tokyo

Focal Press is an imprint of Elsevier

ELSEVIER

Acquisitions Editor: Paul Temme
Project Manager: Paul Gottehrer
Associate Editor: Georgia Kennedy
Marketing Manager: Christine Degon Veroulis
Cover Design: Chris Jackson and Jim Ver Hague

Focal Press is an imprint of Elsevier.
30 Corporate Drive, Suite 400, Burlington, MA 01803, USA
Linacre House, Jordan Hill, Oxford OX2 8DP, UK

∞ Recognizing the importance of preserving what has been written, Elsevier prints its books on acid-free paper whenever possible.

Library of Congress Cataloging-in-Publication Data
Application submitted

British Library Cataloguing-in-Publication Data
A catalogue record for this book is available from the British Library.

ISBN 13: 978-0-240-80878-9
ISBN 10: 0-240-80878-9

For information on all Focal Press publications
visit our website at www.books.elsevier.com

06 07 08 09 10 11 10 9 8 7 6 5 4 3 2 1

Printed in China

Dedication

From Jim

This book is dedicated to Amy and Jamey. This little story is for them.

Once upon a time, there was a Dad whose kids grew up to be very talented, creative designers. And the old Dad was, oh, so proud of them. His kids were such great fun to be with. And the old Dad was, oh, so honored to have them as friends. His kids were good and kind and gentle. And the old Dad felt, oh, so blessed at his wonderful, good fortune. His kids helped him understand his life more fully. And the old Dad loved them both, oh, so very much! The End.

From Chris

I dedicate this book to my wife, Justine. Heartfelt thanks for all of your loving support, patience, and encouragement. You allowed me to spend far too many nights away from you working late on this book. Words cannot express how much you mean to me. You complete my life. I love you.

This book is for my parents, Roger and Glenda. Thank you for teaching me that I could do anything. Your love, generosity, words of wisdom, and never-ending support has allowed me to fulfill my dreams. You are my inspiration, and I love you both.

From Both

We would sincerely like to thank our students enrolled in Computer Graphics Design at the Rochester Institute of Technology. The concept for this book started as a special topics course taught in the spring of 2005. We thank the students enrolled in that class for their enthusiasm and creativity. This book is for you.

Contents

Chapter 7
Using a Camera in 3D **217**

Chapter 8
Using Virtual Reality Concepts **277**

Introduction

Flash was originally designed for two-dimensional animation. Throughout its evolution, it has grown to produce many rich-media applications. Currently, new media designers have yet to break out of a two-dimensional world into a more robust three-dimensional environment. This book explores the possibilities of utilizing 3D space within Flash.

What's This Book About?

Interactivity is an important component in delivering rich-media content. This book provides multimedia designers, developers, and programmers with tools to create interactive systems within a three-dimensional world. Chapter exercises consist of practical applications as well as experimental projects. Each exercise provides step-by-step instructions and tips for you to use in conceptualizing solutions, visualizing data, and developing practical interactive applications.

Entering the Third Dimension

Your journey begins with illustrating depth. There are many ways to reproduce visual depth cues to simulate the illusion of depth. Visual depth cues include perspective, relative size, interposition, aerial perspective, light and shadows, surface shading, and texture gradient. The first two chapters provide exercises that focus on illustrating these cues to create the illusion of three-dimensional characters and environments.

From static drawings, we proceed to motion and the concept of parallax scrolling. This is a common 2D animation technique that simulates depth. Changing scale to suggest three-dimensional space is explored by zooming objects in simple one-point perspective. Exercises demonstrate zooming using both Flash tweening techniques as well as simple ActionScript code.

Navigating in the Third Dimension

The next section explores navigation in 3D space. This involves moving objects and changing your point of view. Establishment of z-axis movement leads in a natural way to the introduction of objects in 3D space that can be moved in any direction.

Movement of an object in a circular path is easily done both with simulated 3D as well as actual 3D. As a way of introducing the desired motion, it is first helpful to discuss circular motion in the normal x-y plane. Exercises incorporate basic trigonometry. From there, it is easy to construct elliptical motion simply by changing vertical scale factors in Flash. The elliptical motion in the x-y plane visually looks like circular motion in the x-z plane. This provides a natural transition to include actual three-dimensional rotation in the x-z plane.

Rotating in the Third Dimension

The transition to 3D space opens up a wide variety of easily obtained, more complex movements such as spiral rotations and sinusoidal motion. An extension of these concepts leads to the introduction of a camera in 3D space that can be zoomed, panned, and rotated.

QTVR (QuickTime Virtual Reality) is another 3D technique used in Flash. In an object movie format, the method consists of taking a series of individual "snapshots" of an object rotating in equal increments about a vertical or y-axis. The individual images are imported into Flash, and then simple scripts can be written to rotate the object clockwise or counterclockwise. Another QTVR concept involves taking snapshots at equal increments while rotating 360 degrees in one spot. This involves the stitching together of the individual shots into one panoramic image. This image can be imported into Flash where, as before, simple scripts enable the user to rotate in a 3D environment.

Practical Applications

The last section of this book brings together the key concepts to develop applications of real and simulated 3D space in a traditional 2D environment. These practical applications consist of interactive environments and games. To enhance the creative process, the development of each project is discussed in detail, from creating the graphics to the scripts that drive the project. Reusable templates and code samples are provided on the CD to help expand your development and technical skills. As you complete each

hands-on exercise, you learn how to conceptualize and build a variety of interactive 3D solutions. As a result, you will develop reusable templates and creative methodologies that can be applied to everyday projects.

Who This Book Is For

The primary audience for this book is Flash multimedia designers and developers. This book assumes that you have some prior Flash experience. If you are new to Flash, go through the tutorials provided with the Flash application to learn its interface. If you are a Flash animator, you will find this book helpful in learning more about interactivity. If you are interested in 3D-oriented conceptualization and programming, then this book is for you.

Conventions

To help you get the most out of this book, let's look at the text conventions used.

Menu selections are presented like this: Edit > Paste in Place.

File names, layer names, and code within the text appear in a mono-space typeface, like this: `2_1_parallaxScroll.fla`.

Code blocks are separated from the text like this:

```
1    // comments are in red
2    code appears in this typeface;
3    line numbers appear to the left
4
```

Source Code

All of the source code is provided on the accompanying CD. As you work through each chapter's exercises, you can choose to type in the code manually or review the finished example in the `Completed_Exercises` folder.

About the Authors

Jim Ver Hague

Jim Ver Hague is a Professor of Computer Graphics Design in the School of Design, College of Imaging Arts and Sciences at the Rochester Institute of Technology. He has more than 30 years of experience in the field of computer graphics, ranging from the U.S. space program to microcomputer-based applications in graphic design to the design of web-based training, online educational modules, and interactive diagnostic tools for the medical profession. Jim has lectured, consulted, and conducted workshops internationally in the fields of multimedia, electronic publishing, computer-aided information design, and computer art and sculpture.

Chris Jackson

Chris Jackson is a computer graphics designer and Associate Professor in the School of Design, College of Imaging Arts and Sciences at the Rochester Institute of Technology. Additionally, Chris continues to be a Flash designer, developer, and consultant for worldwide corporations such as Eastman Kodak. Chris has an extensive background in graphic design, printing, and interactive multimedia. His professional work has received over 25 distinguished national and international awards for online communication. Chris continues to publish and present his research and professional work at ACM SIGGRAPH and the Society for Technical Communication (STC).

Acknowledgements

This book has taken many months to write. We owe a debt of gratitude to all at Focal Press, but especially Paul Temme, Hastings Hart, and Georgia Kennedy. Thank you for all your support and advice in enabling us to help bring this book to print.

Credits

The authors wish to thank the following people who have graciously agreed to let us reproduce some of their work with permission in this book. Use of their work is limited strictly to the exercises provided.

> James Ver Hague for vases and glassware used in Chapters 6 and 11.
> Amy Ver Hague for the panorama used in Chapter 8.
> Shilpa Desai for the object movie images used in Chapter 8.
> Amy Bendall for the Museum Trail Project used in Chapter 11.

Exploring 3D in Flash

We live in a three-dimensional world. Objects and spaces have width, height, and depth. Various specialized immersive technologies such as special helmets, gloves, and 3D monitors have produced very effective and exciting computer-generated virtual reality environments.

The first thing you should know about 3D and Flash is that there is no 3D in Flash. That is, there are no inherent 3D capabilities built into Flash, either through drawing tools or through scripting commands. The kinds of virtual realities mentioned above are just not possible with Flash.

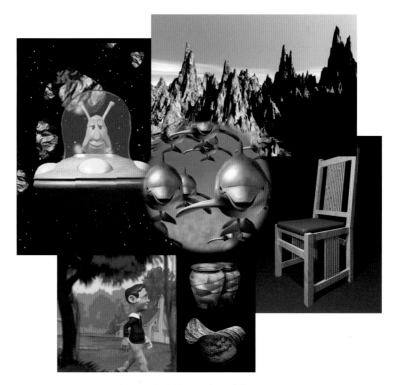

Figure 1.1 Examples of 3D imagery

What Flash does know how to do, however, is display vector shapes and calculate expressions. With that, there is much that we can do if we are willing to look at 3D from another viewpoint. In traditional three-dimensional computer graphics, 3D objects are normally projected onto the monitor screen used as a picture plane. In many other situations we interact in varying degrees with three-dimensional environments projected onto a two-dimensional surface. This is true of photography, film, video, and many fine-art paintings. We perceive three-dimensionality through visual and motion cues. If we focus on the imagery as pictorial representations of 3D objects and spaces, we open up a broad spectrum of potential exploration (Figure 1.1).

For example, we can create the illusion of 3D through a variety of drawing techniques. The movement of objects themselves can produce a sense of 3D space. We can create actual 3D objects, scenes, and animations in software packages outside of Flash and then import the results into Flash. Even though layers in Flash are all at the same distance to the viewer, we can use them to set up a rudimentary 3D space. We can use ActionScript to dynamically create mathematically calculated three-dimensional spaces and objects from scratch. And we can use combinations of each of these to create a rich panoply of environments.

Flash is based upon 2D objects and positioning. Objects are always the same distance from the screen. Movement in this depthless space is either left and right along the horizontal or x-axis, or up and down along the vertical or y-axis, or along both axes. To create a 3D space, there needs to be a sense of depth towards or away from the screen. This involves moving along the z-axis. In Flash, the z-axis doesn't exist, so we need either to find ways to simulate one or to mathematically define one. Exploring ways in which this can be achieved is the purpose of this book.

Types of Projections

Before we get into Flash 3D, let's look at the different ways in which objects can be projected as 3D drawings. All 3D drawings have four elements in common. They each have

1. a three-dimensional object
2. a picture plane for capturing the object's projected image
3. projection rays to project the object onto the picture plane's surface
4. a viewer to observe the object's image on the picture plane

The 3D drawing varies depending on the relationship between the projector rays and the picture plane as shown in Figure 1.2. The projector rays can intersect the picture plane in three ways, which produce different types of drawings discussed in the next section.

Orthographic projections. When all of the projector rays meet the picture plane at right angles, the projection is an orthographic projection. Multiview and paraline drawings are examples of this type of projection.

Oblique projections. When all of the projector rays are parallel to one another and at an oblique angle to the picture plane, the projection is an oblique projection. General oblique and transoblique drawings are examples of this type of projection.

Perspective projections. When all of the projector rays form various angles to the picture plane and converge to a single point, the projection is a perspective projection. One-point, two-point, and three-point perspective drawings are examples of this type of projection.

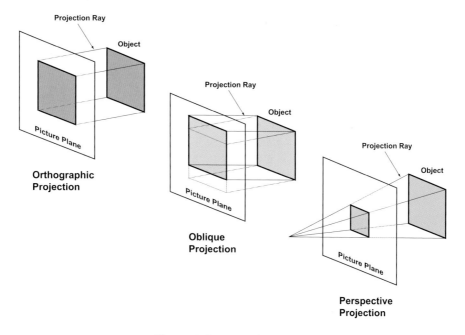

Figure 1.2 Types of projections

Types of 3D Drawings

It will be helpful to briefly discuss some of the more common types of 3D drawings used by designers, artists, and architects. In some cases, the drawings are roughly sketched out by designers without the use of a formal projection system. In others, they might be carefully constructed or generated with 3D software.

Multiview Drawings

Multiview drawings may consist of elevation, plan, and sectional views. These views are commonly used in 3D programs. Three-dimensional objects are often constructed by creating the top (plan), front, and side (elevation) views of the object. Simple 3D objects such as extrusions and lathed objects use cross-sections of the shape.

Multiview drawings are often called orthographic projections since they are typically rendered at right angles from one another. Figure 1.3 shows a typical multiview arrangement of a simple 3D object. Although none of the multiview drawings separately can truly represent the actual configuration of a three-dimensional object, there are many times when just a front view or side view adequately conveys the sense of 3D objects or space.

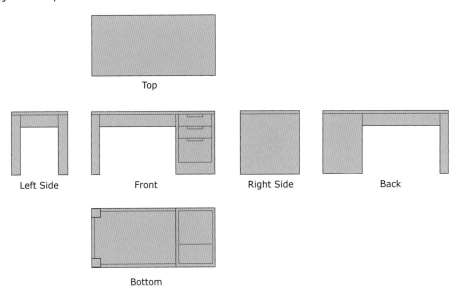

Top

Left Side Front Right Side Back

Bottom

Figure 1.3 Typical multiview arrangement

Single-View Drawings

Single-view drawings present more than one side of an object in the same view. There are two types of single-view drawings: paraline and perspective. In paraline drawings, any two parallel lines or planes remain infinitely parallel, while in perspective drawings, parallel lines appear to converge at one or more vanishing points. When drawing or sketching by hand for generating 3D ideas or for scanning, paralines are faster and easier to construct than perspectives.

Paraline Drawings

Figure 1.4 shows an example of two of the most frequently used paraline drawings, both of which can easily be constructed. With isometric drawings, the three primary axes of measurement include two ground-plane axes drawn at 30° angles from a horizontal and a vertical height axis parallel to the picture plane. All measurements are made along (or parallel to) these three axes at exact scale, which makes isometric drawings the easiest to construct.

Exact shapes in each dimension are characteristic of isometric drawings. While they are easy to construct, isometric drawings have a few drawbacks. A main one is that the three visible faces are always turned at the same angle to the picture plane. Another drawback is that isometric drawings tend to look somewhat unnatural due to a lack of foreshortening.

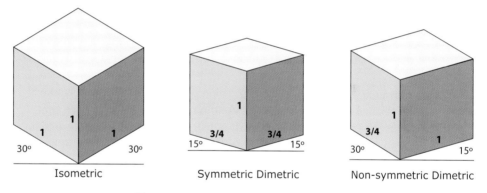

| Isometric | Symmetric Dimetric | Non-symmetric Dimetric |

Figure 1.4 Isometric and dimetric drawings

Like isometric drawings, dimetric drawings have one axis parallel to the picture plane. Dimetric drawings can be either symmetric or nonsymmetric as shown above. They are characterized by having two of the three axes drawn at the same scale. Convenient scale ratios such as 1:3/4 or 1:2/3 are normally used. Dimetric drawings tend to look a little more realistic than isometric drawings because of foreshortening. In addition, the nonsymmetric versions provide the advantage of enabling you to place more emphasis on important views while downplaying less exciting ones.

Another class of paraline drawings is oblique drawings as shown in Figure 1.5. True size and shape are retained in plan oblique drawings. The plan is usually tilted at an angle, and the height lines are drawn as verticals. Different variations can be obtained by changing the angle of the plan and altering the scale ratio between the plan and the receding height lines.

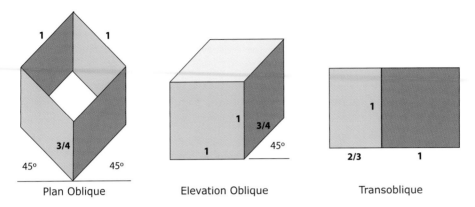

| Plan Oblique | Elevation Oblique | Transoblique |

Figure 1.5 Plan oblique, elevation oblique, and transoblique drawings

Elevation oblique drawings are characterized by having one set of planes presented in true size and shape. All planes parallel to the picture plane are drawn in true shape and at the same scale. Planes perpendicular to the picture plane are drawn at a reduced scale. Convenient scale ratios such as 1:3/4 or 1:2/3 are often used. As with plan obliques, the angle of the perpendicular planes can be altered to meet individual needs.

Transoblique drawings are a special case of paraline drawings that show only two orthogonal surfaces in a single view, unlike the other drawings we have seen that depict three surfaces in the same view. Elevation planes parallel to the picture plane are typically drawn at true size and shape. Perpendicular planes are drawn at some convenient scale such as 3/4 or 2/3. The result is a drawing that is somewhat more than 2D but somewhat less than 3D.

Paraline Drawings in Flash

Flash provides the tools to create paraline drawings of simple shapes based on multiview orthographic drawings. The following short exercises will acquaint you with the basic steps of scaling, rotating, and transforming shapes to generate paraline drawings.

Exercise 1.1: Creating an Isometric Drawing

Step 1: Getting started

Open the file 1_1_desk.fla in the Chapter 1 folder on the accompanying CD. The artwork for this exercise consists of four of the six orthographic projections of the desk from Figure 1.3. The text and each view are on separate layers in the movie Timeline (Figure 1.6). It will be helpful to zoom in to 200% and hide the text layer.

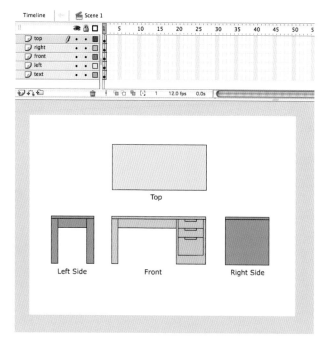

Figure 1.6 Front, top, and side views of a desk

Step 2: Create the right side isometric

Use the arrow selection tool to select the right side view. If the Transform palette is not visible, choose Window > Transform to open it. Select the Skew option and enter a vertical skew value of −30 degrees (Figure 1.7). Flash will skew the right side the correct amount while maintaining the required size relationships.

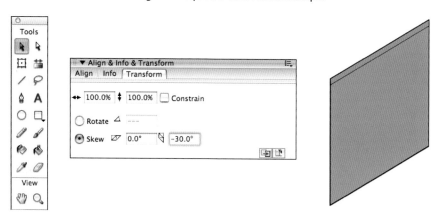

Figure 1.7 The right side isometric with a negative vertical skew

Step 3: Create the front isometric

For convenience, hide the top view layer. Select the front view. Choose the Skew option in the Transform palette and enter a vertical skew value of 30 degrees. Move the front view into position with the side view as shown in Figure 1.8.

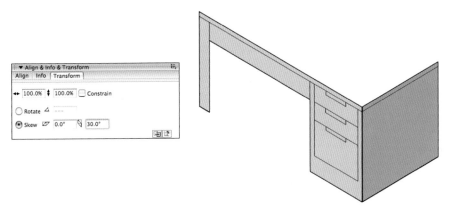

Figure 1.8 The front isometric with a positive vertical skew

Step 4: Create the left side isometric

Next select the left side view. Choose the Skew option in the Transform palette and enter a vertical skew value of −30 degrees as with the right side. Move the left side view into position with the front view to establish the thickness of the table leg as shown in Figure 1.9.

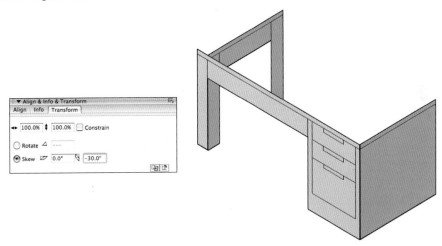

Figure 1.9 The left side isometric with a negative vertical skew

Step 5: Create the top isometric

Turn the top view back on so that it can be seen. Unlike the other views, the top view must be skewed both horizontally and vertically. The question is, how much of each do we need? It's not really obvious, but with a little bit of thought we can work it out.

We have seen from the previous views that we can transform horizontal lines up to the left and right by entering vertical skew values of +30 and −30 degrees respectively. For the top view, we will need to use a vertical skew value of 30 degrees to match up with the front view.

To transform the vertical lines of the top view, we need to do the opposite and skew horizontally. The 90-degree vertical lines of the top view must be parallel to the horizontal lines of the side views, which are now at a 30-degree angle. The vertical lines of the top view must then transform a net amount of 60 degrees to match up. How do we know if it is +60 or −60 degrees? The small diagrams in the Transform palette indicate the direction of positive skew angles. In Flash, positive values of angles are measured clockwise.

We now have the information we need to skew correctly. Use the arrow selection tool to select the top view. In the Transform palette, select the Skew option and enter 60 degrees for the horizontal skew and 30 degrees for the vertical skew. Move the top isometric into position with the rest of the drawing as shown in Figure 1.10, and you are done with the exercise. Save your file as desk_Isometric.fla.

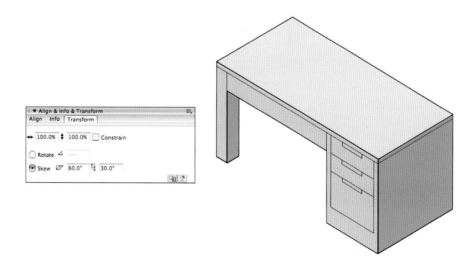

Figure 1.10 The top isometric with horizontal and vertical skews

Exercise 1.2: Creating a Symmetric Dimetric Drawing

Step 1: Getting started

Open the file 1_1_desk.fla in the Chapter 1 folder on the accompanying CD. As in the previous exercise, it will be helpful to zoom in to 200% and hide the text layer.

Step 2: Set the horizontal scale factor

Referring to Figure 1.4, we see that for symmetric dimetric drawings, we need to change the horizontal scale of each view to 75%. Choose Edit > Select All. In the Transform palette, set the width (horizontal scale) to 75% (Figure 1.11).

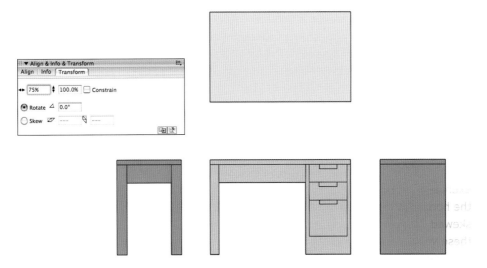

Figure 1.11 Use the transform palette to set the width of all objects to 75%.

Step 3: Skew the front and side views

As with the isometric drawing, we will need to vertically skew the sides and front views.

1. Select the right side view and set the vertical skew to −15 degrees.
2. Select the front view and set the vertical skew to 15 degrees.
3. Select the left side view and set the vertical skew to −15 degrees.
4. Move the sides into position as shown in the left side of Figure 1.12.

Step 4: Complete the left side view

We need to add some thickness to the rear leg of the desk. We can do this easily by

making a copy of the front, pasting it in, and moving it into position. Since the copy is on top of the original front view, choose Modify > Arrange > Send to Back. Your drawing should now look like the right side of Figure 1.12.

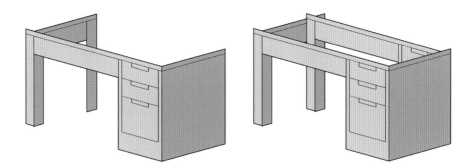

Figure 1.12 Front and sides of the symmetric dimetric desk drawing

Step 5: Complete the drawing

We just need to transform the top view to complete the drawing. Select the top view. We have previously set the width to 75% in the Transform palette, and we must now also set the height to 75% so that its height matches the width of the sides.

To determine the skew angles, we will apply the same reasoning as in the previous exercise. The horizontal sides of the top must be vertically skewed 15 degrees to match the horizontals of the front side. The vertical sides of the top must be horizontally skewed 75 degrees to align with the −15 degree skew of the right and left sides. Enter these values in the Transform palette, then move the top into position, and you should have the results of Figure 1.13. Foreshortening the drawing by changing the width makes the desk appear more realistic than in the isometric drawing. Save your file as desk_Dimetric1.fla.

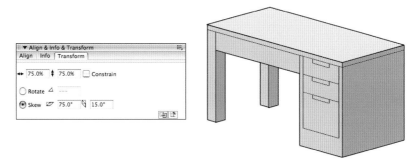

Figure 1.13 The completed symmetric dimetric desk drawing

Exercise 1.3: Creating a Nonsymmetric Dimetric Drawing

Referring to Figure 1.4, we see that for nonsymmetric dimetric drawings, we have a little more flexibility to emphasize one side more than another because of the two different horizontal scale factors and the vertical skew angles. So for a change of pace, in this drawing we will place primary emphasis on the front of the desk and secondary emphasis on the left side.

Step 1: Getting started

Open the file `1_1_desk.fla` in the Chapter 1 folder. As in the previous exercise, it will be helpful to zoom in to 200% and hide the text layer.

Step 2: Skew the front view

Select the front view. Because it is the primary view, we do not need to change any scale factors. In the Transform palette, set the vertical skew angle to −15 degrees.

Step 3: Size and skew the left side

Select the left side view. In the Transform palette, set the width to 75% and the vertical skew angle to 30 degrees. Move the left side into position with the front (Figure 1.14).

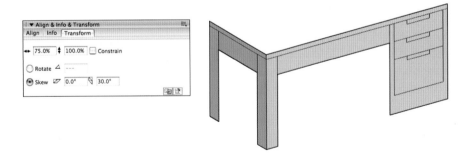

Figure 1.14 Size and skew the left side of the dimetric drawing

Step 4: Add the right side thickness

Select the right side view. We will use it to define the depth of the desk drawers. In the Transform palette, set the width to 75% and the vertical skew angle to 30 degrees. Move the right side into position with the front as shown in Figure 1.15.

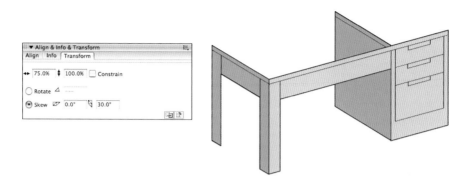

Figure 1.15 Size and skew the right side of the dimetric drawing.

Step 5: Add the left leg thickness

The left rear leg of the desk is only partially defined. If we had a back view available, we could use it to give the leg thickness. Since we don't, let's try what we have done before by copying and pasting the front view and then moving the copy into position to define the leg. As before, choose Modify > Arrange > Send to Back to get the front copy behind the original.

Unlike earlier, we still have a problem. The duplicated front needs to be behind every-thing. We can easily solve this by adding a new "back" layer between the text layer and the left layer and pasting the copy into the new layer as shown in Figure 1.16.

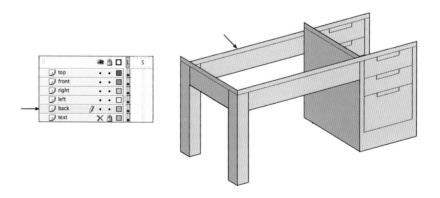

Figure 1.16 Place the front copy on a separate layer below the others.

Step 6: Complete the drawing

We just need to transform the top view to complete the drawing. Select the top view. To match the vertical sections of the top with the horizontal width of the sides, we have set the top view's height to 75% in the Transform palette.

To determine the skew angles, we will apply the same reasoning as in the previous exercises. The horizontal sides of the top must be vertically skewed −15 degrees to match the horizontals of the front side. The vertical sides of the top must be horizontally skewed −60 degrees to align with the 30 degree skew of the right and left sides. Enter these values in the Transform palette, then move the top into position, and you should have the results of Figure 1.17. As with the previous exercise, foreshortening the left and right sides by changing the width makes the desk appear more realistic than in the isometric drawing. Save your file as `desk_Dimetric2.fla`.

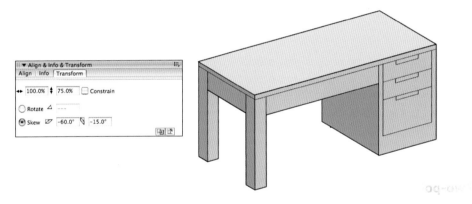

Figure 1.17 The completed nonsymmetric dimetric desk drawing

Tip: Use `1_1_desk.fla`, Figure 1.5, and what you have learned in the last three exercises to develop plan oblique, elevation oblique, and transoblique drawings of the desk as shown in Figure 1.18.

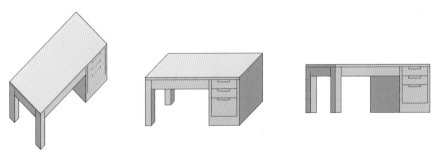

Figure 1.18 Plan oblique, elevation oblique, and transoblique desk drawings

Types of Perspective Drawings

Perspective drawings are the most realistic type of representational drawing. If all projection rays of an object converge on a common vanishing point, their intersection with the picture plane produces a perspective image of that object. This is the most realistic of the 3D drawings. Three types of perspective drawings can occur.

One-point Perspective

If one face of an object is parallel to the picture plane, or if horizontal lines and vertical lines are parallel to the picture plane, the resulting image is a one-point perspective (Figure 1.19).

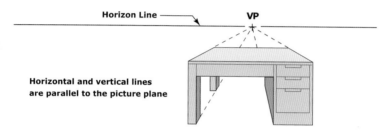

Figure 1.19 One-point perspective drawing has one vanishing point.

Two-point Perspective

If only vertical lines are parallel to the picture plane and no faces of the object are parallel to the picture plane, the resulting image is a two-point perspective (Figure 1.20).

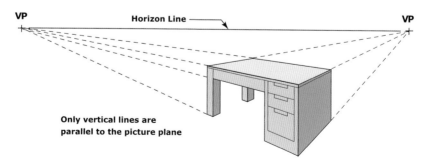

Figure 1.20 Two-point perspective drawing has two vanishing points.

Three-point Perspective

If no faces or edges of an object are parallel to the picture plane, the resulting image is a three-point perspective (Figure 1.21).

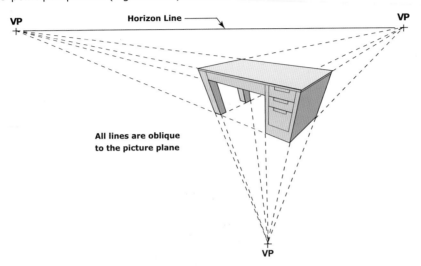

Figure 1.21 Three-point perspective drawing has three vanishing points.

While it is possible to create perspective drawings in Flash or Illustrator, constructing them in a 3D program such as Swift 3D and importing them into Flash is often faster and easier and provides greater flexibility.

Summary

This chapter focused on creating the illusion of 3D through a variety of drawing techniques. Key concepts to remember include the following:

- All 3D drawings have four elements in common: a three-dimensional object, a picture plane, projection rays, and a viewer to observe the object's image on the picture plane.
- Types of 3D drawings include multiview, single-view, and paraline.
- Perspective drawings are the most realistic type of representational drawing.

The next chapter focuses on visual depth cues and how to reproduce them in Flash.

2

Depth Cues:
Creating the Illusion of Depth

The illusion of depth can be illustrated within a two-dimensional space. The key words here are *illusion* and *illustrated*. Whether you are drawing on a piece of paper or painting pixels on a computer screen, you are working with two physical dimensions: height and width. Depth is the third dimension. However, you can't reach into the computer screen or extend objects in front of it. You can look only at the flat picture being projected.

So if there is no actual depth in the image, how do we simulate three-dimensional space? The answer is right in front of us. We start with our perception of depth and the visual cues found in the real world. Artists throughout the centuries have relied on their depth perception to vividly construct three-dimensional worlds on two-dimensional surfaces.

This chapter focuses on depth perception and how to reproduce it through visual cues. When you have finished reading the chapter, you will be able to

- Describe how our eyes perceive distance
- List visual cues that create the illusion of depth
- Reproduce depth cues in Flash

Depth Perception

Take a moment to look at the environment around you. What do you see? You see a world in three dimensions. Now focus on an object that is close to you. Your mind tells you how far the object is from you, the space it occupies in front of or behind something else, and its three-dimensional shape. What makes this incredible is that our eyes are producing only two-dimensional images. It is the human brain that assembles each image and extrapolates the depth.

This sense of depth is a result of stereoscopic vision (Figure 2.1). Our eyes are spaced apart, which produces a slightly different image on each retina. To demonstrate this, hold this book in front of you. Take turns closing one eye. Notice the difference in what you see from the left eye to the right. Your left eye will see the left side of the book, while the right eye will reveal the right side of the book.

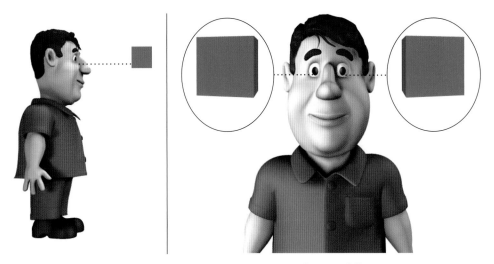

Figure 2.1 Stereoscopic vision—each eye produces a different image.

Our brain interprets this retinal difference and then merges the two images into a single three-dimensional image. The resulting image allows us to perceive depth and estimate distance. The difference between each retinal image is a direct result of the depth of the objects that we are looking at—the closer the object, the greater the difference in each retinal image. Distant objects, such as mountains, are so far away that our eyes produce essentially the same image, making depth imperceptible.

Stereoscopic vision isn't the only way our brain interprets depth. Similar to a camera lens, our eyes adjust themselves to bring something into focus. Try the following experiment. Hold your finger in front of you. Position it about six inches from your face and focus on it. What happens to the objects in the distance? They are blurry and out of focus. Our brain uses the eye's focal adjustment to determine the distance of the object from ourselves. We perceive the finger to be closer to us based on the level of detail our eyes adjusted to.

Finally, knowing an object's relative size in relation to other objects helps the brain perceive depth. Take a look at Figure 2.2. We perceive the skyscrapers in the picture

to be hundreds of feet tall, even though the picture itself is only inches high. We can take advantage of these visual cues when working in a two-dimensional medium. The next section focuses on visual depth cues. These include linear perspective, relative image size, interposition, aerial perspective, light and shadows, surface shading, and texture gradient.

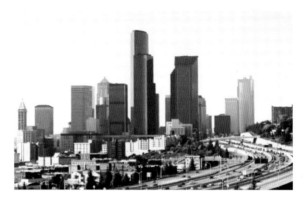

Figure 2.2 Depth perception based on knowing the relative size

Visual Depth Cues

In the previous chapter we looked at types of 3D drawings and the concept of linear perspective. In linear perspective, parallel lines that recede into the distance appear to get closer together or converge. In Figure 2.3 the building's architectural lines give the indication that it is angled and that the surfaces recede in depth. Perspective is a visual depth cue that can be simulated within a two-dimensional world. What other information in our environment allows us to perceive depth?

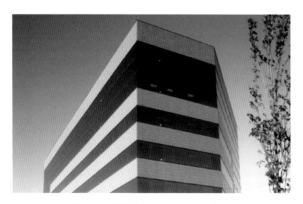

Figure 2.3 Linear perspective

A simple visual cue called relative size is easy to reproduce. Take a look at Figure 2.4. The size of each object suggests its relative distance to the viewer. Objects larger in scale are perceived to be in closer proximity than smaller scaled objects. Even though this is a flat, two-dimensional image, the man on the left appears closer because of his larger size when compared to other men in the scene.

Figure 2.4 Relative size—which man is closer?

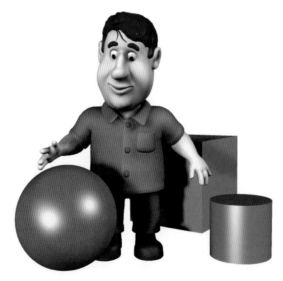

Figure 2.5 Interposition—which object is closer?

Figure 2.5 demonstrates another depth cue: interposition, or overlapping shapes. All of the objects are at the same distance from the screen to your eyes, yet the composition portrays a sense of depth. Overlapping objects assist in creating this illusion. The red ball is partially blocking the view of the man. It appears to be closer to the viewer. The cast shadow also helps establish that the ball's position is in front of the man.

 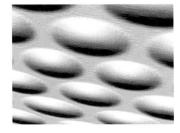

Figure 2.6 Depth perception based on light and shadow

Light and shadows are essential in creating the illusion of three-dimensional space. Without these two elements, objects would appear flat. Highlights are a result of light illuminating or reflecting off an object. Shadows exist where the light cannot reach. Light and shadows differentiate parts of an object that are at different depths. Figure 2.6 demonstrates how light and shadows affect the perception of depth. Both images are the same. The image on the right has been flipped vertically. Notice what happens to the highlights and shadows and how depth is perceived. The raised bumps in the left image become recessed pits in the right image.

Surface shading defines form by giving an object a three-dimensional feel. In Figure 2.7 the light is coming from the left. The highlights showcase the light's angle and define the red ball's smooth surface.

The gradient shading across the ball's surface shows the falloff of light around the object. It helps illustrate the object's spherical shape. The illusion of roundness is achieved through the curvature of the shadows near the bottom. The cast shadow underneath the ball also helps establish where the light is coming from.

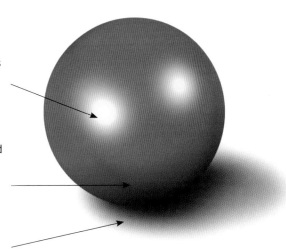

Figure 2.7 Light and shadows

Our atmosphere scatters light, which affects our depth perception. Figure 2.8 simulates this occurrence. Both men are the same size and distance from the viewer. The right image has been blurred, and the overall coloring is blended into the background. With these changes, the man on the right appears slightly farther away than the man on the left. This depth change in coloring and clarity is known as aerial perspective.

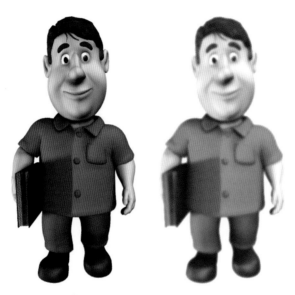

Figure 2.8 Aerial perspective

Our last visual depth cue is texture gradient. This borrows concepts from linear perspective and relative size. Surfaces such as brick walls, tiled floors, and even waves in the ocean have a texture to them. The farther away we are from a surface, the smoother and denser its texture appears (Figure 2.9).

Figure 2.9 Texture gradient

Simulating Depth Cues in Flash

Flash provides you with an assortment of tools and programming code to simulate depth. Our first example continues your journey in developing three-dimensional worlds within a two-dimensional environment. Let's begin.

Exercise 2.1: Depth Cues

Step 1: Getting started

Open the file 2_1_DepthCues.fla in the Chapter 2 folder on the accompanying CD. This Flash movie contains the artwork you need to complete this exercise. Here we have a mad scientist who has accidently cloned himself (Figure 2.10).

The artwork in this example consists of two instances of the same movie clip—MC_ Scientist. The movie clip is located in the Library. Each instance has been added to a separate layer in the Timeline.

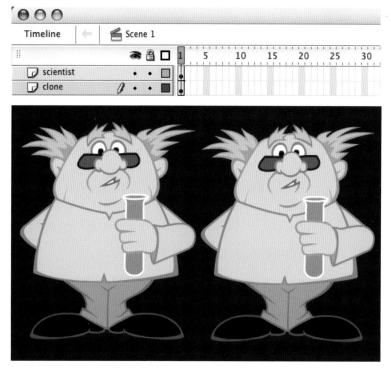

Figure 2.10 Mad scientist and his clone on separate layers

Step 2: Simulate relative size

Both scientists are equal in size. Visually, they appear to be the same distance from you. Let's change that. Remember that relative size deals with scale. Objects larger in scale are perceived to be closer to the viewer than smaller scaled objects. Select the Free Transform tool from the Tools palette. Click on the clone (scientist on the right). Position the cursor over the upper-right handle. Click and drag to the left while holding down the Shift key. This will reduce the clone's scale uniformly (Figure 2.11).

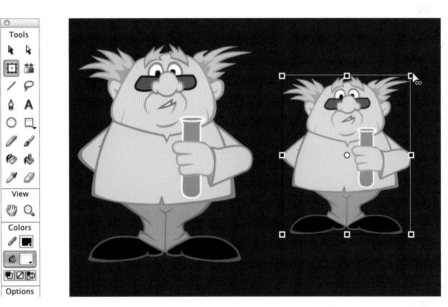

Figure 2.11 Scaling the clone using the Free Transform tool

You just simulated relative size. By reducing the size of the clone, it now appears that the clone is further away. An alternative method to scaling in Flash is to use the Transform palette (Window > Transform) and enter numeric values to scale (Figure 2.12).

Figure 2.12 Transform palette

Step 3: Simulate interposition

Interposition deals with overlapping images to simulate depth. The Timeline in Flash controls the arrangement of objects, or stacking order, through layers. By default, each new Flash document gives you a single layer to work with in the Timeline. Each layer can hold more than one object.

Within a layer there is a stacking order. All ungrouped shape fills and lines are always at the bottom. Grouped objects, symbol instances, and bitmaps are stacked above. You can further control the stacking order of these elements by clicking on an object and selecting Modify > Arrange. It is good practice to create new layers to organize your content better. To create a new layer, click on the Insert Layer button located at the bottom-left corner of the Timeline (Figure 2.13). Each new layer has a stacking order. Items in a higher layer will appear on top of items in a lower layer.

Figure 2.13 Insert Layer button

Notice that this file contains two layers: a `scientist` and a `clone` layer. The clone is on a lower layer. Click and drag the clone to the left. He now appears underneath the higher layer (`scientist`), adding further to the illusion of depth. This demonstrates the stacking order in Flash as well as the visual depth cue of interposition (Figure 2.14).

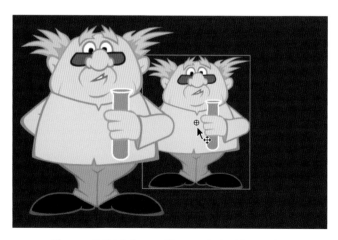

Figure 2.14 Interposition and stacking order

Step 4: Simulate aerial perspective

So far you have simulated relative size through scaling and interposition through the layer stacking order. Let's play around with the lighting in this scene. You may be asking yourself, "Where are the lights in Flash?" There aren't any lights. You simulate a change in lighting through an object's color and clarity. For this example, the scientist and his clone are in a dark and mysterious lab. The clone is further away from us in the darkness. Let's simulate the effects that lighting would have on this situation by applying basic color effects to the symbol instance.

Click on the clone. Go to the Properties palette. Each instance of a symbol can have color effects applied to it. Click on the Color drop-down menu and select Brightness. White is 100% and black is −100%. Adjust the brightness to −30%. Visually, the clone recedes into the depths (Figure 2.15).

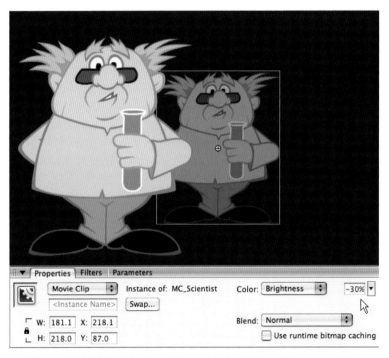

Figure 2.15 Adjusting brightness to simulate aerial perspective

That solves the coloring of the object. We are halfway there. Next is clarity. Flash offers additional filters that can be applied to symbol instances. These filters include Drop Shadow, Blur, Glow, and Bevel. Let's take a closer look at the Blur filter. Make sure the clone instance is still selected on the Stage.

Go to the Properties palette again and click on the Filters tab. Click on the "+" to add a new filter to the instance. Select Blur from the drop-down menu. Instantly the object is blurred on the Stage. The Blur filter can be adjusted horizontally (Blur X) and vertically (Blur Y). Click on the lock icon to link both properties together. Reduce the amount of blur by changing the blur factor to 3. Set the Quality to High. You have now completed the effect of aerial perspective (Figure 2.16). Save your file.

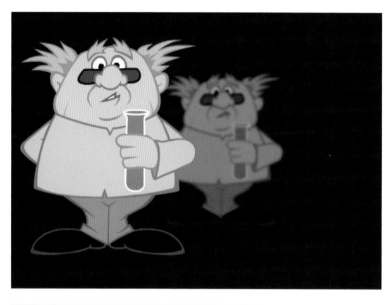

Figure 2.16 Adding the Blur filter to simulate aerial perspective

Exercise Summary

This exercise demonstrated some of the basic tools that allow you to create the illusion of three-dimensional space in Flash. The Free Transform tool adjusts an object's relative size. Layers in the Timeline control an object's appearance in terms of stacking order. The Properties palette offers color effects and filters to simulate different lighting situations. The next exercise continues with lighting effects. It focuses on creating surface shading and shadows to enhance an object's three-dimensional shape. You will be using the Brush and Gradient tools in Flash.

Exercise 2.2: Cartoon Surface Shading

Step 1: Getting started

Open the file 2_2_Shading.fla in the Chapter 2 folder. The superhero on the Stage was traced from a scanned drawing. There are many ways to create artwork such as a cartoon character in Flash. Figure 2.17 illustrates the process used for this exercise. A rough pencil sketch was first created to define the basic shape of the superhero (left image). The outlines were then cleaned up using a black pen (middle image).

The outlined superhero was scanned into Photoshop at 300 dpi to retain as much detail as possible. The scan was saved as a JPEG and imported into Flash. The imported scan was placed on its own layer in the Timeline. The layer was locked to prevent it from accidentally moving. New layers were created above the locked layer. The scan was then retraced using the pencil tool and filled in with basic colors (right image).

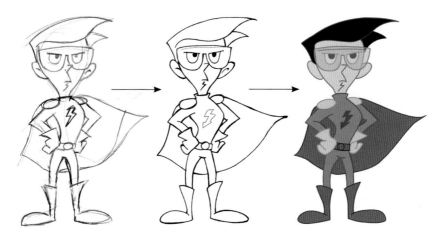

Figure 2.17 Evolution of a Flash cartoon character

After the scanned drawing was traced, it was deleted from the Timeline. What's left are several layers that contain separate body parts of the superhero. Figure 2.18 shows the stacking order of the layers. Why separate your character into so many layers? The answer is more control, especially for animation.

Flash cartoon characters should be composed of several layers. It is good practice to create a different layer for each body part. The benefit you gain is more flexibility in adjusting or changing your character. If you plan to animate, the layers provide you with the ability to fine-tune each part's movement. The number of layers is up to you. They will not increase the file size of your document.

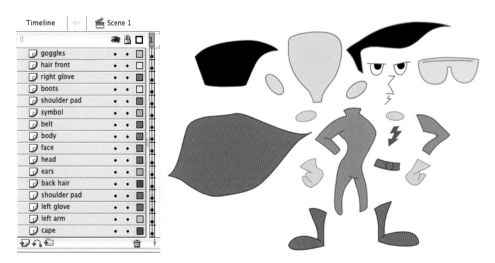

Figure 2.18 Anatomy of a Flash cartoon character

Our superhero looks rather flat. This is a result of the vector artwork. There are two types of graphics you can create on the computer: vector and raster. Flash creates vector graphics. This type of graphic is created from the lines, curves, and fills that make up its geometry. The resulting image is small in file size but not photorealistic.

Raster graphics, also called bitmaps, are made up of tiny units called pixels. Pixels are grouped together in a grid that forms the image. The resulting image can be photorealistic but larger in file size. Another drawback to raster images is scalability. Vector graphics use math to store and create an image. This makes them resolution-independent. They can be scaled without losing detail. If a raster graphic is scaled too large, the pixel grid will become noticeable, creating a pixellated image (Figure 2.19).

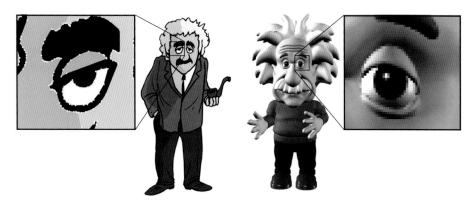

Figure 2.19 Vector graphics versus raster graphics

Step 2: Select a fill color

Adding surface shading to our superhero will make him appear more three-dimensional. The Brush tool in Flash is an excellent tool to create shading. Before using the Brush tool, pick an appropriate color. Choosing what color to paint is simple. Start with the fill color used on the shapes. Let's start the surface shading with the superhero's head.

Select the Eyedropper tool from the Tools palette. Make sure the fill color is also selected in the Tools palette. Move the cursor over the superhero's head and click. You have just stored that pink color as the fill color (Figure 2.20).

Figure 2.20 Selecting a fill color

Step 3: Decrease the fill color's brightness

Shading illustrates the falloff of light's luminosity on an object. Decrease a color's brightness slightly, and you have a color for shading. The Color Mixer panel allows colors to be mixed and altered. By default, the Color Mixer uses RGB (red, green, and blue) color values. Another setting is HSB (hue, saturation, and brightness). Since the brightness needs to change, this is a better setting to use.

Figure 2.21 Changing the Color Mixer settings to HSB

To change from RGB to HSB, click on the menu icon at the top-right edge of the Color Mixer panel. Select HSB from the drop-down menu (Figure 2.21). The Color Mixer panel will update with the HSB color values.

Decrease the brightness value (B) from 100% to 90% (Figure 2.22). This creates a new fill color to paint with. The new, darker, pink color will provide the surface shading.

Figure 2.22 Adjusting the brightness

Step 4: Set Brush tool options

The Brush tool paints shapes with the fill color. Select the Brush tool. Notice that there are options associated with this tool. These options are located at the bottom of the Tools palette. They include Brush Mode, Brush Size, and Brush Shape. Select the Brush Mode drop-down menu. There are several painting options to choose from. Select Paint Inside from the list (Figure 2.23). This will allow you to paint brush strokes directly inside a single filled shape.

Figure 2.23

Step 5: Paint in the surface shading

Make sure the head layer is selected in the Timeline. This is the filled shape you need to paint on. For this exercise, the light source is coming from the right side. To simulate the roundness of our superhero's head, the shading would appear on the left.

With the Brush tool selected, move the cursor over the head. Position it on the left side. It is important that the point of the cursor is on the pink fill (Figure 2.24). Click and drag to start painting the surface shading.

Figure 2.24 Finished cast shadow

31

Don't worry about keeping the brush strokes within the lines. The Paint Inside mode that you selected in Step 4 applies the strokes only in the area that you started to paint on (pink head). When you are done painting, release the mouse. The shading will remain only inside the head shape (Figure 2.25).

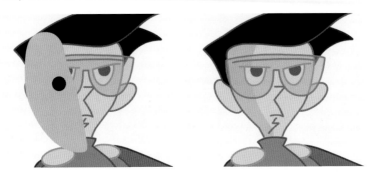

Figure 2.25 Painting the shading (left image) and Paint Inside results (right image)

Step 6: Create surface shading for remaining body parts

Let's see how much you have learned. Repeat steps 2 through 5 to add shading to the rest of the body. First select a color fill using the filled shapes in the superhero. Decrease the color's brightness using the Color Mixer panel. Make sure the correct layer is selected in the Timeline. Use the Brush tool to paint the surface shading. To see the completed exercise, open the file `2_2_Shading_DONE.fla` in the `Completed_Exercises` folder within Chapter 2 (Figure 2.26).

Figure 2.26 Surface shading completed

Step 7: Select All and Copy

The surface shading helps define the superhero's form and gives him a three-dimensional look and feel. A cast shadow will further enhance the illusion of 3D space. A cast shadow also reinforces the lighting setup. Choose Edit > Select All. This will select all the vector shapes. Copy the selected shapes (Edit > Copy).

Step 8: Create a new layer and adjust the stacking order

Click on Insert Layer button located at the bottom-left corner of the Timeline. Rename the layer to `shadow`. Position the layer at the bottom of the Timeline (Figure 2.27).

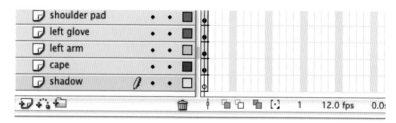

Figure 2.27 Creating a new layer for the cast shadow

Step 9: Paste and change the fill color

Paste a copy of the superhero into this new layer. Make sure the layer's content is still selected. Go to the Tools palette and click on the "Fill color" swatch (Figure 2.28). This opens the Color Swatches pop-up palette. Select a light tan color (#CC9933). All the shapes' fills will be set to this color.

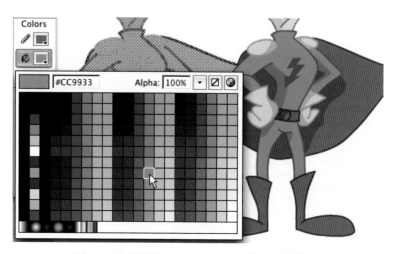

Figure 2.28 Changing the color fill to #CC9933

Step 10: Delete all the strokes

Delete all the colored strokes from the shadow layer. This leaves you with only a solid filled shape that will act as the cast shadow (Figure 2.29).

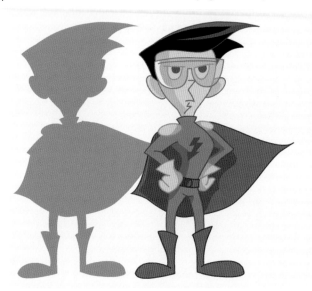

Figure 2.29 Deleting the strokes

Step 11: *Skew the shadow*

Skewing the shadow horizontally will add perspective. The Skew tool is found in the Transform palette. Open the Transform palette (Window > Transform). Click on the radio button for Skew and enter −60 degrees in the first Skew field, which governs the horizontal skew. Click and drag the skewed shadow to align it with the superhero's boots (Figure 2.30).

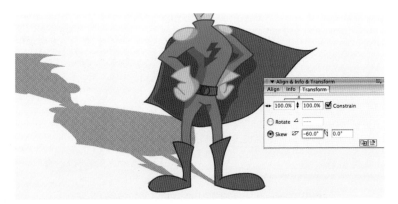

Figure 2.30 Skewing the shadow and repositioning it

Step 12: *Save and test movie*

This completes this exercise. Save your file. Choose Control > Test Movie.

Exercise Summary

Traditional animators use similar shading techniques to make cartoon characters appear more three-dimensional. It is a combination of darkening a fill color and brushing it onto a shape. The Color Mixer creates and adjusts colors. The HSB color space provides an easy method to decrease the brightness of a color. This creates the shade color.

The Brush tool applies this color to your object. The Paint Inside option paints brush strokes only within a single filled area. This type of surface shading produces a hard-edged look. There is another technique that uses gradient fills to create soft shading. Let's take a look at how gradients help reproduce the illusion of depth.

Exercise 2.3: Using Gradients

Step 1: Getting started

Open the file 2_3_Gradients.fla in the Chapter 2 folder. Here we have a sphere and a cube on the Stage (Figure 2.31). There are visual cues in this composition that create an illusion of depth. What are they?

The red ball is overlapping the blue cube. This interposition suggests that the ball is closer to the viewer. The cast shadows reference a light source, and the shading on the cube suggests a three-dimensional object. Gradients can provide this composition with a more realistic three-dimensional look and feel.

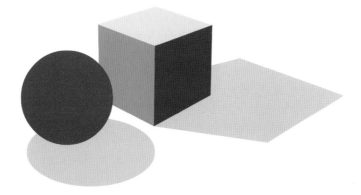

Figure 2.31 What depth cues are in this composition?

Step 2: Add a gradient fill

Gradients can create convincing 3D effects in Flash. Select the red circle on the Stage. Go to the Tools palette and click on the Color Fill swatch. This opens the Color Swatches pop-up palette. Select a red gradient fill swatch at the bottom of the palette (Figure 2.32). The red color in the ball will change to a circular gradient that blends red and black together.

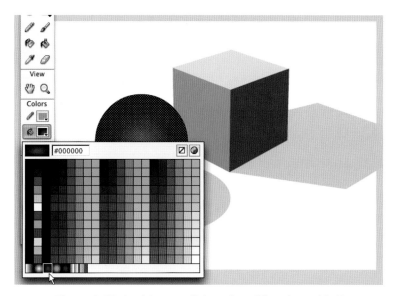

Figure 2.32 Applying a radial gradient fill to the red ball

Step 3: Use the Gradient Transform tool

Select the Gradient Transform tool in the Tools palette. This tool modifies a gradient fill within a shape. There are different transformers available with this tool. Each transformer adjusts the gradient fill to create a more believable three-dimensional object. Let's take a closer look at a couple of the transformers (Figure 2.33).

The center handle moves the center point of the gradient. Based on the cast shadows, there is a light source above and to the left of the primitive shapes. The gradient fill should also reflect this. Click on the center handle and move it up and to the left.

The scale transformer is the middle handle on the right. It scales the gradient symmetrically. Click on this handle and drag to the right to increase the scale evenly. Dragging to the left reduces the scale. The red circle now looks more like a three-dimensional sphere.

Step 11: Create a movie clip symbol

Make sure the cube's shadow is still selected. Select Modify > Convert to Symbol. The Symbol Properties dialog box appears. Type in **cube Shadow** for the name. Make sure the type is set to Movie clip (Figure 2.41). Click OK. The reason you are creating a movie clip out of the shadow is so that you can apply a Blur filter to it. Filters cannot be applied to basic shapes on the Stage.

Figure 2.41 Symbol Properties dialog box

Step 12: Add the Blur filter

Go to the Properties palette again and click on the Filters tab. Click on the "+" to add a new filter to the instance. Select Blur from the drop-down menu. Instantly the object is blurred on the Stage. The Blur filter can be adjusted horizontally (Blur X) and vertically (Blur Y). Increase the Blur X factor to 10. Keep the Blur Y factor at 5.

Step 13: Create another movie clip and add a Blur filter

Click on the sphere's shadow. Select Modify > Convert to Symbol. The Symbol Properties dialog box appears. Type in **sphere Shadow** for the name. Make sure the type is set to Movie clip. Click OK. Go to the Filters tab and add the Blur filter to the shadow movie clip instance. Increase the Blur X and Blur Y factor to 10.

Step 14: Create a new layer

Click on Insert Layer button. Rename the layer to **highlight**. Put the layer at the top of the Timeline. A highlight will give the sphere a shiny look and feel.

Step 15: Create a highlight shape

Select the Oval tool from the Tools palette. Set the Stroke Color to none and the Fill Color to white. On the highlight layer draw a small white oval near the top of the sphere (Figure 2.42).

Figure 2.42 Highlight

41

Step 16: Create another movie clip and add a Blur filter

Make sure the highlight shape is still selected. Select Modify > Convert to Symbol. Type in **highlight** for the name. Make sure the type is set to Movie clip. Click OK. Go to the Filters tab and add the Blur filter to the shadow movie clip instance. Increase the Blur X and Blur Y factor to 15. This feathers the edge and creates a more realistic highlight.

Step 17: Rotate the highlight

Select the Free Transform tool from the Tools palette. Rotate the highlight instance slightly to the left (Figure 2.43).

Step 18: Save and test movie

This completes the exercise. Save your file. Select Control > Test Movie to see the final results. As you can see, gradients can greatly enhance the shading of an object and produce a more realistic illusion of depth. The next exercise applies gradients to a character to reproduce soft shading.

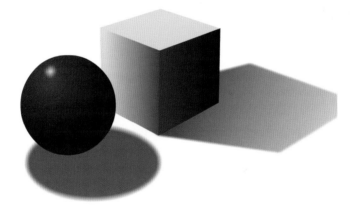

Figure 2.43 Completed gradient exercise

Exercise 2.4: Creating Soft Shading

Step 1: Getting started

Open the file 2_4_softShade.fla in the Chapter 2 folder. This exercise reproduces soft-shading techniques that many high-end animation companies use to simulate three-dimensional objects (Figure 2.44). It builds on the previous two exercises. The Flash movie contains the artwork you need to complete this exercise. The different parts of the cartoon character have been divided up into separate layers in the Timeline.

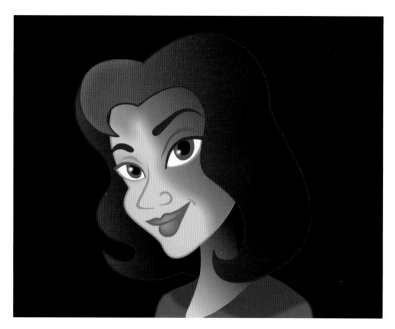

Figure 2.44 Soft-shading technique

Step 2: Add new swatches to the color palette

Let's start with the hair. Record the brown color being used. This will be one of the blended colors in the linear gradient applied in the next step. Open the Color Swatches tab in the Color panel. Select the Eyedropper tool from the Tools palette. Click on the brown hair. The color swatch appears in the Color Swatches panel (Figure 2.45).

Figure 2.45 Adding color swatch to the palette

Step 3: Add a linear gradient fill

Select the hair shape in front of the woman's face and add the grayscale linear gradient. Go to the Color Mixer panel. Double-click on the white (left) color pointer. Select the light brown color swatch added in Step 2.

43

Step 4: Use the Gradient Transform tool

Select the Gradient Transform tool in the Tools palette. Click on the rotate handle and drag to the left to rotate the linear gradient slightly. Click on the scale handle and close up the span between the blended colors. Click and drag the move handle to reposition the gradient in the hair (Figure 2.46).

Figure 2.46 Gradient Transform tool

Step 5: Add a linear gradient fill

Select the hair shape behind the woman's face and add the grayscale linear gradient. Repeat Steps 3 through 4 to modify the gradient fill in the hair (Figure 2.47).

Step 6: Select a fill color

Next, we will focus on shading the head. Go to the Tools palette and click on the Color Fill swatch. This opens the Color Swatches pop-up palette. Select the light brown color swatch added in Step 2.

Step 7: Create a new layer and adjust the stacking order

Click on Insert Layer button. Rename the layer to **shadow**. Position the new layer in between the `head` and `face` layers in the Timeline.

Figure 2.47 Gradient Transform tool

Step 8: Paint the surface shading

With the Brush tool selected from the Tools palette, move the cursor over the head. Click and drag to start painting the surface shading (Figure 2.48). When you are done painting, release the mouse.

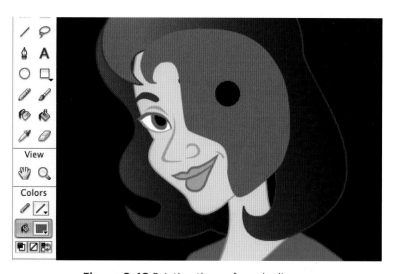

Figure 2.48 Painting the surface shading

Step 9: Add a linear gradient fill

Select the surface shading shape you just created and add the grayscale linear gradient. Go to the Tools palette and click on the Color Fill swatch. This opens the Color Swatches pop-up palette. Select the first grayscale gradient fill swatch at the bottom of the palette.

Go to the Color Mixer panel. Double-click on the white (left) color pointer. Select the color swatch #FFCC99. Double-click on the black (right) color pointer. Select the brown hair color swatch added in Step 2 (Figure 2.49).

Step 10: Use the Gradient Transform tool

Select the Gradient Transform tool in the Tools palette. Click on the rotate handle and drag to the left to rotate the linear gradient slightly. Click and drag the move handle to reposition the gradient (Figure 2.50).

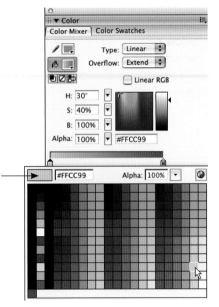

Figure 2.49 Color Mixer

Figure 2.50 Gradient Transform tool

Step 11: Create a movie clip and add a Blur filter

Adding the Blur filter to the shadow will produce the soft-shading effect. First, the shadow needs to be converted into a movie clip. Click on the shadow. Select Modify > Convert to Symbol. The Symbol Properties dialog box appears. Type in **face shading** for the name. Make sure the type is set to Movie clip. Click OK. Go to the Filters tab and add the Blur filter to the shadow movie clip instance. Increase the Blur X and Blur Y factor to 25. This produces the soft shading (Figure 2.51).

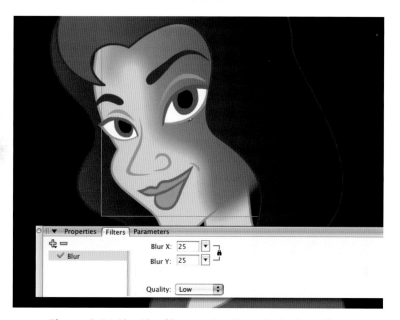

Figure 2.51 The Blur filter creates the soft shading effect.

Step 12: Copy and paste the head fill into a new layer

Some of the soft shading spills out of the head shape and onto the neck. A mask layer will correct this. A mask layer defines a visible area that reveals a nested layer below. For this exercise, the shadow layer created in Step 7 will be the nested layer. The visible area that will restrict the soft shading only to the head will be the head color fill itself.

Click on the Selection tool from the Tools palette. Select the filled shape in the head layer and copy it (Edit > Copy). Do not select the stroke surrounding the head shape. Only the fill is needed. Create a new layer above the shadow layer. Rename it to **Mask shadow**. Paste the filled shape in place (Edit > Paste in Place). This keeps the registration of the pasted shape consistent to the head color fill shape.

47

Step 13: Create a mask layer

Make sure that the `Mask shadow` layer is selected in the Timeline. On a Mac, Control+click on the layer and select Mask. On a PC, right-click and select Mask. The mask uses the head color fill to reveal the soft-shading layer below. Notice that the `shadow` layer in the Timeline has indented to show that it is a nested layer. The areas of shading that spilled out of the head are now hidden (Figure 2.52).

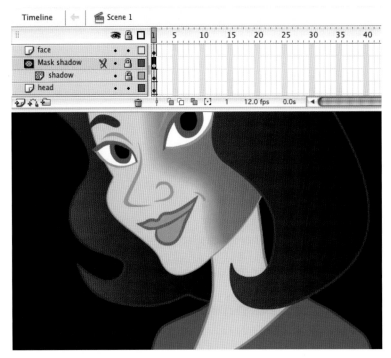

Figure 2.52 Results of the mask layer

Step 14: Add a linear gradient fill

Shading the woman's neck is next. Select the neck shape and add the grayscale linear gradient. Go to the Color Mixer panel. Double-click on the white (left) color pointer. Select the color swatch #FFCC99. Double-click on the black (right) color pointer. Select the dark brown color swatch #663300.

Step 15: Use the Gradient Transform tool

Select the Gradient Transform tool in the Tools palette. Click on the rotate handle and drag to the left to rotate the linear gradient slightly. Click and drag the move handle to reposition the gradient (Figure 2.53).

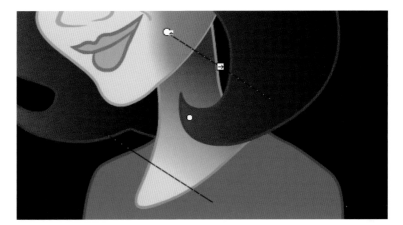

Figure 2.53 Gradient Transform tool

Step 16: Select a fill color

Let's add soft shadows to the woman's shoulders. Select the Eyedropper tool from the Tools palette. Make sure the fill color is also selected in the Tools palette. Move the cursor over the blue shirt and click. You have just stored that blue color. Go to the Color Mixer. Make sure you are using the HSB color settings. Decrease the brightness value (B) from 60% to 45%. This creates a new fill color to paint with. The new, darker, blue color will provide the surface shading.

Step 17: Create a new layer and adjust the stacking order

Click on Insert Layer button. Rename the layer to **shirt shadow**. Position the new layer in between the `shoulders` and `neck` layers in the Timeline.

Step 18: Paint the surface shading

With the Brush tool selected from the Tools palette, move the cursor over the shoulder. Click and drag to start painting the surface shading (Figure 2.54). When you are done painting, release the mouse.

Figure 2.54 Painting the surface shading

Step 19: Create a movie clip and add a Blur filter

Click on the shirt shadow. Select Modify > Convert to Symbol. The Symbol Properties dialog box appears. Type in **shirt shading** for the name. Make sure the type is set to Movie clip. Click OK. Go to the Filters tab and add the Blur filter to the shadow movie clip instance. Increase the Blur X and Blur Y factor to 10 (Figure 2.55).

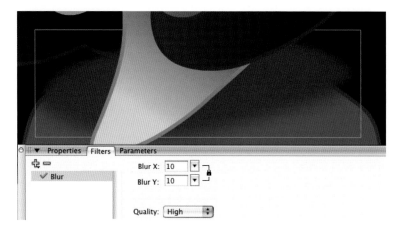

Figure 2.55 The Blur filter creates the soft-shading effect.

Step 20: Copy and paste the shoulder fill into a new layer

Click on the Selection tool from the Tools palette. Select the filled shape in the shoulder layer and copy it (Edit > Copy). Create a new layer above the shirt shadow layer. Rename it to **Mask shirt**. Paste the filled shape in place (Edit > Paste in Place). This keeps the registration of the pasted shape consistent to the shoulders' color fill shape.

Step 21: Create a mask layer

Make sure that the Mask shirt layer is selected in the Timeline. On a Mac, Control+click on the layer and select Mask. On a PC, right-click and select Mask. The areas of shading that spilled out are now hidden.

Step 22: Save and test movie

This completes the exercise. Save your file. Select Control > Test Movie to see the final results. To further enhance the composition, add some white highlights to the eyes. Follow the same procedure from the previous exercise to create the highlights. See Figure 2.44 for the completed look. The last exercise wraps up this chapter on illustrating depth cues. It continues to explore the filters to create a drop shadow.

Exercise 2.5: Casting Shadows

Step 1: Getting started

Open the file `2_5_Shadows.fla` in the Chapter 2 folder. This Flash movie contains the artwork you need to complete this exercise. Here we have a snowboarder on the Stage (Figure 2.56). The artwork is an instance of the movie clip `MC_snowBoarder`. The movie clip is located in the Library.

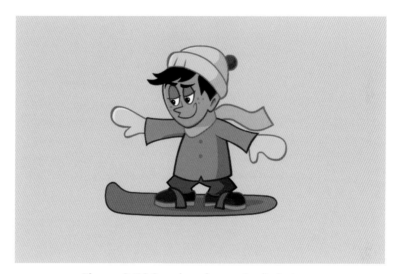

Figure 2.56 Snowboarder movie clip instance

Step 2: Duplicate the instance

Click on the snowboarder and select Edit > Duplicate. A copy appears on top of the original artwork. Click and move the duplicated snowboarder off the original so that you will be able to see the drop shadow effect more clearly.

Step 3: Add Drop Shadow filter

Make sure the duplicated snowboarder is still selected. Go to the Properties palette and click on the Filters tab. Click on the "+" to add a new filter to the instance. Select Drop Shadow from the drop-down menu. Instantly a drop shadow appears underneath the duplicated snowboarder (Figure 2.57). The drop shadow adds the illusion of depth, but currently it is not the desired effect we need for this exercise. The shadow needs to visually establish a ground for our snowboarder to rest on. It will also assist in simulating a directional light source.

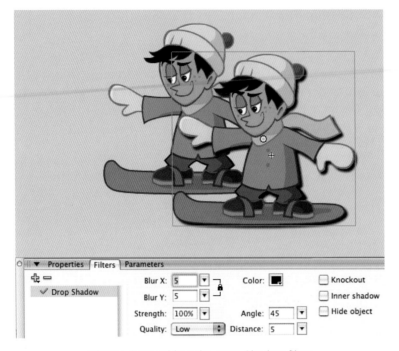

Figure 2.57 Adding the Drop Shadow filter

Step 4: Adjust drop shadow settings

We want to see only the drop shadow, so check the Hide Object box. Adjust the Strength from 100% to 30%. Change the blur factor from 5 to 10 for Blur X and Y. These settings will help make the shadow more convincing in illustrating depth.

Step 5: Skew the drop shadow

Skewing the drop shadow horizontally will add perspective. The Skew tool is found in the Transform palette. Open the Transform palette (Window > Transform). Click on the radio button for Skew and enter 45 degrees in the Skew Horizontally text box.

Step 6: Flip the drop shadow vertically

Choose Modify > Transform > Flip Vertical. This will flip the drop shadow so that it acts more like a cast shadow from the original snowboarder.

Step 7: Scale the drop shadow

Select the Free Transform tool from the Tools palette. Position the cursor over the top-middle handle. Click and drag down to scale the drop shadow vertically. Position the drop shadow at the base of the original snowboarder (Figure 2.58).

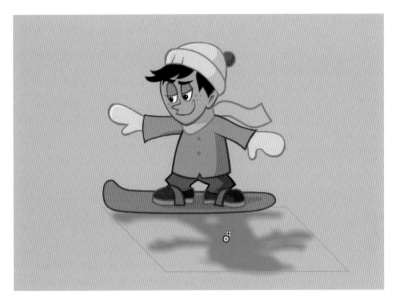

Figure 2.58 Positioning the drop shadow under the snowboarder

Step 8: Adjust stacking order

Remember that each layer has its own stacking order. The drop shadow is stacked on top of the original snowboarder art. This is a result of the duplication process. To fix the stacking order, select Modify > Arrange > Send to Back. The drop shadow is now underneath the snowboarder, completing the illusion of depth.

Select Control > Test Movie. Notice that the movie clip of the snowboarder animates and that the shadow also mimics the movements. Save your file.

This exercise explored the possibility of using the Drop Shadow filter to simulate a cast shadow from a light source. Typically drop shadows are used for buttons or text. Experiment with these filters and tools. With a few simple steps you can simulate three-dimensional space. As you can see with this finished example, Flash has the ability to add movement to static images.

Summary

This chapter focused on depth perception and how to reproduce it through visual cues. Key concepts to remember include the following:

- Visual depth cues Include linear perspective, relative image size, interposition, aerial perspective, light and shadows, surface shading, and texture gradient.

- Relative size deals with scale. Objects larger in scale are perceived to be in closer proximity to the viewer than smaller scaled objects.

- Interposition deals with overlapping images to simulate depth.

- A depth change in coloring and clarity is known as aerial perspective.

- Light and shadows are essential in creating the illusion of three-dimensional space. Without these two elements, objects would appear flat. Highlights are a result of light illuminating or reflecting off an object. Shadows exist where the light cannot reach.

The visual depth cues studied in this chapter simulate depth to a certain degree. Movement adds life to a two-dimensional world. The next chapter expands on the visual depth cues you learned by adding the elements of motion and time.

3

Animating Depth:
Tweening Movement

The previous chapter explored visual depth cues and techniques that reproduce them within a two-dimensional world such as Flash. These visual depth cues add dimension to a still image. Let's review these visual cues. Figure 3.1 contains relative size, interposition, shadows, aerial perspective, and texture gradients. This collection of visual cues depicts depth to a certain degree. As the viewer, we can determine what is foreground, middle ground, and background. As a static image, the scene has gone as far as it can in portraying a three-dimensional world.

Figure 3.1 Combined depth cues

Movement further enhances our perception of depth. Animation is an illusion. It is a representation of movement or change in time. In Flash, animation can be achieved through the movement of an object's position or a change in its appearance over time. The key words are *change* and *time*. Each Flash file contains a Timeline that allows

you to change an object's properties over time. Each frame in the Timeline represents a single moment in time. By changing the content in each frame, you create an animation. This chapter focuses on movement to enhance depth perception. When you have finished reading the chapter, you will be able to

- Describe parallax scrolling
- Describe the animation concept of tweening
- Create motion tweens in Flash
- Reproduce camera movements in Flash

Parallax Scrolling

Remember the last time you were riding in a car looking out at the passing landscape. The car was moving at a consistent speed, but different parts of the landscape appeared to be moving at different speeds. Objects farthest away, such as rolling hills, appear smaller and move slower when compared to objects in the foreground that race past the car. How does this happen?

The illusion is caused by two factors. One is your viewing position or vantage point, and the other is the relative distance the objects are from you. Take a look at the following example (Figure 3.2). Imagine you are in a helicopter looking straight down on three people crossing a street. Each person moves the same distance in the same amount of time. From your viewpoint above, you witness a consistent speed and distance traveled.

Figure 3.2 Top view

Now imagine yourself sitting in a car watching the same three people cross the street. Your vantage point has changed. The speed and distance traveled appear to differ for each person (Figure 3.3). Why?

Figure 3.3 Side view

It all relates to our perception of depth. The person farthest away is not actually moving slower or traveling less ground. When we changed our vantage point from looking straight down to eye level, we see more of the space surrounding each person. Each person moves relative to the space they occupy. Objects closer to us will appear to travel farther and move more quickly than objects farther away.

Flash Animation Methods

Before we apply this principle, let's take a look at animation methods within Flash. As mentioned at the beginning of this chapter, Flash contains a Timeline that keeps track of objects on the Stage over time. This Timeline is divided into frames. Each frame represents a single moment in time. By changing the content in each frame over a period of time, you create an animation. How do you change the content?

The most basic animation method is called frame-by-frame animation. Each frame is manually changed by you over a certain period of time. Figure 3.4 demonstrates a typical example of a frame-by-frame animation—a walk cycle. The figure shows six frames out of a 15-frame animation created in Poser, a 3D application. Each frame contains a different image of a boy walking in place. When each frame is played one after another, the illusion of movement is achieved. To see this in action, go to the Chapter 3 folder on the accompanying CD and open the file `3_1_FramebyFrame.fla`.

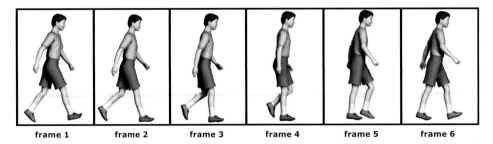

| frame 1 | frame 2 | frame 3 | frame 4 | frame 5 | frame 6 |

Figure 3.4 Frame-by-frame animation

`3_1_FramebyFrame.fla` contains the boy walking in place at the center of the Stage. He is an instance of a movie clip symbol. Double-click on the instance to open its Timeline. Notice that each frame in the Timeline holds a black dot (Figure 3.5). Each dot represents a keyframe. Keyframes signify change. In animation, a keyframe artist would draw only the significant changes to a character or object. Since each frame requires a new graphic to complete the walk cycle, every frame is a keyframe.

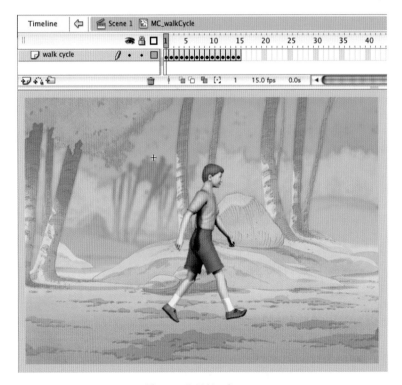

Figure 3.5 Keyframes

Tweening is another popular animation method in Flash. What is a tween? Since a key-frame artist creates only the significant changes within an animation, another artist fills in the transitional frames between each keyframe, hence *tweening*. Flash has two types of tween features: shape and motion. A shape tween allows you to move, scale, rotate, change color, and morph only shapes drawn directly on the Stage. A motion tween allows you to animate only symbol instances or grouped objects on the Stage. Let's create a simple motion tween.

Exercise 3.1: Basic Motion Tween

Step 1: Getting started

Make sure the file `3_1_FramebyFrame.fla` in the Chapter 3 folder is still open in Flash. If you have been following along with the chapter, close out of the instance Timeline by clicking on Scene 1. There are many Timelines within Flash. Every Flash file contains a root Timeline (Scene 1). Every symbol has a unique Timeline. To see which Timeline is currently being displayed on the Stage, look at the icons at the top of the Timeline.

Step 2: Create a starting point

You are going to animate the boy walking across the Stage. In Scene 1, click and drag the boy to the left of the Stage. This will represent the first keyframe in the animation (Figure 3.6). It will be the starting position for the boy.

Figure 3.6 Positioning the boy on the left side of the Stage

Step 3: Insert a new keyframe

Go to the Timeline and select the empty cell at frame 60. Choose Insert > Timeline > Keyframe. A new keyframe will appear at frame 60 (Figure 3.7). Select the `background` layer and click on the empty cell at frame 60. Choose Insert > Timeline > Frame. This extends the background image to remain on the same number of frames as the boy.

Figure 3.7 Inserting a new keyframe at frame 60

Step 4: Set the ending position

Just like a traditional keyframe artist would do, create a significant change. For this exercise the change will be the boy's location on the Stage at frame 60. Make sure the time marker (red vertical bar) is at frame 60. Click and drag the boy to the right of the Stage. This will represent the second keyframe in the animation (Figure 3.8).

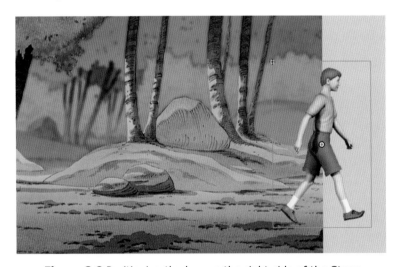

Figure 3.8 Positioning the boy on the right side of the Stage

Step 5: Create a motion tween

Now that you have established a start keyframe and an end keyframe, it is time to let Flash do all the hard work by filling in the transitional frames in between. Select the `walker` layer in the Timeline. Click on the first keyframe on frame 1. Go to the

Properties palette. Each keyframe you create can have a tween applied to it. Click on the Tween drop-down menu and select Motion (Figure 3.9). In the Timeline you will see the frames in between both keyframes turn blue with a line pointing to the last keyframe (Figure 3.10). This indicates that a motion tween has been applied.

Figure 3.9 Applying a motion tween

Figure 3.10 Motion tween applied in the Timeline

Step 6: Save and test your movie

Save your file as 3_2_MotionTween.fla. Choose Control > Test Movie to see the finished results. This exercise demonstrates two animation methods in Flash. The walk cycle is a frame-by-frame animation made up of 15 unique images, one frame after another. The movement across the Stage is a tweened animation. Flash created all the transitional frames required between a starting keyframe and an ending keyframe. Now that you can animate in Flash, let's simulate some depth using the tweening method.

Exercise 3.2: Parallax Scrolling Using Bitmap Images

How do artists achieve depth in their paintings? They paint objects in the foreground, middle ground, and background. Think of each ground as a separate layer in Flash. To achieve parallax scrolling, each layer must move at a different speed. Let's experiment.

Step 1: Getting started

Open the file 3_3_parallaxTween.fla in the Chapter 3 folder on the accompanying CD. In this exercise you will create a scrolling background similar to the ones seen in Saturday morning cartoons. A completed version is provided in the Chapter 3 folder on the CD. To see the finished results, locate and play 3_3_parallaxTween_DONE.swf (Figure 3.11).

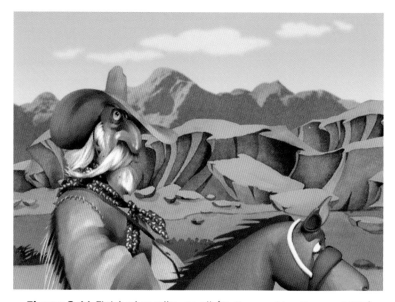

Figure 3.11 Finished parallax scroll (3_3_parallaxTween_DONE)

Step 2: Set up the Timeline

The Timeline contains one layer labeled sky. This layer will hold the sky and clouds graphic. To achieve depth in this exercise, we will need a foreground, a middle ground, and a background layer. Create three new layers and rename each accordingly. Remember the stacking order in Flash: items in a higher layer will appear on top of items in a lower layer. Make sure the foreground layer is on top (Figure 3.12).

Figure 3.12 Creating three new layers in the Timeline

Step 3: Add the graphics to the layers

The Library contains all the files that you need to complete this exercise. If it is not visible, open the Library (Window > Library). Each layer's artwork has been created in a graphic symbol.

Click and drag each graphic symbol to the appropriate layer: GRAPHIC fore is put on the foreground layer, GRAPHIC middle goes on the middleground layer, GRAPHIC back goes on the background layer and finally, GRAPHIC sky goes on the sky layer.

Step 4: Reposition graphics on the Stage

Reposition all the graphics on the Stage to create your background composition (Figure 3.13). Make sure that the left edge of each graphic is aligned to the left edge of the Stage. The widths of the graphics were built larger than the Stage width to achieve the scrolling effect. They will extend beyond the right side of the Stage.

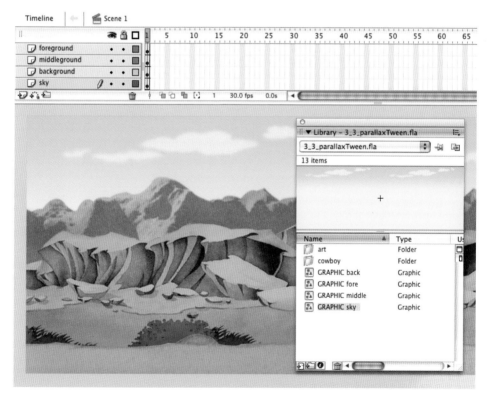

Figure 3.13 Creating your background composition

Step 5: Hide layers

With the composition in place, it is time to create the scrolling animation. Let's start with the foreground layer. Before we do this, hide all the layers except the `foreground` layer (Figure 3.14). This will allow you to see the Stage when creating the tweens.

Figure 3.14 Hiding all the layers except the foreground layer

Step 6: Create a movie clip

Currently the bitmap image of the foreground is contained within a graphic symbol. Symbols help reduce the file size of the published Flash file. Flash stores the symbol once in memory and allows you to create as many copies as needed without affecting the file size. There are three types of symbols in Flash: movie clip, button, and graphic.

We are going to nest this graphic symbol in a movie clip. Why? Graphic symbols and movie clips both contain their own Timelines, separate from the root Timeline that you are working on now. However, when these symbols are placed on the root Timeline, they behave differently. Let's examine this more closely.

A movie clip's Timeline plays independently from the root Timeline. If we create a ten-frame animation in a movie clip and drag that movie clip to just one frame in the root Timeline, Flash will play all ten frames when published even though the movie clip occupies just one frame in the root Timeline. A graphic symbol's Timeline is linked directly to the root Timeline. If we take the previous example and use a graphic symbol instead of a movie clip, Flash will play only the first frame of the ten-frame animation when published. In order to see all ten frames, the graphic symbol would need to occupy ten frames in the root Timeline.

To simulate a parallax scroll, each layer will contain a motion-tweened animation that varies in lengths of time. We use the graphic symbol to create the motion tween. Remember that motion tweens work only with symbols or grouped objects. This motion tween is stored within a movie clip, which gives us the ability to layer several animations together on one frame. Each animation can then be different in time.

Single-click on the foreground image to select it. Choose Modify > Convert to Symbol. A dialog box appears. Enter **MC scrollingFore** for the name. Make sure to set the type to "Movie clip." The registration should be in the center (Figure 3.15). Click OK. You have just nested a graphic symbol within a movie clip.

Figure 3.15 Converting a symbol to a movie clip

Step 7: Open the movie clip's Timeline

Double-click on the foreground image to open the movie clip's Timeline. The Timeline will change to display one layer that holds the graphic symbol of the foreground image. You can still see the Stage in the background. Basically, you have opened another Timeline on top of the root Timeline.

If you get lost, look at the icons at the top of the Timeline window (Figure 3.16). They indicate the current Timeline that you are working on. To return to the root Timeline, click on Scene 1. All other Timelines will close to reveal only the root Timeline.

Figure 3.16 Opening the movie clip to reveal its Timeline

Step 8: Create a motion tween

In the Timeline, click on the empty cell at frame 60. Choose Insert > Timeline > Keyframe. Go to the Stage and click and drag the foreground image to the left. Drag it until the right edge of the graphic aligns with the right edge of the Stage (Figure 3.17).

Figure 3.17 Clicking and dragging the image to the left at frame 60

Go to the Timeline and select the first keyframe on frame 1. Go to the Properties palette. Click on the Tween drop-down menu and select Motion (Figure 3.18).

Figure 3.18 Applying a motion tween

Step 9: Test your movie

Save your file. Choose Control > Test Movie to see the finished results. The foreground layer is scrolling while the other layers remain static. Notice that there is a slight pause in the motion every once and a while. This can be easily fixed within the motion tween to create a smoother animation.

What is causing the slight pause? The answer is in the artwork itself. Figure 3.19 illustrates how the artwork was created in Photoshop to achieve a seamless scroll.

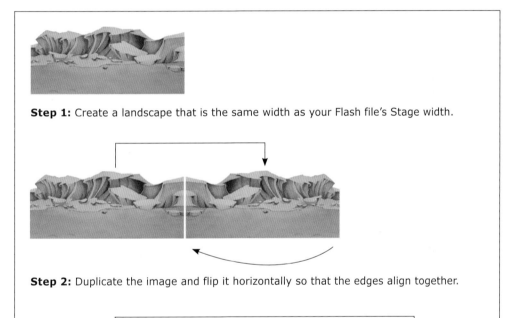

Step 1: Create a landscape that is the same width as your Flash file's Stage width.

Step 2: Duplicate the image and flip it horizontally so that the edges align together.

Step 3: Duplicate the initial landscape again and add it to the end of the flipped copy.

Figure 3.19 Creating a seamless scrolling image in Photoshop

As you can see in Figure 3.19, the first and last sections of the scrolling artwork are identical. So, our motion tween holds two keyframes that contain the same imagery:

frame 1 and frame 60. By default, movie clips loop unless you script them not to. For this exercise we want to take advantage of the loop. That is what is creating the constant scrolling. The problem lies within the keyframes. As the playback head leaves frame 60, it goes back to display the content on frame 1. It is the same image, and that is what is causing the slight pause in motion (Figure 3.20).

Figure 3.20 Frames 1 and 60 display the same content, which causes a pause in the motion.

Step 10: Correct the motion tween to achieve a seamless scroll

Fixing this problem is very easy. We know that the first and last keyframe contain the same imagery. Go to the Timeline and select frame 59. This is the frame just before the last keyframe. Choose Insert > Timeline > Keyframe. This new keyframe records the image's position at that point in time. The position is different from that of frame 1 yet still maintains the correct tween (Figure 3.21).

Figure 3.21 Creating a new keyframe on frame 59 to record the image's position

Step 11: Delete the last keyframe

You no longer need the last keyframe. Select the keyframe in frame 60. Choose Edit > Timeline > Remove Frames. Save and test your movie. The pause is now eliminated, and the scroll is seamless. Close the published file. Go to the Timeline and click on the Scene 1 icon to return to the root Timeline.

Step 12: Animate the middleground layer

Turn on the `middleground` layer's content. Select the graphic symbol on the Stage and convert it to a movie clip (Modify > Convert to Symbol). Name it **MC scrollingMiddle** and make sure the type is set to "Movie clip" (Figure 3.22).

Figure 3.22 Converting a symbol to a movie clip

Double-click on the middle ground image to open the movie clip's Timeline. In the Timeline, click on the empty cell at frame 180. Choose Insert > Timeline > Keyframe. Go to the Stage and click and drag the middle ground image to the left. Drag it until the right edge of the graphic aligns with the right edge of the Stage (Figure 3.23).

Figure 3.23 Clicking and dragging the image to the left at frame 180

69

Go to the Timeline and select the first keyframe on frame 1. Go to the Properties palette. Click on the Tween drop-down menu and select Motion. Save and test your movie.

The middle ground contains 180 frames, which cause it to take three times longer to complete its motion tween than it takes the foreground (60 frames). These different speeds create an illusion of depth (Figure 3.24) through parallax scrolling. Objects closer to us will appear to travel farther and move more quickly than objects farther away.

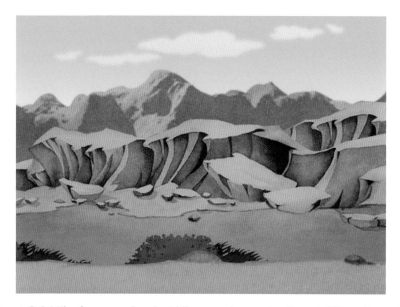

Figure 3.24 The foreground and middle ground are animating at different speeds.

To correct the slight pause in the motion, select frame 179 and insert a keyframe to record the image's position. Select the keyframe in frame 180. Choose Edit > Timeline > Remove Frames (Figure 3.25). Save and test your movie.

Figure 3.25 Creating a new keyframe on frame 179 and removing the keyframe at 180

Close the published file. Go to the Timeline and click on the Scene 1 icon to return to the root Timeline.

Step 13: Animate the background layer

Turn on the `background` layer's content. Select the graphic symbol on the Stage and convert it to a movie clip (Modify > Convert to Symbol). Name it **MC scrollingBack** and make sure the type is set to "Movie clip" (Figure 3.26).

Figure 3.26 Converting a symbol to a movie clip

Double-click on the background image to open the movie clip's Timeline. In the Timeline, click on the empty cell at frame 360. Choose Insert > Timeline > Keyframe (Figure 3.27). Go to the Stage and click and drag the background image to the left. Drag it until the right edge of the graphic aligns to the right edge of the Stage.

Figure 3.27 Creating a keyframe at frame 360

Go to the Timeline and select the first keyframe on frame 1. In the Properties palette, click on the Tween drop-down menu and select Motion. To correct the slight pause in the motion, select frame 359, and insert a keyframe to record the image's position. Select the keyframe in frame 360. Choose Edit > Timeline > Remove Frames.

Save and test your movie.

71

Step 14: Animate the sky layer

Turn on the `sky` layer's content. Select the graphic symbol on the Stage and convert it to a movie clip (Modify > Convert to Symbol). Name it **MC scrollingSky** and make sure the type is set to "Movie clip" (Figure 3.28).

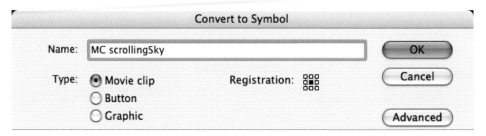

Figure 3.28 Converting a symbol to a movie clip

Double-click on the sky image to open the movie clip's Timeline. In the Timeline, click on the empty cell at frame 540. Choose Insert > Timeline > Keyframe (Figure 3.29). Go to the Stage and click and drag the sky image to the left. Drag it until the right edge of the graphic aligns with the right edge of the Stage.

Figure 3.29 Creating a keyframe at frame 540

Go to the Timeline and select the first keyframe on frame 1. In the Properties palette, click on the Tween drop-down menu and select Motion. To correct the slight pause in the motion, select frame 539 and insert a keyframe to record the image's position. Select the keyframe in frame 540. Choose Edit > Timeline > Remove Frames.

Save and test your movie. You should now have all the layers animating at different speeds, completing the parallax scroll effect. The last thing needed is a character in the foreground to give the movement meaning and purpose.

Step 15: Add the cowboy movie clip

In the Library there is a folder labeled
`cowboy`. Double-click on the folder to
open it. Locate the movie clip labeled
`MC_cowboy`.

The movie clip contains a motion tween
of the cowboy bouncing up and down.
Click and drag the movie clip to the
`foreground` layer. Position it close to the
center of the screen (Figure 3.30).

Save and test your movie.

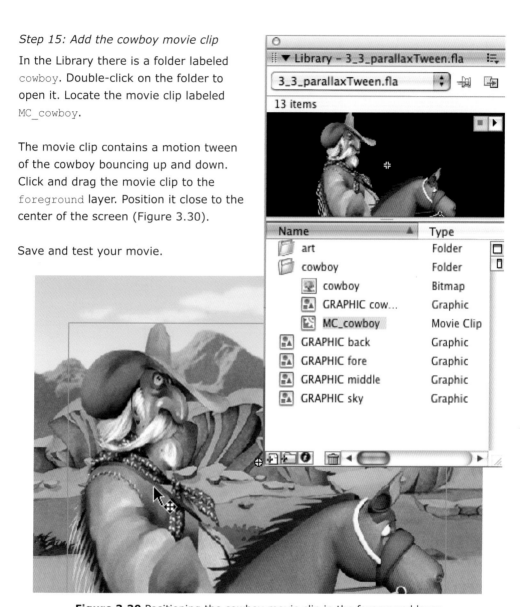

Figure 3.30 Positioning the cowboy movie clip in the foreground layer

Exercise Summary

This exercise demonstrated how to create parallax scrolling using motion tweens. The
foreground moves faster than the middle ground. The middle ground moves faster than
the background. The sky and clouds move ever so slowly. This perception is a result of
the observer's point of view riding alongside the cowboy.

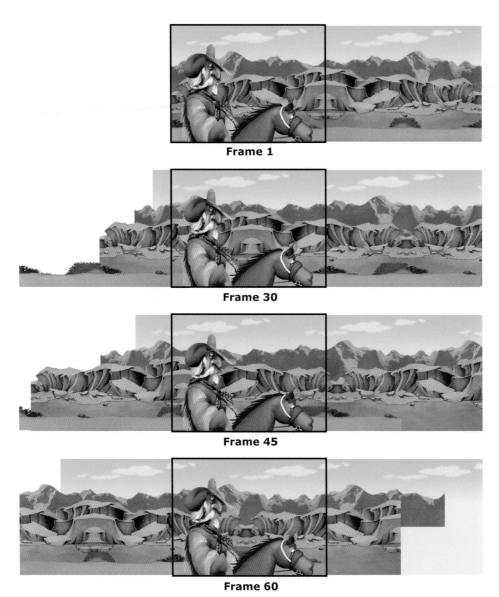

Frame 1

Frame 30

Frame 45

Frame 60

Figure 3.31 Parallax scroll over time

Figure 3.31 shows each layer's movement over time. In addition to the technical steps, the artwork was prepared specifically to achieve the seamless scroll (refer to Figure 3.19). Each layer is a bitmap image created in Photoshop and saved as a PNG file. The PNG file format retains the alpha channel for each layer. Parallax scrolling can also be applied to vector artwork created in Flash. Let's see how to create the vector artwork.

Exercise 3.3: Parallax Scrolling Using Vector Art

This exercise walks you through a similar process for creating a parallax scroll using vector art. The tweening techniques are the same to achieve the parallax movement. Creating the scrolling artwork in Flash takes some preparation. This exercise focuses on the preparation. The completed version is provided in the Chapter 3 folder on the CD. To see the finished results, play `3_4_parallaxVector_DONE.swf` (Figure 3.32).

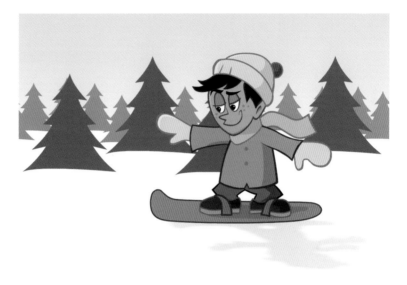

Figure 3.32 Finished parallax scroll (`3_4_parallaxVector_DONE`)

Step 1: Getting started

Open the file `3_4_parallaxVector.fla` in the Chapter 3 folder. This Flash movie contains the artwork you need to complete this exercise. The Timeline contains four layers: `sky and ground`, `background`, `middleground`, and `foreground`. The `foreground` layer contains the snowboarder and his drop shadow from Chapter 2. He will remain in this position on the Stage. The illusion of movement and depth will be achieved through the tweening of the pine trees.

Step 2: Hide layers

Let's start with the `background` layer. Before we do this, hide all the layers in the Timeline except the `background` layer. This will allow you to see the Stage when creating the scrolling artwork. It is good practice to get in the habit of hiding or locking layers that you are not working on. This will prevent any accidental changes that could take time to correct later on.

Step 3: Reposition the tree

The pine tree is vector art created in Flash using the Pen tool. It has been converted into a movie clip. Click and drag the tree instance to the left edge of the Stage. Center the top of the tree to the left edge of the Stage (Figure 3.33).

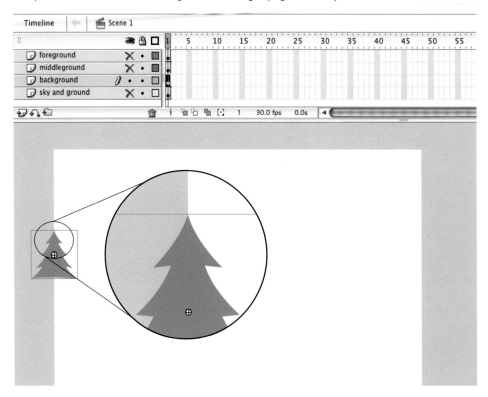

Figure 3.33 Dragging the tree to the left edge of the Stage

Step 4: Copy and paste in place

While the tree is still selected, choose Edit > Copy. Then choose Edit > Paste in Place. This creates a duplicate copy of the tree in the same position, on top of the original.

Step 5: Reposition the duplicated tree

Click and drag the pasted tree to the right edge of the Stage. Hold down the Shift key while dragging the tree. This will constrain its vertical movement as you drag. Center the top of the tree to the right edge of the Stage. At this point you should have two trees on the Stage. Both trees are at the same vertical position. Why do this?

In order for the parallax scrolling to appear as continuous movement, both ends of the scrolling graphic must match. You accomplished this by duplicating the tree in the same position and dragging it to both ends of the Stage (Figure 3.34).

Figure 3.34 Both ends must match for the parallax scrolling to work.

Step 6: Create a forest

Two trees are boring. We want to create a forest of trees. Since a tree is still copied to the computer's clipboard, paste in several more trees. Fill in the space between each end tree. Position these trees wherever you want (Figure 3.35).

Figure 3.35 Pasting several copies of trees and positioning them

Step 7: Double the width of the forest (Part 1)

You completed one requirement for the parallax scroll to work—both ends must match. The second requirement is that the scrolling graphic must be at least twice the width

of the Stage in order to create the illusion of continuous movement. Currently our row of trees is the same size as the Stage width. Let's fix that. Select all your trees and choose Edit > Copy. Then select Edit > Paste in Place. You have duplicated the forest and pasted it exactly on top of the original row of trees.

Step 8: Double the width of the forest (Part 2)

While the pasted trees are still selected, click and drag them to the left. Hold down the Shift key to constrain vertical movement. Align the tree that was on the right edge of the Stage to the one on the left edge. You have now doubled the width of your forest and still maintained matching ends (Figure 3.36).

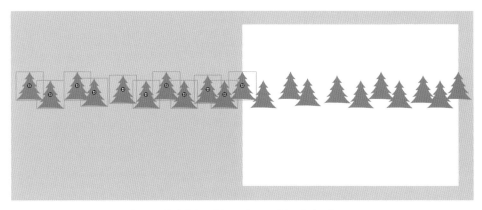

Figure 3.36 Doubling the width of the forest

Step 9: Delete a duplicate tree

There is one tree too many. Select the tree in the middle of the forest and delete it. You are now left with the original tree that you moved in Step 3.

Step 10: Group the trees into a graphic symbol

Group all the trees together. Select all the trees and convert them into a graphic symbol (Modify > Convert to Symbol). Name it **forest Back** and make sure the type is set to Graphic (Figure 3.37). This will make it easier to animate later.

Figure 3.37 Converting all the trees to a graphic symbol

Step 11: Create a movie clip

Nest the graphic symbol in a movie clip (choose Modify > Convert to Symbol). Name it **MC_scrollingBack** and make sure the type is set to "Movie clip" (Figure 3.38). Why?

A movie clip's Timeline plays independently from the root Timeline. To simulate a parallax scroll, each layer will contain a motion-tweened animation that varies in lengths of time. We tween the graphic symbol inside the movie clip. The movie clip gives us the ability to layer several animations together on one frame.

Figure 3.38 Converting to movie clip

Step 12: Create a keyframe

Double-click on the movie clip that you just created. This opens its Timeline. Here you will create a motion tween using the nested graphic symbol. Click on the empty cell at frame 60. Choose Insert > Timeline > Keyframe.

Step 13: Reposition the graphic

Make sure the time marker is still at frame 60. Select the row of trees on the Stage. Click and drag the trees to the right. Hold down the Shift key while dragging to constrain the vertical movement. Align the tree on the left end of the graphic symbol to the left edge of the Stage (Figure 3.39).

Figure 3.39 Repositioning the trees

79

Step 14: Create a motion tween

Click on the first keyframe on frame 1. Go to the Properties palette. Click on the Tween drop-down menu and select Motion. Flash will generate all the in-between frames creating the scrolling movement.

Step 15: Save and test your movie

Choose Control > Test Movie. The background row of trees animates in a looping scroll. There is a slight pause due to the fact that the first frame and the last frame contain roughly the same image. Close the tested movie.

Step 16: Create a new keyframe

To correct the slight pause, create a new keyframe at frame 59. This keyframe records the movement of the graphic symbol at that point in time. Select the last keyframe and choose Edit > Timeline > Remove Frames (Figure 3.40). Save and test the movie again. Now the slight pause in the animation is eliminated.

Let's review. The animation techniques with vector art are the same as in the previous exercise, which used bitmaps. To create a continuous scroll, the artwork needs to have matching ends. The width also needs to be at least twice the width of the Stage.

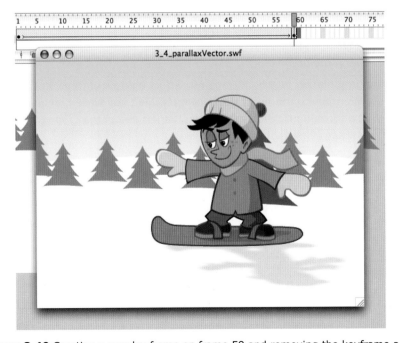

Figure 3.40 Creating a new keyframe on frame 59 and removing the keyframe at 60

Step 17: Reveal the middleground layer

Close the movie clip's Timeline by clicking on Scene 1 in the top-left corner of the Timeline. On the root Timeline, hide the `background` layer and turn on the `middle-ground` layer. This layer contains a larger pine tree.

This larger tree is an instance of the same symbol used in the background. Symbols help reduce the final file size of your document. Figure 3.41 illustrates how the tree was altered. The symbol was scaled 200% in the Transform panel. The scaling doesn't affect the quality of the image, since vector art is resolution-independent.

The color was darkened to reflect atmospheric perspective. Due to lighting conditions, objects closer to us will appear darker than objects further away. Technically, this was accomplished by selecting the movie clip instance and changing the Brightness value in the Properties panel from 100% to –30%.

Figure 3.41 Tree symbol properties for the `middleground` layer

Step 18: Animate the middleground layer

Let's see how much you have learned. The animation technique is the same as before. The only difference is the number of frames used for the scrolling movement. Instead of using 60 frames to complete its cycle, use 40 frames. Reducing the number of frames in between two key frames will speed up the animation.

This will reinforce the parallax motion. Objects closer to the viewer's perspective will appear to move faster than objects further away. Figure 3.42 summarizes the artwork preparation for the middle ground. Don't forget to correct for the slight pause in the animation. Refer to step 16 to see how to correct this. When you are done, save and test the movie.

Both ends must match for the parallax scrolling to work.

Double the width of the forest to create a continuous scroll.

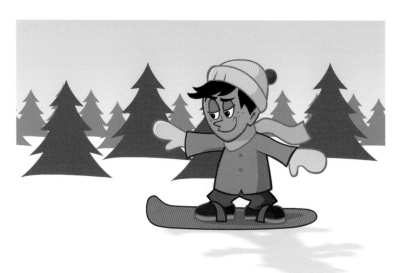

Figure 3.42 Artwork preparation and finished parallax scrolling

Cinematography in Flash

In the motion picture business, a cinematographer uses the camera to help tell the story. A moving camera adds to the sense of depth in a scene. Unfortunately, there isn't a camera tool in Flash that you can physically move around the Stage. So, if there is no camera in Flash, how do we simulate camera movements?

Moving the camera across the screen horizontally is called *panning* (Figure 3.43). The previous two exercises simulated this technique. Separate layers of artwork were motion tweened either left or right across the Stage. The difference in speed creates the illusion of depth, but the movement is still two-dimensional. The imagery is moving along the x-axis. Panning can also be vertical, in which the imagery moves along the y-axis. What about the z-axis?

Figure 3.43 Horizontal panning

Trucking is another cinematography term that describes a camera's movement (Figure 3.44). A camera moving inwards from a wide shot to a close-up shot is referred to as a *truck in*. The opposite movement is referred to as a *truck out*. Here the camera is moving along the z-axis to achieve a sense of depth. Since there is no camera to move in Flash, the image's dimensions must be scaled to simulate trucking. Let's experiment.

Figure 3.44 Truck in

Exercise 3.4: Scaling Movement

Step 1: Getting started

Open the file 3_5_scaling.fla in the Chapter 3 folder on the accompanying CD. This Flash movie contains the artwork you need to complete this exercise. The Timeline contains two layers: floor and runner. The runner layer is an instance of a movie clip. We will create a simple motion tween that incorporates scaling. Let's get started.

Step 2: Scale the runner

Select the runner on the Stage. Go to the Transform panel and scale him proportionally to 10%. Position him along the horizon line of the floor (Figure 3.45).

Figure 3.45 Scaling the runner to 10% and repositioning

Step 3: Insert a new keyframe

Go to the Timeline and select the empty cell at frame 30. Choose Insert > Timeline > Keyframe. A new keyframe will appear at frame 30. Select the floor layer and click on the empty cell at frame 30. Choose Insert > Timeline > Frame. This extends the floor image to remain on the same number of frames as the runner.

Step 4: Scale the runner

Select the runner layer in the Timeline. Click on the keyframe that you created on frame 30. Go to the Transform panel and scale him proportionally back to 100%. Position him as shown in Figure 3.46.

Figure 3.46 Scaling the runner to 100% on frame 30 and repositioning

Step 5: Create a motion tween

Now that you have established a start keyframe and an end keyframe, create a motion tween for the runner. Select the first keyframe. Go to the Properties panel and select Motion from the Tween drop-down menu.

Step 6: Save and test the movie

Test the movie. The runner scales up in size over time to simulate that he is running towards you from the background.

Exercise Summary

Scaling movement can add a lot to simulating depth in Flash. For this exercise, the object is scaled to achieve a three-dimensional look and feel. Another approach would be to scale background elements while keeping the runner in a fixed position. Locate and open the `3_5_scaleWalls.fla` file in the `Completed_Exercises` folder in Chapter 3. In this example the runner is stationary on the Stage. There are nine layers that contain an instance of a doorway movie clip. Each doorway has been scaled differently and has had its brightness adjusted to create the illusion of perspective. Each layer contains a motion tween applied over 30 frames.

Figure 3.47 Scaling and adjusting brightness for each doorway

For each layer, the first keyframe (Figure 3.47, left image) gets tweened to the last keyframe (right image). The applied motion tween changes the scale and brightness of the image.

To create the look of a never-ending tunnel, the last keyframe in each layer is very important. At this point in time, the dimensions and brightness of the doorway image are identical to the first keyframe of the doorway one layer below. The movement and brightness change created by the motion tween completes the illusion (Figure 3.48).

Figure 3.48 Running down a never-ending tunnel

Exercise 3.5: Using Trucking to Simulate Depth in Flash

Step 1: Getting started

Open the file `3_6_depthIllusion.fla` in the Chapter 3 folder on the accompanying CD. This exercise pushes movement along the z-axis further. Scaling an image larger to simulate camera movement creates a minimal illusion of depth. What happens if we scale multiple layers as when we create parallax scrolling? A much greater sense of depth is achieved (Figure 3.49).

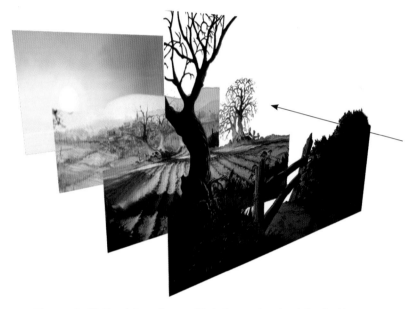

Figure 3.49 Truck in using multiple layers to simulate depth

The Timeline contains four layers: `sky`, `background`, `middleground`, and `foreground`. The artwork on each layer is an instance of a movie clip. The imagery was created in Photoshop and saved as a PNG file to retain the alpha channel. With the exception of the sky, all other images were built larger than the Stage size. Why?

The artwork needs to be scaled to simulate a camera trucking in. Bitmap images are resolution-dependent. This means that the pixels will become more noticeable as the image dimensions are increased. To correct this, the artwork was created at the largest size possible. After being imported into Flash, each image was scaled down to create the composition on frame 1. Scaling down a bitmap image doesn't create pixellation as scaling it up does. The foreground image was scaled at 55%. Both the middle ground and background images are at 50% of their original size.

Step 2: Insert a new keyframe

Go to the Timeline and select the empty cell at frame 60. Choose Insert > Timeline > Keyframe on each layer.

Step 3: Scale the artwork

Select the `foreground` layer in the Timeline. Click on the keyframe that you created on frame 60. Go to the Transform panel and scale it to 100%. Select the `middleground` layer at frame 60. Go to the Transform panel and scale it to 70%. You may need to lock or hide the `foreground` layer to select the middle ground artwork. Select the `back-ground` layer at frame 60. Go to the Transform panel and scale it to 60%.

Reposition the artwork similar to Figure 3.50. When creating this type of animation, always scale first before positioning the artwork on the Stage. Scaling always changes the position of the art.

Figure 3.50 Scaling each layer and repositioning

Step 4: Create a motion tween

Create a motion tween on each layer. Select the first keyframe. Go to the Properties panel and select Motion from the Tween drop-down menu.

Step 5: Save and test the movie

Notice the sense of depth achieved by scaling each layer differently (Figure 3.51).

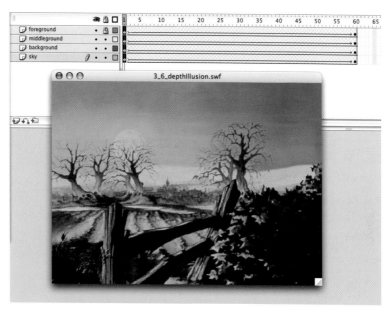

Figure 3.51 Applying a motion tween to each layer

Exercise Summary

This exercise reflects how our mind interprets 3D space. In Chapter 2, we discussed how our stereoscopic vision creates two separate images that our mind merges into a single three-dimensional image. The resulting image allows us to perceive depth and estimate distance. A distant object, such as the moon in the sky, is so far away that our eyes produce essentially the same image, making depth imperceptible. That is why the sky with the moon is not scaled.

Continue to experiment with the file. Add more keyframes later in time. Increase the scale and position of each layer and apply motion tweens. To see a completed version of the exercise, open `3_6_depthIllusion_DONE.fla` in the `Completed_Exercises` folder in Chapter 3.

Summary

This chapter focused on movement to enhance depth perception. Key concepts to remember include the following:

- Parallax scrolling is caused by two factors. One is your viewing position or vantage point, and the other is the relative distance the objects are from you.

- Objects closer to us will appear to travel farther and move more quickly than objects farther away.

- The most basic animation method is called frame-by-frame animation. Each frame is manually changed by you over a certain period of time.

- Keyframes signify change.

- Moving the camera across the screen horizontally or vertically is called *panning*.

- *Trucking* is another cinematography term that describes a camera's movement. A camera moving inwards from a wide shot to a close-up shot is referred to as a *truck in*. The opposite movement is referred to as a *truck out*.

The next chapter expands on the animation concepts from this chapter using ActionScript, Flash's programming language.

4

Programming Depth:
Interactive Movement

The previous chapter explored how animation enhances the illusion of depth. Motion tweens were used in Flash to create parallax scrolling and to simulate camera movements. This chapter explores using ActionScript to add interactivity to your Flash files. ActionScript is Flash's programming language. It allows you to create a variety of interactions, from simple to complex.

ActionScript uses object-oriented programming (OOP). Objects are the types of data that Flash can store. Examples of objects include graphics, sounds, and text. Objects belong to a larger group called a class. Examples of classes include the `MovieClip` class, `Sound` class, and `Math` class. Each object and class has a unique set of properties that can be accessed, controlled, and altered through ActionScript.

This chapter focuses on the `MovieClip` class and its properties such as `_width`. The exercises will incorporate ActionScript to create interactive parallax scrolling and camera movements. When you have finished reading the chapter, you will be able to

- Describe objects, classes, properties, and methods
- Construct ActionScript code for specific events
- Create interactive movement in Flash
- Reproduce camera movements using ActionScript

The Main Event

Flash is event-driven. Events can be external or internal. External events are the ways that the user interacts with the file. Examples of external events include clicking with the mouse, moving the mouse, and pressing a key on the keyboard. The user does not have control over internal events, which can be the playback marker leaving one frame to play the next or the completion of a sound.

Flash uses event handlers to detect and translate events to create a response to the action. Here is a simple event: a user clicks with the mouse on a button. This is an external event. If the button contains the event handler `onRelease`, it will detect the click. The Flash file responds to the user by going to another frame. Let's experiment with events to create interactive motion. The motion will create an illusion of depth.

Exercise 4.1: Parallax Scrolling Using ActionScript

Step 1: Getting started

Open the file `4_1_parallaxCode.fla` in the Chapter 4 folder. This Flash movie contains the artwork you need to complete this exercise. The Timeline has one layer labeled `sky`. This exercise will create parallax scrolling using vector artwork. The movement will be controlled through ActionScript. A completed version is provided in the Chapter 4 folder on the CD. To see the finished results, locate and play `4_1_parallaxCode_DONE.swf` (Figure 4.1).

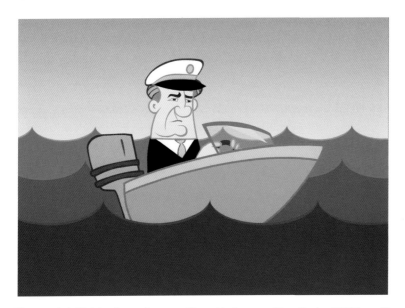

Figure 4.1 Finished parallax scrolling (`4_1_parallaxCode_DONE.swf`)

Step 2: Create a new layer and add artwork

Create a new layer above the `sky` layer. Rename it to **background**. If the Library is not visible, open it (Window > Library). Click and drag the `waves` movie clip symbol to the `background` layer. This is vector-based art and has matching endpoints for scrolling.

Step 3: Scale and reposition the waves

Go to the Transform panel and scale the waves to 60%. Make sure that the left edge of the graphic is aligned to the left edge of the Stage. The width was built larger than the Stage width to achieve the scrolling effect. It will extend beyond the right side of the Stage (Figure 4.2).

Figure 4.2 Scaling the waves to 60% and aligning the left edge to the left edge of the Stage

Step 4: Create two new layers

Add two more layers to the Timeline and label each **foreground** and **middleground** as shown in Figure 4.3.

Figure 4.3 Creating and labeling two new layers

Step 5: Add artwork

Select the empty keyframe in frame 1 of layer `middleground`. Open the Library and click and drag a new instance of the `waves` movie clip to the Stage.

Step 6: Scale and reposition the waves

Go to the Transform panel and scale the waves to 80%. Make sure that the left edge of the graphic is aligned to the left edge of the Stage (Figure 4.4).

Figure 4.4 Scaling the waves to 80% and aligning the left edge to the left edge of the Stage

Step 7: Add artwork and reposition

Select the empty keyframe in frame 1 of layer `foreground`. Click and drag a new instance of the `waves` movie clip to the Stage. You do not need to scale this instance. Align the left edge of the graphic to the left edge of the Stage (Figure 4.5). You just applied the relative scale principle. Let's review.

You created three layers that represent the foreground, middle ground, and background. Each layer contains an instance of the same movie clip. To create the illusion of depth, you scaled the instances to reflect their position in a three-dimensional space. The foreground instance is larger than the background instance because it should appear closer to the viewer.

Figure 4.5 Positioning the foreground waves to finish the composition

Step 8: Adjust the brightness

Select the middleground instance. Go to the Properties panel and select Brightness from the Color drop-down menu. Set the Brightness to –20% (Figure 4.6).

Figure 4.6 Adjust the middle ground waves' brightness to –20%

Step 9: Adjust the brightness

Select the `foreground` instance. Go to the Properties panel and select Brightness from the Color drop-down menu. Set the Brightness to −40% (Figure 4.7). You just applied the aerial perspective principle. To create the illusion of depth, you altered the color of the instances to suggest three-dimensional space.

Figure 4.7 Adjusting the foreground waves' brightness to −40%

Step 10: Name the instances

Now that you have established a three-dimensional environment, the next step is to add movement. Motion will further enhance the illusion of depth. To do this, you are going to create a function in ActionScript that will change the position property for each instance. First, however, you need to name each instance. Select the `background` instance. Go to the Properties panel and enter **backwater_mc** in the instance name box (Figure 4.8).

Figure 4.8 Instance name for the background movie clip

Select the `middleground` instance. Go to the Properties panel and enter **midwater_mc** in the instance name box (Figure 4.9).

Figure 4.9 Instance name for the middle ground movie clip

Select the `foreground` instance. Go to the Properties panel and enter **forewater_mc** in the instance name box (Figure 4.10).

Figure 4.10 Instance name for the foreground movie clip

Step 11: Create a new layer

Add a new layer above the `foreground` layer and label it **actions** (Figure 4.11). Open the Actions panel. If the Actions panel is not open, you can access it by choosing Window > Actions.

Figure 4.11 Creating a new layer and labeling it **actions**

Step 12: Enter the ActionScript

Enter the ActionScript as shown. Let's deconstruct the script. First you are creating a function called `parallax`. This function animates each instance's position on the screen. Each instance name is referenced, and the horizontal position (`_x`) for each is decreased a specific amount (`-=`). This will move each instance to the left. The `onEnterFrame` script continuously calls to the `parallax` function, creating constant movement on the screen.

```
1    function parallax()
2    {
3        forewater_mc._x -= 6;
4        midwater_mc._x -= 4;
5        backwater_mc._x -= 2;
6    }
7
8    this.onEnterFrame = function()
9    {
         parallax();
     }
```

Step 13: Save and test movie

Save the Flash file and test it. Choose Control > Test Movie. Each layer of water is moving at a different speed, but there is a problem. Each layer keeps moving off the screen (Figure 4.12). To solve this, you need to add a condition to your code.

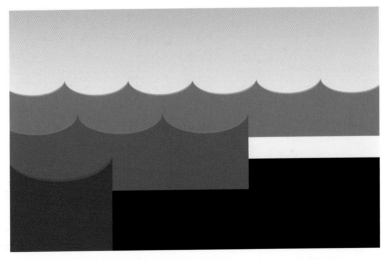

Figure 4.12 Each instance moves at a different speed but keeps going.

Step 14: Enter the ActionScript

Open the Actions panel and add three lines to the ActionScript as shown.

```
1   function parallax()
2   {
3       if(forewater_mc._x <= -(forewater_mc._width/2)){
            forewater_mc._x = 0;}
4       if(midwater_mc._x <= -(midwater_mc._width/2)){
            midwater_mc._x = 0;}
5       if(backwater_mc._x <= -(backwater_mc._width/2)){
            backwater_mc._x = 0;}
6
7       forewater_mc._x -= 6;
8       midwater_mc._x -= 4;
9       backwater_mc._x -= 2;
10  }
11
12  this.onEnterFrame = function()
13  {
14      parallax();
15  }
```

So what does this new code do? It checks to see whether the horizontal position (`_x`) for each instance is less than or equal to half of its width (`_width`). If it is, then half of the instance has moved off the left edge of the Stage.

```
if(forewater_mc._x <= -(forewater_mc._width/2))
```

When this condition is true, the code resets the horizontal position of each instance to zero. Setting a position to zero aligns it to the left edge of the Stage. This means that the instance will snap back to its position aligned with the left edge of the Stage.

```
forewater_mc._x = 0;
```

These three new lines of code create the illusion of continuous movement on the screen. Save and test the movie. You have completed parallax scrolling.

Step 15: Create a new layer

The last thing needed is a character to give the movement meaning and purpose. Create a new layer above the `middleground` layer. Rename it to **boat**. If the Library is

not visible, open it (Window > Library). Click and drag the `motorBoat` movie clip symbol to the `boat` layer. Save and test your movie. Choose Control > Test Movie to see the finished results.

Figure 4.13 Finished parallax scrolling

Exercise Summary

This exercise deals with internal events. The user doesn't interact with the file. The internal event occurs every time this file enters a frame (`onEnterFrame`). Even though there is only one frame in the Timeline, Flash constantly leaves and re-enters it.

The `MovieClip` property that is being changed is the horizontal position on the Stage. This is referred to as `_x`. The vertical position is referred to as `_y`. Every time Flash enters the frame, the `_x` property is reduced by a certain value. This will cause the graphic to move to the left. Adding to the `_x` property will make the graphic move to the right. Since the goal is to create continuous movement, a condition was added that checks another `MovieClip` property, `_width`. If the horizontal movement of the movie clip instance reaches a point that is less than or equal to its width, the instance resets its horizontal position to align with the left edge of the Stage.

The next exercise creates parallax scrolling that is under user control. The external events caused by the user will create the scrolling movement. Let's take a look.

Exercise 4.2: Parallax Scrolling Under User Control

This exercise walks you through a similar process for scripting parallax scrolling using bitmap art. The completed version is provided in the Chapter 4 folder on the CD. To see the finished results, play `4_2_parallaxControl_DONE.swf` (Figure 4.14). Move the cursor back and forth across the Stage to change the direction of the scroll.

Figure 4.14 Finished parallax scrolling (`4_2_parallaxControl_DONE.swf`)

Step 1: Getting started

Open the file `4_2_parallaxControl.fla` in the Chapter 4 folder on the accompanying CD. This Flash movie contains the artwork you need to complete this exercise. The Timeline contains four layers: `background`, `middleground`, `walker`, and `foreground`. The `walker` layer contains the walk cycle from Chapter 3. The boy will remain in this position on the Stage. The illusion of movement and depth will be achieved by animating the environment around him.

Before you start coding, let's deconstruct how the bitmap images were created in Photoshop. As discussed in Chapter 3, for parallax scrolling, the artwork's width must be at least twice the width of the Flash Stage. Get into the habit of figuring out the Stage size you will use. The default size is 550×400 pixels. Other common Stage sizes are 640×480 pixels and 800×600 pixels. This exercise uses the default settings.

To prepare the bitmap images to scroll properly, each layer's starting width was at least 550 pixels. The middle ground and foreground graphics were a little bit larger. The image was duplicated and added to the right end of the graphic. This doubles the size of the artwork (Figure 4.15). The Clone Stamp tool was used to blend the seams and make both edges match.

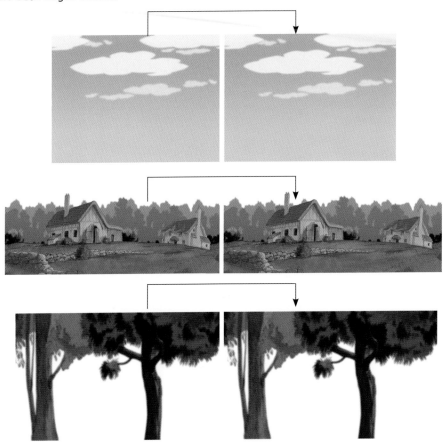

Figure 4.15 Creating a seamless scrolling image in Photoshop

The sky and clouds artwork was saved as a JPEG file. The middle ground and foreground artwork were saved as PNG files. PNG files retain the transparency of the alpha channel. After being imported into Flash, the artwork was converted into a movie clip and positioned on the appropriate layer in the Timeline.

Step 2: Name the instances

In order to reference movie clip instances through ActionScript, you must first name

each instance. Select the `background` instance. Go to the Properties panel and enter **background_mc** in the instance name box. Select the `middleground` instance. Go to the Properties panel and enter **middleground_mc** in the instance name box. Select the `foreground` instance. Go to the Properties panel and enter **foreground_mc** in the instance name box (Figure 4.16).

Figure 4.16 Instance name for the foreground movie clip

Step 3: Create a new layer

Add a layer above the `foreground` layer and label it **actions**. Open the Actions panel. If the Actions panel is not open, choose Window > Actions.

Step 4: Enter the ActionScript

Enter the ActionScript as shown. You are creating a function called `parallax`. This function animates each instance's position on the screen. For this exercise, the animation will change based on user input. The external event is the position of the cursor on the Stage. The Flash player keeps track of the cursor's position using two properties: `_xmouse` and `_ymouse`. The horizontal position is stored in `_xmouse`; the vertical position is stored in `_ymouse`.

```
1    function parallax(layer, speed)
2    {
3        if(_xmouse > Stage.width/2){
4            layer._x -= speed;
5        }else{
6            layer._x += speed;
7        }
```

This script tests to see where the cursor is in relationship to the Stage width. The Stage has a property called `width`. Dividing it by two gives you the Stage's horizontal center. Depending on where the cursor is (to the left or to the right of center Stage), the movie

clip instance will move a defined speed in the appropriate direction. This code looks similar to the first exercise except for `layer` and `speed`. We will come back to these later in the exercise.

Step 4: Enter the ActionScript

Add to the ActionScript as shown. This script prevents each layer from moving off the screen, taking into account which direction the artwork is moving. It checks to see how far the instance has moved to the right or left. If it has moved too far, Flash shifts it back over to create a seamless loop.

```
1    function parallax(layer, speed)
2    {
3        if(_xmouse > Stage.width/2){
4            layer._x -= speed;
5        }else{
6            layer._x += speed;
7        }
8
9        if(layer._x <= 0){
10           layer._x = layer._x + layer._width/2;
11
12       }else if(layer._x >= layer._width/2){
13           layer._x = layer._x - layer._width/2;
14       }
```

This completes the `parallax` function. If you test the movie, you won't see anything move. In order for the function to work, it needs to be called. Since we want the movement to loop, the function needs to be called constantly. As you learned from the previous exercise, an `onEnterFrame` handler can continuously call to a function.

Step 5: Enter the ActionScript

Add to the end of ActionScript as shown. Each instance will call the `parallax` function.

```
15
16   foreground_mc.onEnterFrame = function(){parallax(this,10);}
17   middleground_mc.onEnterFrame= function(){parallax(this,5);}
18   background_mc.onEnterFrame = function(){parallax(this,2);}
```

The code calls the `parallax` function every time it enters the frame. It also passes two parameters into the function (`this,10`). Parameters are additional bits of information that a function may need in order to execute the code correctly. For this example, `this` refers to the instance name of the movie clip calling the function. The number `10` refers to the speed at which the instance will move.

foreground_mc.onEnterFrame = function(){parallax(this,10);}

The parallax function has two parameters associated with it: `layer` and `speed`. When the function is called from the movie clip, the instance name stored in `this` is passed into the function's parameter `layer`. The numeric value (10) is passed into the function's parameter `speed`.

function parallax(layer, speed)

The function uses the information passed into its parameters to move the correct instance at the defined speed. This type of programming makes the code reusable and allows you to revise or update it more efficiently.

Step 6: Name the instances

Select the `walker` instance. Go to the Properties panel and enter **walker_mc** in the instance name box (Figure 4.17).

Figure 4.17 Instance name for the walk cycle movie clip

The walk cycle needs to reflect the movement based on the cursor's position. We could create a new movie clip with the artwork flipped horizontally, but that would add to the final file size. A better way to control this is through the `MovieClip _xscale` property. This property allows you to scale the dimensions of a movie clip through ActionScript. The `_xscale` property scales the horizontal dimensions; the `_yscale` property scales the vertical dimensions.

Step 7: Enter the ActionScript

Add to the ActionScript as shown. This script changes the `walker_mc` instance to walk in the correct direction. Setting the `_xscale` property to –100 flips the movie clip horizontally. Setting it to 100 puts it back to the original dimensions (Figure 4.18).

```
1    function parallax(layer, speed)
2    {
3        if(_xmouse > Stage.width/2){
4            layer._x -= speed;
5            walker_mc._xscale = 100;
6        }else{
7            layer._x += speed;
8            walker_mc._xscale = -100;
9        }
10
11       if(layer._x <= 0){
12           layer._x = layer._x + layer._width/2;
13       }else if(layer._x >= layer._width/2){
14           layer._x = layer._x - layer._width/2;
15       }
16   }
17
18   foreground_mc.onEnterFrame = function(){parallax(this,10);}
19   middleground_mc.onEnterFrame= function(){parallax(this,5);}
20   background_mc.onEnterFrame = function(){parallax(this,2);}
```

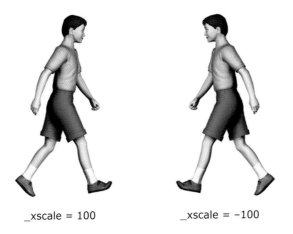

_xscale = 100 _xscale = -100

Figure 4.18 Positive and negative horizontal scales

Step 8: Save and test movie

Save and test your movie. Choose Control > Test Movie to see the finished results. Move the cursor back and forth to change the direction of movement (Figure 4.19).

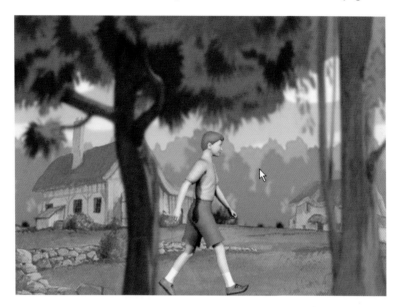

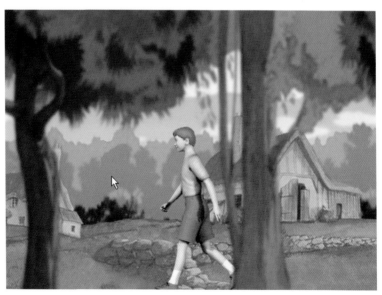

Figure 4.19 Finished parallax scrolling

Exercise Summary

This exercise deals with external events. The user interacts with the file through the position of the cursor. Flash detects the cursor's position and moves the layers accordingly. The next exercise simulates depth using keyboard interactions.

Exercise 4.3: Depth Illusion Under User Control

This exercise focuses on another external event—keypress. Flash can detect a keypress for any key on the keyboard. Here we will use the arrow keys to scale movie clip instances on the Stage. This scaling will simulate depth. The completed version is provided in the Chapter 4 folder. Play 4_3_depthIllusion_DONE.swf (Figure 4.20) to see the finished results. Press the Up Arrow and Down Arrow keys.

Figure 4.20 Finished depth illusion (4_3_depthIllusion_DONE.swf)

Step 1: Getting started

Open the file 4_3_depthIllusion.fla in the Chapter 4 folder on the accompanying CD. This Flash movie contains the artwork you need to complete this exercise. There are five layers in the Timeline that contain an instance of a doorway movie clip. Each doorway has been scaled differently and had its brightness adjusted to create the illusion of perspective. Each instance has been given an instance name: door1_mc to door5_mc. These names will be referenced through ActionScript to scale the dimensions of the instance. Always remember to name your instances.

Step 2: Inspect the man movie clip

The character is an instance of a movie clip. Double-click on it to open its Timeline. It contains three frames (Figure 4.21). Each frame has been labeled with a frame label: `stop`, `forward`, and `backward`. Frame labels are assigned in the Properties inspector. These labels can be referenced in ActionScript. For this exercise, they will be used to navigate to a particular frame based on which key the user presses.

The artwork is different for each frame. Frame 1 contains a static filled shape of the character. Frames 2 and 3 contain nested movie clips. Each movie clip holds a walk cycle. Frame 2 holds a forward walk cycle. Frame 3 holds a backward walk cycle. The different artwork is used to reflect the movement of walking up or down the hallway.

The `actions` layer contains a simple command: `stop()`. This prevents Flash from playing the frames in sequence. It holds the playback marker on the first frame.

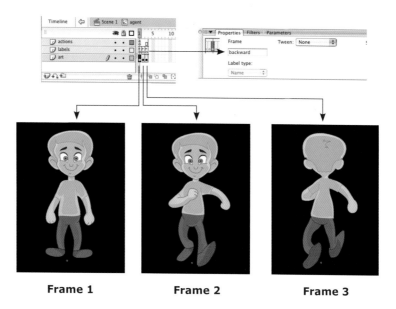

| Frame 1 | Frame 2 | Frame 3 |

Figure 4.21 Character made up of three frames

Step 3: Create a new layer

Close out of the movie clip Timeline by clicking on Scene 1. This takes you back to the root Timeline. Add a new layer above the `man` layer and label it **actions**. Open the Actions panel. If the Actions panel is not open, choose Window > Actions.

Step 4: Enter the ActionScript

Enter the ActionScript as shown.

```
1    //stop the main timeline
2    stop();
3
4    //record a stopping point for the zooming
5    stopZoomIn = door5_mc._xscale;
6    stopZoomOut = door1_mc._xscale;
7
8    //zoom on keyPress
9    _root.onEnterFrame = function()
10   {
11       if (Key.isDown(Key.UP)) {
12           if (door1_mc._xscale < stopZoomIn){
13               door1_mc._xscale = door1_mc._yscale += .5;
14               door2_mc._xscale = door2_mc._yscale += 1;
15               door3_mc._xscale = door3_mc._yscale += 2;
16               door4_mc._xscale = door4_mc._yscale += 4;
17               door5_mc._xscale = door5_mc._yscale += 8;
18           }
19       }
20
21       if (Key.isDown(Key.DOWN)) {
22           if (door1_mc._xscale <> stopZoomOut){
23               door1_mc._xscale = door1_mc._yscale -= .5;
24               door2_mc._xscale = door2_mc._yscale -= 1;
25               door3_mc._xscale = door3_mc._yscale -= 2;
26               door4_mc._xscale = door4_mc._yscale -= 4;
27               door5_mc._xscale = door5_mc._yscale -= 8;
28           }
29       }
30   }
```

Let's deconstruct the script. You are recording the horizontal dimensions (_xscale) of the largest door (door5_mc) and the smallest door (door1_mc) in two variables. Variables act as storage containers for data. These variables can be called later in the script to retrieve the stored information. Why store this information? These variables will prevent the doorways from scaling too big or too small.

```
        stopZoomIn = door5_mc._xscale;
        stopZoomOut = door1_mc._xscale;
```

The next set of code happens with the `onEnterFrame` of the main Timeline (`_root`). It checks to see whether the Up Arrow or Down Arrow key is pressed on the keyboard. Depending on which one is pressed, each of the five doorways is scaled differently. The difference in scaling will create the illusion of depth.

There are two more conditions that Flash checks before it scales the doorways. When the user presses the Up Arrow key, Flash calculates whether or not the smallest door's horizontal dimension (`door1_mc`) is smaller than the original horizontal dimension of `door5_mc`. The original dimension was stored in the variable `stopZoomIn`. If the dimension is smaller, the doors will scale. Once the horizontal dimension of `door1_mc` equals the original dimension of `door5_mc`, the doorways stop scaling.

The other condition occurs when the user presses the Down Arrow key. Flash checks to see whether the horizontal dimension of `door1_mc` is not smaller than its original horizontal dimension. The original dimension was stored in the variable `stopZoomOut`.

Step 5: Save and test movie

Save and test your movie. Choose Control > Test Movie to see the results. Press the Up Arrow and Down Arrow keys to scale the doorways. The next step is to make the character react to the movement.

Step 6: Enter the ActionScript

Add to the bottom of the ActionScript as shown.

```
32  man_mc.onEnterFrame = function()
33  {
34      if (animate=="backward"){
35          this.gotoAndStop("backward");
36      }
37      if (animate=="forward"){
38          this.gotoAndStop("forward");
39      }
40      if (animate=="stop"){
41          this.gotoAndStop("stop");
42      }
43  }
44
45  Key.addListener(man_mc);
46  man_mc.onKeyUp = function(){
47      animate = "stop";
48  }
```

Step 7: Add to ActionScript

Adjust the ActionScript you typed in step 4.

```
1    //stop the main timeline
2    stop();
3
4    //record a stopping point for the zooming
5    stopZoomIn = door5_mc._xscale;
6    stopZoomOut = door1_mc._xscale;
7
8    //zoom on keyPress
9    _root.onEnterFrame = function()
10   {
11       if (Key.isDown(Key.UP)) {
12           if (door1_mc._xscale < stopZoomIn){
13               door1_mc._xscale = door1_mc._yscale += .5;
14               door2_mc._xscale = door2_mc._yscale += 1;
15               door3_mc._xscale = door3_mc._yscale += 2;
16               door4_mc._xscale = door4_mc._yscale += 4;
17               door5_mc._xscale = door5_mc._yscale += 8;
18               animate = "backward";
19           }
20       }
21
22       if (Key.isDown(Key.DOWN)) {
23           if (door1_mc._xscale <> stopZoomOut){
24               door1_mc._xscale = door1_mc._yscale -= .5;
25               door2_mc._xscale = door2_mc._yscale -= 1;
26               door3_mc._xscale = door3_mc._yscale -= 2;
27               door4_mc._xscale = door4_mc._yscale -= 4;
28               door5_mc._xscale = door5_mc._yscale -= 8;
29               animate = "forward";
30           }else{
31               animate = "stop";
32           }
33       }
34   }
```

These additions and changes control the man_mc movie clip instance. A variable called animate stores the frame label name. Depending on which key the user presses, man_mc will navigate to the appropriate frame. If no keys are pressed, man_mc navigates to frame 1, which is labeled stop. How does Flash know that there are no keys being

pressed? A key listener is added at the end of the script and has an `onKeyUp()` method defined. This Flash object "listens" for a specific event. When a user releases any key on the keyboard, the event is broadcasted to Flash. The listener intercepts the broadcasted message and tells `man_mc` to navigate to the frame labeled "stop."

Step 8: Save and test movie

Save and test your movie. Choose Control > Test Movie to see the finished results (Figure 4.22). This completes this exercise.

Figure 4.22 Finished depth illusion

Summary

This chapter focused on the `MovieClip` class and its properties such as `_width`. The exercises incorporated ActionScript to create interactive parallax scrolling and camera movements. Now that you have finished reading the chapter, you should be able to

- Describe objects, classes, properties, and methods
- Construct ActionScript code for specific events
- Create interactive movement in Flash
- Reproduce camera movements using ActionScript

The next chapter focuses on trigonometry and how it can help simulate 3D space.

5

Math Primer:
Trigonometry 101

Many designers' eyes glaze over and they throw up their hands at the mere mention of trigonometry. Typically one hears exasperated expressions such as, "I can't do math," or "trig is too hard," or "it's all so abstract." If you are one of those people, then we have some good news for you. You won't have to get involved with a lot of math, because ActionScript is going to take care of that for you. Once you get your feet wet, you'll find that you keep using much of the same stuff over and over. And rather than being abstract, drawing a rough sketch of what you need or want usually leads you to the solution.

This chapter is broken down into the basic concepts that you will need, with some examples that demonstrate how to use those concepts. Following is what we will be covering:

- What is trigonometry?
- Coordinate systems
- Angles
- The Pythagorean theorem
- The distance between two points
- Trig functions
- Circular motion and elliptical motion
- Sine and cosine waves
- Inverse trig functions

What Is Trigonometry?

Well, what exactly is trigonometry anyway that it should instill such fear in the hearts and minds of so many? Admittedly, it's a rather imposing word. Let's take a look at it and break the word apart.

trigonometry \longrightarrow **trigon • metry**

\longrightarrow **measuring trigons**

Now that's more like it. Trigonometry is all about trigons, or shapes with three sides. Most of our closest friends like to refer to these shapes as triangles. Trig (let's shorten the word so it doesn't sound so imposing) has to do with the study of triangles and the relationship of their sides and angles. Since all triangles have only three sides and three angles, how bad can it be? Not bad, honestly.

It's true there are a lot of different types of triangles in this world. Figure 5.1 shows a few of them. Obtuse triangles have an angle greater than 90 degrees. Isosceles triangles have two angles (and two sides) that are the same. Acute triangles all have angles less than 90 degrees. A special type of triangle, called a right triangle, is one where one of the angles is equal to 90 degrees and is often indicated with a little square in the corner of the 90-degree angle. One of the neat things about triangles is that the angles inside them always add up to 180 degrees. Most of trig, and certainly the topics we'll be covering in this chapter, have to do with right triangles.

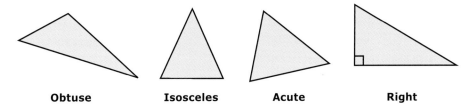

| Obtuse | Isosceles | Acute | Right |

Figure 5.1 Different types of triangles

Coordinate Systems

Coordinate systems provide a way of laying out and measuring space. Probably the most common are Cartesian coordinate systems, named after the French mathematician and philosopher Rene Descartes ("I think, therefore I am"). If you have ever used a grid, you are already familiar with them. A Cartesian coordinate system is simply a set of equally spaced horizontal and vertical lines (a grid), with a horizontal axis called the x-axis and a vertical axis called the y-axis. The left graphic in Figure 5.2 shows a standard coordinate system. The monitor screen provides a convenient place for such a coordinate system, and we will refer to these as the screen coordinates.

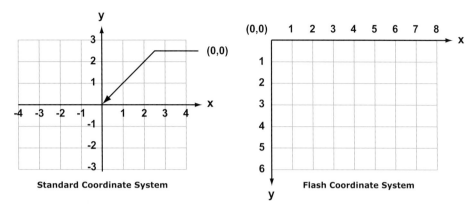

Figure 5.2 Examples of Cartesian coordinate systems

Flash Coordinates and Screen Coordinates

Flash also uses a Cartesian coordinate system, shown in the right graphic of Figure 5.2, albeit one which is a little strange until you get used to it. In order to position objects in Flash, we will need to use Flash coordinates rather than screen coordinates. The origin or (0,0) point in the screen coordinate system is typically located in the center of the Flash Stage, and it is often convenient to use this. The origin of the Flash coordinate system is located in the upper-left corner of the Stage as shown.

The main difference in the two systems is the vertical y-axis. In the screen coordinate system, positive y-values are up, while in the Flash coordinate system, positive y-values are down. To see what the transformation from the screen coordinate system to the Flash coordinate system is, let's look at a simple example.

Figure 5.3 shows a corresponding point in both coordinate systems. To see the relationship between these, note that the origin of the screen coordinate system is located at the point (8,6) in the Flash coordinate system. From here to get to the desired point in Flash units, we have to go 4 to the left and 2 up. Because the positive y-axis of Flash is down, we will need to go up −2 to get to our point. From this we can write

$$(12,4) = (8,6) + (4,-2)$$

The point (12,4) in Flash coordinates is equal to the center point of the screen system in Flash coordinates and, except for the negative y-axis value, the location of the point in screen coordinates.

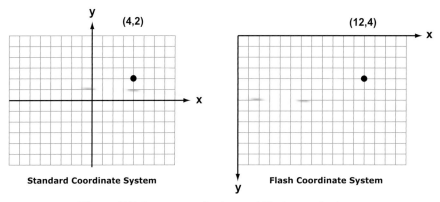

Figure 5.3 Screen coordinates and Flash coordinates

We can generalize the preceding passage in the following way. If the origin of the screen coordinate system is at some point (xo,yo) on the Stage and we are at some point (xs,ys) in screen coordinates, then we can transform that point into its corresponding Flash coordinates (_x,_y) by the following expressions:

$$_x = xo + xs$$
$$_y = yo - ys$$

Figure 5.4 Transformation from screen to Flash coordinates

Angles

In Flash, positive angles are measured from the x-axis and are rotated in a clockwise direction as shown in Figure 5.5. Angles of rotation are measured in degrees (0 to 360). Negative angles (0 to −360) are measured in a counterclockwise direction from the x-axis. The rotation of an object is about its registration point.

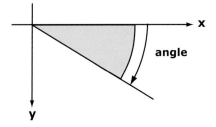

Figure 5.5 Measuring angles in Flash

Just about everybody knows that there are 360 degrees in a circle, but not too many people know why. Do you? Well, we don't either. Somewhere along the way, someone decided that it would be convenient to have a circle divided into 360 parts, perhaps as an approximation to the number of days in a year.

Unfortunately for many of us and especially those working with ActionScript, there is another unit of angle measurement called radians. A long time ago, some Greek was thinking about circles and said to himself, "Suppose I have an arc of a circle that is equal in length to the radius of the circle. I'll call the angle that the arc makes a radian. I wonder how many of those make up half a circle. Wouldn't it be nice if the number were a whole number?"

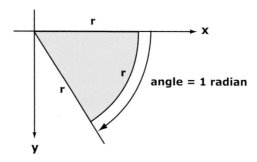

Figure 5.6 One radian of a circle

It certainly would have been nice if three or four made up a semicircle but alas, it was not to be. It turned out that a little more than three radians make up a semicircle. The Greeks found that the number is about 3.14159 and is often written as the Greek letter π. Flash refers to this number as `Math.PI` so that you don't have to remember it in order to use it.

"That's interesting," you may be thinking, "but why should I care about any of this?" The reason is that while most of us feel comfortable measuring angles in degrees, the folks who write software such as Flash prefer to measure angles in radians. So, like it or not, we often need to bounce back and forth between degrees and radians.

Figure 5.7 provides the necessary formulas that you will need for converting from one to the other. Note that there are 360 degrees or 2π radians in a circle. Try to learn them if you can or write them down on your hand or just refer to these equations when you need them.

> **Degrees to radians: angleInRadians = angleInDegrees * (Math.PI/180)**
> **Radians to degrees: angleInDegrees = angleInRadians * (180/Math.PI)**

Figure 5.7 Converting degrees and radians

If you want to get a feel for the numerical difference between degrees and radians, open `angleCalculator.swf` in the Chapter 5 folder. You can turn the steering wheel and the car clockwise and counterclockwise by using the Left Arrow and Right Arrow keys. The angle of the car and steering wheel is provided in both degrees and radians. Note that Flash allows you to go more than 360 degrees both positively or negatively without error. Also note that when specifying angles, a value of −30 degrees will yield the same results as 330 degrees and so forth.

Figure 5.8 Angles in degrees and radians

Let's take a quick look at the script for the calculator. Open `angleCalculator.fla` in the Chapter 5 folder. Click on the `actions` layer to display the script shown in Figure 5.9. The variable `angleInDegrees` will control the turning of both the steering wheel and the car. We begin by initially setting this angle to 0 degrees in line 2 since no rotation has yet occurred.

An `onEnterFrame` handler in line 4 will be needed so that we will be able to see the rotation. Line 7 checks to see whether the Right Arrow key is pressed. If it is, the angle is updated by 2 degrees, which will result in a clockwise rotation. In line 8, a similar test checks to see whether the Left Arrow key is pressed. If so, the angle is decreased by 2 degrees for a counterclockwise rotation.

Next, the rotations of the steering wheel and the car movie clips are set to the new value of the angle in lines 11 and 12. Note that visually, it appears that the steering wheel and the car are rotating at different angles. This is only an illusion since the steering wheel was designed with the ball at the top as its initial position and the car was designed to be pointing to the right as its initial position.

```
1   // initialze the starting angle
2   angleInDegrees = 0;
3
4   this.onEnterFrame = function()
5   {
6       // check the arrow keys to change the angle
7       if ( Key.isDown(Key.RIGHT)){ angleInDegrees += 2;}
8       if ( Key.isDown(Key.LEFT) ){ angleInDegrees -= 2;}
9
10      // rotate the steering wheel and car
11      wheel_mc._rotation = angleInDegrees;
12      car_mc._rotation   = angleInDegrees;
13
14      // get the angle in radians
15      angleInRadians = angleInDegrees * Math.PI/180;
16
17      // display the angle info
18      degrees_txt.text = angleInDegrees;
19      radians_txt.text = angleInRadians;
20  };
```

Figure 5.9 Script for the radian calculator

In line 15, the rotation angle is converted from degrees to radians using the formula from Figure 5.7. Finally, the current value of the angle in both degrees and radians is displayed by setting it to the text of the dynamic text fields, `degrees_txt` in line 18 and `radians_txt` in line 19.

121

The Pythagorean Theorem

Here's something else that we'll use all the time in various ways. Named after the Greek philosopher Pythagoras, the Pythagorean theorem states that for a right triangle, the square of the hypotenuse is equal to the sum of the squares of the other two sides. What's a hypotenuse? It's the longest side, the one opposite the right angle. This is one of the foundations of trig and appears many times in all kinds of situations.

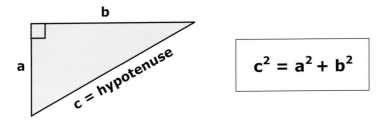

Figure 5.10 The Pythagorean theorem

Figure 5.11 illustrates some common right triangles and the proportional relationships of their short sides to their hypotenuses.

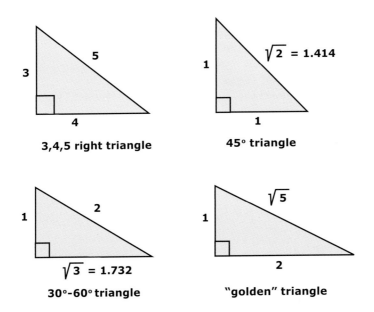

Figure 5.11 Common triangles and the ratios of their sides

Distance Between Two Points

The Pythagorean theorem enables us to easily calculate the distance between any two points. Here's how it works. Suppose we want to know the distance between two points (x1,y1) and (x2,y2). Referring to Figure 5.12, let dx represent the difference between the x-axis values of the two points and let dy represent the difference between the y-axis values of the two points. Then dx = x2 − x1 and dy = y2 − y1. The distance between the two points forms the hypotenuse of a right triangle with dx and dy as the other two sides.

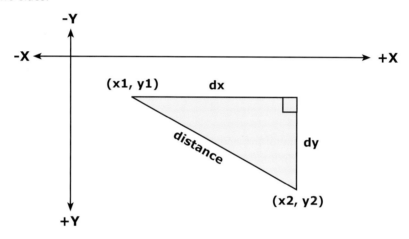

Figure 5.12 Calculating the distance between two points

From the Pythagorean theorem we know that $distance^2 = dx^2 + dy^2$ or

$$distance = \sqrt{dx^2 + dy^2}$$

In ActionScript, the square root is a defined function that we can use for just such occasions as this. The equation for the distance expression above would be written as shown in Figure 5.13.

distance = Math.sqrt(dx * dx + dy * dy)

Figure 5.13 Formula for the distance between two points

The Trig Functions

Sine, cosine, and tangent are known as the trig functions. All they do is represent the three ratios of the sides of a right triangle in relation to the angles in the triangle. Referring to Figure 5.14, the three trig functions are defined as follows:

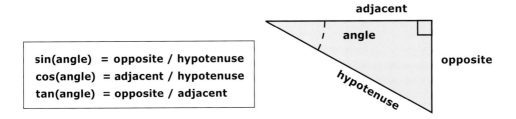

sin(angle) = opposite / hypotenuse
cos(angle) = adjacent / hypotenuse
tan(angle) = opposite / adjacent

Figure 5.14 Definition of the trig functions

In English we say that the sine of the angle labeled *angle* is equal to the side opposite from *angle* divided by the hypotenuse. The cosine of *angle* is equal to the side adjacent (but not the hypotenuse) to *angle* divided by the hypotenuse. The tangent of *angle* is equal to the opposite side divided by the adjacent side.

In an earlier discussion, it was pointed out that the sum of the interior angles of all triangles is equal to 180 degrees. When we have a right triangle, the two angles that are not the right angle must then add up to 90 degrees. Again referring to Figure 5.14 above, we see that

$$\sin(\text{angle}) = \cos(90 - \text{angle})$$
$$\cos(\text{angle}) = \sin(90 - \text{angle})$$

In other words, the sine of one angle in a right triangle is the cosine of the other angle and vice versa. Later when we graph these functions, we will see that they essentially create the same curves.

That's all well and good, but how can we use this stuff? Let's begin by taking a look at a fairly common general situation that will give us some tools to apply in a more specific exercise to follow. Suppose we have a circle with some known radius r. Let's also suppose that we are at some point on the circle at an angle in degrees named *angle* from the x-axis. Typically we might want or need to know what the coordinates (x,y) are of that point on the circle.

Referring to Figure 5.15, we see that we can construct a right triangle from the origin (0,0) to the point (x,y). With that, we can apply the definitions of sine and cosine above to write

$$\text{sin(angle)} = \text{opposite / hypotenuse} = y / r$$
$$\text{cos(angle)} = \text{adjacent / hypotenuse} = x / r$$

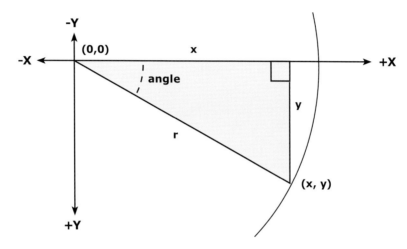

Figure 5.15 Calculating a point on a circle

If we multiply both sides of each of the equations by r we then get

$$x = r * \text{cos(angle)}$$
$$y = r * \text{sin(angle)}$$

and in ActionScript we would write

```
x = r * Math.cos(angle);
y = r * Math.sin(angle);
```

There, that wasn't too bad, and in a perfect world, it would be nice to say that we're done. Unfortunately it's not a perfect world. Why? Because we started out by knowing our angle in degrees, but ActionScript, like most computer languages, wants to have its trig function angles in radians. We will need one additional line that converts our angle in degrees to an angle in radians.

```
a = angle * Math.PI / 180;
x = r * Math.cos(a);
y = r * Math.sin(a);
```

Let's generalize the preceding passage just a little bit more. Suppose the center of the circle is at some arbitrary point (xo,yo) as shown in Figure 5.16 and we want to know the coordinates of a point for any particular angle.

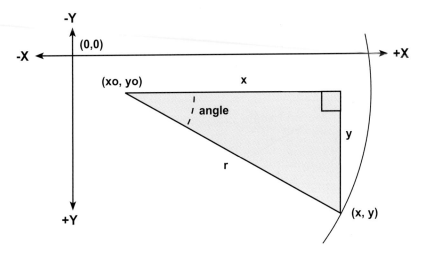

Figure 5.16 Calculating a point on an offset circle

The equations above need to be modified as follows:

$$a = angle \; * \; Math.PI \; / \; 180$$
$$x = xo + r * Math.cos(a)$$
$$y = yo + r * Math.sin(a)$$

Figure 5.17 Formulas for calculating a point on any circle

Exercise 5.1: Circular Motion of One Object

Now that we know how to calculate the coordinates of a point on a circle when we are given its angle, let's see what we can learn from solving the simple problem of having a single object move along a circular path. Suppose we have a top view of a roulette "training" wheel. It's not a real wheel but a simplified one so that, like so many of us, the roulette ball can practice going around in circles. Figure 5.18 illustrates a typical screen from our exercise.

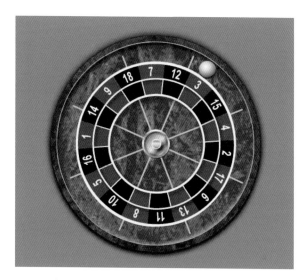

Figure 5.18 Circular motion of one object

Step 1: Getting started

Open the 5_1_circRotation.fla file in the Chapter 5 folder. Our objective is to use ActionScript to get the ball travelling in a circular motion around the rim of the roulette wheel. Our movie consists of five layers. The background layer holds a copy of the roulette wheel. A mask layer has been created with instance name mask_mc to define the edge of the rim around which the ball will travel. The masked layer has a second copy of the roulette wheel named wheel_mc. This wheel will move in the opposite direction to the ball. The white ball is held in the ball layer with a movie clip named object_mc. The actions layer will contain our script that makes everything work.

Step 2: Define the path characteristics and object starting angle

The first thing we need to do is to provide some information about the circular path the object will follow. Let's place the center of the circle (xc,yc) in the center of the Stage by setting xc = Stage.width/2 and yc = Stage.height/2.

We also need to set the radius of the circular path the ball will follow. In many situations the radius is known explicitly at the outset by construction. In this example, we will let Flash calculate the radius for us. Referring to Figure 5.19, the desired radius r is equal to the radius of the wheel rim (the mask) minus the radius of the ball. In both cases, the radius of each is equal to half of the width of each so that

$$r = (\text{Mask width}) / 2 - (\text{Ball width}) / 2$$

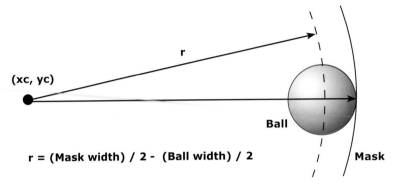

r

(xc, yc)

Ball

r = (Mask width) / 2 - (Ball width) / 2

Mask

Figure 5.19 Calculating the radius of the ball path

This gives us what we are after and only needs to be converted to ActionScript as shown below. We'll also set the starting angle of the object to 0 degrees.

```
1    // define the circular path characteristics
2    xc = Stage.width/2;   // horizontal center of circle
3    yc = Stage.height/2;  // vertical center of circle
4    r  = mask_mc._width/2-object_mc._width/2; // radius
5
6    // set the object starting angle in degrees
7    angle = 0;
8
```

Step 3: Position the object on the circle

Since we want the object to follow the circular orbit, we need to place it on the curve. Rather than physically placing the object, we will do it with scripting and a little trig. Let's define a function setObject that will place the ball on the circle for any angle using similar expressions to that of Figure 5.17.

```
9     // set the object on the circle
10    function setObject()
11    {
12        a = angle*Math.PI/180;
13        object_mc._x = xc + r * Math.cos(a);
14        object_mc._y = yc + r * Math.sin(a);
15    }
16
```

Step 4: Create the motion

We are now ready to create the circular motion. To do this, we will use an `onEnterFrame` handler so that we can keep looping on the frame and update the angle each time.

```
17    // set up the frame loop
18    this.onEnterFrame = function()
19    {
20        angle += 5;    // update the angle
21        setObject();   // move the object
22
23    }
```

Notice the use of the expression `this.onEnterFrame`. Here `this` refers to the root Timeline. The statement `angle += 5` is used to increase the angle by 5 degrees each time the frame is entered.

Save your movie as `5_1_roulette1.fla` and test it. You should see the ball rotating clockwise around the roulette wheel. You can speed up the motion by simply changing the angle update to a larger number such as 10.

Tip: Verify that you can rotate the ball counterclockwise by using any one of the following three changes:

```
angle -= 5
object_mc._y = yc - r * Math.sin(a)
object_mc._x = xc - r * Math.cos(a)
```

Step 5: Add the wheel rotation

Now that the ball is moving, let's make the wheel rotate in the opposite direction. The registration point of the wheel is centered on the object and located at the middle of the Stage. Although we could rotate the wheel at a different speed than the ball, it is easy and convenient to simply use the opposite angle of rotation of the ball. This can be done by inserting a single line of code in line 22 as shown here.

```
19    {
20        angle += 5;    // update the angle
21        setObject();   // move the object
22        wheel_mc._rotation = -angle; // rotate wheel
23    }
```

Step 6: Make it stop

Okay, now that everything is moving properly, we really don't want it to go on forever. Let's add a play button that we can use to start and stop the spinning. Add a new layer above the mask layer and name it **play button**. Drag `playBtn` from the Library onto the Stage and center it as shown in Figure 5.20. In the Properties window name the instance **play_btn** and set its alpha value to 0.

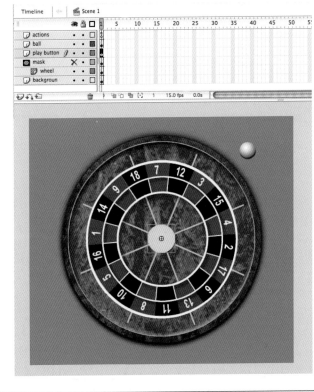

Figure 5.20 Adding a play button

Now let's make a few additions to the script. Let's define a new function `initAngles`. Inside the function we will set `angle` to 0 and define the maximum angle, `maxAngle`, that we will allow the ball and wheel to turn. It would be nice to vary the amount of

spin each time, so we'll use the `Math.random()` function to provide that capability. Since the random function yields a number between 0 and 1, we'll multiply the random value obtained by 540. This will give us a number between 0 and 540 degrees. Just to make sure that the ball and wheel spin at least one complete revolution, we'll add 360. This will create angles between 360 degrees and 900 degrees, or between from one to two and a half revolutions. Why 540? No reason other than, through trial and error, it produced movement that seemed neither too short nor too long. Replace lines 6 and 7 with the following lines.

```
 6    // initialize the object and wheel angles
 7    function initAngles()
 8    {
 9        angle:Number = 0;
10        maxAngle:Number = Math.random()*540 + 360;
11    }
12    // set the object on the circle
13
```

Next let's define the play button actions. When the user clicks on the button, we'll set a variable called `spin` to true. We will also make a call to the `initAngles()` function. Each time the user clicks on the play button, the ball will be reset to its starting position and a new maximum angle of rotation will be determined. Insert these lines after the `setObject()` function and before the frame loop.

```
21    play_btn.onRelease = function()
22    {
23        spin = true;
24        initAngles();
25    }
26
27    // set up the frame loop
```

The rest of the action takes place in the frame loop. Insert lines 30 and 31 where we first set up a test to see whether `spin` is set to true. If it is, then we will spin the ball and wheel as previously. They both will continue until `angle` is greater than the maximum angle, which is tested by inserting lines 35 and 36. Once `angle` passes the test, then `spin` is set to false and everything stops until the play button is clicked again. Save your movie as 5_1_roulette2.fla and test it. Care to place your bets?

```
28   this.onEnterFrame = function()
29   {
30       if (spin == true)
31       {
32           angle += 5;    // update the angle
33           setObject();   // move the object
34           wheel_mc._rotation = -angle; // rotate the wheel
35           if ( angle > maxAngle ) { spin = false; }
36       }
37   }
```

Exercise 5.2: Circular Motion of Multiple Objects

Now that we have one object rotating in a circle, let's see what needs to be done to rotate several objects that are equally spaced around a circle. Lots of things move around in circles. Let's go for a ride on the Silverfish Ferris wheel shown in Figure 5.21.

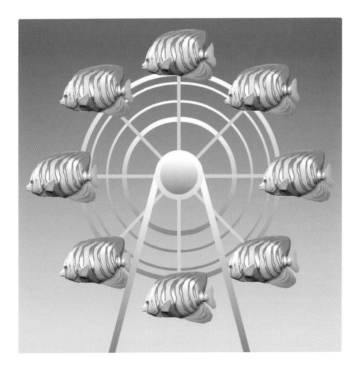

Figure 5.21 Circular motion of multiple objects

The general idea is as follows. We are first going to make duplicate copies of the object, distribute those copies around the desired circle, and then apply what we learned earlier to animate them. For reference, open 5_2_fishFerris.swf in the Chapter 5 folder.

Step 1: Getting started

Open 5_2_circRotation.fla in the Chapter 5 folder. The movie consists of five layers. The bottom layer contains the sky and the circular elements of the Ferris wheel. These can go on the background since they won't move. The spokes in the next layer will be used to create the movement of the wheel. The fish objects (of which there is only one at the moment) are layered on top of the wheel spokes but underneath the Ferris wheel supports. The top layer, as usual, is the actions layer.

One fish car has been placed off the Stage. Duplicates will be created on the Stage, but it is convenient to have the original out of view. Let's begin by defining the circular path characteristics the cars will follow. The circle will be centered horizontally on the Stage and 15 pixels above the vertical center of the Stage. The radius is set to 200 pixels.

```
1    // define the circular path characteristics
2    xc = Stage.width/2;        // xc = horizontal center of circle
3    yc = Stage.height/2 - 15;  // yc = vertical center of circle
4    r  = 200;                  // r = radius of circle
5
```

Step 2: Define the object characteristics

Let's enter some information about the objects we are going to create. We want to make it easy to handle the rotation of any number of objects rather than just one, so let's define a variable named numberOfObjects and set it to some value, in our case 8. We'll use a starting angle of 0 degrees as before so that the first fish created starts out on the x-axis.

```
6    // define the object characteristics
7    numberOfObjects = 8; // number of objects to rotate
8    startAngle = 0;      // starting rotation angle on the circle
9
```

Step 3: Determine the angle between objects

Once we have set the number of objects, we can calculate the angle between any two objects, circleAngle, so that we can distribute them equally around the circle. For

example, with eight objects as shown in Figure 5.22, `circleAngle` will be equal to 360/8, or 45 degrees.

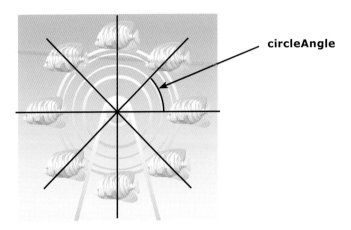

Figure 5.22 Illustration of `circleAngle`

```
10    // calclate the angle between any two objects on a circle
11    circleAngle = 360/numberOfObjects;
12
```

Step 4: Create the objects

We can now write a script, shown below, to create the objects that will be distributed equally around the circle. To do this, we will use a `for` loop that starts counting at 0, goes to 1 less than the number of objects specified, and increments by 1 each time through the loop. For each iteration of the loop we are duplicating the original object movie clip, `object_mc`, then naming it and setting its depth value. The duplicated clips are named "object0" at depth 0, "object1" at depth 1, and so forth, up to and including "object7" at depth 7.

```
13    // create the objects desired for the circular motion
14    for (i = 0; i < numberOfObjects; i++)
15    {
16        object_mc.duplicateMovieClip("object"+i, i)
17    }
18
```

Step 5: Add the circular motion

Adding the circular motion to each of the objects is pretty much a combination of using the loop in Step 4 with the circular motion used in Exercise 5.1. As before, we will use an `onEnterFrame` handler so that we can keep looping on the frame. We then need to do some calculations for each of the rotating objects.

First we need to figure out at what angle to place each object on the circle. Referring to Figure 5.22, we can see that object 0 starts at 0 degrees, object 1 at 45 degrees, object 2 at 90 degrees, etc. So, in general, object `i` will start at `i` * 45 degrees or, more generally, `i` * `circleAngle`. We just need to add `startAngle` to correctly specify the angle for each object.

```
19   // create the circular motion
20   this.onEnterFrame = function()
21   {
22       // for each rotating object ...
23       for (i = 0; i < numberOfObjects; i++)
24       {
25           // calculate the angle of the object
26           myAngle = i * circleAngle + startAngle; //in degrees
27           a = myAngle * Math.PI/180;               //in radians
28
```

Once the angle has been determined, the position on the circle can be obtained by applying the now familiar equations. Note the syntax `this["object"+i]` used. Flash requires this notation when objects have been named in this manner through duplicating a movie clip. Updating `startAngle` by a negative number makes the objects and the spokes spin in a counterclockwise direction. The amount specified is strictly your choice, depending upon the speed you want.

```
29           // calculate the x- and y-coordinates
30           this["object"+i]._x = xc + r * Math.cos(a);
31           this["object"+i]._y = yc + r * Math.sin(a);
32       }
33       // update the startAngle increment and rotate the spokes
34       startAngle -= 2;
35       spokes_mc._rotation = startAngle;
36   }
37
```

Save your movie as `5_2_fishFerris.fla` and test it. You should see the eight fish rotating in a counterclockwise circular orbit. There's just one small problem. Even though we layered the graphics so that the fish would be inside the supports, they are not doing what they are supposed to do. Here's why. Any object on the Stage has a depth value that reflects the Flash layering. Objects using Flash layers typically all have depth values around –16384. When we duplicated `object_mc`, we set the depth of its copies to 0, 1, 2, etc. Consequently, they all have higher depth values than the layered graphics and will be on top of all of them.

Can we still get the supports on top? Yes, we can by using two handy ActionScript functions, `getNextHighestDepth()` and `swapDepths()`. The first returns the next available depth value, and the second enables a movie clip to swap its current depth for another depth. Insert the following lines as shown before the frame loop, and all will be fine. Save and test the results.

```
19    // put the frame outside of the objects
20    frame_mc.swapDepths(getNextHighestDepth());
21
22    // create the circular motion
23    this.onEnterFrame = function()
```

Exercise 5.3: Circular Motion Extended

Now that we can have objects move along a circular path, let's push this idea a little further. One of the limitations of the previous exercise is that all of the fish were pointing in the same direction. While it was appropriate for that application, it would be nice if we also knew how to get each of the objects to point in a different direction for a more symmetrical arrangement around the center. Something suggestive perhaps of dolphins performing synchronized swimming as in Figure 5.23. For an animated reference, open `5_3_dolphinSwim1.swf` in the Chapter 5 folder.

Step 1: Getting started

Open `5_3_circRotation.fla` in the Chapter 5 folder. At this point, other than the number of objects and the circle radius, it has basically the same script as the previous exercise except that the motion is in a clockwise direction. Choose Control > Test Movie to verify the similar motion.

Figure 5.23 Example of variation in rotational angle

Let's add a statement to the script that says whatever angle an object is on the circle, rotate that object the same amount around its registration point. Save your movie and test it. You should see the six dolphins in the formation shown in Figure 5.23 above rotating in a circular orbit.

```
29          // calculate the x- and y-coordinates
30          this["object"+i]._x = xc + r * Math.cos(a);
31          this["object"+i]._y = yc + r * Math.sin(a);
32
33          // rotate each object about its center point
34          this["object"+i]._rotation = myAngle;
35        }
36      // update the startAngle increment
37      startAngle += 2;
38    }
39
```

Step 2: Create more complex motion

Although the dolphins rotate, they stay in the same formation. It would be more interesting to vary the formation somewhat, similar to the way synchronized swimmers do. It turns out we can do this by making the rotation of each object depend in some man-

ner on `startAngle`, since it is constantly changing. A simple way of doing this is given below. The factor of 2 just speeds up the rotation of each object about itself.

```
33        // rotate each object about its center point
34        this["object"+i]._rotation = myAngle + 2*startAngle;
35      }
```

Tip: Try substituting −2 or −3 for +2 in the line above for a very different effect.

Step 3: Add simple user interactivity

Up to this point, the movie has been a passive experience for the user. Let's add a little interactivity through keyboard control. An easy-to-implement technique is to increase or decrease the radius using the Up Arrow and Down Arrow keys.

```
36        // update the start angle
37        startAngle += 2;
38
39        // check up & down arrow keys to change the radius
40        if ( Key.isDown(Key.UP) )    { r += 5; }
41        if ( Key.isDown(Key.DOWN) ) { r -= 5; }
42      }
```

Another simple technique is to use the Left Arrow and Right Arrow keys to control the direction and speed of rotation of the objects about their registration points. Define a direction variable `d` as follows.

```
6     // define the object characteristics
7     numberOfObjects = 6; // number of objects to rotate
8     startAngle = 0;      // starting rotation angle
9     d = 3;               // direction & speed of rotation
10
```

Modify the object rotation line and then add the test for the Left Arrow and Right Arrow keys.

```
34        // rotate each object about its center point
35        this["object"+i]._rotation = myAngle + d*startAngle;
36      }
```

```
43
44        // use space bar & shift keys to control direction
45        if ( Key.isDown(Key.LEFT ) ) { d -= 1; }
46        if ( Key.isDown(Key.RIGHT) ) { d += 1; }
47    }
```

When the Left Arrow key is pressed, if the dolphins are rotating clockwise about their own registration points, their rotation will slow down as the value of d decreases until ultimately their motion will become counterclockwise. If the Left Arrow key continues to be pressed, their counterclockwise motion will speed up. A similar but opposite behavior will occur when the Right Arrow key is pressed. Save your movie with the name 5_3_dolphinSwim1.fla and check that it's working properly.

Step 4: Add additional user interactivity

There is one other keyboard control that would be nice to have, and that is to use the spacebar and Shift keys to decrease and increase the number of objects respectively. This takes just a little more work than the others but produces some very nice effects.

Basically we want to use these keys to adjust the numberOfObjects variable. We can do this easily enough, but it also means that we must perform a new calculation of the circleAngle. The remaining task is then to either add new objects or remove existing ones. To accomplish this, we will first define an initObjects() function that will be built by inserting a few new lines around some of the code that we are already using.

```
11    // initialize the number of objects
12    function initObjects()
13    {
14        // calclate the angle between any two objects
15        circleAngle = 360/numberOfObjects;
16
17        // create the objects
18        for (i = 0; i < numberOfObjects; i++)
19        {
20            object_mc.duplicateMovieClip("object"+i, i)
21        }
22    }
23
24    initObjects();
25
```

Next we need to add the test for the spacebar and Shift keys below the previous key tests. For the Shift keys we will increase the number of objects by 1 and then call our initObjects() function to create a new set of dolphins.

For the spacebar, we need to do a similar thing, but we also have to physically remove an object from the Stage. We first reduce the number of objects by 1. Because we begin counting the object numbers at 0, the new value of the numberOfObjects represents the top object which can be removed using removeMovieClip(). We then call the initObjects() function to generate a new set.

```
53
54        // use the shift keys & spacebar
55        // to change the number of objects
56        if ( Key.isDown(Key.SHIFT) )
57        {
58            numberOfObjects += 1;
59            initObjects();
60        }
61        if ( Key.isDown(Key.SPACE) )
62        {
63            numberOfObjects -= 1;
64            this["object"+numberOfObjects].removeMovieClip();
65            initObjects();
66        }
67    }
```

That should do it. Add a text layer with instructions if you wish. Save your movie as 5_3_dolphinSwim2.fla. Don't forget to use all six keys to make the dolphins perform.

Elliptical Motion

If you have ever used Photoshop, Illustrator, Flash, or a host of other programs, you know that you select the Oval tool to generate circles as well as ellipses, the fancy name for ovals. The reason is that circles are simply special cases of ellipses. We know that all circles have a uniform radius. Perhaps it is easiest to think of ellipses as stretched circles with a horizontal radius xr and a vertical radius yr as shown in Figure 5.24. When xr = yr, you have a true circle. If you want to get a feel for how changing xr and yr affects the overall elliptical shape, open the ellipsor.swf file in the Chapter 5 folder.

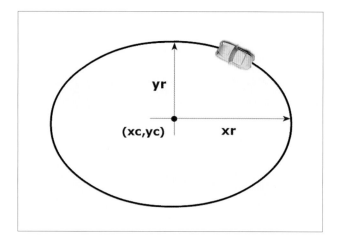

Figure 5.24 Elliptical motion of an object

You can use the Left Arrow and Right Arrow keys to narrow and widen the horizontal radius. The Up Arrow and Down Arrow keys will lengthen and shorten the vertical radius. The car traversing the path will adjust accordingly.

Let's take a quick look at the script. Open `ellipsor.fla` in the Chapter 5 folder. As before, we begin by defining the path characteristics. This consists of specifying the coordinates (`xc,yc`) of the center of the path as well as the initial horizontal radius `xro` and the initial vertical radius `yro`. They are defined as half the width and half the height respectively. Our path is initially a circle, so these two values will start out the same.

```
1   // define the elliptical path characteristics
2   xc  = path_mc._x;        // xc = horizontal center of path
3   yc  = path_mc._y;        // yc = vertical center of path
4   xro = path_mc._width/2;  // xro = initial path x-radius
5   yro = path_mc._height/2; // yro = initial path y-radius
```

We are using the arrow keys to modify the shape of the curve, so we'll define a function `checkKeys()` to specify the desired behaviors. The way in which we'll modify the path will be to change the horizontal and vertical scale factors _xscale and _yscale. The scale factors each begin with a value of 100%. If we press on the Right Arrow key, the _xscale will keep increasing by 2; if we press on the Left Arrow key, it will decrease by 2. This will serve to widen or narrow the path horizontally. Similar changes occur with _yscale as we press on the Down Arrow key and Up Arrow key.

141

```
 7    // check the arrow keys to change the scale factors
 8    function checkKeys()
 9    {
10        if ( Key.isDown(Key.RIGHT)) { path_mc._xscale += 2; }
11        if ( Key.isDown(Key.LEFT) ) { path_mc._xscale -= 2; }
12
13        if ( Key.isDown(Key.UP)   ) { path_mc._yscale += 2; }
14        if ( Key.isDown(Key.DOWN) ) { path_mc._yscale -= 2; }
15    }
```

In the frame loop, the first thing we do is to place a call to the checkKeys() function in line 20 to modify the shape of the path. Next, the scale factors are translated into numerical values of the horizontal and vertical radii. This is done in lines 23 and 24 by taking their initial values multiplied by the scale factors and then dividing by 100.

```
17    // set up the frame loop
18    this.onEnterFrame = function()
19    {
20        checkKeys();
21
22        // change the x-radius and y-radius of the path
23        xr = xro * path_mc._xscale/100;
24        yr = yro * path_mc._yscale/100;
25
```

Here's how it works. Suppose the initial value for the vertical radius is 300. By pressing a few times on the Down Arrow key you might change the vertical scale factor _yscale to 90. The new value of the vertical radius will then be (300 * 90 / 100) or 270. The scale factor divided by 100 represents the number as a fraction.

Once the two radii have been determined, the car can be placed on the path by first updating the angle in degrees (line 27), converting it to radians (line 28), and then applying the standard trig formulas that we have been using (lines 29 and 30). The only difference is that we now apply the horizontal radius to get the correct x-axis value and apply the vertical radius to get the correct y-axis value.

The last task is to rotate the object to the new angle in line 31. We must subtract 90 degrees to orient the car properly on the path.

```
26        // move the car along the path
27        angle -= 5;  // update the angle
28        a = angle*Math.PI/180;
29        object_mc._x = xc + xr * Math.cos(a);
30        object_mc._y = yc + yr * Math.sin(a);
31        object_mc._rotation = angle - 90;
32    }
```

Tip: Use either the Left Arrow key or the Up Arrow key to completely flip the path around. Although the path will appear to look the same, a negative scale factor will be generated. Negative scale factors can be very useful in flipping objects horizontally or vertically. In our case, the negative scale factor that is generated will give the car a very complex motion. It spins on its own axis in a counterclockwise movement while traveling around the path in a clockwise direction.

Sine and Cosine Waves

Now that we can have objects moving along circular and elliptical paths using the sine and cosine functions, let's take a look at the graphs of these functions. Both functions are examples of periodic functions, or functions that repeat themselves. To help you

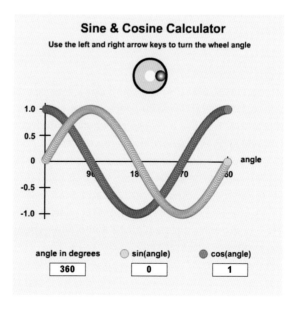

Figure 5.25 Plotting the sine and cosine functions

get a visual comparison of these functions at different angles, go to the Chapter 5 folder and open `sinCosCalculator.swf`.

You can use the Right Arrow and Left Arrow keys to turn the angle of the wheel. Along the horizontal axis is the angle of the wheel. As it is turned, the value of the sine and cosine functions are plotted along the vertical axis for each angle. The results produce several items worth noting. Once the angle reaches 360 degrees, the graphs simply repeat themselves and form a wave pattern, hence the use of the terms *sine waves* and *cosine waves*. These types of waves occur all over the place, and we'll look at a simple example shortly. Another interesting characteristic of the two waves is that if we shift the sine wave back 90 degrees or the cosine wave forward 90 degrees, they are identical.

Let's take a look at the script for the calculator. The starting angle in degrees is initially set to 0 as usual. In line 3, the variable A for the amplitude is set to 100. The amplitude is a measure of the maximum height of a wave form. For sound waves, the greater the amplitude, the louder the sound. Since the maximum value for a sine and cosine wave is 1, setting the amplitude to 100 scales the results up by a factor of 100 pixels so that we can see the curves easily.

```
1    // initialze the starting angle and amplitude
2    angleInDegrees = 0;
3    A = 100;
4
```

The frame loop begins in line 5, and the first thing done is to test whether the Right Arrow or Left Arrow keys have been pressed. Here's what happens when the Right Arrow key has been pressed. First we increase the angle in degrees in line 10. The `sin_mc` and `cos_mc` movie clips are yellow and orange dots located at the bottom of the screen. These will be duplicated in lines 13 and 14 each time the Right Arrow key is pressed. The variable `k` is set to the angle in degrees and used to place each duplicate on its own level. The variable `j` is set to be 500 greater than `k`. This enables the `sin_mc` copy to be placed on its own level higher than the `cos_mc` copy. The value 500 was chosen only because it is a sufficiently big number to avoid any overlapping of levels.

When the Left Arrow key is pressed, we first store the current value of the angle in degrees in `k` (line 18). Since we are moving backwards, we need to remove the current copies of the `sin_mc` and `cos_mc` movie clips (lines 19 and 20). Then we need to decrease the angle in degrees. After converting the angle in degrees to radians in line

144

```
5    this.onEnterFrame = function()
6    {
7        // check the arrow keys to change the angle
8        if ( Key.isDown(Key.RIGHT) )
9        {
10           angleInDegrees += 2;
11           k = angleInDegrees;
12           j = k+500;
13           sin_mc.duplicateMovieClip("sin"+k, j);
14           cos_mc.duplicateMovieClip("cos"+k, k);
15       }
16       if ( Key.isDown(Key.LEFT)  )
17       {
18           k = angleInDegrees;
19           _root["sin"+k].removeMovieClip();
20           _root["cos"+k].removeMovieClip();
21           angleInDegrees -= 2;
22       }
23
```

25, we rotate the wheel at the top and then calculate the sin and cos of the current angle in lines 31 and 34. After multiplying by the amplitude, the points are plotted on the graph. Note that (70, 290) is the origin of the axes of the graph.

```
24       // get the angle in radians
25       angleInRadians = angleInDegrees * Math.PI/180;
26
27       // rotate the wheel and display sine & cosine
28       wheel_mc._rotation = angleInDegrees;
29       m = angleInDegrees;
30       _root["sin"+m]._x = 70 + m;
31       _root["sin"+m]._y = 290 - A * Math.sin(angleInRadians);
32
33       _root["cos"+m]._x = 70 + m;
34       _root["cos"+m]._y = 290 - A * Math.cos(angleInRadians);
35
```

The last part of the script displays the numerical values of the current angle, sin and cos in dynamic text boxes placed at the bottom of the Stage. The expressions for sin and cos may look a little strange. The values for Math.sin and Math.cos are multiplied by 10000 and rounded off with a Math.round in lines 38 and 40. This rounds the value

145

off to the nearest integer, and this number is divided by 10000 to get a number with a decimal point. The net effect of multiplying and then dividing by 10000 is to round the sin and cos functions off to the nearest four decimal points.

```
36        // display the numerical values
37        degrees_txt.text = angleInDegrees;
38        sin_txt.text = Math.round(10000*Math.sin(angleInRadians))
39                                /10000;
40        cos_txt.text = Math.round(10000*Math.cos(angleInRadians))
41                                /10000;
42    };
```

Exercise 5.4: Using Sine Wave Motion

Now that we have seen what a sine wave looks like, let's take a look at an example of sinusoidal motion. One of the first and most classical demonstrations of this appeared in the study of the motion of a clock's pendulum, a major advance in technology at the time. Open `5_4_clockWatcher.swf` in the Chapter 5 `Completed_Exercises` folder to see the motion of a pendulum and test your powers of observation like a true scientist. For our pendulum we will assume that all of its weight is concentrated at a point in the bottom, and we'll live in an ideal world that has no friction.

Figure 5.26 Sinusoidal motion in a pendulum

Step 1: Getting started

Open 5_4_sineWave.fla in the Chapter 5 folder. Before we get to the script, it might be helpful to take a quick look at some of the key elements. For the pendulum to rotate properly, its registration point must be set to the top center of the object with the top of the pendulum located at the center of the clock as shown in Figure 5.27. This was easy to accomplish by placing the pendulum layer on top of the clock layer. Since we want the pendulum to be visually behind the clock, a mask is needed to produce the right effect. You can see the mask by unlocking its layer.

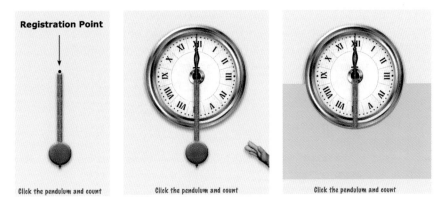

Figure 5.27 Positioning the pendulum and its mask

Step 2: Initialize pendulum variables

The first thing we need to do is to initialize some key pendulum variables that we will be using. The amplitude is set to 30 in line 2. Recall that this will dictate how far the pendulum will swing back and forth. The other variable we'll set is the frequency, which is a measure of how many times the pendulum swings back and forth per minute. At first the pendulum is not moving, so we set the frequency to 0. We will update this later after the user clicks on the pendulum.

```
1    // initialize pendulum variables
2    A = 30;   // A = amplitude (maximum amount of swing)
3    f = 0;    // f = frequency
4
```

Step 3: Get at the actual time

It seems like a nice idea to have our clock show the actual time. Fortunately for us, Flash enables us to do this quite easily. We'll define a function getTime(), which we

147

can use in a frame loop to constantly update the current time. Since Flash provides time with a 24-hour rather than a 12-hour clock, we'll define a variable ampm and set it initially to "am" in line 8. Next we define a new object called newDate by invoking the built-in Date object in line 9 that provides information from the system clock as properties of the object.

To set the hour of the day, we'll define a variable myHour and use the getHours() property in line 10 to extract the hour. Since we are on 24-hour clock time, we need a couple of tests to convert to U.S. 12-hour timekeeping. If the hour is 12 or greater than 12, we are in the afternoon or evening, and so we will then set ampm to "pm" (lines 11 and 13). Also, since we want only hours that are less than or equal to 12, we will subtract 12 from anything greater than 12 (line 14). Extracting the number of minutes and seconds is straightforward and given in lines 16 and 17.

```
5    function getTime()
6    {
7        // script to extract the time from the newDate object
8        ampm = "am";
9        newDate = new Date();
10       myHour = newDate.getHours();
11       if (myHour > 11)
12       {
13           ampm = "pm";
14           if (myHour > 12) { myHour = myHour - 12;}
15       }
16       myMinute = newDate.getMinutes();
17       mySecond = newDate.getSeconds();
18   };
19
```

Step 4: Define the frame loop actions

Inside the frame loop, we want the clock to keep time and show the correct position of the second, minute, and hour hands. Each time through the loop, we will issue a call to the getTime() function in line 23. From there we need to convert to the proper angle of rotation for each of the three hands. Since there are 60 seconds in a minute and the second hand must rotate 360 degrees in a minute, then the second hand must rotate six degrees for each second. So we just need to multiply the number of seconds by 6 to get the correct rotation of the second hand as given in line 24.

148

We could do the same calculation for the minute hand. Note, however, that when we do this we have to wait one complete minute before the minute hand moves. With normal clocks, the minute hand moves slowly and continuously as the minute progresses. To have that effect, we need to include the additional fraction of a minute given by the term mySecond/60 in line 25.

The hour hand is handled in a similar way. Since there are 12 hours and 360 degrees, we need to multiply the number of hours by 30 to get the correct rotation. As above, when we do this we have to wait one complete hour before the hour hand moves. With normal clocks, the hour hand moves slowly as the hour progresses. To have continuous movement of the hour hand, we need the additional term provided in line 26.

```
20    // define the frame loop actions
21    this.onEnterFrame = function()
22    {
23        getTime();
24        seconds_mc._rotation = mySecond * 6;
25        minutes_mc._rotation = (myMinute + mySecond/60) * 6;
26        hours_mc._rotation   = myHour * 30 + (myMinute/60) * 30;
27    }
28
```

Step 5: Define the pendulum actions

The last step is to define the behavior of the pendulum itself. We are instructing the user to click on the pendulum to set it in motion, so we need an onRelease handler. Once the user clicks on the pendulum, we need to store the current time in a variable startTime, since we will be stopping the pendulum movement after 30 seconds. In order to see the pendulum motion, we need to provide an onEnterFrame handler. However, since we're dealing here with pendulum actions, it is convenient to place it inside the onRelease handler.

```
29    // define the pendulum actions
30    pendulum_mc.onRelease = function()
31    {
32        startTime = mySecond;
33        pendulum_mc.onEnterFrame = function()
34        {
```

Each time we enter the frame, we need to update the frequency angle (in degrees) in line 35 so that the pendulum can rotate to a new angle. Line 36 uses something in math and Flash known as the modulo function. The statement f = f % 360 means that we are restricting the values of f to less than 360. It is the remainder that you would get when you divide f by 360.

For example, 360/360 has a remainder of 0, 380/360 has a remainder of 20 and so on. If we traced out the values, they would be 0, 20, 40, ... , 320, 340, 0. Why bother? Well, we know the sin function repeats after 360 degrees, so there is no reason to go higher than that, and it keeps the size of f from becoming unnecessarily large. The greater good is in knowing how to restrict numbers to a range of values easily.

```
35          f += 20;      // update the time factor
36          f = f % 360;  // keep the range between 0 and 360
37
```

The calculation of the pendulum angle is straightforward and identical to what we have done previously. What we next need to do is to stop the pendulum after 30 seconds. We use an if statement to check to see whether the difference between the current time and the starting time when we first clicked on the pendulum is equal to 30 seconds (line 43). We need to use the Math.abs() function so that we always have a positive number. Once time is up, we will stop the movement by deleting the onEnterFrame handler and resetting the pendulum rotation angle to 0 (lines 45 and 46). Save your movie as 5_4_clockWatcher.fla and test it.

```
38              // calculate the pendulum swing angle
39              angle = A * Math.sin( f * Math.PI/180 );
40              pendulum_mc._rotation = angle;
41
42              // if time is up, stop the pendulum & reset it
43              if ( Math.abs(mySecond - startTime) == 30)
44              {
45                  delete pendulum_mc.onEnterFrame;
46                  pendulum_mc._rotation = 0;
47              }
48          }
49      }
50
```

Tip: How would you change the script so that a different random answer comes up each time you click the pendulum? Use the relationship between the answer to this movie and its frequency angle update to guide you.

The Inverse Trig Functions

Sine, cosine, and tangent have inverse functions called arcsine, arccosine and arctangent. In general, you use sine, cosine, and tangent when you know an angle and want to calculate lengths or distances. You use arcsin, arccos, and arctan when you know lengths or distances and want to calculate the corresponding angle in radians. The arctan is generally used more than the other two functions. In fact, ActionScript has a special second arctan function, `Math.atan2(y,x)`, that comes in handy most often. This gives the angle whose tangent (opposite/adjacent) is y/x.

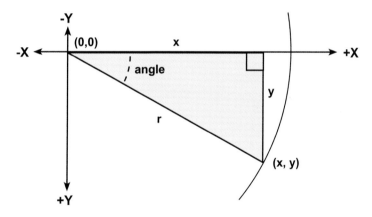

Figure 5.28 Calculating the angle of a point on a circle

Let's quickly look at how we might use `atan2`. Suppose we know that we are at some point (x,y) on a circle as shown in Figure 5.28. We might want to know some information about that circle such as the angle, in degrees, that we are at on the circle. Here's what we need.

> **a = Math.atan2(y, x)**
> **angle = a * 180 / Math.PI**

Figure 5.29 Formula for the angle of a point on a circle

The inverse trig functions available in Flash are

Math.asin(z)	$-1 <= z < = 1$
Math.acos(z)	$-1 <= z < = 1$
Math.atan(z)	z can be any number
Math.atan2(y,x)	x and y can be any numbers

Exercise 5.5: Using the atan2 Function

The `atan2` function is often used in situations such as aiming and shooting at targets in games. It is also used for tracking the location of the cursor, as we will see in this exercise. For reference, open `5_5_froggie.swf` in the Chapter 5 folder. What we have, as shown in Figure 5.30, is a flying bug whose position will be determined by the location of the cursor. The frog's eyes continuously look at the bug wherever it goes. If the bug gets too close to the frog's mouth, it will flick its tongue and eat the bug. Breaking this down, we have three tasks in ActionScript: move the bug, rotate the eyes, and test the bug for closeness to the tongue.

Figure 5.30 Using the `atan2` function

Step 1: Getting started

Open `5_5_atan2.fla` in the Chapter 5 folder. Since we want the bug to follow the cursor without the cursor showing, we'll begin by hiding the cursor. Also, at this point, the frog has not yet flicked its tongue, so we will set the variable `flicked` to false.

```
1    // initialize
2    Mouse.hide();      // hide the normal cursor
3    flicked = false; // the tongue has not yet been flicked
4
```

Step 2: Move the bug

Let's define a function, `moveBug()`, that will enable the bug to move. The first thing we want to do is to set the bug's position to the coordinates of the cursor. This is straight-forward, but the results aren't satisfactory. The bug needs to be a little more uneven in its movement. To accomplish this, we will add `Math.random()*10` to both the horizontal and vertical position of the bug in lines 8 and 9. So although the bug will globally follow the cursor, there will be random variations between 0 and 10 in its location.

```
5    function moveBug()
6    {
7        // set the bug location to the cursor position
8        bug_mc._x = _xmouse + Math.random()*10;
9        bug_mc._y = _ymouse + Math.random()*10;
10
```

There is one other thing we will add to make the movement a little more realistic. When we move the cursor to the right, we expect the bug to face to the right. When we move the cursor to the left, we expect the bug to face to the left. This can easily be done by setting the bug's `_xscale` to either 100 (pointing right) or –100 (pointing left).

To do this, we have to look at the current horizontal location of the cursor. If the current x-axis value is less than the previous x-axis value of the cursor, then the cursor has moved to the left. In this case we will set the scale factor to –1 (line 13). If the current location is greater than the previous x-axis value of the cursor, then the cursor has moved to the right, and we will set the scale factor to 1 (line 15). If there has been no change in the cursor, we'll set the scale factor to be the same as the value it was last set to (line 17).

```
11       // set the direction of the bug according to
12       // the horizontal movement of the cursor
13       if  (_xmouse < oldx ) {scaleFactor = -1;}
14       else
15       if  (_xmouse > oldx ) {scaleFactor = 1;}
16       else
17       {scaleFactor = lastScale;}
```

Once we have determined the scale factor, we set the `_xscale` of the bug to 100 times the scale factor. We must then store the current position of the mouse and scale factor for use the next time the function is called. This is given in lines 20–22.

```
19          // record current x-position and scale factor
20          bug_mc._xscale = 100 * scaleFactor;
21          oldx = _xmouse;
22          lastScale = scaleFactor;
23      }
24
```

Step 3: Rotate the eyes

The first thing we need to do is to calculate the difference between the bug's position and the left and right eyes. By doing separate calculations, we can make each eye move independently of the other. Let's look at a typical situation with the left eye in Figure 5.31.

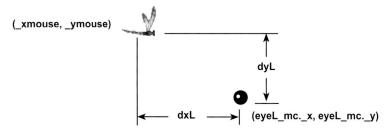

Figure 5.31 Difference between the bug and the left eye

The difference amounts, `dxL` and `dyL`, are illustrated in Figure 5.32 and given in lines 28 and 29. The calculation of the angle formed is determined by `atan2(dyL,dxL)` in line 35 and converted to the left angle in degrees in line 39. Figure 5.32 shows the angle

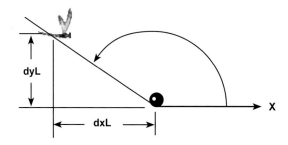

Figure 5.32 The angle determined by `atan2(dyL, dxL)`

calculated. In this case, Flash would yield a negative value since it is smaller than the equivalent positive angle. A similar calculation holds for the right eye.

```
25   function rotateEyes()
26   {
27       // calculate difference between bug position & the eyes
28       dxL = _xmouse - eyeL_mc._x;   // left eye
29       dyL = _ymouse - eyeL_mc._y;
30
31       dxR = _xmouse - eyeR_mc._x;   // right eye
32       dyR = _ymouse - eyeR_mc._y;
33
34       // get the angles in radians
35       L_angleInRadians = Math.atan2(dyL,dxL);
36       R_angleInRadians = Math.atan2(dyR,dxR);
37
38       // convert to degrees
39       L_angleInDegrees = L_angleInRadians * 180/Math.PI;
40       R_angleInDegrees = R_angleInRadians * 180/Math.PI;
41
42       // rotate the eyes
43       eyeL_mc._rotation = L_angleInDegrees + 90;
44       eyeR_mc._rotation = R_angleInDegrees + 90;
45   }
46
```

The last step in the process is to set the left eye rotation to the left angle in degrees as shown in line 43. But wait a minute. What's up with the extra 90 degrees in the equation? Where is that coming from? The answer is either poor planning or it's there to make a point. We'll take the high road and state that we're trying to make a point. In these types of problems you sometimes have to add or subtract various amounts depending upon where the registration points of objects may be.

In our case, the registration points were set in the lower center of the eye as shown in the left graphic of Figure 5.33. As a result the eye is off by −90 degrees. This can be quickly seen by omitting the extra 90 in lines 43 and 44. When you test the movie and position the bug along a horizontal axis to the eyes, they will look either up or down depending on the mouse location instead of sideways. To make things come out right we need to add an extra 90 degrees. An alternative and better solution is to set the registration point to left center initially as shown in the right graphic of Figure 5.33.

Figure 5.33 Setting the registration point

Step 4: Check distance from the tongue

The next thing we need to do is check to see whether the bug is close enough to the tongue to eat. We begin by setting the tongue's alpha to 0 if it has been flicked so that we no longer see it (line 50). Next we calculate the distance between the bug and the tongue using the equation for the distance between two points (lines 54–56).

If the distance is less than the height of the tongue and we haven't yet flicked, then the frog is ready to eat (line 59). Note that the registration point for the tongue is at the bottom of the tongue so that we can test for distance and rotate the tongue correctly.

```
47    function tongueTest()
48    {
49        // if the tongue has been flicked, then hide it
50        if ( flicked == true) { tongue_mc._alpha = 0;} ;
51        else
52        {
53            // calculate the distance between the bug and tongue
54            dxT  = _xmouse - tongue_mc._x;
55            dyT  = _ymouse - tongue_mc._y;
56            dist = Math.sqrt( dxT * dxT + dyT * dyT );
57
58            // if the bug is too close
59            if ( dist < tongue_mc._height && flicked == false)
60            {
```

When the bug is close enough to eat, there are several things we must do. We calculate the angle between the bug and the tongue in radians, again using the atan2 function in line 62. After converting the angle to degrees, we set the rotation of the tongue to that angle. As before, we must add 90 degrees in line 63 because of the placement of the registration point in the lower center, in this case a necessity. We show the tongue by setting its alpha to 100 (line 64). The bug is eaten when its alpha is set to 0 (line 65). We then restore the arrow cursor and set flicked to true (lines 66 and 67).

156

```
61          // calclate the tongue angle and eat the bug
62          T_angle = Math.atan2(dyT,dxT);   // in radians
63          tongue_mc._rotation = T_angle * 180/Math.PI + 90;
64          tongue_mc._alpha = 100;
65          bug_mc._alpha = 0;
66          Mouse.show();
67          flicked = true;
68      }
69   }
70 }
71
```

Step 5: Write the frame loop

Our final step is pretty easy. We simply have to write a frame loop that calls each of the functions that we have just identified and discussed.

```
72   this.onEnterFrame = function()
73   {
74       moveBug();
75       rotateEyes();
76       tongueTest()
77   };
```

Save your movie as 5_5_froggie.fla and test it. When you move the bug near the frog's mouth, you should quickly see the tongue flick and the bug get eaten.

Tip: Can you set up a button that would enable a user to get another bug?

Moving Away From 2D

So far all of our movement has been very flat in appearance. One way we can move toward more three-dimensional-looking motion is by using different imagery and using elliptical rather than circular paths.

Open ellipsor2.fla in the Chapter 5 folder. This is identical to ellipsor1.fla which we have seen previously except that a different object is used. Changing the orbit from a circle to an ellipse whose height is less than its width provides a greater sense of being in a 3D space as shown in Figure 5.34.

157

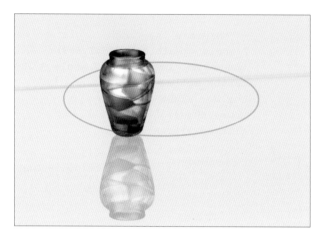

Figure 5.34 A sense of 3D space using elliptical motion

Let's push the sense of a 3D space a little more. Although the elliptical orbit is more 3D-looking, the effect suffers from the fact that the object is always the same size. Our experience tells us that objects farther away from us should appear smaller than objects that are close to us, so we need some way to systematically vary the size of the object. Fortunately, there is a very nice relationship that we can take advantage of. Referring to the Figure 5.34, we would expect that as the y-axis value of the object increases (from top to bottom), then the size of the object should increase. Let's see how we can convert this concept into ActionScript.

We'll start by defining a variable under object characteristics named `minSize`, which will represent the minimum size that the object will be when it is the farthest away from us. This size is expressed as a percentage of the original size, which we will assume to be the size when the object is closest to us.

```
 5   yro = path_mc._height/2;  // yro = initial path y-radius
 6   angle = 0;                // angle = starting angle on path
 7
 8   // define minimum object size as a percent of the original
 9   minSize = 60;
10
```

Next, let's calculate the minimum and maximum y-axis values of the ellipse, which we'll call `ymin` and `ymax` respectively. Since the user can control the path, we will need to put this calculation inside the frame loop so that it can be updated to match user input.

158

```
36        // calculate the min & max y-values for the ellipse
37        ymin = yc - yr;
38        ymax = yc + yr;
39
```

Finally, once we have determined the object's position, we need to scale it according to where it is located. This is a somewhat complicated expression. We start the _yscale at minSize and add to it the proportion of how far it has moved from its minimum vertical position compared with how far it can move. We multiply this latter value by (100 − minSize) to get the correct scale. Once this is known, we must also set the _xscale to the same amount to scale things up uniformly.

```
40        // calculate the size based on its current y-value
41        // the maximum size is 100% of the original size
42        object_mc._yscale = minSize +
43                    (object_mc._y - ymin) * (100 - minSize)
44                    /(ymax - ymin);
45        object_mc._xscale = object_mc._yscale;
46    }
```

As a check, when object_mc._y = ymin, the scale is just minSize. Also, when object_mc._y = ymax, then

```
  object_mc._yscale = minSize + (ymax-ymin)*(100-minSize)/(ymax-ymin)
                    = minSize + 1*(100-minSize) = 100
```

If you find this expression confusing, don't worry. In actual 3D, all this becomes very simple. Save your movie as 5_6_vaseRotating.fla and test it. The visual effect should be more realistic-looking with the object changing size as it orbits. Try different values of minSize with different elliptical shapes.

Circles in Perspective

Without actually coming out and formally stating it in so many words, what we have done so far is to start with circular motion in the vertical x-y plane, and then we created the illusion of rotating the circle onto the horizontal x-z plane by vertically scaling it into an elliptical shape.

Figure 5.35 shows circles on several horizontal planes in perspective. In one-point perspective along the z-axis, ellipses as perspectives of horizontal circles can vary in proportion from a straight line to nearly full circles.

The different ellipses provide a comparison of circles of equal size that are at the same viewing distance from the picture plane but vary in the distances above and below the horizon. The circles are horizontally centered at the center of vision (COV). The plane that is through the horizon generates a straight line edge of the circle.

When we move from simulated 3D to actual 3D using one-point perspective along the z-axis, it will be quite easy to look at objects rotating in different horizontal planes relative to the horizon. We'll see what's involved in the next chapter.

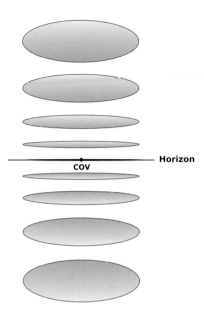

Figure 5.35 Circles on horizontal planes in perspective

Summary

This chapter focused on trigonometry. Key concepts to remember include the following:

- Flash measures angles in radians.
- The Pythagorean theorem states that for a right triangle, the square of the hypotenuse is equal to the sum of the squares of the other two sides.
- Sine, cosine, and tangent represent the three ratios of the sides of a right triangle in relation to the angles of the triangle.
- The trig functions are useful for creating circular and elliptical motion.
- The atan2 function is useful when you have two points and want to know what angle they make with each other.

The next chapter focuses on the fundamentals of 3D space.

6

Fundamentals of 3D Space

So far we have dealt with creating the illusion of 3D space while staying within a 2D environment. It's time that we take a step into the third dimension. Working in 3D space brings a sense of depth and movement that can be difficult to achieve in a strictly two-dimensional world. Like anything, there are various degrees of complexity when working in 3D. In this chapter we will be dealing with movie clips that are defined in 3D space. We can think of these as two-dimensional planes that are living in a three-dimensional world. This will give us simpler expressions while providing a wealth of imagery to work with. We will work with more complex 3D shapes later.

This chapter is broken down into the basic concepts of 3D space that you will need to become familiar with. Following is what we will be covering:

- Perspective projection
- Degrees of freedom
- Translation
- Rotation

Perspective Projection

Since all 3D drawings are projections onto a picture plane, what we need to know is how to create the rays from the object to the picture plane for a perspective projection. While this might seem to be a bit complicated, it is actually a quite simple and straight-forward procedure.

Figure 6.1 illustrates the basic concepts of perspective drawing where a viewer is observing an object's two-dimensional image on the surface of a picture plane. Straight line projections extend from the viewer's eye position to points on the object to be drawn in perspective. The intersections of the projections with the transparent picture plane yield points on the perspective drawing of the object. Connecting these points

provides the perspective drawing. Note that the projection rays can make the image on the picture plane either larger than, smaller than, or the same size as the object itself.

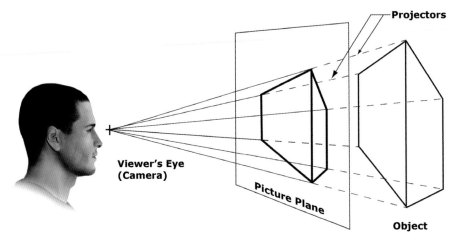

Figure 6.1 Basic perspective projection

In computer graphics, the picture plane is generally assumed to be the monitor screen. A line from the viewer's eye perpendicular to the picture plane is called the center of vision (COV) of the perspective as shown in Figure 6.2. A horizontal line drawn on the picture plane at the point of intersection of the COV with the picture plane is called the horizon line.

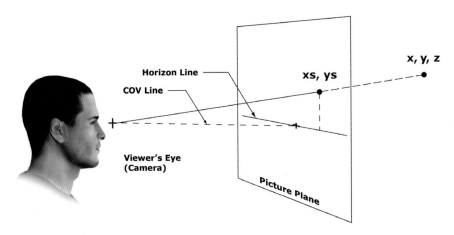

Figure 6.2 Projecting a 3D point onto the picture plane

Points in 3D space are defined by x-, y-, and z-coordinates, typically measured from an origin that is the point of intersection of the COV with the picture plane. The x-value is the horizontal distance from the origin, with positive values to the right and negative values to the left. The y-value is the vertical distance from the origin, with positive values above and negative values below the origin. The z-value is the depth from the origin, with positive and negative values going into and coming out of the screen respectively.

The origin of the two-dimensional perspective drawing is also at the point of intersection of the COV with the picture plane. The two-dimensional coordinates xs,ys are called screen coordinates and are measured from the origin.

To see how to convert from 3D coordinates to screen coordinates, let's look along the x-axis in Figure 6.3. The projection of the y-axis value of the 3D point intersects the picture plane at some screen value ys. We will assume that the viewer is some known distance d from the picture plane. This gives us two similar triangles whose sides are in proportion to one another. Thus the ratio of the height and the base of both triangles must be the same. We can write this as

$$ys/d = y/(d+z)$$

Multiplying both sides of the equation by d, we get

$$ys = y * d/(d + z)$$

Similarly, we get

$$xs = x * d/(d + z)$$

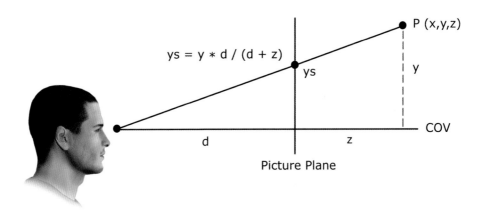

Figure 6.3 Side view of projection onto the picture plane

So we can convert from 3D coordinates to 2D screen coordinates just by multiplying the x- and y-values by the quantity d/(d + z). We'll call this quantity dr, the distance ratio, which is the ratio of the distance of the picture plane to the viewer divided by the total distance in the z-direction of a 3D point to the viewer.

To summarize the preceding discussion with what we previously found, the transformation from a point P(x,y,z) in 3D space to Flash coordinates is given by the equations below where (xo,yo) are the Flash coordinates of the COV line (that is, the origin of the 3D coordinate system).

$$_x = xo + x * dr \qquad dr = d \ / \ (d+z)$$
$$_y = yo \ - y * dr$$

Exercise 6.1: Something Fishy

Let's look at a simple example of how we can apply the distance ratio with ActionScript. Open the file 6_1_fishy.fla in the Chapter 6 folder. A typical screen shot from the movie is shown in Figure 6.4. In this example we are looking right down the z-axis, which is located in the middle of the screen with objects coming at us, so we will be dealing with one-point perspective here.

Figure 6.4 Example screen of Exercise 6.1

The file contains three layers. Layer 1 contains the background. Layer 2 has a movie clip with an instance name of `object_mc`, located just off the upper left of the Stage. Layer 3 will contain the actions needed to generate the imagery. In this exercise we are going to duplicate a fish 25 times and randomly assign a location in 3D space to each duplicate.

Step 1: Getting started

Let's begin by setting up some information about our 3D world. Enter the script below in the `actions` layer. In line 2 we are defining the viewer distance to be 200. Although the units of measurement can be anything you want as long as they are consistent, it is usually easiest to think in terms of pixels.

In lines 6 and 7, we set the center of the Stage to be the origin (xo,yo) of the screen coordinates, which also serves as the origin of the 3D coordinate system. Positive and negative values of x and y will be measured from that point.

```
1   // set the viewer distance d from the screen
2   var d:Number = 200;
3
4   // set the center of the stage xo, yo as the origin
5   // of the screen coordinates
6   var xo:Number = Stage.width/2;
7   var yo:Number = Stage.height/2;
8
```

Step 2: Create the objects

Next let's make some copies of the fish. In line 10 we are setting the number of duplicated fish to be 25. The actual duplication process is given in lines 13–19. The `for` loop states that the steps inside the loop are to be repeated beginning with i=0 and with i incremented by 1 (i++) for as long as i is less than `numObjects`. Thus i will take on the values 0, 1, 2, ..., and 24.

Line 15 duplicates the fish movie clip for each value of i, creating movie clips named "object0", "object1", "object2", and so on, up to "object24", with each ball on its own separate depth level 0, 1, 2, ..., and 24.

In line 13 we are defining the variable `thisObj`, which will temporarily hold the name of each duplicated fish. If you are not familiar with the notation, it may seem a little

165

strange to you, but it is required by Flash. The notation tells Flash that the object name
is a string found in the root Timeline. A string is just a sequence of alphanumeric char-
acters enclosed in quotes ("object0", "object1", etc.). Lines 17 and 18 are calls to func-
tions that identify what we want to have happen with each duplicated fish. We want to
give a location for each object in 3D space and then display that object.

```
9    // set the number of objects to be created
10   var numObjects:Number = 25;
11
12   // duplicate the object movie clip
13   for (var i:Number = 0; i < numObjects; i++)
14   {
15       duplicateMovieClip(object_mc,"object"+i,i);
16       var thisObj:MovieClip = _root["object"+i];
17       placeObj();
18       displayObj();
19   }
20
```

Step 3: Randomly place each object

The script below defines the function `placeObj()`. Here's what the function does. In
the previous step, we assigned the temporary name `thisObj` to each duplicated object,
and now we want to give it some location in 3D space.

```
21   function placeObj()
22   {
23       // pick a random point in 3D space
24       thisObj.x = Math.random() * 600 - 300; // -300 < x < 300
25       thisObj.y = Math.random() * 400 - 200; // -200 < y < 200
26       thisObj.z = Math.random() * 300 - 100; // -100 < z < 200
27   }
28
```

We can assign x-, y-, and z-location properties to `thisObj` that will represent its 3D
coordinates. We will choose these coordinates as random values but within some limits.
Let's look at how the x-value is determined. With `Math.random()`, ActionScript's random
function, we randomly produce a decimal point number between 0 and 1. The number
generated is multiplied by 600, which yields some number between 0 and 600. Finally,
300 is subtracted, which results in some number between −300 and +300.

A similar process is used to provide y- and z-coordinates. Each time the random function is called, a new number will be generated so that x, y, and z will have different random values and will have different values for each fish. This will give us a different location in 3D space for each fish.

Step 4: Display each object

Now that we have positioned each fish in 3D space, we need to convert those coordinates to screen coordinates in order to display it. That task is given to the `displayObj()` function. To get the screen coordinates, we first calculate the distance ratio based on the object's z-value as shown in line 32.

```
29    function displayObj()
30    {
31        // calculate the distance ratio dr
32        var dr:Number = d/ (d + thisObj.z);
33
```

The object's screen coordinates (xs, ys) are then computed in lines 35 and 36. Finally, to position the ball in Flash coordinates, we use lines 41 and 42. Recall that for Flash, the (0,0) point of the Stage is in the upper-left corner and that the positive y-axis points down instead of up.

```
34        // calculate the screen coordinates xs, ys
35        var xs:Number = thisObj.x * dr;
36        var ys:Number = thisObj.y * dr;
37
38        // set the location of the object on the stage
39        // note the minus sign for y is because the y-axis
40        // in Flash points down instead of up
41        thisObj._x = xo + xs;
42        thisObj._y = yo - ys;
43
```

There is one remaining thing that we must consider. We have discussed how objects that are farther away from us appear smaller. How can we take this fact into account when working in 3D? The answer lies in the distance ratio. When an object is at z = 0 so that dr = 1, it seems natural to want to see the object at actual size. When an object is infinitely far away from us so that dr = 0, then the object size should be 0. Suppose an object is located at a distance ratio of 1:2. We might reasonably expect that the object will appear to be half of its original size. To get an appropriate size for

each object, we can set its scale to be a percentage of its distance ratio as shown in line 45.

```
44        // set the size as a percent of its distance ratio
45        thisObj._xscale = thisObj._yscale = 100 * dr;
46
47    }
```

Save your file as 6_1_fishy_DONE.fla and test your movie. Your results should be similar to Figure 6.5. The size and position of the fish in your movie will, of course, be different since they are being randomly generated.

Figure 6.5 Initial output with incorrect ordering

Looking closely at the figure, we see there is a problem. Something fishy is going on. Although the fish vary in size and position, there are smaller fish in front of larger ones. This is not correct because the smaller ones are farther back in 3D space and should be behind larger fish. What we need is some way to order or sort the fish so that the ones with lower z-values will be in front of those with higher z-values. Recall that z = 0 is located at the screen and that positive numbers go into the screen.

Step 5: Z-sorting the objects

Add the script below to what you already have. We can get the proper ordering or

layering of the fish simply through the inclusion of line 49. Here's how it works. When we first duplicated the fish, we set each one at a different depth value, starting at 0 and ending at 24. These depth values automatically create a layering order in Flash such that higher depths are on top of lower depths. To see what the depth of `object_mc` is, type `trace(object_mc.getDepth())` in line 3. The `getDepth()` function retrieves the depth of an object, and the `trace` command displays the information in the Output window of Flash.

Depth values in Flash can range from −16383 to 1048575. An object can be assigned a new depth value using the `swapDepths()` function. Since objects with large values of z are farther back in space, by setting the depth to be the negative of the z-value, we can place those objects on a lower layer, and thus they will be behind closer objects. This process is sometimes referred to as z-sorting. It's not perfect but works for most situations. Note that `Math.round` simply rounds off the z-value to a whole number.

```
47        // set the object depth based on its z-location so
48        // that closer objects are on top of farther objects
49        thisObj.swapDepths(Math.round(-thisObj.z));
50    }
```

Save your file and test your movie again. Your results should be similar to Figure 6.4, with smaller fish behind the larger, closer ones.

Degrees of Freedom

Objects in our 3D world have the potential to move in any one or combination of six different ways, which are often called degrees of freedom. There can be movement parallel to each of the x-, y-, and z-coordinate axes, which are typically called translation degrees of freedom. An object can also have three rotation degrees of freedom, which is rotation about each of the coordinate axes as shown in Figure 6.6. If an object is moving in all six degrees of freedom, the motion can be complex to specify. We will look at examples of this in a later chapter using simple objects, but for now, let's investigate some of the rich possibilities of movement in one or several degrees of freedom.

We'll begin by first considering the translation degrees of freedom, and in particular, movement along the z-axis. This might seem a bit oversimplified, but in the case of z-axis motion, we might be in for a bit of an unexpected surprise.

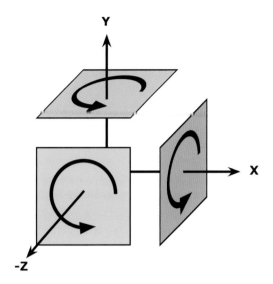

Figure 6.6 The three rotational degrees of freedom

Exercise 6.2: Belly Up

Open the file 6_2_bellyUp.fla in the Chapter 6 folder. The script here is exactly the same as the one you created in the previous exercise except that the z-values begin farther back in space as can be seen in line 26. Let's add some scripting that will enable the fish to move toward us.

Step 1: Define the distance of movement in the z-direction

Let's have all of the fish move toward us at a rate of three pixels every frame. For more complicated motion, we might want to define a separate function, but for now we'll just add a line to the placeObj() function. What we need is a variable dz that defines the distance each object will move in the z-direction. Since we want the fish to come toward us, this number has to be negative. Add the line shown below.

```
21    function placeObj()
22    {
23        // pick a random point in 3D space
24        thisObj.x = Math.random() * 600 - 300; // -300 < x < 300
25        thisObj.y = Math.random() * 400 - 200; // -200 < y < 200
26        thisObj.z = Math.random() * 300       //    0 < z < 300
27        thisObj.dz = -3; // movement in the z-direction
28    }
```

Step 2: Add the frame loop actions

Add the script below to the bottom of what you already have. In order to see the fish swim toward us, we will need to add a frame loop for the motion. Each time we enter the frame, we need to loop over all of the objects (line 56) and in each case, get a new updated value for its z-coordinate (line 59), and then display the object (line 60).

```
53    // create the movement for each object
54    this.onEnterFrame = function()
55    {   // loop over the objects
56        for (var i:Number=0; i<numObjects; i++)
57        {
58            thisObj = _root["object"+j];
59            thisObj.z += thisObj.dz;       // update the z-value
60            displayObj();                  // display the object
61        }
62    }
```

Save your file and then test the movie. Did anything unexpected happen? If you let the movie run long enough, what you will see is each fish getting closer to you until, at some point, it gets too close and then flips over belly up and moves back in space as in Figure 6.7. Why is this happening?

Figure 6.7 Result of objects moving past the viewer

The answer lies in the expression for the distance ratio `dr = d/(d + thisObj.z)`. As long as the z-value of a fish is greater than −d so that `d + thisObj.z` is a positive number, everything is fine, because the fish is in front of the viewer.

When the z-value of a fish is less than −d, the fish is behind the viewer, and then `dr` becomes a negative number. Since the screen coordinates and the size of the fish are based on `dr`, this causes a reverse in the direction and the scale factors of the fish. What happens is that, like a lens, the image gets inverted both horizontally and vertically, and then its size decreases as it moves away from you. So, unless you are after an effect where the object seems to bounce off a wall and then go back in space, we will need to add a test that prevents this from happening.

Step 3: Check whether an object is too close to the viewer

The test to see whether an object is too close to the viewer is straightforward. There are two decisions we need to make. The first is to specify what we mean by "too close." It could mean that an object has reached the viewer so that its z-value is equal to the negative of the viewer distance. Or it could mean that an object is sufficiently close to "in my face" without actually being there. We will specify the latter with 30 pixels being close enough.

The other decision is what to do with the object when it does get too close. That very much depends on what we want the user experience to be. For our unruly school of fish, we will remove any that swim past us. In other situations, often in games, the object gets relocated back in 3D space and keeps moving forward. Add the following lines to the `displayObj()` function. Save your movie as `6_2_bellyUp_DONE.fla` and test it. Hopefully no more belly up.

```
48        // set the depth based on its z-location so that
49        // closer objects are on top of farther objects
50        thisObj.swapDepths(Math.round(-thisObj.z));
51
52        // check if the object is too close to the viewer
53        if ( thisObj.z <= -d + 30)
54        {
55            thisObj.removeMovieClip();
56        }
57   }
```

Exercise 6.3: More Complex Movement

Now that we have things moving in one direction, let's extend what we know. Open 6_3_rockOn.fla in the Chapter 6 folder. Except for the number of objects and a greater range of z-values, this file has the same script as the previous exercise. The frame rate has been increased to 24 frames per second (fps) for faster motion. Test the movie to see what it looks like. While it seemed somewhat natural for the fish to be swimming in unison, the rocks look strange all moving at the same rate. We need to have more variety in their movement. Open 6_3_rockOn_DONE.swf to see where we are headed.

Figure 6.8 Complex translational movement

Step 1: Vary the z-direction movement

Rather than having all the rocks move at the same speed, let's use the random function to enable each rock to move at a different speed. Change line 27 to the one shown below. For each rock, the -Math.random()*10 generates a number between 0 and -10 to which a -3 is added. So each rock will have a change in z-value between -3 and -13. Test your movie to see the difference that different speeds make.

```
26          thisObj.z = Math.random() * 300 + 300;
27          thisObj.dz = -Math.random() * 10 - 3;
28      }
```

Step 2: Replenish the rocks

Since we appear to be in rather deep space, we might expect to run into more rocks. We could increase the number of rocks that we duplicate, but that might bog things down at some point. Instead let's use our check for an object being too close to the viewer as an opportunity to recycle rocks. Instead of using removeMovieClip() to delete a rock, let's just send it back into deep space by using a call to the placeObj() function as shown in line 55. Again test your movie. You should now have several light years of rocks to go through.

```
52        // check if the object is too close to the viewer
53        if ( thisObj.z <= -d + 30)
54        {
55            placeObj();
56        }
```

Step 3: Add movement in the x- and y-directions

We're making progress, but it doesn't seem reasonable that all of the rocks would be moving only along the z-axis. Let's provide some movement in the x- and y-directions for the rocks as well. We can randomly vary these movements in a manner similar to what we did in the z-direction. The effect won't be as striking as when we varied the change in the z-direction, but it provides a wider variety of crossing directions. Replace line 27 with the lines shown below to generate the incremental movement of each rock.

```
27
28        //move random incremental distance in x-,y-,z-directions
29        thisObj.dx =  Math.random() * 10 - 5;
30        thisObj.dy =  Math.random() * 10 - 5;
31        thisObj.dz = -Math.random() * 10 - 3;
32    }
33
```

We will need to add the incremental movement to the current position of each rock to get an updated position. We are already updating the z-location of each rock and just need to add similar expressions for x and y as shown. Note that we could have defined a separate update function to include these lines and then call the update function. Alternatively, we could also have placed the lines in the displayObj() function. Since we already had the z-value update, it seemed easier to just add the additional lines at this location in the script.

```
68          thisObj = _root["object"+i];
69
70          // update the current position of each object
71          thisObj.x += thisObj.dx;
72          thisObj.y += thisObj.dy;
73          thisObj.z += thisObj.dz;
74
75          displayObj();
```

Step 4: Create more variations in the rocks

So far we have made the movement of the rocks quite a bit more interesting, but the rocks all look the same. Is there any way that we can alter the appearance of the rocks to suggest greater variety without physically adding more rocks? As it turns out, the answer is yes. One very simple technique is to randomly set the rotation value of each rock in the placeObj() function. Having each rock moving with a different orientation makes it much more difficult to tell that they are all the same.

```
31          thisObj.dz = -Math.random() * 10 - 3;
32
33          // modify the appearance of each object
34          thisObj._rotation = Math.random() * 360;
35
```

We can also easily alter the appearance of the rocks by setting them initially to different scale factors in 3D space. We will define local scale factors xscale and yscale to randomly generate scale values between 50 and 150 for each rock. This will provide variation in both the width and height of the rocks.

```
33          // modify the appearance of each object
34          thisObj._rotation = Math.random() * 360;
35          thisObj.xscale = Math.random() * 100 + 50;
36          thisObj.yscale = Math.random() * 100 + 50;
37      }
```

Since the rocks no longer have the same scale, we need to make a small adjustment in our displayObj() function. Rather than having a single line of code as before to set the scale based on the distance ratio, we now need to replace it with separate statements to reflect our setting of the local scale factors in the placeObj() function.

```
54          // set the size as a percent of its distance ratio
55          thisObj._xscale = thisObj.xscale * dr;
56          thisObj._yscale = thisObj.yscale * dr;
57
```

Save and test your movie. There should be a very noticeable difference in the appearance of the rocks from the changes we have made. We will put just a few finishing touches in the next step, and we'll be done.

Step 5: Add finishing touches

We'll complete this exercise by including a few additional items to enhance the overall effect. For example, from our discussion of aerial perspective in Chapter 2, we would like to have objects farther away from us appear darker than objects close to us. Since the rocks are appearing on basically a black background, we can easily get the effect we want by varying the alpha of each rock.

The fundamental variable that we have relating to distance from us is the distance ratio. An obvious choice would be to set the alpha to 100 times the distance ratio to give us values between 0 and 100. While this works, visually it seems to take too long for the rocks to get bright, so we will increase the alpha by 200 times the distance ratio as shown below. Note that we can get better and more sophisticated results by using the color transform operator, but this is simpler and meets our need.

We can create more interesting rock motion by having each rock rotate a little as it moves. We'll increment by 2 degrees each time through the loop. Add the following lines after line 56.

```
54          // set the size as a percent of its distance ratio
55          thisObj._xscale = thisObj.xscale * dr;
56          thisObj._yscale = thisObj.yscale * dr;
57
58          // relate the object's alpha to the distance ratio
59          // for aerial perspective
60          thisObj._alpha = 200 * dr;
61
62          // add some rotation to each object as it moves
63          thisObj._rotation += 2;
64
```

176

There's one more observation that we need to make. If you test your movie and look closely, you will notice that many of the rocks go outside of the Stage area before they reach the z-value necessary to recycle them. Since we can't see them once they are off the Stage, it makes sense to relocate them back in deep space whenever they are no longer visible to us.

Let's add a simple test to our script that will do what we want. We'll just check to see if the _x value of each object is either less than 0, which means it is off the Stage on the left, or greater than the width of the Stage, which means that it is off on the right. Similarly, we'll check to see if the _y value is less than 0 or greater than the Stage height, which means it is off the top or bottom. We'll also place the check for an object being too close to the viewer on a single line in line 70 for better readability.

```
69        // check if the object is too close to the viewer
70        if ( thisObj.z <= -d + 30) { placeObj(); }
71
72        // check for going outside of the Stage area
73        if ( thisObj._x < 0  )          { placeObj(); }
74        if ( thisObj._x > Stage.width ) { placeObj(); }
75        if ( thisObj._y < 0 )           { placeObj(); }
76        if ( thisObj._y > Stage.height) { placeObj(); }
77
```

Save your file as 6_3_rockOn_DONE.fla and test your movie. It should appear quite a bit different from what we started out with. Have a safe journey.

Tip: In the two previous exercises we used swapDepths() to perform a z-sorting on the objects so that objects closer to us would be in front of those farther away. Is that requirement necessary in this exercise?

Rotation in the x-z Plane

As we saw earlier, there are three rotational degrees of freedom about the three coordinate axes. We explored some of the possibilities of rotation about the z-axis in Chapter 5 since it corresponds to normal 2D rotation. We also saw that by distorting a circular path into an elliptical one that we could simulate rotation about the y-axis in the x-z plane. Let's use what we did there to provide a jumping-off point to look at actual 3D rotation in the x-z plane shown in Figure 6.9.

177

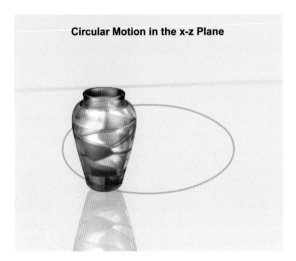

Figure 6.9 Circular rotation about the y-axis

Exercise 6.4: Circular Rotation About the Y-Axis

Open `6_4_xzRotation1.fla` located in the Chapter 6 folder. The script is the same as `ellipsor2.fla` from Chapter 5 except that the ellipse has been given fixed proportions and the key press interactivity has been removed to focus on the motion.

Step 1: Initialize the viewing parameters

In order to move from a 2D world to a 3D world, we need to specify the distance d from the viewer's eye to the screen along the center of vision. Recall from Chapter 1 that the center of vision is a line from the viewer's eye perpendicular to the picture plane which is the monitor screen. We'll set the distance to be 600 pixels. We also need to define where we want the center of vision to intersect the screen. This will be the origin (xo,yo) of our screen coordinate system. Replace lines 1–6 with the lines shown below.

```
1   // set the viewer distance d from the screen
2   var d:Number = 600;
3
4   // define the origin xo, yo of the screen coordinates
5   var xo:Number = Stage.width/2;
6   var yo:Number = 0;
7
```

Previously, the origin has been set at the center of the Stage. We can place it anywhere we like. Now we are setting the origin to be horizontally centered, but the vertical origin is located at the top of the Stage. Let's look at the reason for doing this.

In 3D space the path will be a circular orbit about the y-axis or about a line parallel to the y-axis. We want our object to generally follow the path shown on the left side of Figure 6.10 when projected onto the screen. In 3D space, there are actually many combinations of viewer distance, location of path, and radius of path that can produce the elliptical path shown.

The 2D view of the path and object indicates that we will be looking down on them somewhat in 3D space. Since we are mapping the origin of the 3D coordinate system to the origin of the screen coordinates, the rotation must be on a plane below the origin in order for us to look down on it. Placing the vertical origin of the screen coordinates at the top of the Stage provides room to see the path of motion on the Stage. If we used the center of the Stage as we have done previously, the motion would be all or partially below the Stage.

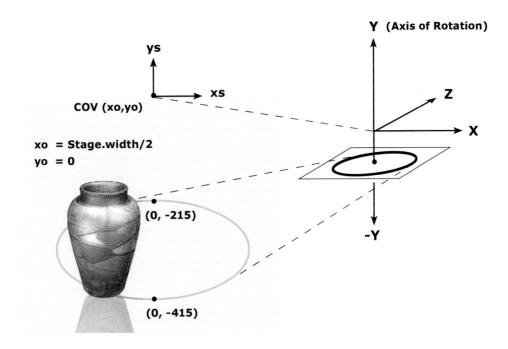

Figure 6.10 Setting the path of motion in the x-z plane

Step 2: Define the path characteristics

As before, we need to provide some information about the path the object will take. The essential items to specify are the location of the center of the circle in 3D space and its radius. We'll use the right side of Figure 6.10 as a guide and consider a path that is rotating about the y-axis and centered on a plane somewhere below the x-z plane so that the horizontal center x_c and depth center z_c will be 0. For the radius of our circular path, we will use r = 200 to match the width of the 2D image for convenience.

What remains is to figure out the vertical center of the path in 3D. We know from Figure 6.10 that the plane of motion needs to be a negative number. Is there some way to figure out what the number should be? As it turns out, there is by looking at the top and side views of the 3D path drawn to scale as shown in Figure 6.11.

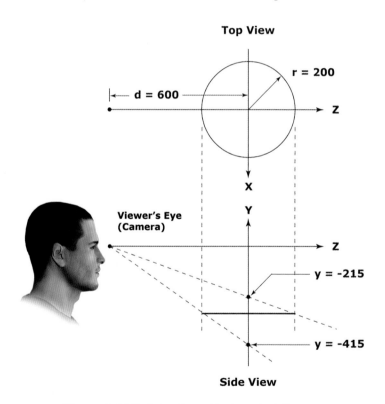

Figure 6.11 Defining the path characteristics

When looking at the circular path from the side view, the viewer will see the top and the bottom of the circular path at y = −215 and y = −415 when projected into screen coordinates. You can determine these numbers by clicking on the ellipse and referring

to its values in the Properties window. The y-value of the top of the ellipse is 215 in Flash coordinates, which becomes a negative number in screen coordinates. The height of the ellipse is 200, so the bottom of the ellipse is located at 415 in Flash coordinates and −415 in screen coordinates.

In the side view, if we extend lines from the viewer's eye through the points −215 and −415, the intersections of these lines with projected lines of the circular path from the top view will give us the vertical location of the x-z plane of the path. We could use trig to figure out this value, but we can just as easily read the value from the rulers in the drawing and see that −280 is close enough. Enter the values below for the path characteristics and delete the remaining 2D script, which will be replaced with our 3D script.

```
8    // define the path characteristics
9    var xc:Number = 0;     // xc = horizontal center of path
10   var yc:Number = -280;  // yc = vertical center of path
11   var zc:Number = 0;     // zc = depth center of path
12   var r:Number = 200;    // r  = path radius
13
```

Step 3: Place the object on the path of motion

As we have done before, let's create a function to place the object on the circular path. We need to place it in 3D space, so we will define x-, y-, and z-properties that will contain the 3D coordinates of the object as shown below. Note that because we are following a circle in the x-z plane, we can use the standard trig functions for a circle using x and z. The y-value just specifies where the circular plane is located vertically. Notice that in earlier versions of the placeObj() function, we had nothing inside the parentheses. Here we are using the generic name thisObj to represent any object that we may care to use with this function. Items like this are often referred to as arguments.

```
14   // place the object on the path of motion
15   // angle is starting angle of the object on the path
16   var angle:Number = 0;
17   function placeObj(thisObj)
18   {
19       var a:Number = angle*Math.PI/180;
20       thisObj.x = xc + r * Math.cos(a);
21       thisObj.y = yc;
22       thisObj.z = zc + r * Math.sin(a);
23   }
24
```

Step 4: Display the object on the screen

Again, just as we had before, we need a function to display the object on the screen. We will use the generic argument `thisObj` as we did in the last step. Other than that, everything else is a repeat of earlier `displayObj` functions.

```
25    // display the object on the screen
26    function displayObj(thisObj)
27    {
28        // calculate the distance ratio dr
29        var dr:Number = d/(d + thisObj.z);
30
31        // calculate the screen coordinates xs,ys
32        var xs:Number = thisObj.x * dr;
33        var ys:Number = thisObj.y * dr;
34
35        // set the location of the object on the Stage
36        // note minus sign for y is because the y-axis
37        // in Flash points down instead of up
38        thisObj._x = xo + xs;
39        thisObj._y = yo - ys;
40
41        // set the size as a percent of distance ratio
42        thisObj._xscale = thisObj._yscale = 100 * dr;
43
44        // set object depth based on its z-location so that
45        // closer objects are on top of farther objects
46        thisObj.swapDepths(Math.round(-thisObj.z));
47    }
48
```

Step 5: Create the motion along the path

The next step is to set the object in motion on its circular path. There is very little to do. We need an `onEnterFrame` handler to loop over the frame. Each time we just need to update the angle, place the object in its new location in 3D space, and display it on the screen. Add the lines shown, and test your movie to check that the motion follows the dark gray circle.

```
49     // create the motion along the path
50     this.onEnterFrame = function()
51     {
52         angle += 5;
53         placeObj(object_mc);
54         displayObj(object_mc);
55     }
```

Step 6: Add some user interaction

Let's add some simple user interaction as a final step. We'll set the circular motion to be clockwise if the cursor is on the left side of the Stage and counterclockwise if the cursor is on the right side of the Stage. Add the lines shown below, and you're done.

```
49     // create the motion along the path
50     this.onEnterFrame = function()
51     {
52         // update the angle increment based on _xmouse
53         if (_xmouse > xo ) {angle += 4; }
54         else angle -= 4;
55         placeObj(object_mc);
56         displayObj(object_mc);
57     }
```

Save your file as 6_4_xzRotation1_DONE.fla and test the movie. Select the circle and set its alpha to 0 in the Properties window. Test your movie again. Even on a flat background, there is a good sense of movement in a 3D space. Notice how simple the change in size due to perspective becomes. There is no complicated expression like the one we had when simulating the 3D movement in a 2D world.

Rotating Multiple Objects

Let's extend the above to include multiple objects. It's really a simple task since we can use the script in the example above and add to it appropriate parts of the 2D rotation script from 5_3_dolphinSwim1.fla in Chapter 5. Open the file 6_5_xzRotation2.fla in the Chapter 6 folder. Test the movie so that you can see what the result is.

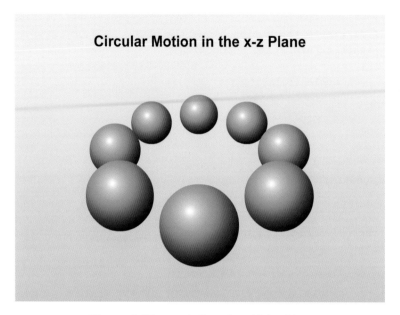

Figure 6.12 x-z rotation of multiple objects

There have been a few minor changes from the last example for presentation purposes. The origin of the screen coordinate system is still located at the top middle of the Stage, but the distance has been shortened to 400. There have been a few adjustments to the path characteristics to fit conveniently on the Stage. The original values from the previous example are included as comments for reference.

```
1   // set the viewer distance d from the screen
2   var d:Number = 400;
3
4   // define the origin xo, yo of the screen coordinates
5   var xo:Number = Stage.width/2;
6   var yo:Number = 0;
7
8   // define the path characteristics
9   var xc:Number = 0;    // xc = horizontal center of path
10  var yc:Number = -250;//-280 // yc = vert. center of path
11  var zc:Number = 50;   // 0; // zc = depth center of path
12  var r:Number  = 160;  //200;// r  = path radius
13
```

As with the 2D rotation we will need to define the number of objects to create (line 15) and calculate the angle between any two objects on the circular path (line 19). In our case with eight objects, `circleAngle` is 360/8 or 45 degrees.

The objects we need are created with a simple `for` loop that duplicates the `object_mc` movie clip the specified number of times (lines 22–25).

```
14    // set the number of objects to be created and startAngle
15    var numberOfObjects:Number = 8;
16    var startAngle:Number = 0;// starting angle on the circle
17
18    // calclate the angle between any 2 objects on a circle
19    var circleAngle:Number = 360/numberOfObjects;
20
21    // create the objects for the circular motion
22    for (var i:Number = 0; i < numberOfObjects; i++)
23    {
24        object_mc.duplicateMovieClip("object"+i, i);
25    }
26
27    // place the object on the path of motion
28    function placeObj(thisObj,i)
29    {
30        // calculate the angle of the object
31        var myAngle:Number = i * circleAngle + startAngle;
32        var a:Number = myAngle * Math.PI/180;   // in radians
33
```

Since we now have multiple objects, the `placeObj` function needs the addition of calculating the angle `myAngle` at which each object is on the path (line 31). At the beginning when `startAngle = 0`, the calculation for `myAngle` takes on the values `i*circleAngle` or 0, 45, 90, ..., and 315 degrees respectively. The angles are then converted to radians in line 32.

The `displayObj` function is exactly as in the previous example, so let's go to where the motion occurs in the `onEnterFrame` handler. All we need to add is a loop over all of the objects (line 72), set `thisObj` to the current object (line 74), and then make calls to the place and display functions.

```
64    // create the motion along the circular path
65    this.onEnterFrame = function()
66    {
67        // update the angle increment based on _xmouse
68        if ( _xmouse > xo ) {angle += 4; }
69        else angle -= 4;
70
71        // loop over all the objects
72        for (var i:Number i = 0; i < numberOfObjects; i++)
73        {
74            thisObj = this["object"+i];
75            placeObj(thisObj,i);
76            displayObj(thisObj)}
77        }
78    }
```

A Little More User Interaction

Instead of having only uniform clockwise or counterclockwise motion, let's look at the situation where we want to have the motion gradually slow down as the user moves the cursor toward the center of the objects and speed up as the cursor moves away from the center toward the outside of the Stage. A typical application might be where we want the user to click on the objects for additional information. We can do this by modifying the test we have for the horizontal position of the cursor.

Exercise 6.5: Variable Speed of Rotation

Open 6_5_xzRotation2.fla. We'll use this as a starting point for setting up the variable speed of rotation. We are going to create a relationship between the horizontal speed of the cursor and the speed with which the objects rotate in a circle.

Step 1: Define the angle change

Let's define the variable angleChange, which is a measure of how far the horizontal position of the cursor is from the center of the Stage, which we have previously defined as xo. We'll need to place this inside the onEnterFrame handler. First, we'll calculate how far the horizontal location of the cursor is from the center of the Stage using _xmouse-xo. We'll round the number off and store it in angleChange. Then we use this to update startAngle, which controls the motion. Modify lines 67 through 69 in the script to those shown here.

```
64      // create the motion along the circular path
65      this.onEnterFrame = function()
66      {
67          // update the angle increment based on how far
68          // _xmouse is from the center of the Stage
69          var angleChange:Number = Math.round(_xmouse-xo);
70          startAngle += angleChange;
71
```

Test your movie and see what happens. When the cursor is near the center of the Stage, the objects generally behave as expected. In the center they stop altogether, and, depending on whether you move the cursor left or right, the objects will rotate clockwise or counterclockwise. When you move the cursor out a littler farther, weird things begin to happen. The objects appear to speed up and slow down, sometimes rotating clockwise, sometimes counterclockwise.

The problem is that the objects are spinning too fast and produce an effect that, in the movies, are like wagon wheels rotating backwards due to differences in wheel rotation speed and the film rate. In our case, angleChange gives a number between −320 and 320, since our Stage width is 640 pixels. We need to make angleChange produce a smaller number.

Step 2: Add a speed factor

Let's define a variable named speedFactor as part of the object characteristics. We'll set its value to 40, but it can be anything you like.

```
14      // set the number of objects to be created and startAngle
15      var numberOfObjects:Number = 8; //object_mc._totalframes;
16      var startAngle:Number = 0;      // starting rotation angle
17      var speedfactor:Number = 40;    // controls speed of motion
```

In the angleChange calculation, we will divide the number by speedfactor, which will now yield a number between −8 and 8 after we round it off. We'll use this to update startAngle, which controls the motion at a more reasonable rate. Make the one-line change below, test your movie, and check that the objects rotate at variable speeds.

```
65      // create the motion along the circular path
66      this.onEnterFrame = function()
67      {
68              // update the angle increment based on how far
69              // _xmouse is from the center of the Stage
70              var angleChange:Number = Math.round((_xmouse - xo)/
                                                  speedfactor);
71              startAngle += angleChange;
```

Step 3: Change the graphics

You may be thinking that this is all very well and good, but all of the objects are the same. For most applications, different objects are needed. Let's see how we might modify what we have at this point. As a first step, let's change the background into a more application-oriented image. Go to the Stage and select the background. In the Properties window, choose the Swap option as shown in Figure 6.13.

Figure 6.13 Selecting the Swap option

The Swap Symbol dialog box will appear. Select bg2 and click OK. The new background, shown in Figure 6.14, will appear on the Stage.

Figure 6.14 Swapping the background

Double-click `greenBallMC` in the Library window to go to the symbol edit window. Our movie clip actually consists of nine frames with different graphics in each frame as shown in Figure 6.15. This offers several possibilities for us generally. One thing we could do is to have the movie clip run through some kind of animated sequence. We would then see that sequence occurring as the objects rotated in 3D space.

Figure 6.15 Embedding objects inside the rotating movie clip

Step 4: Access the additional object frames

In our case we have a `stop()` command in the `actions` layer. This enables us to access different frames individually and provides a convenient storage place to hold different objects that we want to follow our circular path. We can access these frames quite easily when we duplicate the object movie clip with a simple one-line addition to our code.

```
22    // create the objects for the circular motion
23    for (var i:Number = 0; i < numberOfObjects; i++)
24    {
25        object_mc.duplicateMovieClip("object"+i, i);
26        this["object"+i].gotoAndStop(i+2);
27    }
28
```

As we loop over the number of objects that we want to create, we just tell the duplicated movie clip to go to a different frame. For example, `"object0"` will go to frame 2, `"object1"` will go to frame 3, and so forth.

Save your movie as `6_5_xzRotation3_DONE.fla` and test it to make sure that you have eight different objects rotating about the y-axis, as shown in Figure 6.16, and that the speed of rotation is determined by the horizontal location of the cursor.

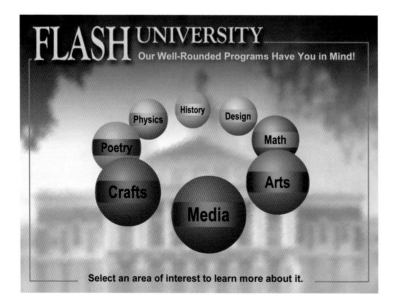

Figure 6.16 Rotation about the y-axis with multiple objects

Tip: Verify that the expression

```
var numberOfObjects:Number = object_mc._totalframes-1;
```

will work as a general means to enable us to rotate any number of objects from within the `object_mc` movie clip.

Exercise 6.6: Rotating Bitmap Objects

If we look at the size of the .swf file from the previous exercise, it weighs in at about a reasonable 26 KB, with about half that size being taken up by the background image. The objects that we used were all vector graphics. Suppose the objects to be rotated are bitmaps instead. What does that do to the file size?

Let's look a simple example. Suppose we wanted to use eight bitmap graphics such as those shown in Figure 6.17. Each object is about 130 pixels wide by 384 pixels high. As transparent .png files, the size of the three are 76 KB, 84 KB, and 60 KB respectively, for an average of about 73 KB each. Clearly, importing eight of these would produce a file size that would be excessively large. The way around this problem is to load them dynamically when we need them. Let's take a look at what's involved. We'll use the previous exercise as a jumping-off point.

Figure 6.17 Sample bitmap objects to be rotated

Step 1: Getting started

As a first step, let's change the background into a more appropriate image. Go to the Stage and select the background. In the Properties window, choose the Swap option. The Swap Symbol dialog box will appear. Select bg3 and click OK. The new background will appear on the Stage.

Step 2: Create the objects for the circular motion

At this point we no longer need the green ball, so select it and delete it from the Stage. If you wish, you can also delete it from the Library. We no longer need it because we are going to create empty movie clips on the fly and load our objects into them. This can be done by changing the two lines of code shown below.

```
22    // create the objects for the circular motion
23    for (var i:Number = 0; i < numberOfObjects; i++)
24    {
25        this.createEmptyMovieClip("object"+i, i);
26        this["object"+i].loadMovie("vases/vase"+(i+1)+".png");
27    }
```

Since the number of objects is set to 8 and we are inside of a for loop, line 25 creates empty movie clips named "object0" at depth 0, "object1" at depth 1, ..., and "object7" at depth 7. In line 26, .png files are loaded from a vases folder into the empty movie clips in the following way: "vase1.png" goes into clip "object0", "vase2.png" goes into clip "object1", and so forth until eight vases have been loaded.

Save your movie as xzRotation4.fla and test it. You should have eight different objects rotating around in a manner similar to that of Figure 6.18. As the figure shows, there is some good news and some bad news. The good news is that it was a very quick and easy substitution to get the bitmap images loaded and rotating. Moreover, if we look at the size of the .swf file, we see that it is only 4 KB, which is good news indeed.

The bad news is that the objects aren't where we expected them to be and that they appear to be a little squished together. The latter problem is quickly solved by increasing the radius, which we will do shortly. Moving the circle of objects to the left and up somewhat is also easy to do by changing xc and yc, the coordinates of the center of the path.

Figure 6.18 Dynamically imported vases

Before we do that, however, it might be good to discuss what happened. In our previous examples, the registration point of the objects being rotated was placed in a location that was consistent with the movement along a circular path. For example, with a vase, the logical placement of the registration point is at or near the bottom center of the object as shown in Figure 6.19. When we create an empty movie clip, however, the registration point is in the upper-left corner. It is this placement that caused the downward shift to the right in the motion path.

Figure 6.19 The registration point with an empty movie clip

Step 3: Reposition the objects

We're ready to make some adjustments to the path characteristics to reposition the objects on the screen. Besides the placement of the path, the objects look somewhat cramped together, so changing the radius of the path to open up the space between objects might be a good place to start. The current radius is 160. Modify the radius to suit your taste. Suggested values lie in the range of 180–220. Figure 6.20 shows the objects at a radius of 200.

Figure 6.20 Vases with a radius of 200 pixels

Next we might look at changing xc and yc, the coordinates of the center of the path. Figure 6.21 shows the objects with the center shifted to $xc = -75$ and $yc = -150$. The value for xc was determined first. The average width of the vases is about 150 pixels. Moving xc to the left from 0 to -75 has the same effect as shifting the registration point from the left side of the objects to the middle. After making that change, you can visually see that yc needs to be moved up about 100 pixels from -250 to -150.

Referring again to Figure 6.21, we see that the vases are perhaps a little too close to us. We've modified the horizontal and vertical center of the motion path, and there is nothing to prevent us from pushing the center of the path back in space by changing zc. Figure 6.22 shows the effect of increasing zc from 50 pixels to 100 pixels. This produces a circular motion of the objects that fits comfortably on the screen.

Figure 6.21 Vases with $xc = -75$ and $yc = -150$

Figure 6.22 Vases with $zc = 100$

Step 4: Add aerial perspective

As a final step, let's add a little aerial perspective to the vases. We'll do a simple aerial perspective here, leaving a somewhat more complicated technique for a later example. For this exercise, we will relate the alpha of each object to its distance ratio in the same way that the object size is determined. We just need to add the two lines shown below to the `displayObj` function to get what we need.

```
58    // set the size based as a percent of distance ratio
59    thisObj._xscale = thisObj._yscale = 100 * dr;
60
61    // set the alpha based as a percent of distance ratio
62    thisObj._alpha = 100 * dr;
63
```

After inserting the lines, save your file and test your movie to make sure that the movement and aerial perspective are working properly. Figure 6.23 shows a final version with an additional modification of setting the viewer distance d to 500.

Tip: With objects that are created in vector graphics, it doesn't matter how big they get scaled. In this exercise we are using bitmaps, and when we scale them larger than

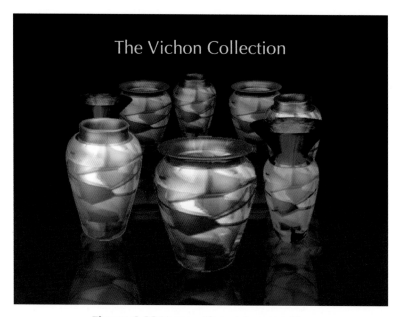

Figure 6.23 Vases with aerial perspective

100%, they start to become pixellated and look a little rough around the edges. For best results, the maximum scale should be 100%. Since the scale factors _xscale and _yscale are equal to 100*dr, the largest value for dr needs to be 1. Since dr = d/(d+z), we will get dr = 1 only when z = 0. In order to achieve this, we have to pay attention to the relationship between the radius r and the depth of the center of rotation zc. The maximum and minimum values of an object rotating in a circle on the x-z plane are zc+r and zc-r respectively. We will get what we want by setting zc = r.

The Flexibility of 3D

In the last exercise we saw how a few simple changes to the path characteristics enabled us to quickly make visual adjustments. Now that we have completed rotating objects about the y-axis, let's take a closer look at the parameters that are easily modified and give you a tremendous amount of control over the look of your projects.

Viewing Distance

One very important control that you have is the viewing distance d from the viewer to the screen. Figure 6.24 shows the effects of three examples with different values for d. Our initial value for d is 400. When we increase d to 500, the objects are farther from us and the perspective is flattened. When we decrease d to 300, the objects are closer to us and the perspective is more exaggerated.

Figure 6.24 Effects of changing the viewing distance

Circle Radius

As we saw in the last exercise when the objects looked too cramped together, another obvious one-line code change that affects the overall appearance is the radius of the circular path. Figure 6.25 shows three examples with different values for the radius r.

Figure 6.25 Changing the radius of the circular path

Plane of Circular Motion

The horizontal plane in which the objects have their circular rotation can be raised or lowered so that the objects are either above the viewer's eye level, straight on and even with it, or below the viewer's eye level. The location of this plane is determined by the value of yc. As shown in Figure 6.26, when yc is 0, the position of the objects is at eye level. As yc increases, the plane moves up and we see more of the bottom of the objects. When yc has negative values, the planes are below eye level and we see more of the top of the objects.

Figure 6.26 Changing the vertical center of the circular path

It is important to note the relationship between yc and yo, the vertical origin of the 3D coordinate system. Our original values, $yo = 0$ and $yc = -250$, were selected so that the objects would display approximately in the center of the Stage. As the rotation plane moves up or down, we will see that the objects begin to move off the Stage if yo remains constant. If we want to keep the objects generally centered on the Stage, we must make adjustments to yo as yc is moved. Referring to Figure 6.26, we see that the difference between yo and yc is equal to 250 in each case. Keeping the same relative distance between yo and yc will result in the objects staying in the center of the Stage.

Horizontal Center of the Circle

Suppose you want your objects to orbit on a tilted path. One solution, of course, would be to tilt the orbital path. However, there's another, easier solution. Changing the horizontal center, xc, of the orbital circle either to the left or right moves it farther away from the center of vision. This in turn will change the perspective of the orbit as shown in Figure 6.27 with xc values of $xc = 300$ and $xc = -300$.

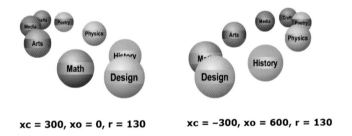

xc = 300, xo = 0, r = 130 xc = −300, xo = 600, r = 130

Figure 6.27 Changing the horizontal center of the circular path

The farther the paths are from the horizontal center of vision xo, the greater the angle of tilt when they are converted to screen coordinates. As we saw with changes in the vertical center, changes in the horizontal center xc need to be accompanied by adjustments to xo in order to display the rotating objects in the center of the Stage.

Rotation in the y-z Plane

A circular path rotation in the y-z plane is equivalent to a rotation about the x-axis or a line parallel to the x-axis. Everything that we discussed regarding rotation about the y-axis also holds for rotation about the x-axis. We can use the same functions

placeObj and displayObj as before, the only difference being that the equations of a circle in the placeObj function are as shown below.

```
29    // place the object on the path of motion
30    function placeObj(thisObj,i)
31    {
32        // calculate the angle of the object
33        var myAngle:Number = i * circleAngle + startAngle;
34        var a:Number = myAngle * Math.PI/180;   // in radians
35
36        // put it on the circle
27        thisObj.x = xc;
38        thisObj.y = yc + r * Math.sin(a);
39        thisObj.z = zc + r * Math.cos(a);
40    }
41
```

Some minor modifications to the origin and path characteristics are necessary, but they are basically switching around x- and y-values. To see an example of Exercise 6.4 in which the rotation is about the x-axis, open yzRotation1.swf in the Chapter 6 folder. Figure 6.28 shows a sample screen from the movie.

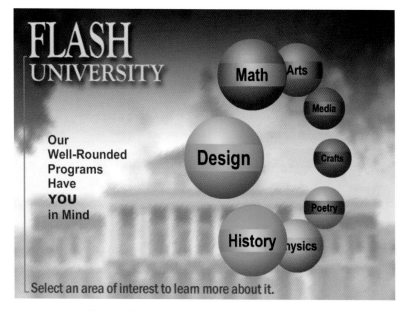

Figure 6.28 Circular rotation in the y-z plane

Tilted Rotation

Figure 6.27 shows that one way of obtaining tilted rotating objects is by moving the horizontal center of the path away from the horizontal center of vision. Another simple method is to make a quick modification to the script of 6_5_xzRotation3_DONE.fla. Figure 6.29 shows the result, which is saved as xzRotation3a.fla. To create the tilt, a one-line change in the placeObj() function is needed and shown below. We simply make the y-component of the object vary in the same way as the x-component.

```
36        // put it on the circle
37        thisObj.x = xc + r * Math.cos(a);
38        thisObj.y = yc + r * Math.cos(a);
39        thisObj.z = zc + r * Math.sin(a);
40
```

The only other changes made were cosmetic ones to position the path of motion on the screen. The horizontal center xc was increased from 0 to 50 to move the path to the right. The vertical center yc was moved up 30 pixels to raise the path. Finally, the radius was reduced from 160 to 120 pixels.

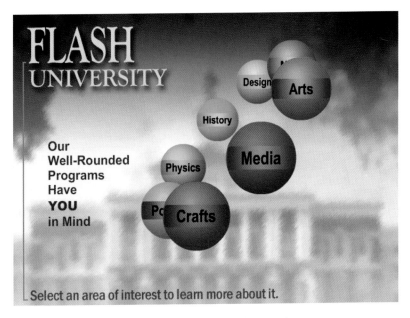

Figure 6.29 Tilted circular rotation

You may be wondering whether it's possible to control the tilt of the path. The answer is that you can. The expressions

```
thisObj.x = xc + r * Math.cos(a);
thisObj.y = yc + r * Math.cos(a);
```

essentially determine the center point and radius of the circular path in the x- and y-directions. When the radius is the same for both, they contribute equally, and the tilt is at a 45-degree angle as Figure 6.29 shows. If the radius were 0 for the y-component, the result would be a horizontal circular path as in Figure 6.23. If the radius were 0 for the x-component, the result would be a vertical circular path as in Figure 6.28.

To alter the tilt, then, all we have to do is provide different radius sizes for the x- and y-directions. For example, the expressions

```
thisObj.x = xc + r * Math.cos(a);
thisObj.y = yc + r * Math.cos(a)/4;
```

produce the results shown in Figure 6.30. In this example, xzRotation3b.fla , the vertical contribution to the path is only one-fourth of the horizontal contribution. The effect here is quite similar in 3D to what we saw with ellipsor.fla in 2D.

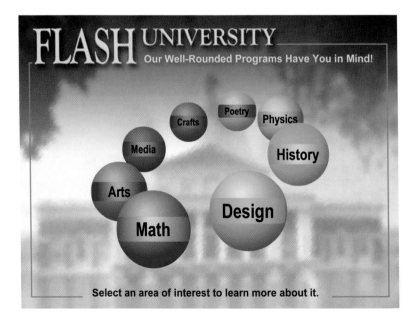

Figure 6.30 Tilted circular rotation with horizontal emphasis

Exercise 6.7: Spiral Rotation

In this exercise, we will look at how the circular rotation in `6_5_xzRotation3_DONE.fla` can easily be expanded into a more complicated spiral rotation and how to control it. To see an example of where we are headed, open `6_7_xzSpiralRotation_DONE.swf`. Figure 6.31 shows a sample screen shot of the file. The changes that we will make all take place within the `placeObj` function and involve only a few lines of code.

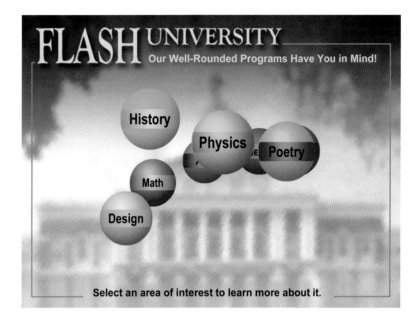

Figure 6.31 Example of spiral rotation

Step 1: Getting started

Open `6_5_xzRotation3_DONE.fla`. As a first step, let's create the tilted rotation just discussed. Modify the line shown and test your movie. The path of rotation should be at a 45-degree angle.

```
36        // put it on the circle
37        thisObj.x = xc + r * Math.cos(a);
38        thisObj.y = yc + r * Math.cos(a);
39        thisObj.z = zc + r * Math.sin(a);
40
```

Step 2: Create a spiral rotation

Enough fooling around. Let's get down to it and create a spiral. Modify the y contribution to the path by dividing the cosine of the angle by 2 as shown below. When you test the movie, you should get a rather sweeping spiral motion. This is what's happening: as we noted in Chapter 5, the cosine is a periodic function that repeats itself. When we use a/2 inside the cosine function for y, then it takes twice as long to repeat itself as it does for the x-value. This value is called the frequency, and we can say that the frequency of the y-component is half that of the x-component.

```
36        // put it on the circle
37        thisObj.x = xc + r * Math.cos(a);
38        thisObj.y = yc + r * Math.cos(a/2);
39        thisObj.z = zc + r * Math.sin(a);
40
```

Step 3: Reduce the z radius value

Our spiral has a nice sense of depth to it, but it runs off of the screen. We can adjust for this in a number of ways, one of which is to reduce the movement in the z-direction. The perspective will be a little less dramatic but will still work quite well. Let's reduce the radius in the z-direction by cutting it in half as shown below. Note that the division here is outside of the sine function.

```
36        // put it on the circle
37        thisObj.x = xc + r * Math.cos(a);
38        thisObj.y = yc + r * Math.cos(a/2);
39        thisObj.z = zc + r * Math.sin(a)/2;
40
```

Step 4: Tighten up the spiral

By decreasing the frequency in the y-direction, we can tighten the spiral and increase the number of revolutions before the path returns to its initial position. Make the change below, then save your movie as 6_7_xzSpiralRotation_DONE.fla and test it.

```
36        // put it on the circle
37        thisObj.x = xc + r * Math.cos(a);
38        thisObj.y = yc + r * Math.cos(a/4);
39        thisObj.z = zc + r * Math.sin(a)/2;
40
```

Tip 1: Starting from `6_5_xzRotation3_DONE.fla` as you did in this exercise, repeat Step 1 and then make similar changes in the x-direction for Steps 2–4 to get a spiral that rotates about the x-axis. Open `yzSpiralRotation.swf` as a reference for what you'll get (see Figure 6.32).

Tip 2: For a very different organic effect, open your `6_7_xzSpiralRotation_DONE.fla` file and first comment out line 37 as shown.

```
36        // put it on the circle
37        // thisObj.x = xc + r * Math.cos(a);
38        thisObj.y = yc + r * Math.cos(a/4);
39        thisObj.z = zc + r * Math.sin(a)/2;
40
```

Then set the x-coordinate of the objects to be equally spaced when being created. Open `yzRotation2.swf` to see the effect (Figure 6.33).

```
22        // create the objects for the circular motion
23        for (var i:Number = 0; i < numberOfObjects; i++)
24        {
25            object_mc.duplicateMovieClip("object"+i, i);
26            this["object"+i].gotoAndStop(i+2);
27            this["object"+i].x = i* 75 - 260;
28        }
```

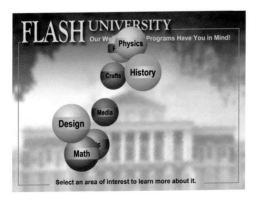
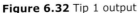

Figure 6.32 Tip 1 output

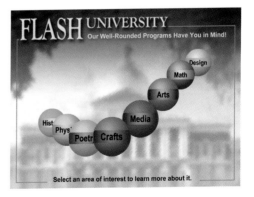

Figure 6.33 Tip 2 output

Tip 3: If you prefer a more free-form rotation of objects about the y-axis, here is a simple change you can make to `6_5_xzRotation3_DONE.fla`. First, comment out line 38, which puts all of the objects on one plane.

```
36        // put it on the circle
37        thisObj.x = xc + r * Math.cos(a);
38        // thisObj.y = yc;
39        thisObj.z = zc + r * Math.sin(a);
40
```

Next, set the y-coordinate of the objects to be chosen at random within some range of values when being created. In the example below, the range of vertical values lies between −350 and −100. Since the vertical origin `yo` is set to 0, this range places the objects conveniently on the screen. Open `xzFreeRotation.swf` to see the effect (Figure 6.34).

```
22        // create the objects for the circular motion
23        for (var i:Number = 0; i < numberOfObjects; i++)
24        {
25            object_mc.duplicateMovieClip("object"+i, i);
26            this["object"+i].gotoAndStop(i+2);
27            this["object"+i].y = 250*Math.random() - 350;
28        }
```

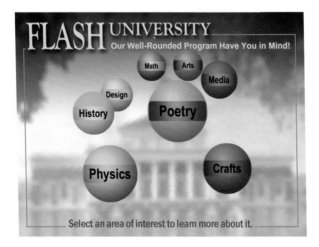

Figure 6.34 Tip 3 output

Exercise 6.8: Sinusoidal Motion

In Chapter 5, we looked at a 2D application of sinusoidal motion in the form of a clock pendulum. Recall that the motion is periodic and, roughly speaking, repeats itself in a back-and-forth manner. In this exercise we will explore some of the potential of sinusoidal motion in 3D. Here we will look at motion that goes in and out. To see where we are initially headed, open `6_8_zSineMotion1.swf` as a reference.

Step 1: Getting started

Open `6_8_zSineMotion.fla`. It's not much of a file, just a `background` layer and an `actions` layer with nothing in it. Still, it meets our needs, so we'll give it our stamp of approval. We're going to be using some bitmaps for our objects. Rather than reinventing the wheel, we can use Exercise 6.6 as a starting point. Since you probably don't want to type any more than you have to, also open `xzRotation4.fla`. As a first step, copy the script from `xzRotation4.fla` and paste it into `6_8_zSineMotion.fla`.

Step 2: Get some objects

Since we're using different images, we just need to replace one line of code as shown below to dynamically load them as we did in Exercise 6.6.

```
22    // create the objects for the circular motion
23    for (var i:Number = 0; i < numberOfObjects; i++)
24    {
25        this.createEmptyMovieClip("object"+i, i);
26        this["object"+i].loadMovie("stamps/fame"+(i+1)+".jpg");
27    }
```

If you are of a curious nature, you may have looked inside the `stamps` folder and discovered that there are 10 stamps and not 8 as we have specified. So let's make another simple change and set the number of objects to 10.

```
14    // set the number of objects to be created and startAngle
15    var numberOfObjects:Number = 10;
16    var startAngle:Number = 0;      // starting rotation angle
17    var speedfactor:Number = 40;    // controls speed of motion
```

Test your movie at this point to make sure the images are loading properly. You should get circular rotating objects as in Figure 6.35.

Figure 6.35 Objects rotating from Step 2

Step 3: Create the sinusoidal motion

We're almost done. Let's equally space the objects in the x-direction. We'll do this when we load them. Through a little trial and error, inserting the following line does the job.

```
25        this.createEmptyMovieClip("object"+i, i);
26        this["object"+i].loadMovie("stamps/fame"+(i+1)+".jpg");
27        this["object"+i].x = i*60 - 400;
28    }
```

Since we defined the x-coordinates of the objects at the outset, we need to disconnect them from the circular rotation. Either comment out or delete the following line.

```
36        // put it on the circle
37        //thisObj.x = xc + r * Math.cos(a);
38        thisObj.y = yc;
39        thisObj.z = zc + r * Math.sin(a);
40
```

We are currently changing the alpha for aerial perspective, but this effect works better with it turned off, so also either comment out or delete the following line.

```
62    // set the alpha based as a percent of distance ratio
63    // thisObj._alpha = 100 * dr;
64
```

There you have it. Save your file as `6_8_zSineMotion1.fla` and test it. You should see something similar to Figure 6.36. Piece of cake. Sweet!

Figure 6.36 Completed sinusoidal motion

Step 4: Create a different perspective

It's easy to get variations of the motion that are quite different and with very little work. For example, let's allow the y-coordinates of the objects to move in the same way as the z-coordinates but in the opposite direction.

```
36    // put it on the circle
37    //thisObj.x = xc + r * Math.cos(a);
38    thisObj.y = yc - r * Math.sin(a);
39    thisObj.z = zc + r * Math.sin(a);
40
```

The objects will be too high when we do this, so we will need to lower the vertical origin yo of the screen coordinates.

```
4    // define the origin xo, yo of the screen coordinates
5    var xo:Number = Stage.width/2;
6    var yo:Number = 160 //0;
7
```

Save your movie as `6_8_zSineMotion2.fla` and test it. You should get results similar to Figure 6.37.

Figure 6.37 Sinusoidal motion in y and z

Tip: Try using `thisObj.y = yc - r * Math.sin(a)/2` in line 38 and `yo = 160` in line 6 for a different effect. Save the results as `6_8_zSineMotion3.fla`.

Step 5: Create even more motion

Since changing the y-coordinates of the objects to include a sine function produced such nice results in the previous step, it might seem reasonable to change the sine to a cosine and see what happens. Modify line 38 to the following. Just to be on the safe

```
36       // put it on the circle
37       //thisObj.x = xc + r * Math.cos(a);
38       thisObj.y = yc + r * Math.cos(a)/2;
39       thisObj.z = zc + r * Math.sin(a);
40
```

side, we'll reduce the amplitude a little by dividing by 2 as shown. We'll also need to adjust the vertical origin as in the last step. Use the change indicated here.

```
4   // define the origin xo, yo of the screen coordinates
5   var xo:Number = Stage.width/2;
6   var yo:Number = 40;
7
```

Save your movie as and test it. You should get a spiral motion shown in Figure 6.38 different than what we previously have seen. If you wish, you may fine-tune the placement of the objects by trying other values such as `Math.cos(a)/3` or `Math.cos(a)/4`.

Figure 6.38 Sinusoidal spiral motion from Step 5

Spinning on an Axis

In the examples and exercises that we have looked at using rotation, the planar objects have always faced us. It is natural to ask what's involved in an object spinning about its own axis, either horizontally or vertically. A simple but not totally accurate solution can be found by modifying the horizontal or vertical scale factors. Let's look first at a single object, and we'll wrap up by considering multiple objects.

Let's take a moment to discuss what we want to have happen by holding a sheet of paper in your right hand facing you. This will serve as our object.

Rotate the paper counterclockwise 90 degrees about a vertical axis as shown in the right side of Figure 6.39 so that only the left edge can be seen (in theory). This is an angle of 0 degrees in terms of Flash angles, while the front is at an angle of 90 degrees. At 0 degrees the horizontal scale factor is 0, while at 90 degrees the horizontal scale factor is 100.

Figure 6.39 Relationship between scale factor and angle

Now hold the paper facing you in your left hand. We are at 90 degrees and a scale factor of 100. Rotate the paper clockwise so that only the right edge can be seen as shown in the left side of Figure 6.39. We are now at 180 degrees, and again the scale factor is 0. Rotate the paper 90 degrees clockwise again and you will see the back of the paper (or the front reversed with transparent paper). Now we are at an angle of 270 degrees and the scale factor is –100. This is exactly the behavior we get from a sine function.

The bottom line, then, is that as we rotate the paper, the scale factor is equal to 100 times the sine of the angle. In our 3D program, we can calculate the horizontal scale factor as a percentage of the distance ratio the way we normally do and then multiply by the sine of the angle that we are at. A similar analysis leads to the conclusion that we can multiply the vertical scale factor by the sine of the angle to create an object spinning vertically.

The file `objectSpinning1.fla` is an example that lets you use the arrow keys to spin the object about its own x- or y-axis. The script is basically the same as the script in `6_5_xzRotation3_DONE.fla` with the radius set to 1 and provision made for arrow keys. Let's wrap up by looking at multiple objects spinning as they are going through a circular

rotation about the y-axis as shown in Figure 6.40. Open the file `objectSpinning2.fla`. The script used is a copy of the script from `6_5_xzRotation3.fla` with a few minor additions which we will note below.

Figure 6.40 Objects spinning while rotating

In defining the path characteristics, the angle `a` of the object in radians is initialized and then set in the `placeObj` function.

```
8    // define the path characteristics
9    var xc:Number = 0;       // xc = horizontal center of path
10   var yc:Number = -150;    // yc = vert. center of path
11   var zc:Number = 200;     // 0; // zc = depth center of path
12   var r:Number  = 350;     // r  = path radius
13   var a:Number  = 0        // a = angle of object in radians
```

```
33       // calculate the angle of the object
34       var myAngle:Number = i * circleAngle + startAngle;
35       a = myAngle * Math.PI/180;   // in radians
36
```

The next thing needed is the sine function multiplier in the horizontal scale factor to produce horizontal spinning.

```
59    // set the size based as a percent of distance ratio
60    thisObj._xscale = thisObj._yscale = 100 * dr;
61    // addition for horizontal spinning
62    thisObj._xscale *= Math.sin(a);
63
```

The final addition is the inclusion of a little bit of aerial perspective for each object. Note that a factor of 150 is used instead of the normal 100 to keep the objects that are farther away from becoming too pale.

```
64    // apply aerial perspective to each object
65    thisObj._alpha = 150 * dr;
66
```

One important note is that the objects are included in the file rather than loaded in. The reason for this is that the registration points for the objects can be placed in the center of their shapes, which makes changing the scale for spinning a straightforward process. When the registration point is in the upper-left corner the expressions for scaling become more complicated. The reader can refer to the file objectSpinning3.fla to see what's involved with spinning a single object loaded into an empty movie clip.

Summary

We've covered a fair amount of ground moving and rotating objects in 3D space. The value of experimenting with the 3D variables is hard to overstate, not to mention a lot of fun. In the next chapter we'll look at making the viewer or camera an integral part of a 3D scene.

Key concepts to remember from this chapter include the following:

- Points in 3D space are defined by x-, y-, and z-coordinates measured from an origin that is the point of intersection of the center of vision with the picture plane.
- We can convert from 3D coordinates to 2D screen coordinates

by multiplying the x- and y-values by the distance ratio quantity $d/(d+z)$, which is the ratio of the distance of the picture plane to the viewer divided by the total distance in the z-direction of a 3D point to the viewer.

- Z-sorting of objects is necessary to keep objects farther away from being on top of objects closer to us.

- To keep objects moving toward us on the z-axis, it is necessary to include a "too close" test.

- Objects in our 3D world have the potential to move in any one or combination of six different ways. There are three translational degrees of freedom and three rotational degrees of freedom.

- When loading bitmaps into movie clips, remember that the registration points are in the upper-left corner of the movie clip.

- Parameters that give 3D circular rotations a great deal of flexibility over the look of your projects include the viewing distance, radius, the plane of circular motion, and simple changes to the trig functions used.

7

Using a Camera in 3D

In the last chapter, we talked about how we could move one or more objects around in 3D space while we, as the viewer or camera, remained in one place. But we know from film and television that it is very common to have one or more cameras move around a scene, so we would like to be able to incorporate some camera movement into Flash. We'll start out with some simple camera movement to get our feet wet. Then, we'll move to the creation of a camera object and its relationship to objects in a scene. This will lead us to consider different ways in which a user can move interactively through a 3D space, including rotating a camera. The main topics of this chapter will be

- simple camera translation
- viewer objects and scenes
- interactive navigation in 3D space
- viewer rotation
- background considerations

Exercise 7.1: Simple Camera Translation

Let's start by creating some objects around which we can move a camera. Open the `7_1_puppyCam.fla` file in the Chapter 7 folder. The entire script is included as a reference on the following page to reinforce concepts we discussed previously. It has the usual `placeObj()` and `displayObj()` functions that we have been using.

In this example, a litter of nine Poser puppies are placed in random horizontal locations, with each one 50 pixels progressively farther away from the screen. Figure 7.1 displays a sample screen shot from the file. Our game plan is to modify the script so that a viewer will be able to move in and out in the z-direction as well as left and right in the x-direction. To achieve this, we will need to add a few lines of code that contain some camera considerations.

```
1    // set the viewer/camera distance d from the screen
2    var d:Number = 100;
3
4    // set the center of the stage xo, yo as the origin
5    // of the screen coordinates
6    var xo:Number = Stage.width/2;
7    var yo:Number = Stage.height/2;
8
9    // set the number of objects to be created
10   var numberOfObjects:Number = 9;
11
12   // create the objects and place them in 3D space
13   for (var i:Number = 0; i < numberOfObjects; i++)
14   {
15       duplicateMovieClip(object_mc,"object"+i,i);
16       thisObj = this["object"+i];
17       placeObj(thisObj,i)
18   }
19
20   function placeObj(thisObj,i)
21   {
22       // pick a random horizontal location in 3D space
23       thisObj.x = Math.random()*1200 - 600; //-600 < x < 600
24       thisObj.y = -150;
25       thisObj.z = i*50;
26   }
27
28   // display the object on the screen
29   function displayObj(thisObj)
30   {
31       // calculate the distance ratio dr
32       var dr:Number = d/(d + thisObj.z);
33
34       // calculate the screen coordinates xs, ys
35       var xs:Number = thisObj.x * dr;
36       var ys:Number = thisObj.y * dr;
37
38       // set the location of the object on the Stage
39       // note minus sign for y is because the y-axis
40       // in Flash points down instead of up
41       thisObj._x = xo + xs;
42       thisObj._y = yo - ys;
43
44       // set the size based as a percent of distance ratio
45       thisObj._xscale = thisObj._yscale = 100 * dr;
46
47       // set the object depth based on its z-location so that
48       // closer objects are on top of farther objects
49       thisObj.swapDepths(Math.round(-thisObj.z));
50   }
51
52   this.onEnterFrame = function()
53   {
54       // loop over all the objects
55       for (var i:Number = 0; i < numberOfObjects; i++)
56       {
57           thisObj = this["object"+i];
58           displayObj(thisObj);
59       }
60   }
```

Figure 7.1 Sample screen shot from `puppyCam.swf`

Step 1: Initialize the incremental camera movement and speed

Let's begin by initializing two variables, `camdz`, which will control the movement of the camera in and out, and `camdx`, which will control the movement of the camera left and right. We will also define the variable `camspeed`, which will control how fast the camera moves. Insert the lines below to initialize these variables.

```
1    // set the viewer/camera distance d from the screen
2    var d:Number = 100;
3
4    // initialize the incremental camera movement and speed
5    var camdz:Number = 0;
6    var camdx:Number = 0;
7    var camspeed:Number = 5;
```

Step 2: Add some camera movement

We are going to put the camera movement under user control. Let's use the arrow keys to do that. The Up Arrow and Down Arrow keys will enable the camera to zoom in and out, while the Left Arrow and Right Arrow keys will allow the camera to pan left and right. We'll need to put this inside the `onEnterFrame` handler to see the movement.

```
57    this.onEnterFrame = function ()
58    {
59        // check the arrow keys to adjust the camera movement
60        if (Key.isDown(Key.UP))                {camdz = -camspeed; }
61        else if (Key.isDown(Key.DOWN))   {camdz =  camspeed; }
62        else if (Key.isDown(Key.RIGHT))  {camdx = -camspeed; }
63        else if (Key.isDown(Key.LEFT))   {camdx =  camspeed; }
64        else camdz = camdx = 0;
65
66        // loop over all the objects
```

Step 3: Update the objects

We are ready to take the camera's movement into account. To do that, we'll apply what you know about the theory of relativity. What's that, you say? You know nothing about the theory of relativity? Betcha do. Einstein used to think up thought experiments to develop his theory. Suppose you and a friend stand five feet apart in empty space. Your friend moves one foot closer to you. How far apart are the two of you now? If you say four feet, you are halfway there.

Now suppose your friend moves back a foot so that you are both again five feet apart. This time you move one foot closer to your friend. Once more, how far apart are you? That's right, Albert, the two of you are again four feet apart. So the movement is relative. It doesn't matter which one you moves, the result is the same. Why do we have to be in empty space? The answer is that we don't necessarily, but it just makes the thought experiment sound more impressive.

The point of all this is that we can see the effects of moving the camera by moving the objects in the opposite direction. Moving the camera to the right is like moving the objects to the left and so forth. So let's apply this portentous concept to our example with a few lines of code at the beginning of displayObj(). It's disgustingly simple. It should be pointed out, however, that what we are doing works best when the background is fairly nebulous in form.

```
34    function displayObj(thisObj)
35    {
36        // update the 3D coordinates based on the camera movement
37        thisObj.x += camdx;
38        thisObj.z += camdz;
39
```

Save your movie as 7_1_puppyCam_DONE.fla and test your movie with the arrow keys. When you use the Up Arrow and Down Arrow keys, the objects grow and shrink as expected. Notice that as you use the Left Arrow and Right Arrow keys to move the camera horizontally, the adjustment for parallax scrolling occurs automatically. This provides a very strong perception of the puppies being in a 3D environment.

Notice also that when you use the Left Arrow key, the objects appear to move to the right as shown in Figure 7.2. Is this what you expected to happen? Some people are surprised by the movement, others assume it. There's not necessarily a correct answer, but it should be something to think about when setting up a user interaction and the instructions that you provide.

Figure 7.2 Effect of moving the camera horizontally to the left

Step 4: Make a minor adjustment

Recall that in the previous chapter, we needed a test to keep objects from getting too close to the camera so they wouldn't flip over and come back into the scene belly up. We need a similar test here, but we have to be a little careful. We may not want to see a puppy that gets too close when the camera is zooming in, but when we zoom back out, we expect that puppy to still be there and to see it. We can have what we want by turning the visibility of any puppy on and off. We just need to modify our script by inserting a few lines as shown below.

```
40     // check if the object is too close to the viewer
41     if (thisObj.z <= -d + 40)
42     { thisObj._visible = false; }
43     else thisObj._visible = true;
44
45     // calculate the distance ratio dr
```

The test says that if the object is less than or equal to 40 pixels from the camera, then turn the visibility of the object off, otherwise turn the visibility on. If you're wondering where the 40 pixels comes from, it was obtained by a quick trial and error of different values.

Step 5: Add a final refinement

As our final step, let's add a little aerial perspective. In some of the previous examples and exercises we've done that by varying the alpha of the objects. This works in certain situations such as when there is a fairly uniform light or dark background or when you have objects that have some transparency to begin with. Recall that when we discussed aerial perspective in Chapter 2, we mentioned blurring and an overall color blending into the background as characteristics of aerial perspective. Let's look at how we can control the amount of blurring based on an object's depth. We'll save the color blending for a later discussion.

Here's what we want to do. When the puppies are close to us, we want them to be in sharp focus. As they move farther back in space, we want them to become more blurred. Fortunately, Flash 8 with ActionScript 2 makes this an easy job. Filters such as a Blur filter, a Drop Shadow filter, and others are available in their own package called `flash.filters`. Movie clips now have a property called `filters`, which is an array containing the filters that have been applied to it. Although we will be applying only a Blur filter, it is possible to have multiple filters assigned to an object.

The parameters that need to be defined for a Blur filter are `blurX`, `blurY`, and `quality`. The first two represent the amount of horizontal and vertical blur respectively. Separate blur factors in the x- and y-directions enable motion blur effects. In our case we will want the blur to be uniform, so we will use the same value for each. The `quality` is the number of times to perform the blur. We will use a medium value of 3, which approximates a Gaussian Blur filter.

To apply the blur filter in our case involves only a few lines of code as shown below. We first define the variable `blur`, which takes an object's z-coordinate, divides by 100, and

```
38    thisObj.z += camdz;
39
40    // apply a blur filter based on depth value
41    var blur:Number = Math.round(thisObj.z/100);
42    thisObj.filters = [new flash.filters.BlurFilter(blur,blur,3)];
43
```

rounds off the number. The farther back in space, the larger the blur value. The next line shows the syntax for the blur filter. We are creating a new array, putting a blur filter into it, and then applying it to the filters property of the object. Not bad, eh?

Save your movie as `7_1_puppyCam_DONE.fla` and test it. You should see puppies that are in sharp focus in the foreground and that get fuzzier as they go back in space. When you zoom in, they should come more into focus. If you keep zooming, puppies should disappear as expected and reappear when you zoom back out.

Viewer Objects and Scenes

Now that you're familiar with moving the camera, let's make the viewer into a little more integrated part of the 3D environment. We are going to create a viewer object and then provide that viewer with a location in 3D space just as we have been doing for the objects we are viewing. We use the term *viewer* rather than *camera* just to personalize the process, but we are functionally talking about the same thing as the camera. Open `dolphinCam.fla` to view the script we will be discussing. In this example, we are placing the viewer at the origin of the 3D world coordinates.

We will still define the distance d from the viewer to the picture plane as before. It may be helpful to think of the picture plane as a frame through which we are viewing the 3D world as shown in Figure 7.3. The picture plane will move with the viewer, but this distance will remain constant as the viewer moves. We will set the viewer speed (line 6) just as we did the camera speed in the previous example. The variable `tooClose` will be used to determine when an object is too close to the viewer to be seen (line 7).

Figure 7.3 The viewer and the picture plane

```
1    //create a viewer object with properties x,y,z for its position
2    viewer = {x:0, y:0, z:0 }
3
4    // set the viewer parameters
5    var d:Number = 200;    // distance from viewer to picture plane
6    var viewerSpeed:Number = 10;  // the viewer speed
7    var tooClose:Number = 20;     // the too close distance
8
```

Next, we will create a picture plane onto which we will project the objects that we define in 3D space. The easiest way to do this is to create an empty movie clip that we will name "scene3D" at a depth of 0. We can position our scene anywhere we like on the Stage, but for most situations the center of the Stage will work the best.

```
9    // create the picture plane: a movie clip named scene3D
10   // and position it in the center of the Stage
11
12   createEmptyMovieClip("scene3D", 0)
13   scene3D._x = Stage.width/2;
14   scene3D._y = Stage.height/2;
15
```

At first glance it may seem like we are doing extra work in defining the picture plane. The advantage to this approach is that by creating the picture plane and specifying its location in Flash coordinates, the location of the picture plane also serves as the origin of the 3D coordinate system.

We will be attaching objects to the picture plane, and their position will be relative to the location of the picture plane. The effect of all this is that by referencing the picture plane, we can easily and directly transform from 3D world coordinates to Flash coordinates. Except for a minus sign in the y-direction, the screen coordinates and the Flash coordinates are now essentially the same.

The next step is to add objects to the 3D scene. We first specify the desired number of objects (line 17) as we have done previously. We will create the objects we want, but this time we will attach them to the 3D scene (line 22) rather than to the root Timeline as we have done before. We will end up with 15 copies of the dolphin movie clip attached to scene3D. As each copy is attached, we will place it in 3D space (line 24).

224

```
16    // set the number of objects to be created
17    var numberOfObjects:Number = 15;
18
19    // add objects to the scene in 3D space
20    for (var i:Number = 0; i < numberOfObjects; i++)
21    {
22        scene3D.attachMovie("dolphin","object"+i,i);
23        thisObj = scene3D["object"+i];
24        placeObj();
25    }
26
```

Notice that we are using the `attachMovie` method rather than the `duplicateMovie` method we have been using. Either can be used, but `attachMovie` doesn't require that the object be on the Stage or in the Timeline initially. It is critical, however, that the movie clip to be attached has the proper linkage established.

To set the linkage, select the movie clip in the Library window and then click on the Properties icon at the bottom of the window. When the Symbol Properties window opens, select the Export for ActionScript option under Linkage. The name of the movie clip will appear in the Identifier box. You can use either the name of the movie clip or another name if you wish. The important thing to remember is that the identifier name is the one that you reference when you attach a movie. Click the OK button when done.

Figure 7.4 Setting the linkage of a movie clip

Next, let's define our `placeObj()` function. Since dolphins are both smart and playful, let's apply a combination of some structure plus some randomness to our placement of them as shown in Figure 7.5. We'll place them randomly within limits in both the x- and z-directions as we have done before.

```
27    // place an object in 3D space (with z relative to the viewer)
28    function placeObj()
29    {
30        thisObj.x = Math.random() * 1000 - 500; // -500 < x < 500
31        thisObj.y = 300 *(i % 3) - 300;          // y = -300, 0, 300
32        thisObj.z = Math.random() * 400 + 150;  //  150 < z < 450
33    }
34
```

In the y-direction, we'll cycle the position of each dolphin to be in one of three locations, either at $y = -300$, $y = 0$, or $y = 300$. This is how it works. We have defined the number of objects to be 15. The expression `(i % 3)` takes the remainder left when any number for `i` is divided by 3 as shown below:

```
i      =  0  1  2  3  4  5  6  7  8  9  10  11  12  13  14
i % 3 =  0  1  2  0  1  2  0  1  2  0   1   2   0   1   2
```

Figure 7.5 Example placement of dolphins

When these values are multiplied by 300 and then 300 is subtracted from the result, the values –300, 0, 300 are created. Using the modulo (%) function is a handy way of organizing multiple objects into some kind of structured formation.

Now let's look at the displayObj() function. Since we have now made the viewer an integral part of the 3D world, we will need to measure relative distances from the viewer to the objects. This is done by taking the coordinates of each object and subtracting the coordinates of the viewer (lines 39–41). After that has been determined, we are able to calculate the perspective ratio pRatio. This is equivalent to the distance ratio that we have used previously, the only difference being that we are now dealing with relative coordinates.

```
35      // display the 3d objects in the picture plane
36      function displayObj()
37      {
38          // calculate the relative translation
39          var tx:Number = thisObj.x - viewer.x; // tx,ty,tz are the
40          var ty:Number = thisObj.y - viewer.y; // object's coordinates
41          var tz:Number = thisObj.z - viewer.z; // relative to viewer
42
43          // calculate the perspective ratio
44          var pRatio:Number = d/tz;
45
```

Once the perspective ratio has been calculated, we can then easily determine the location of an object by multiplying the relative distances by the perspective ratio. This can be seen in Figure 7.6 with an object at point P(x1,y1,z1) and the viewer at point P(x2,y2,z2). Using similar triangles as we did in Chapter 6, we find that ys/d = ty/tz and then multiplying both sides by d gives ys = ty*(d/tz).

Figure 7.6 also shows that the perspective ratio d/tz will have a value of 1 when tz = d and will have a value less than 1 when tz > d. Multiplying the perspective ratio by 100 will give the correct scale.

```
46          // apply the perspective ratio to the location and size
47          thisObj._x =   tx * pRatio;
48          thisObj._y = -ty * pRatio; // minus sign for Flash coords
49          thisObj._xscale = thisObj._yscale = 100 * pRatio;
50
```

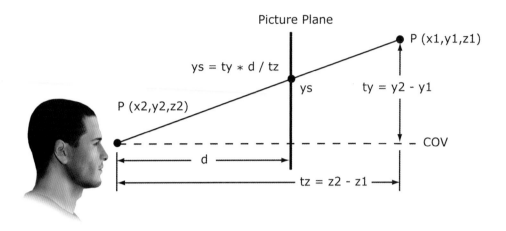

Figure 7.6 Projection onto the picture plane with relative coordinates

To complete the `displayObj()` function, the z-sorting is carried out as before using the `swapDepths()` function. We'll also include a test to turn off the visibility of any objects that get too close to the viewer.

```
51      // set the object depth based on its z-location so that
52      // closer objects are on top of farther objects
53      thisObj.swapDepths(Math.round(-thisObj.z));
54
55      // check if the object is too close to the viewer
56      if ( tz <= tooClose)
57      { thisObj._visible = false; }
58      else thisObj._visible = true;
59   }
60
```

The remaining part of our script is to create the animation that occurs as a result of the camera movement. As before, this will be done in an `onEnterFrame` handler. In this example, we are using the Up Arrow and Down Arrow keys to move the viewer's z-position closer to or farther from the objects respectively (lines 65–66). The Right Arrow and Left Arrow keys move the viewer's horizontal location right and left accordingly (lines 67–68).

Finally, after the viewer's position has been updated, we loop over all of the objects in the scene and place a call to the `displayObj()` function, where we compute new relative distances for display in the picture plane.

```
61     // create the viewer or object movement
62     this.onEnterFrame = function()
63     {
64         // check keys to adjust camera movement
65         if (Key.isDown(Key.UP))            {viewer.z += viewerSpeed;}
66         else if (Key.isDown(Key.DOWN))    {viewer.z -= viewerSpeed;}
67         else if (Key.isDown(Key.RIGHT))   {viewer.x += viewerSpeed;}
68         else if (Key.isDown(Key.LEFT))    {viewer.x -= viewerSpeed;}
69
70         // loop over the objects and display them
71         for (var i:Number = 0; i < numberOfObjects; i++)
72         {
73             thisObj = scene3D["object"+i];
74             displayObj();
75         }
76     }
```

Exercise 7.2: Interactive Navigation in 3D Space

So far our user interaction, whether with the mouse or with arrow keys, has been limited to movement in two of the three dimensions. Typically, we have used the Up Arrow and Down Arrow keys to zoom in and out while also using the Left Arrow and Right Arrow keys to control horizontal movement.

In this exercise we are going to explore navigating in all three dimensions. We will use the mouse to control horizontal and vertical movement and the Up Arrow and Down Arrow keys will control zooming in and out. There are other combinations of mouse and arrow keys that could be used. For example, the mouse might control the horizontal and depth movement, while the Up Arrow and Down Arrow keys would control the vertical movement. Similarly, but less intuitively, the Left Arrow and Right Arrow keys could control horizontal movement, while the mouse controls the depth and vertical movements. There are, of course, other possibilities as well.

Open 7_2_maskCam_DONE.swf to get an idea of where we are headed. Figure 7.7 shows an example screen of the file. At first, the mouse navigation may seem a little strange and awkward until you get more comfortable with it. Remember that the mouse is controlling the movement of the viewer and not the objects, so moving the mouse to the right causes the objects to shift to the left and vice versa.

229

Figure 7.7 Sample screen shot from `maskCamDone.swf`

Step 1: Getting started

Open `7_2_maskCam.fla` and `dolphinCam.fla`. We will use the script from our previous discussion as a starting point. To begin, copy the script from `dolphinCam.fla` and paste it into the Actions window of `7_2_maskCam.fla`.

For convenience, we'll leave the position of the viewer at the origin of our 3D world (line 2). Let's set the picture plane distance `d` to be 150 pixels from the viewer (line 5). We'll also set the closeness distance to 100 pixels (line 7). And how do we get this number? The old-fashioned way, through trial and error. Change the lines as shown.

```
1   //create a viewer object with position properties x,y,z
2   viewer = {x:0, y:0, z:0 }
3
4   // set the viewer parameters
5   var d:Number = 150;    // distance from viewer to picture plane
6   var viewerSpeed:Number = 10;  // the viewer speed
7   var tooClose:Number = 100;    // the too close distance
8
```

Step 2: Setting up the 3D scene

We next need to set up our 3D scene. This scene will be more highly structured than previous examples in terms of placement of objects. In this case a movie clip in the scene layer named scene3D has been created, so we will not need to create an empty movie clip. Select the scene layer and double-click on scene3D in the Library window to go to the symbol editing window.

Inside scene3D are 15 movie clips named object1 through object15 located as shown in Figure 7.8. These movie clips merely function as placeholders for the images that we are going to use. Their size is unimportant, while their placement serves to indicate the eventual layout of the scene. The layout functions as a general floor plan looking down on the x-z plane. The row of objects, object1–object5, will be closest to the viewer while the row of objects, object11–object15, will be farthest away. The naming order is important for the 3D coordinates that will define each placeholder in space. The reason for these placeholders is that we will be loading the images dynamically into them to reduce the file size of our movie. These placeholders could be generated on the fly as empty movie clips, but creating them this way is helpful in visualizing what we want.

Since we already have an existing scene3D movie clip, we need to delete line 12 from our script as shown.

Figure 7.8 Placeholder movie clips for scene3D

```
 9    // create the picture plane: a movie clip named scene3D
10    // and position it in the center of the Stage
11
12    createEmptyMovieClip("scene3D", 0)
13    scene3D._x = Stage.width/2;
14    scene3D._y = Stage.height/2;
15
```

Step 3: Define the coordinate data

We are going to provide the actual coordinates for each of the placeholders to position them in 3D space. For our needs, it is convenient to put the coordinates into three arrays named xdata, ydata, and zdata to store the x-, y-, and z-values for the objects. The placeholders suggest what we are after, namely three rows deep with each row containing five images. The vertical value of all objects will be the same. Add the lines below to the script after numberOfObjects. Each of the arrays could go on a single line, but we have written them with multiple lines to indicate the 3D layout of the objects.

```
18    // define the coordinate arrays
19    xdata = []; ydata = []; zdata = [];
20
21    xdata = [ -1000, -500, 0, 500, 1000,
22                -1000, -500, 0, 500, 1000,
23                -1000, -500, 0, 500, 1000 ]
24
25    ydata = [ 100, 100, 100, 100, 100,
26                100, 100, 100, 100, 100,
27                100, 100, 100, 100, 100 ]
28
29    zdata = [  600,  601,  602,  603, 604,
30               900,  901,  902,  903, 904,
31              1200, 1201, 1202, 1203, 1204 ]
32
```

The x-coordinate data is based on the fact that the images to be used are each about 450 pixels wide so that placing them 500 pixels apart guarantees that there will be no overlapping of images. The z-coordinate data places each row of objects essentially 300 pixels apart. Notice, however, that each object has a different z-value. This is necessary because we will later employ the swapDepths() function to sort the objects according to their z-coordinates. Flash requires that each object has its own distinct depth value,

so we must have some variation in the z-coordinate. Setting the objects in each row one pixel apart from each other satisfies this requirement but is not noticeable visually. We did not mention this previously when choosing the z-coordinates randomly, as it normally is not a problem. When it does occur, you will see a smaller object in front of a larger one.

Step 4: Load the placeholder images

Now that we have defined where we want to place the objects in the scene, let's go ahead and load the images into their placeholders. To do this, we'll loop over the number of objects. We need to change the `for` loop command in line 34 slightly to account for the fact that the numbering of our objects begins with 1. We'll use line 36 to connect each image located in the `masks` folder with its corresponding placeholder inside the `scene3D` movie clip. Modify the script as shown.

```
33    // add objects to the scene in 3D space
34    for (var i:Number = 1; i <= numberOfObjects; i++)
35    {
36        scene3D["object"+i].loadMovie("masks/mask_"+i+".png");
37        thisObj = scene3D["object"+i];
38        placeObj();
39    }
40
```

Step 5: Position the objects in 3D space

We're ready to write the `placeObj()` function that will actually set the objects to the 3D coordinate data that we provided above. The important thing to remember here is that the numbering for the objects starts with 1, but the index numbering of arrays begins with 0. So for each object number `i`, we will need to reference an index value `i-1` to get the correct coordinate data.

```
41    // place an object in 3D space
42    function placeObj()
43    {
44        thisObj.x = xdata[i-1];
45        thisObj.y = ydata[i-1];
46        thisObj.z = zdata[i-1];
47    }
48
```

Step 6: Display the objects

The next thing we need to do is modify the script to display the objects. Looking at the script, you might expect that the `displayObj()` function will require some adjustments, but it is fine for now. If you think about it, that may not be too surprising since the process for converting 3D coordinates to screen coordinates remains the same.

Where we must make a few changes is in the `onEnterFrame` handler. For the time being, we will keep the same user interactivity with the arrow keys just to make sure the movie is working fine overall. The first line that needs some adjusting is where we loop over the objects to display them (line 85). We need to modify the `for` loop command as before to account for the fact that the numbering of our objects begins with 1 and ends with the number of objects specified.

We also need to insert a call to the `placeObj()` function (line 88) before we place a call to the `displayObj()` function. This is a little strange, since it would seem that once the object has been assigned its 3D coordinates as properties, it should be able to remember them. However, this is not the case, and it is apparently related to the fact that each object has an image loaded into it. Since an image loaded into a movie clip inherits the position, rotation, and scale properties of the movie clip, the added complexity requires resetting the position each time the frame is entered.

```
84        // loop over the objects and display them
85        for (i=1; i<=numberOfObjects; i++)
86        {
87            thisObj = scene3D["object"+i];
88            placeObj();
89            displayObj();
90        }
```

Save your movie as `7_2_maskCam_DONE.fla` and test it. Your initial screen should appear as in Figure 7.9. Using the arrow keys, you should be able to zoom in and out as well as move left and right.

Notice that in Figure 7.9, the masks are off center. This may be surprising since the x-coordinates of the masks are symmetric about the origin. The reason for this is that the registration points of the images that were loaded are set to the upper-left corner. The upper-left corner of the middle mask is in the middle of the Stage. This offset is not critical because of our final mouse interaction and could easily be corrected if needed.

Figure 7.9 Initial screen of `maskCamDone.fla`

Step 7: Modify the user interaction

Now let's change the user interaction so that the cursor controls both our left and right movement and our up and down movement. Here's how we'll do it. We'll check to see where the cursor is in relation to the center of the scene to determine which way to move. If the cursor is to the right of the scene center, the difference between the two is positive and the movement will be to the right. If the cursor is to the left of the scene center, the difference between the two is negative and the movement will be to the left. The difference is divided by the `viewerSpeed` so that the movement isn't too rapid. The `viewerSpeed` can be adjusted to suit taste. The vertical movement is handled similarly.

```
75    // create the viewer or object movement
76    this.onEnterFrame = function()
77    {
78        // use mouse for horizontal & vertical viewer movement
79        viewer.x +=  (_xmouse - scene3D._x)/viewerSpeed;
80        viewer.y += -(_ymouse - scene3D._y)/viewerSpeed;
81
```

We will continue to use the Up Arrow and Down Arrow keys to zoom in and out. Delete the two lines that use the Right Arrow and Left Arrow keys to control horizontal movement (lines 85 and 86).

235

```
82        // check keys to adjust viewer movement
83        if (Key.isDown(Key.UP))           {viewer.z += viewerSpeed;}
84        else if (Key.isDown(Key.DOWN)) {viewer.z -= viewerSpeed;}
85        else if (Key.isDown(Key.RIGHT)){viewer.x += viewerSpeed;}
86        else if (Key.isDown(Key.LEFT)) {viewer.x -= viewerSpeed;}
87
```

Save and test your movie. Can you move the mouse and arrow keys to zoom in and navigate to each of the masks?

Step 8: The finishing touches

Let's wrap up this exercise by putting a few simple restrictions on the viewer movement so that all of the objects don't disappear from the screen. We already have a test to see whether an object is too close to the viewer. In the z-direction, we'll keep the viewer from zooming too far away from the objects and also keep the viewer at a minimum distance from the third row of objects. This can be done by inserting the lines below.

```
52        // restrict the viewer z-movement
53        if (viewer.z < -1000 ) { viewer.z = -1000 }
54        if (viewer.z > 900 )    { viewer.z = 900 }
55
```

The results are shown in Figure 7.10. How are these numbers determined? The trace statement `trace(viewer.z)` was used to show values for `viewer.z` in the Output window, and then the chosen values were used in the `if` statements in lines 53 and 54. Test your movie and verify the results of Figure 7.10.

Figure 7.10 The masks at minimum and maximum `viewer.z` values

A similar process can be used to put restrictions on the x-movement shown in lines 57 and 58. The results are shown in Figure 7.11 for the worst cases of maximum zoom.

```
56      // restrict the viewer x-movement
57      if (viewer.x < -1000 ) { viewer.x = -1000 }
58      if (viewer.x > 1200 )  { viewer.x = 1200 }
59
```

Note that the numbers selected to be used are not cast in stone but rather depend on how much movement you would like the objects to have. The main objective is to prevent the user from losing control by having the objects go entirely off the screen. Test your movie and verify that the test is working.

Figure 7.11 The masks at minimum and maximum `viewer.x` values and maximum zoom

As a last step, similar restrictions can be placed on the y-movement shown in lines 61 and 62. The results are shown in Figure 7.12 for the worst cases of maximum zoom. Save and test your movie to make sure that everything works as it should.

```
60      // restrict the viewer y-movement
61      if (viewer.y < -300 ) { viewer.y = -300 }
62      if (viewer.y >  300 ) { viewer.y =  300 }
63
```

Tip: The user interaction above is defined by the movement of the viewer, but there are other possibilities. For example, by changing the expressions for `viewer.x` and `viewer.y` from += to -= in the `onEnterFrame` handler will cause the objects to appear to be following the cursor. Another good approach is to reverse the y and z interaction

Figure 7.12 The masks at minimum and maximum `viewer.y` values and maximum zoom

so that the vertical movement of the cursor zooms in and out while the Up Arrow and Down Arrow keys control the vertical position of the objects.

Interactive 3D Information Spaces

In the previous exercise, we considered some of the ways in which you could explore navigating in all three dimensions. Let's look a little further and see how you might interact with information presented in a three-dimensional space, a 3D information space if you will. Open `flagCam1.fla` to view the script we will be discussing and `flagCam1.swf` to get a sense of the interaction.

Figure 7.13 shows a sample screen from `flagCam1.swf`. What we have are 24 flags from different countries placed in 3D space over a map of Europe. When the viewer clicks a flag, the camera will move toward the selected flag. A message will be displayed that identifies the country of origin. We'll deconstruct the script in sections to explain what's going on, but before we do, let's take a look at the Timeline.

Besides the `actions` layer, there are two additional layers, the `background` layer containing the map and the `type` layer, which holds all of the text. The map has been made into a movie clip with `bg_mc` as its instance name. All of the text has been placed in a movie clip with `title_mc` as its instance name.

Double-clicking on `title_mc` takes you to the editing window. If you select the third line of text, the Properties window shows that the line has been set as Dynamic Text with `flag_txt` as its name as shown in Figure 7.14. We will use this text box to display the name of the country when a flag is selected. Note that the Font rendering method for the text has been set to "Anti-alias for readability," since it won't be animated.

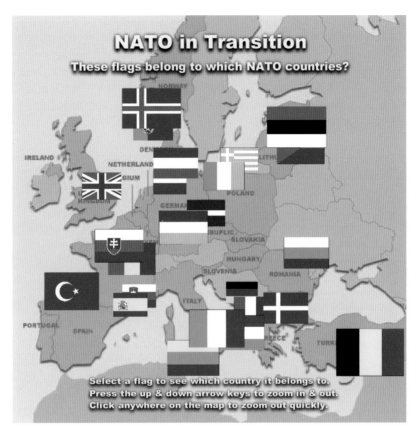

Figure 7.13 Sample screen shot from `flagCam1.swf`

Figure 7.14 Setting a text box to dynamic text

The script begins by creating a viewer object in line 2 as we have done previously. The nice thing about creating new objects is that we are free to specify whatever properties we feel are necessary. In this case, we want to identify the initial position of the viewer to be at the origin of the coordinate system as in the last exercise. We mentioned above that we want the viewer to move toward a flag that's been selected, so we will also define destination coordinates dx, dy, and dz of the viewer. These are initially set to the origin as well.

Lines 4–13 were copied and pasted from the previous exercise. Viewer parameters are initialized, and a picture plane is created and located at the center of the Stage.

```
1    //create a viewer object w/ position & destination properties
2    viewer = {x:0, y:0, z:0, dx:0, dy:0, dz:0 }
3
4    // set the viewer parameters
5    var d:Number = 200;   // distance from viewer to picture plane
6    var viewerSpeed:Number = 20; // the viewer speed
7    var tooClose:Number = 100;    // the too close distance
8
9    // create the picture plane: a movie clip named scene3D
10   // and position it in the center of the Stage
11   createEmptyMovieClip("scene3D", 0)
12   scene3D._x = Stage.width/2;
13   scene3D._y = Stage.height/2;
14
```

In line 16, coordinate arrays are defined as in Exercise 7.2, but the array entries are not specified until a bit later. Before we concern ourselves with the placement of the flags in 3D space, we'll first load them. We'll use a loadMovie() method as in the last exercise, but we don't have any movie clips to load them into, so we'll have to create some additional empty movie clips as shown in line 24. And since we want to use new objects, we will have to modify line 25 to specify the location of the new files.

Lines 28–30 fill the coordinate arrays with values that will be assigned to the flags. It was convenient to assign the values here since we are looping over the number of objects and can avoid an extra loop. The x-coordinates are spaced every 100 pixels apart starting at –1100. The y-coordinates are determined randomly but centered about the y-axis. The z-coordinates are also chosen randomly to provide spatial variety. The placeObj() is where the coordinates for each flag are set to the 3D coordinate data that we provided in lines 28–30.

```
15    // define the coordinate arrays
16    xdata = []; ydata = []; zdata = [];
17
18    // set the number of objects to be created
19    numberOfObjects = 24;
20
21    // add objects to the scene in 3D space
22    for ( var i:Number = 1; i <= numberOfObjects; i++)
23    {
24        scene3D.createEmptyMovieClip("object"+i,i);
25        scene3D["object"+i].loadMovie("flags/flag"+i+".png");
26        thisObj = scene3D["object"+i];
27
28        xdata[i-1] = i*100-1200;                   // -1100,...,1200
29        ydata[i-1] = 2400*Math.random()-1200; //-1200 < y < 1200
30        zdata[i-1] = 800 + 1000*Math.random();//  800 < z < 1800
31        placeObj();
32    }
33
34    // place an object in 3D space
35    function placeObj()
36    {
37        thisObj.x = xdata[i-1];
38        thisObj.y = ydata[i-1];
39        thisObj.z = zdata[i-1];
40    }
```

The `displayObj()` function has nothing new. Since we will use the Up Arrow and Down Arrow keys to enable the user to zoom in and out, we will only restrict the z-movement of the viewer as shown in lines 46 and 47.

```
42    // display the 3d objects in the picture plane
43    function displayObj()
44    {
45        // restrict the viewer z-movement
46        if (viewer.z < -900 ) { viewer.z = -900 }
47        if (viewer.z > 1600 ) { viewer.z = 1600 }
48
```

The next section of the script functions as an initialization for the opening screen. Since some of the flags can become quite large and cover the title and instructions, it was decided that the text should always be seen. In order to do this, we just need to place the text on a layer higher than any of the flags. Line 74 uses swapDepths(32000), which more than gets the job done, since the z-values for the flags have a maximum value of 1800 from lines 30 and 39.

Line 75 makes sure that the message for the selected flag country is not seen initially by setting its visibility to false.

The remaining part of this section creates an array of the names of the flag countries. The names are listed in the same order that the flags are loaded into the scene. Note that the first item in the array is an empty name. This was done for convenience since the flags are numbered 1–24 but the index of arrays begins at 0, so the elements would otherwise be numbered 0–23. At times, lazy designers who like to count on their fingers grow weary of this difference and find it easier to simply add a blank entry. The flag names are entered in the code here for clarity but could just as easily be loaded dynamically into flagArray.

```
71   // ---------------------------------------------------------------
72   // set up the opening screen and flag names
73
74   title_mc.swapDepths(32000); // put the title on top
75   title_mc.flag_txt._visible = false; // turn off the flag text
76
77   // define the array of flag countries
78   flagArray = ["","United Kingdom","Turkey","Spain","Slovenia",
79             "Slovakia","Romania", "Portugal","Poland"
80             "Norway","Netherlands","Luxembourg","Lithuania",
81             "Latvia","Italy","Ireland","Hungary",
82             "Greece","Germany","France","Estonia",
83             "Denmark","Czech Republic","Bulgaria","Belgium"]
84
```

The next section of the script deals with defining the user interaction. There are three ways in which the user can interact with this project. The most important is the user clicking on a flag. Here's what we want to have happen. We need to identify which flag has been selected so that the name of the corresponding country can be displayed. We would also like to move the viewer toward the selected flag.

Since all of the flags are contained in movie clips that have been created inside the scene3D movie clip, we can write a function for the user clicking on the scene (line 89). There is nothing else in the scene but the flags, so we can set up a for loop to loop over them (line 92). We can tell which flag has been selected in line 96 by using a movie clip hitTest() method to check whether the cursor (_xmouse, _ymouse) has hit a flag.

Once the flag has been determined, the visibility of flag_txt is turned on (line 99). After grabbing the name of the country from flagArray, it is put into the text of flag_txt (line 100) and displayed on the screen.

```
85    // --------------------------------------------------------------
86    // define the background and scene actions
87
88    // click on a flag to move the viewer towards it
89    scene3D.onRelease = function()
90    {
91        // loop over the objects in the scene
92        for (k=1; k<=numberOfObjects; k++)
93        {
94            thisObj = scene3D["object"+k];
95            // find the selected flag
96            if ( thisObj.hitTest(_xmouse,_ymouse) )
97            {
98                // turn on the selected flag message
99                title_mc.flag_txt._visible = true;
100               title_mc.flag_txt.text =
101               "You clicked on the flag of " + flagArray[k];
102
103               // set the viewer destination coordinates
104               viewer.dx = thisObj.x;
105               viewer.dy = thisObj.y;
106               viewer.dz = thisObj.z/2;
107               break; // break out of the loop
108           }
109       }
110   }
111
112   // click on background to zoom out
113   var back:Boolean = false;
114   bg_mc.onRelease = function() {back = true; }
115
```

The last action in the scene3D script is to set the destination coordinates of the viewer. The destination coordinates, shown in lines 104–106, are the horizontal and vertical coordinates of the selected flag and half of the z-distance from the viewer to the flag. We do not want the viewer to move all the way to the flag, since we would then be on top of the flag and unable to see anything. Later, we will see that the viewer will move from its current location to the destination coordinates. Going half of the z-distance provides the opportunity for some flags to get larger, some smaller, depending on the relative z-values of the flag and viewer.

The last line of interest in the scene script is the break command in line 107. What this does is to break out of the for loop once a flag has been selected to avoid further testing. While this works well enough for our example here, it is not entirely foolproof. Why? The reason is that we can have partially or fully overlapping flags, since our objects are defined in three-dimensional space and our method of assigning coordinates does not prevent it.

For example, consider the situation shown in Figure 7.15, where we have several flags overlapping in the area inside the black circle. You may be interested in the blue, white, and red flag that's in the foreground. If you happen to click where the black dot is located, you will discover that you have clicked on the flag of Germany rather than the flag of France. Reference to flagArray identifies part of the problem. The entries are in reverse alphabetical order so that in the for loop, the hit test for Germany happens to be performed before the hit test for France. The same type of situation arises with normal alphabetical order. What is needed is to find all objects that pass the hit test and then check to see which one has the smallest z-value, which marks it as closest to the viewer. We'll leave that as an exercise for you.

Figure 7.15 Overlapping flags

The second type of user interaction is clicking on the background map. We'll use clicking on this as a way for the user to quickly zoom out. In line 113, we'll define a variable zoomOut. It's specified as a Boolean variable, which means it can have only the values true and false, and we will initially set it to false since we don't yet want to zoom out. When we click on the map, we will set its value to true (line 114). The mechanics of the zooming out will be done in the next section of the script.

```
112    /// click on the background to zoom out
113    var zoomOut:Boolean = false;
114    bg_mc.onRelease = function() { zoomOut = true; }
115
```

The third type of interaction, using the Up Arrow and Down Arrow keys to zoom the viewer in and out, has been discussed in earlier exercises. The script for this is included in the next section.

The final section of the script deals with controlling the movement of the viewer. We begin by defining the variable step in line 119, whose purpose is to divide some of the viewer movement into steps, as we will soon see. We will use an onEnterFrame handler, as usual, to provide the motion.

The next part of the script controls the movement of the viewer towards the selected flag. Rather than a constant, linear change of movement of the viewer, we will have a nonlinear easing motion as shown in lines 123–125. Here is how it works. We first take the difference between the destination coordinates and the current coordinates. The difference is divided by the value of viewerSpeed and added to the current coordinates.

```
116    // ----------------------------------------------------------
117    // create the viewer or object movement
118
119    var step:Number = 0;  // step number for viewer movement
120    this.onEnterFrame = function()
121    {
122        // move viewer towards the selected flag
123        viewer.x += (viewer.dx - viewer.x)/viewerSpeed;
124        viewer.y += (viewer.dy - viewer.y)/viewerSpeed;
125        viewer.z += (viewer.dz - viewer.z)/viewerSpeed;
126
```

Each time the frame is entered, the difference between the destination and current coordinates is less than before. As a result, the movement is fast initially and then gradually comes to a halt. Figure 7.16 demonstrates the concept in the x-direction. Suppose, for the sake of argument, that we set `viewerSpeed` = 2. The distance from the current viewer position to the destination position is represented by the bottom bar. In the first frame, the difference between the two is computed and divided by 2. The viewer then moves half the distance toward the destination position.

In the next frame, the difference between the destination position and the new current position is again calculated, but this time the difference is half of the previous difference. After dividing by 2, the viewer moves ahead, but by only half the amount of the previous step. Similarly, after each frame, the viewer moves ahead by a smaller amount until eventually the target destination is reached. The motion decelerates until it stops, sort of like braking at a traffic signal.

frame 3

frame 2

frame 1

viewer.x += (viewer.dx - viewer.x) / viewerSpeed

viewer.x

viewer.dx

Figure 7.16 The concept of easing

The next part of the script performs the zoom out after a user has clicked on the map, which sets `zoomOut` to true. When such is the case, `step`, which was set to 0 just before the `onEnterFrame` handler, is incremented by 1 (line 129). The z-coordinate of

```
127    // zoom out when background has been clicked
128    if (zoomOut == true )
129    {   step++;
130        viewer.z -= 2*viewerSpeed;
131        if (step == viewerSpeed )
132        {   zoomOut = false;
133            step = 0;
134            viewer.dz = viewer.z;
135        }
136    }
137
```

the viewer is then reduced by `2*viewerSpeed` (line 130). Unlike the previous motion, this motion is linear, since the amount of reduction in the z-value is always the same. By making this value less, we increase the distance to the flags, which results in the zoom out. This process continues until `step` has the same value as `viewerSpeed` (line 131). When this happens, we are done zooming out, so we reset `zoomOut` to false and `step` to 0.

There is one other not-so-obvious thing that we must do. In line 134, we must set the viewer destination z-value to the current viewer z-value. If we don't, the flags do a strange, continuous collapse and expansion that might possibly qualify as a candidate for the Big Bang theory.

Next, we come to the viewer movement when the user presses on either the Up Arrow or Down Arrow key. Here we simply add or subtract the `viewerSpeed` from the z-value of the viewer as we have done earlier. The only new wrinkle is setting the viewer destination z-value to the current viewer z-value as above in lines 141 and 145 to avoid the same behavior.

```
138        // check arrow keys to adjust viewer movement in and out
139        if (Key.isDown(Key.UP))
140        {    viewer.z += viewerSpeed;
141             viewer.dz = viewer.z;
142        }
143        else if (Key.isDown(Key.DOWN))
144        {    viewer.z -= viewerSpeed;
145             viewer.dz = viewer.z;
146        }
147
```

The script wraps up on familiar ground with a loop over the objects and calls to the `placeObj()` and `displayObj()` functions. You'll make a few changes in the next exercise.

```
148        // loop over the objects and display them
149        for (i=1; i<=numberOfObjects; i++)
150        {
151             thisObj = scene3D["object"+i];
152             placeObj();
153             displayObj();
154        }
155    }
```

Exercise 7.3: Extending an Information Space Functionality

In this exercise we will look at extending the functionality and information value of the example just discussed. The screen will start out the same as shown in Figure 7.17 with the flags randomly placed in 3D space over a map of Europe. What we would like to have happen is that, unlike the previous example, the selected flag will come to the front and be fully displayed as in Figure 7.18. We'll use a combination of viewer movement and flag movement.

Step 1: Getting started

Open `7_3_flagCam.fla` in the Chapter 7 folder. The file is a duplicate of the example we just discussed. We'll start by making a small change near the top of the script. It

Figure 7.17 Typical opening screen of `7_3_flagCam_DONE.swf`

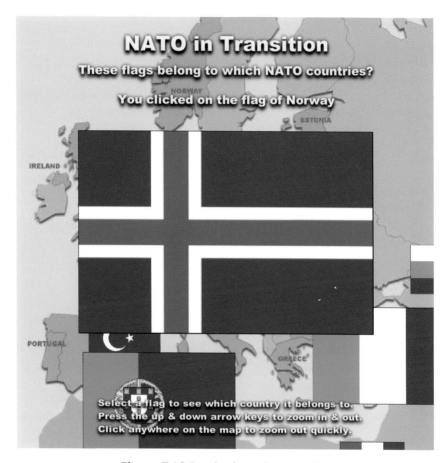

Figure 7.18 Result after selecting a flag

will be helpful later if we adjust the value of `viewerSpeed`. Give it a new value of 10 in line 6 as shown below.

```
1    //create a viewer object w/ position & destination properties
2    viewer = {x:0, y:0, z:0, dx:0, dy:0, dz:0 }
3
4    // set the viewer parameters
5    var d:Number = 200;   // distance from viewer to picture plane
6    var viewerSpeed:Number = 10; // the viewer speed
7    var tooClose:Number = 100;   // the too close distance
8
```

Step 2: Create a placeholder for z-values

We are going to be temporarily changing the z-values of the selected flag in order to have it zoom in. When we click on a new flag, we want the previous flag to return to its original z-value. In order to do this, we need to have a placeholder to store the z-value. A convenient place to do this is in the zdata array. We'll just tack on an extra element in the array that is initially set to 0. Add the two lines shown below.

```
30          zdata[i-1] = 800 + 1000*Math.random();//  800 < z < 1800
31          placeObj();
32      }
33
34      // add a placeholder to store z-value of selected flag
35      zdata[numberOfObjects] = 0;
36
37      // place an object in 3D space
38      function placeObj()
```

Step 3: Initialize zoom in variables

We need to define several variables that will be required to enable us to zoom a flag. The zoomIn variable will be used in the onEnterFrame handler to determine whether to zoom in or not. It has a value of either true or false.

When the user clicks on a flag, we will have to store which flag is selected and the depth that the flag is at. This information is stored in mySelection, which is initialized to 0, and myDepth, which starts at a ridiculously low number of −30,000 to avoid any conflicts with actual depth values. Finally, we define a variable prevId, which will hold the flag number of the previously selected flag so that we can reset its z-value after zooming in. Insert the lines shown.

```
88      // ------------------------------------------------------------
89      // define the scene and background actions
90
91      // initialize variables needed to zoom a flag
92      var zoomIn:Boolean = false; // to zoom or not to zoom
93      var mySelection:Number = 0; // current selected flag number
94      var myDepth:Number = -30000;// depth of current flag
95      var prevId:Number = 0;       // previous selected flag number
96
97      // click on a flag to move the viewer towards it
```

Step 4: Store previous flag z-value information

The currently selected flag will become the previous one when the user clicks on a new flag. We'll store the flag number of the selected flag in `prevId`, minus 1 because we are using the `zdata` array (line 100). Then we retrieve its z-value from the placeholder at the end of the `zdata` array and restore it to its correct location in the array (line 101).

```
 97    // click on a flag to move the viewer towards it
 98    scene3D.onRelease = function()
 99    {
100        prevId = mySelection-1;
101        zdata[prevId] = zdata[numberOfObjects];
102
103        // loop over the objects in the scene
```

If this all seems somewhat convoluted to you, it's because to a certain extent, it is. But the order in which things are done is important. Let's look at a simple example. Suppose you click on flag 10, whatever it may be. Suppose further that its z-location is 1100. We are going to store this number in `zdata[24]`. The viewer will then move toward the flag. When that's done, the flag will zoom in to a z-value of 200 so that we can see it nice and big. As it is moving toward us, its z-value, which is stored in zdata[9], is changing from 1100 to 200. Note that `prevId = 10 – 1`, or 9.

Now suppose you select flag 4. We have to temporarily store its z-value in `zdata[24]` as we did for flag 10. But before we do that—and this is where the order of things is important—we need to reset the z-value of flag 10, located in `zdata[9]`, back to its original value of 1100. That is the function of line 101. Whew! Such a business. Just two simple lines, but critical to everything working properly.

Step 5: Set up for zooming

Next, we have to go inside the `for` loop that determines which new flag has been selected and set things up for zooming. This would be flag 4 in our discussion above. At this point in the script, we have found the new selected flag, so we can set `zoomIn` to true (line 121). The variable `mySelection` is simply the counter in the `for` loop that produced a positive hit test (line 123). We need to store the flag's z-coordinate into the `zdata` placeholder. Referring to flag 4 above as the new selection, line 125 states that we need to set `zdata[24] = zdata[3]`. In a similar fashion, we will store the flag's actual depth in `myDepth` in line 126. We perform a `swapDepths()` in line 127 to temporarily put its depth at 30000, a little below the depth of the title. The break command wraps things up by kicking us out of the `for` loop.

```
115        // set the viewer destination coordinates
116        viewer.dx = thisObj.x;
117        viewer.dy = thisObj.y;
118        viewer.dz = thisObj.z/2;
119
120        // prepare for zooming in on the flag
121        zoomIn = true;
122        // identify the flag number
123        mySelection = k;
124        // store its z-coordinate and depth
125        zdata[numberOfObjects] = zdata[mySelection-1]
126        myDepth = thisObj.getDepth();
127        thisObj.swapDepths(30000);
128        break; // break out of the loop
```

Step 6: Complete the script for zooming in

The onEnterFrame handler is where the actual work of zooming in takes place. There is a fair amount of new code here, and everything between the lines

> // move the viewer towards the selected flag

and

> // zoom out when the background has been clicked

should be deleted and replaced with the script shown here.

We begin by moving the viewer towards the selected flag as before. We define variables diffx, diffy, and diffz, which are measures of the difference between the destination and current positions of the viewer in the x-direction, y-direction, and z-direction respectively (lines 144–146). A variable difft, which is a rough measure of the total difference, is also defined (line 147). The first three variables are used to move the viewer toward the flag and are the same as previously, just written differently (lines 149–151).

The variable difft is used to determine basically when the viewer has reached the destination position. When this number is small enough, less than 6 in this case, and if zoomIn has been set to true, then we will start to zoom in on the flag (line 155).

The process of zooming the flag is done in equal increments. Each time the frame is entered, step is incremented by 1 (line 157). The z-coordinate of the flag is updated

```
138    // create the viewer or object movement
139
140    var step:Number = 0;  // step number for viewer movement
141    this.onEnterFrame = function()
142    {
143        // move the viewer towards the selected flag
144        var diffx = (viewer.dx - viewer.x)/viewerSpeed;
145        var diffy = (viewer.dy - viewer.y)/viewerSpeed;
146        var diffz = (viewer.dz - viewer.z)/viewerSpeed;
147        var difft = diffx + diffy + diffz;
148
149        viewer.x += diffx;
150        viewer.y += diffy;
151        viewer.z += diffz;
152
153        // test for end of viewer motion
154        // if it's done and zoomIn is true, then do it
155        if ( difft < 6 && (zoomIn == true ))
156        {
157            step++;
158            // temporarily increase z-value of the selected flag
159            zdata[mySelection-1]+= (200 - viewer.dz)/viewerSpeed;
160
161            // check to see if we have done all the steps
162            if (step == viewerSpeed )
163            {   zoomIn = false;  // turn off zoom in
164                step = 0;         // reset zoom step
165                // return the flag to its original depth
166                scene3D["object"+mySelection]swapDepths(oldDepth);
167            }
168        }
169
170        // zoom out when the background has been clicked
```

each frame, with its value getting progressively toward 200. This value is stored in the zdata array in line 159 for use when the placeObj() and displayObj() functions are called later. Once all the steps have been completed (line 162), zoomIn and step are reset (lines 163 and 164), and the flag is assigned its original depth value.

Save your movie as 7_3_flagCam_DONE.fla and then test it to make sure everything is working properly. When you click on a flag, you should get results similar to Figure 7.19.

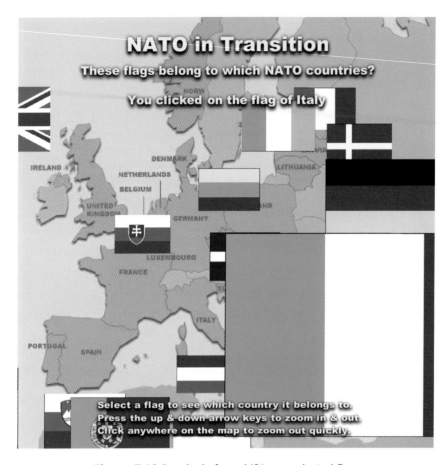

Figure 7.19 Results before shifting a selected flag

Step 7: One final refinement

When a flag is selected and zooms in, it basically goes to the center of the Stage. Since the flags have been loaded into empty movie clips, their registration points are in the upper-left corner of the flag, so we only see part of the flag. We need to move the flag up and to the left.

One way to do this is to offset the position of the flag by half its width and half its height in the `displayObj()` function. Insert the lines shown after the scale calculation, and all should be fine. Save your movie and test it to see whether you get results like that of Figure 7.18. It was work, but the results are pretty good.

```
63        thisObj._xscale = thisObj._yscale = 100*pRatio;
64
65        // adjustment for upper-left registration point
66        thisObj._x -= thisObj._width/2;
67        thisObj._y -= thisObj._height/2;
68
```

Viewer Rotation

We have seen that rotating an object about one of the three coordinate axes is a fairly straightforward process. Rotating a viewer around one of the axes is a bit more complicated. Let's look at the case where the viewer rotates around the y-axis as shown in the left side of Figure 7.20.

As the viewer rotates, the relative coordinates of each object need to be updated. Any point (x,y,z) in 3D space yields a corresponding point (x,z) when projected onto the x-z plane. This point is at some angle A to the x-z plane. When the viewer rotates about the y-axis, that point has new coordinate values (x',z'). What we need to know is, what are the values of (x',z') when the viewer rotates through some angle B? Note that since the rotation is in the x-z plane, the vertical or y-values are unaffected.

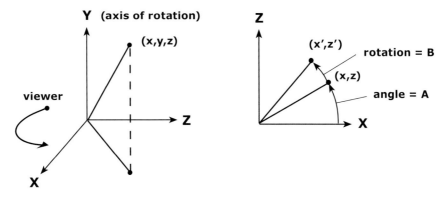

Figure 7.20 Rotation of a viewer about the y-axis

To get the coordinates of the new point expressed in terms of the original point, we need to know how to calculate sin(A+B) and cos(A+B). Let's omit all the gory details

which can be found in a trig book and jump to the answer. The coordinates of the new point are given by

$$x' = x \cos(B) - z \sin(B)$$

$$z' = z \cos(B) + x \sin(B)$$

Similar expressions can be found for rotation about the other axes and will be discussed in a later chapter where we look at rotations about more than one axis. Unlike translations where the order does not matter, the order of rotation about more than one axis affects the final position. This is true for both viewer and object rotation.

Exercise 7.4: Viewer Rotation About the Y-axis

In this exercise, we will look at how to apply the equations that express the updated coordinate values when the viewer undertakes a rotation about the y-axis. Open the file `7_4_glassCam_DONE.swf` in the Chapter 7 folder. Figure 7.21 shows a sample screen from the file. We'll use the arrow keys to control the movement.

Step 1: Getting started

Open `7_4_glassCam.fla` and `7_2_maskCam_DONE.fla` in the Chapter 7 folder. The script from the latter file contains most of what we will need, so copy the script from `7_2_maskCam_DONE.fla` and paste it into `7_4_glassCam.fla`. Let's start by modifying our viewer properties to include an initial angle of rotation about the y-axis (line 2). Set the distance from the viewer to the picture plane to 600 in line 5.

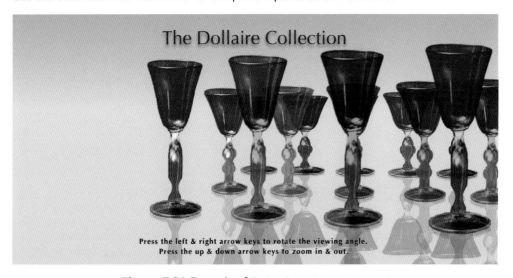

Figure 7.21 Example of `7_4_glassCam_DONE.swf`

We will have to include some additional viewer information to effect the angular rotation. Let's define a viewer rotation angle that is initially set to 2 degrees in line 6, but that could be any number we choose. This represents the incremental change in the viewer angle `ry` during rotation about the y-axis.

```
1    //create a viewer object with position & rotation properties
2    viewer = {x:0, y:0, z:0, ry:0 }
3
4    // set the viewer parameters
5    var d:Number = 600;   // distance from viewer to picture plane
6    var viewerAngle:Number = 2;   // the angular change of viewer
7    var viewerSpeed:Number = 10; // the viewer speed
8    var tooClose:Number = 100;   // the too close distance
9
```

Step 2: Calculate the rotational angle trig functions

There is one other piece of information we will need regarding the angle of rotation of the viewer. As the rotation angle is increased or decreased, we will have to update the sine and cosine of that angle. Let's write a function that will do this for us and, at the same time, convert from degrees to radians. We've actually seen these expressions many times already. Insert these lines before the creation of the picture plane.

```
10   // function to find the sin and cos
11   // of the y-angle of rotation (ry)
12   function calcSinCosY()
13   {
14       viewer.cy = Math.cos(viewer.ry * Math.PI/180);
15       viewer.sy = Math.sin(viewer.ry * Math.PI/180);
16   }
17
```

Step 3: Create the picture plane

Our current exercise has no `scene3D` picture plane defined, so let's add a line of code to create one through an empty movie clip. We'll keep the same coordinates for the placement of the movie clip.

```
18    // create the picture plane: a movie clip named scene3D
19    // and position it in the center of the Stage
20    createEmptyMovieClip("scene3D", 0)
21    scene3D._x = Stage.width/2;
22    scene3D._y = Stage.height/2;
23
```

Step 4: Add objects to the scene

Before we concern ourselves with the exact placement of the objects, let's first add them and use the existing coordinate data. We would like to use a loadMovie() method as in the last exercise, but we don't have any movie clips to load them into. We'll create some additional empty movie clips as shown in line 45. Since we want to use new objects, we will have to modify line 46 to specify the location of the new files.

```
42    // add objects to the scene in 3D space
43    for ( var i:Number = 1; i <= numberOfObjects; i++)
44    {
45        scene3D.createEmptyMovieClip("object"+i,i);
46        scene3D["object"+i].loadMovie("glasses/glass"+i+".swf");
47        thisObj = scene3D["object"+i];
48        placeObj();
```

Notice that the files being loaded are .swf files. This is one of four file formats that can be used with a loadMovie command. The others are .jpg, .gif, and .png. You may be wondering why this particular format was chosen. Because the objects to be loaded have transparency due to a reflected image and no background was desired, the likely format choices were .png and .swf. The .png format is more direct, while converting an image into a .swf format involves an extra step.

There are two reasons why you might use .swf. The first reason is a reduction in file size, which results in faster loading. The glass files typically ran about 88–120 KB as .png files but were only 16–20 KB as .swf files, a pretty substantial savings in file size. The other reason has to do with image quality as can be seen in Figure 7.22. The figure shows part of a screen capture of two glasses that were zoomed in just at the point of being too close to the viewer. The screen capture was then brought into Photoshop and enlarged 200%. The glass on the left was loaded as a .png file, while the glass on the right was loaded as a .swf file. At small to normal sizes, there is no significant differ-

ence in the way each looks on the screen. However, when zoomed in, the glass on the left is much more pixellated than the glass on the right.

Figure 7.22 Comparison of .png and .swf images

The reason for the better image quality in the .swf file is one of the options available when a bitmap is brought into Flash. After an image has been imported, select it in the Library window and click on the Properties Info box at the bottom of the window. When the dialog box appears, select the "Allow smoothing" option as shown in Figure 7.23 and click on the OK button.

Figure 7.23 Setting the smoothing option

After smoothing has been enabled, the images can be placed sequentially on the Timeline as shown in Figure 7.24. Select a frame and the choose File > Export > Export Image. When the dialog box appears, select Flash movie as the format and save the image. The exported image will be a .swf file.

You may not want to use this approach for all circumstances, as it does entail extra work. However, this process is helpful with images that may not be large in terms of pixel dimensions and that may not scale well. As mentioned earlier, the savings in file size may be worth the extra effort.

Figure 7.24 Placement on Timeline for image export

Step 5: Simplify the user interactivity

We're just about ready to preview what we have so far, but first let's simplify the user interactivity to just the arrow keys. Deactivate the mouse control and add detection for the Left Arrow and Right Arrow keys as shown.

```
100        // use mouse for horizontal & vertical viewer movement
101        //viewer.x +=  (_xmouse - scene3D._x)/viewerSpeed;
102        //viewer.y += -(_ymouse - scene3D._y)/viewerSpeed;
103
104        // check keys to adjust viewer movement
105        if (Key.isDown(Key.UP))        {viewer.z += viewerSpeed;}
106        else if (Key.isDown(Key.DOWN)) {viewer.z -= viewerSpeed;}
107        if (Key.isDown(Key.RIGHT))     {viewer.x += viewerSpeed;}
108        else if (Key.isDown(Key.LEFT)) {viewer.x -= viewerSpeed;}
```

Let's see where we are at this point. Save your movie as `7_4_glassCam_DONE.fla` and test it. You should get results similar to Figure 7.25. Clearly, one of the things we need to do is bring the glasses closer together in the x-direction. It would also be helpful to raise the glasses and more closely center the images vertically.

Figure 7.25 Intermediate step of `glassCamDone.swf`

Step 6: Modify the coordinate data

The maximum width of the glasses is about 150 pixels, so spacing them out horizontally every 160 pixels should provide spacing between the glasses. Change the x-coordinate data array to that shown.

261

```
  30    xdata = [-320,-160,    0, 160, 320,
  31             -320,-160,    0, 160, 320,
  32             -320,-160,    0, 160, 320 ]
  33
```

Step 7: Modify the viewer position

The easiest way to move the glasses up on the Stage is to adjust the viewer position. Moving the viewer up about 50 pixels should do the job. Also, judging from the size of the glasses in Figure 7.25, the viewer may be a little too close, so let's move her back. The viewer position here should work and yield the results shown in Figure 7.26.

```
  1    //create a viewer object with position & rotation properties
  2    viewer = {x:50, y:-50, z:-50, ry:0 }
  3
```

Figure 7.26 Layout after modifying the spacing and viewer position

Step 8: Add the viewer rotation

We're finally ready to add the viewer rotation, so let's take a look at the onEnterFrame handler. Instead of using the Left Arrow and Right Arrow keys to move the viewer horizontally, we'll use them to control the angular rotation ry of the viewer about the y-axis.

```
 99          // check keys to adjust viewer movement
100          if (Key.isDown(Key.UP))         {viewer.z += viewerSpeed;}
101          else if (Key.isDown(Key.DOWN)) {viewer.z -= viewerSpeed;}
102          if (Key.isDown(Key.RIGHT))      {viewer.ry += viewerAngle;}
103          else if (Key.isDown(Key.LEFT)) {viewer.ry -= viewerAngle;}
104
```

For each change in the viewer angle of rotation, we will have to get new values of the sin and cos of that angle, so we need to add a call to the calcSinCosY() function before looping over the objects to display them. Insert these lines after checking the arrow keys.

```
110          // get the sin and cos of the rotation angle
111          calcSinCosY();
112
113          // loop over the objects and display them
114          for (i=1; i<=numberOfObjects; i++)
105          {
```

In order to see the effect of the rotation of the viewer on the scene, we have to make an addition in the displayObj() function. We first calculate the relative translation of each object and apply the rotation equations to transform into new coordinates. Enter the lines shown after the calculation of the relative translation and before the calculation of the perspective ratio.

```
 79          // calculate new tx and tz coordinates after rotation --
 80          // find the new tz first but don't use it
 81          // when calculating tx or you get the wrong value
 82          var newtx:Number = tx * viewer.cy - tz *viewer.sy;
 83          var newtz:Number = tz * viewer.cy + tx *viewer.sy;
 84          tx = newtx;
 85          tz = newtz;
 86
```

Save and test your movie. You should be able to rotate the viewer's position as well as zoom in and out on the objects as in Figure 7.27. By pressing down on either the Left Arrow or Right Arrow keys sufficiently long, you can do a complete 360-degree rotation around the objects.

Figure 7.27 Example of viewer rotation

To get a better understanding of how the viewer rotation works, it may be helpful to look at Figure 7.28, where a rotation is shown from above in scale. The left side of the figure shows the viewer looking at the objects in 3D space before any rotation. The blue line represents the picture plane which, in our case, is the Stage or, if you prefer, the monitor screen.

Several typical projection lines are drawn from the viewer to the objects. What the viewer is seeing at this point is shown in Figure 7.26. Notice how the front middle glass blocks those behind it as the top view indicates. The glass to the right of center blocks the glass in the far right as also indicated by the projection lines.

The middle drawing of Figure 7.28 illustrates the viewer physically rotating 20 degrees in a clockwise direction. The picture plane rotates with the viewer while the distance between the viewer and the picture plane remains constant. Projection lines to the same objects as before are drawn. This is the scene as the viewer would see it.

The drawing on the right side of Figure 7.28 is simply the middle drawing rotated back so that the picture plane, the monitor screen, is in its original position. What the viewer sees is shown in Figure 7.27. When you press on the arrow keys, the sensation is often one of rotating the objects rather than that of the viewer rotating. But then again, didn't someone once say that everything is relative?

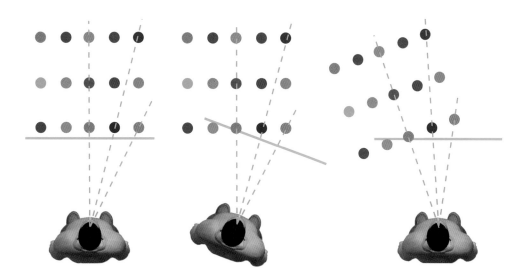

Figure 7.28 Viewer rotation seen from above

Step 9: Add a few refinements

There are a few refinements that should be made for a better user experience. Our tooClose distance for making objects invisible was set to 100 pixels in the previous exercise. For our needs, this distance is, in fact, too close. You may that find a value of 300 yields better results.

```
4     // set the viewer parameters
5     var d:Number = 600;  // distance from viewer to picture plane
6     var viewerAngle:Number = 2;  // the angular change of viewer
7     var viewerSpeed:Number = 10;  // the viewer speed
8     var tooClose:Number = 300;    // the too close distance
9
```

The displayObj() function has a test that restricts the z-movement of the viewer. In the previous exercise, the maximum value the viewer could in the z-direction was 900 pixels. This may be a little closer than is necessary. Try a value of 700 pixels as shown, or do some experimenting and come up with your own value.

```
59    // display the 3d objects in the picture plane
60    function displayObj()
61    {
62        // restrict the viewer z-movement
63        if (viewer.z < -1000 ) { viewer.z = -1000 }
64        if (viewer.z > 700 )    { viewer.z = 700 }
65
```

Also in the `displayObj()` function, you might notice that it contains lines of code that restricts the viewer's x- and y-movement (lines 66–72). Since we are currently dealing with rotation rather than translation, these lines can be deleted or commented out. Alternatively, you could put some limits on the viewer rotation.

Tip: What changes would you have to make to the script to put the rotation under the control of the horizontal position of the cursor? The challenge is to keep the rotation from increasing so quickly that the user is not able to easily control it. Some options include increasing the value of `viewerSpeed`, or alternatively, using the square of the `viewerSpeed` such as in the expression below:

```
viewer.ry += (_xmouse - scene3D._x)/(viewerSpeed*viewerSpeed)
```

Background Considerations

If we look back at the examples in Chapter 6 and this chapter, most of them have backgrounds that fall into one of two categories. A number of them are placed on backgrounds that have an implied, but not clearly defined, horizon line. Examples that fall into this category are illustrated in Figure 7.29. The background on the left has only a suggestion of three-dimensional space, while the background on the right is presented as an actual space. In these cases, the backgrounds are intended to be visually consistent with the objects in the foreground, but they are typically far away from the objects and do not interact with them.

The other type of backgrounds are those that provide a visual backdrop for the foreground objects and that thematically complement the subject matter but are not meant to suggest that they are in the same 3D space as the foreground objects. They are clearly defined, but like the examples above, they are intentionally constructed in such a way that they do not interact with the objects in the foreground. The objects move, scroll, rotate, and zoom relative to one another but not to the background.

Figure 7.29 Objects with visually consistent backgrounds

In many situations, these approaches are valid, and it makes a lot of sense to use them. There are circumstances, however, when the background must be a more important and integral component of the scene. The example shown in Figure 7.31 is the opening screen from `village3D.swf`. Here the background, the village castle, is an actual part of the scene, and consideration has to be given to how other objects in the scene interact with it. To interact with the movie, use the Up Arrow and Down Arrow keys to zoom in and out, and the Left Arrow and Right Arrow keys to pan left and right.

Let's look at how this movie is put together and some of the considerations needed to make it work. The process involves a combination of scripting, placement of objects in 3D space, and testing. Open `village3D.fla` to follow the script.

Figure 7.30 Objects with visually inconsistent backgrounds

Figure 7.31 Opening screen of `village3D.swf`

We can see from playing the movie, as well as from the script itself, what the objects are. There are environmental objects that include the village background, the street, and an archway. There are also people in the form of eight knights standing guard, a protector knight, and the queen. Each of these need to be placed in 3D space. The combination of these 2D drawings placed within a 3D space presents some interesting challenges that must be dealt with, not the least of which is the scale of the respective objects. In a fully 3D software program such as Autodesk Maya or CINEMA 4D, all of the objects would be created to scale with one another. This is clearly impractical within the Flash environment. We will have objects at different scales that must visually appear as if they are at the same scale.

Let's begin with the village and street images. As Figure 7.32 shows, our village scene has a rather flat perspective and almost no street visible, so we decided to add a street that had a much greater sense of depth. Rather than physically merging them in Photoshop, we decided to keep them as separate images and bring them together in Flash since the file size of each was already quite large. Figure 7.33 shows the two images loaded into Flash at different depths. Since we want to be able to pan and zoom, we have to treat the village and street like any other object and provide coordinates for them. Since both images have the same width, the x-values are the same. The difference in y-values was quickly obtained knowing the dimensions of the images. Different z-values were assigned so there would be no problems with the depth sorting.

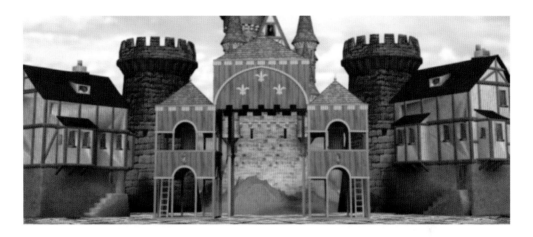

Figure 7.32 The separate village and street images

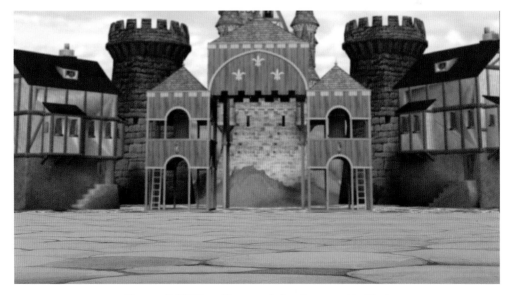

Figure 7.33 The village and street merged in Flash

The question that needed to be answered was what the z-value should be. A little bit of trial and error wasn't particularly fruitful in determining a ballpark number. If the depth is too great, the image fits entirely within the Stage area with no opportunity to pan the image with the camera. If the depth is too shallow, panning works fine, but since this project isn't providing the user with the ability to move up and down vertically, too much of the image would be cropped vertically. A simple answer came in the form of of a 3D grid overlay on the street. Equal divisions of horizontal and vertical lines in the x-z plane provided the number needed. It later proved useful as a rough guide for the placement of people.

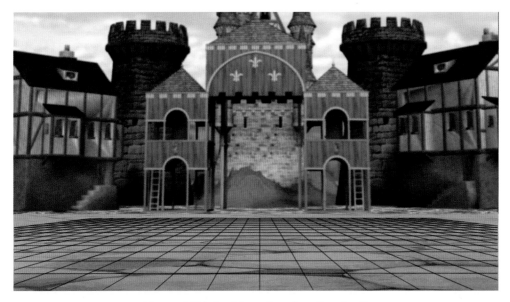

Figure 7.34 A grid overlayed on the street

This is a good time to take a look at the script. It starts out like most scripts, with setting the location of a viewer that works with the overall scene. For example, it was decided to shift the viewer 100 pixels to the right so that background wouldn't start out centered on the Stage. As usual, we are creating an empty movie clip named scene3D and centering it on the Stage (lines 13–15).

In lines 18–25, we begin adding objects to the scene. Because of their size, the three largest graphics are loaded dynamically into empty movie clips. The village and street are placed at the lowest depths. The archway is placed at a depth of 4 rather than 3 because a figure will be placed behind the arch.

270

```
1    //create a viewer object with position x,y,z
2    viewer = {x:100, y:100, z:70}
3    // you play around with these values to see different views
4    // look at -50 vs 50 for y
5
6    // set the viewer parameters
7    var d:Number = 650; // distance from viewer to picture plane
8    var viewerSpeed:Number = 10;// viewspeed used with arrow keys
9    var tooClose:Number = 300;  // the too close distance
10
11   // create the picture plane: a movie clip named scene3D
12   // and position it in the center of the Stage
13   this.createEmptyMovieClip("scene3D", 0)
14   scene3D._x = Stage.width/2;
15   scene3D._y = Stage.height/2;
16
17   // add objects to the scene in 3D space
18   scene3D.createEmptyMovieClip("villageScene", 1);
19   scene3D.villageScene.loadMovie("theVillage/village.jpg");
20
21   scene3D.createEmptyMovieClip("street", 2);
22   scene3D.street.loadMovie("theVillage/street.jpg");
23
24   scene3D.createEmptyMovieClip("wall", 4);
25   scene3D.wall.loadMovie("theVillage/archway.png");
26
```

As a result of the grid overlay discussed earlier, a `placeObj()` function was defined to locate the village and street in space. At this point, it also made sense to add the location of the archway to the function. The arch needed to be located fairly far back in space near the street. Its coordinates were determined with a few tests (Figure 7.35).

```
48       scene3D.street.x = -1440;
49       scene3D.street.y = -230;
50       scene3D.street.z = 1500;
51
52       scene3D.wall.x = -150;
53       scene3D.wall.y = 310;
54       scene3D.wall.z = 1440;
55   }
```

Figure 7.35 Placement of the arch

The placement of the people was made to provide interest and variety. On the surface, it would seem like a fairly simple task. The reality is that the people proved to be the challenge of the project. One of the things that was helpful was to have two sizes of knights, with the larger ones located in the foreground and the smaller ones located in the middle ground. Even though visually, there is the suggestion of a fairly deep space, it terms of actual z-coordinates for objects, the range was fairly narrow.

The most challenging aspect is to get the people to pan realistically. They do fine relative to one another with the appropriate parallax scrolling, but they each also have to pan with respect to the street. Initially, most of the people appeared to be sliding on the street during a pan. To have them appear to be grounded requires some trial and error, and typically involves making adjustments not only in the z-coordinates but also the y-coordinates as well.

Let's look at the script for bringing the people into the scene. Unlike the village, street and archway which were loaded dynamically, the people are embedded into the movie and are brought to the Stage using scene3D.attachMovie. One of the features of this method is that the movie clip that is being attached can also be given initial properties at the time of attachment. This provides a convenient way in which to set the location of each person in 3D space. It is important to remember that the first parameter is the linkage name of the movie clip symbol in the library to attach to a movie clip on the

```
28   scene3D.attachMovie("Queen","Queen",3,{ x:40,  y:-220, z:1450} );
29   scene3D.attachMovie("Guard","Guard",5,{ x:30,  y:-280, z:1409 });
30
31   scene3D.attachMovie("K1","Knight1",7, { x:320, y:-325, z:1405 });
                                          // right back 1
32   scene3D.attachMovie("K1","Knight2",6, { x:550, y:-335, z:1403 });
                                          // right back 2
33   scene3D.attachMovie("K2","Knight3",10,{ x:850, y:-400, z:1351 });
                                          // right mid
34   scene3D.attachMovie("K2","Knight4",11,{ x:380, y:-400, z:601  });
                                          // right front
35
36   scene3D.attachMovie("K3","Knight5",9, { x:-250, y:-320, z:1408});
                                          // left back 1
37   scene3D.attachMovie("K3","Knight6",8, { x:-500, y:-330, z:1404});
                                          // left back 2
38   scene3D.attachMovie("K4","Knight7",12,{ x:-750, y:-400, z:1352});
                                          // left mid
39   scene3D.attachMovie("K4","Knight8",13,{ x:-200, y:-400, z:742 });
                                          // left front
40
```

Stage. This is the name that you enter in the Identifier field in the Linkage Properties dialog box.

The displayObj() function is pretty standard. Since we are using the arrow keys to navigate around the scene, we put some restrictions on the viewer's x-movement and z-movement as shown below. These limits are easy to obtain using a trace(viewer.x) and a trace(viewer.z) command.

```
60       // restrict the viewer x-movement
61       if (viewer.x < -385 ) { viewer.x = -385; }
62       if (viewer.x >  385 ) { viewer.x =  385; }
63
64       // restrict the viewer z-movement
65       if (viewer.z < -120 ) { viewer.z = -120; }
66       if (viewer.z > 1060 ) { viewer.z = 1060; }
67
```

When you zoom in sufficiently toward the knight guarding the queen, the knight will swing his axe at you as shown in Figure 7.36. The test to activate this animation is carried out in the onEnterFrame handler.

Figure 7.36 Screen shot of the guard animation

There are several ways in which a test may be set up. The way in which it was done here was to observe that as you zoom in on the guard, his size changes because the viewer is closer. The displayObj() function performs this by applying the perspective ratio to the _xscale and _yscale of each object. Using a trace(scene3D.Guard. _xscale) command while zooming in provided the desired scale factor.

The Guard movie clip contains the animation sequence. Once the scale factor has been reached, the script below activates that sequence. A gotoAndPlay(scene3D.Guard. _currentframe + 1) statement is issued that tells Flash to play the next frame of the animation. At the end of the sequence, the playback head returns to the first frame and keeps looping. If the scale is less than 100, the sequence stops at the first frame.

```
102    // test to activate the guard animation
103    if (scene3D.Guard._xscale > 100)
104    {scene3D.Guard.gotoAndPlay(scene3D.Guard._currentframe + 1);}
105    else { scene3D.Guard.gotoAndStop(1); }
106
```

A similar test is used for the queen animation shown in Figure 7.37. Using a `trace(scene3D.Queen._xscale)` statement, an appropriate scale was selected to activate a bow to the user.

Figure 7.37 Screen shot of the queen animation

Unlike the guard animation that loops, we would like the queen to bow only once. In the movie clip that contains her animation, there is a `stop()` command on the last frame so that it will not loop automatically. When the scale factor is large enough, an additional test is carried out that checks to see whether the current frame of the animation is less than the total number of frames in the animation. If it is, the animation will continue. If it is not, the movie clip will go to the first frame.

```
107     // test to activate the queen animation
108     if (scene3D.Queen._xscale > 150)
109     {
110      if(scene3D.Queen._currentframe < scene3D.Queen._totalframes)
111      {scene3D.Queen.gotoAndPlay(scene3D.Queen._currentframe + 1);}
112     }
113     else { scene3D.Queen.gotoAndStop(1); }
114
```

There is one other test to be discussed. We want to make sure that the guard animation occurs at the same time as the queen animation. The script below shows how this can be done. If the scale factor for the queen is less than 150, the guard will be displayed by the `displayObj()` function. If the scale factor is greater than or equal to 150, then we will set the visibility of the guard to false.

```
107    // check if guard is visible for display
108    if (scene3D.Queen._xscale < 150) {displayObj(scene3D.Guard)}
109    else { scene3D.Guard._visible = false; }
110
```

Tip: Experiment with different viewer positions. For example, changing the y-value from 100 to 50 creates the illusion that the viewer is lower to the ground, such as a child might be.

Summary

Now that you have finished reading the chapter, you should be able to

- Create a simple camera translation
- Develop interactive navigation in 3D space
- Interact with information presented in a three-dimensional space
- Create movement that eases in or out using ActionScript
- Develop interactions that simulate viewer rotation around one of the axes
- Understand how the background may or may not have to interact with the objects in a scene

In the next chapter, we'll look at how we can apply some of the concepts we have learned thus far to simulating QTVR effects.

8

Using Virtual Reality Concepts

The idea behind virtual reality is to give you the experience of being in an environment, interacting with it, and moving through it, without actually going there. In the '90s, Apple Computer developed QuickTime VR (QTVR) as an extension to QuickTime, to enable users to create and experience virtual reality content through just a mouse and keyboard. Although others have developed similar technologies to Apple's, we will refer to QTVR as being representative of the general concepts we will be discussing here.

The basic idea behind QTVR is the following. Suppose you are standing in someplace of interest, perhaps someplace you've always wanted to visit. You can look all around you, left and right, up and down, any way that you want. You can pick up nearby objects and look at them from any angle. You can move to some other point of interest to you and further explore. QTVR offers the ability to look around in a format called panorama movies, examine things in a format called object movies, and navigate to someplace else where you can repeat the process.

QTVR is popular on the Web. Surfers can examine, in the round, anything from large automobiles to tiny jewelry. Many virtual tours are also available, from exotic places to your local golf course. While Flash is capable of importing video, it is not set up to handle the QTVR extension. We can, however, create much of the same experience of panoramas and object movies in Flash. This chapter focuses on

- Simulating simple object movies
- Object movies on a circular path
- Simulating panoramas

Object Movies

The material needed for an object movie can be created either photographically, with video, or through the use of 3D software. An object movie is a series of still images that show an object from a number of different angles. To create a photographic object

movie, the basic idea is to place an object on a turntable or lazy Susan. Shoot the object at eye level, rotate it 10–20 degrees, and shoot again. Repeat until the object has been completely rotated around to its starting position. Typically 15–36 shots are used. In many 3D software programs, QTVR is an option that can be selected by the user to quickly generate the needed imagery. If the option doesn't exist, it is easy to set up a camera within the software, save the image, rotate the object, and save again.

Once the individual shots have been made, software programs such as VR Worx 2.6 and PiXiMation create the object movie by arranging the images so that when the viewer drags them with the mouse, the object seems to rotate and tilt. Although Flash is not able to import and play QTVR movies, it is easy to simulate simple object movies in Flash, and we will explore some of the possibilities.

Exercise 8.1: Simple Object Movie

In this exercise we will simulate a QTVR object movie that enables the user to rotate an object clockwise or counterclockwise by pressing down on corresponding arrows. We will use ActionScript to control the rotation of the object.

Step 1: Getting started

Open 8_1_objectVR.fla. The Stage size, layers, and buttons needed have already been set up for you. Choose Insert > New Symbol. The Create New Symbol dialog box appears (Figure 8.1). Create a movie clip symbol named **objectMC** and click OK.

Step 2: Import images

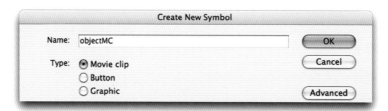

Figure 8.1 The Create New Symbol dialog box

For the movie clip just created, we are going to import a set of JPEG images. Choose File > Import > Import to Stage. Open the file odie_01.jpg in the odieFolder located in the Chapter 8 folder. A dialog box will appear (Figure 8.2). Click Yes to import all of the images in the sequence.

Figure 8.2 Importing all images in a sequence

After a few seconds, the images will be read in as separate keyframes of the movie clip as shown in Figure 8.3. Add an `actions` layer and enter a `stop()` action in frame 1. Choose File > Save As. Save the movie as `8_1_objectVR_DONE.fla`.

Figure 8.3 Importing a sequence of images into a movie clip

Let's spend a minute to scrub through the Timeline. Notice that as we advance from one frame to the next that the object rotates clockwise as shown in Figure 8.4. Conversely, as we scrub from right to left one frame at a time in the Timeline, the object rotates in the opposite direction. We will use this information when we set up the rotation script.

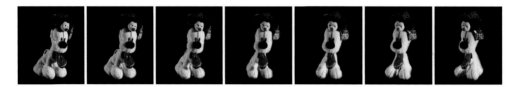

Figure 8.4 Images seen through scrubbing the Timeline

Step 3: Label the movie clip instance

Go to Scene 1, select the `object` layer, and then drag `objectMC` from the Library onto the Stage. Use the Align window to center it on the Stage. In the Properties window, label the instance of the movie clip **object_mc**.

Figure 8.5 Label the movie clip instance

Step 4: Initialize movie clip variables

Enter the script below in the first frame of the `actions` layer. The variable `totalFrames` defines the number of frames used in the object movie clip. We don't need to remember what the number is; Flash can look it up for us. The variable `move` will control whether the frames in the object movie clip move forward or backward.

```
1   // set the number of frames in the object movie clip
2   // and the direction of frame movement in the clip
3   var totalFrames:Number = object_mc._totalframes;
4   var move:Number = 0;
5
```

Step 5: Define the button actions

Select the arrow on the left and give it an instance name of **ccw_btn** in the Properties window. We'll use this for counterclockwise rotation of the object. Similarly, give the arrow on the right an instance name of **cw_btn** for clockwise rotation. Now let's define the desired actions when the user clicks the buttons.

Referring to the script below, when the user presses down on the clockwise arrow, the onPress handler sets the variable move to 1 and then sets it to 0 when the user releases the button. We are going to use this variable to move the playback head one frame forward in the objectMC Timeline. When the user releases the button, the playback head will stop.

When the user presses down on the counterclockwise arrow, the onPress handler sets the variable move to −1 and then sets it to 0 when the user releases the button. We will use this to move the playback head one frame backward in the objectMC Timeline. When the user releases the button, the playback head will stop as before.

```
6    // cw arrow - set up for clockwise move
7    cw_btn.onPress   = function() { move = 1; }
8    cw_btn.onRelease = function() { move = 0; }
9    cw_btn.onReleaseOutside = function() { move = 0; }
10
11   // ccw arrow - set up for counterclockwise move
12   ccw_btn.onPress   = function() { move = -1; }
13   ccw_btn.onRelease = function() { move = 0;  }
14   ccw_btn.onReleaseOutside = function() { move = 0; }
15
```

Step 6: Rotate the object

We are now ready to set up the script to rotate the object. As usual, we will use an onEnterFrame handler so that we can update the object continuously.

The first thing we are doing is setting the variable thisFrame to be the current frame of the object movie clip. Next, thisFrame is updated by whatever the current value of move has been set to. We must check whether the update has caused thisFrame to go beyond the frame numbers of the movie clip. If thisFrame is greater than total-Frames, the number of frames in the clip, we want to cycle back to the first frame for continuous clockwise motion. Note that to have smooth motion, the first frame and last frame should not be the same image.

```
16    // rotate the object
17    object_mc.onEnterFrame = function()
18    {
19        // get the current frame
20        var thisFrame:Number = object_mc._currentframe;
21
22        // update to the next frame
23        thisFrame += move;
24
25        // test the ends of the movie clip
26        if (thisFrame > totalFrames) { thisFrame = 1; }
27        if (thisFrame < 1) { thisFrame = totalFrames; }
28
29        // display the object
30        object_mc.gotoAndStop(thisFrame);
31    }
```

Similarly, if the update produces a value less than 1 for `thisFrame`, we must reset its value to `totalFrames` for continuous counterclockwise motion. Once `thisFrame` has been determined, we direct the object movie clip to go to and stop at the updated frame value.

Save and test your movie. Press each arrow to make sure that the object rotates in each direction properly. This completes the exercise. After the scripts from the last chapter, this probably feels like child's play.

Tip 1: Remove the buttons and modify the script so that the object rotates clockwise when the user presses down left of center of the object and counterclockwise when pressing down right of center of the object. Open the file `8_1_objectVR2_DONE.swf` in the `Completed_Exercises` folder as a reference.

Tip 2: An alternative to pressing the mouse down is to simply move the mouse slowly right or left to rotate the object clockwise or counterclockwise as demonstrated in `8_1_objectVR3_DONE.swf`. Be forewarned, the script is so short, it's disgusting.

Hint: using the modulo (%) function helps by eliminating the need for the if statements that test the ends of the movie clip. Why is the 1 needed in the following line?

```
this.gotoAndStop( 1 + (framePos % totalFrames) )
```

Exercise 8.2: Object Movie on a Circular Path

In this exercise, we will extend the previous exercise to include the object travelling in a circular path as we did in Chapter 6. Our main challenge will be to relate the rotational view of the object to its location on the circular path.

Step 1: Getting started

We'll begin where we left off, so open 8_1_objectVR1_DONE.fla in the Chapter 8 folder. Most of what we need has already been done in Chapter 6. Open 8_2_objectVR. fla. It is a duplicate of the earlier Chapter 6 file xzRotation4.fla.

Copy object_mc in 8_1_objectVR1_DONE.fla and paste it into the object layer of the file 8_2_objectVR.fla. Select the background layer and delete it.

Step 2: Make initial script changes

We have to modify the script in a few places to take into account that we have only one object. Change the lines indicated below.

```
14   // set the number of objects to be created and startAngle
15   var numberOfObjects:Number = 1;
```

```
78        // loop over all the objects
79        for (var i:Number = 0; i < numberOfObjects; i++)
80        {
81            thisObj = object_mc;
82            placeObj(thisObj,i);
83            displayObj(thisObj);
```

Delete these lines, as they are no longer needed.

```
22   // create the objects for the circular motion
23   for (var i:Number = 0; i < numberOfObjects; i++)
24   {
25       this.createEmptyMovieClip("object"+i, i);
26       this["object"+i].loadMovie("vases/vase"+(i+1)+".png");
27   }
```

Save your movie as `8_2_objectVRorbit.fla` and test it. It should follow a circular path, although not a centered one, as shown in Figure 8.6.

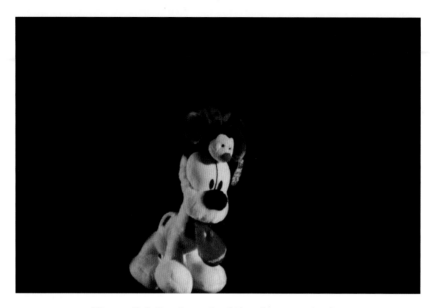

Figure 8.6 Circular path of the object movie clip

Step 3: Adjust the center point of the circular path

We have a similar situation to one in Chapter 6 where the registration points of the frames of the object are all in the upper-left corner. Let's compensate for that by changing the center point of the circular path. We'll move the path to the left and up to take into account the registration points, and we'll move it a little farther back in space so that the object easily fits on the Stage.

```
 8    // define the path characteristics
 9    var xc:Number = -200;   // xc = horizontal center of path
10    var yc:Number = 0;      // yc = vertical center of path
11    var zc:Number = 200;    // zc = depth center of path
12    var r:Number  = 200;    // r  = path radius
13
```

Step 4: Add the total number of frames in the object movie clip

It will be useful to define a variable that identifies the number of frames in our object movie clip, so let's add that to the script with lines 14 and 15 as shown.

```
14    // define the total frames in the object movie clip
15    var totalFrames:Number = object_mc._totalframes;
16
```

Step 5: Rotate the object on its circular path

It's time to get the object rotating about its own axis as it follows the circular path. Let's begin with line 72 even though no changes are necessary here. We need to update the angle increment `angleChange`, which is the amount that the angle changes as it moves in its circular path. This amount is based on how far the cursor is from the center of the Stage. This difference is divided by `speedfactor` to control how fast the object moves. The value of `angleChange` is then added to `startAngle` to determine the location of the object on the circular path.

```
70    // update the angle increment based on how far
71    // _xmouse is from the center of the Stage
72    var angleChange:Number = Math.round((_xmouse - xo)/
                                                speedfactor);
73    startAngle += angleChange;
74
75    // use the angle to set the frame position
76    thisFrame = 1 + Math.round(startAngle*totalFrames/360)%
                                                totalFrames;
```

Line 76 is a bit tricky. We want to create a relationship between `startAngle` and a corresponding frame in `object_mc`, which we'll call `thisFrame`. What we need is that the ratio of `startAngle` to 360 degrees is the same as the ratio of `thisFrame` is to `totalFrames`. Expressed as an equation, we have

$$startAngle/360 = thisFrame/totalFrames$$

from which we get

$$thisFrame = startAngle*totalFrames/360$$

We can apply the modulo (%) function to the quantity on the right above so that only the numbers in the range −(`totalFrames-1`) through +(`totalFrames-1`) are generated. In our specific case, this means the numbers −35 through +35, including 0. Since our object has 36 frames, we need to add 1 to `thisFrame`.

```
77
78          // check for a negative frame number
79          if (thisFrame < 0 ) { thisFrame += totalFrames; }
80
81          // display the current frame of the object
82          object_mc.gotoAndStop(thisFrame % totalFrames);
83
84          // loop over all the objects
```

Note that we need the test in line 79 since we can have negative angles that will generate corresponding negative values for thisFrame.

The final addition to our script is to go to the correct frame of the object movie clip as shown in line 82. We again use the modulo function to guarantee that we stay within the range of the movie clip's frames. Save and test your movie. You should get some pretty wild behavior of the object as it follows the path. Let's pull in the reins a little bit.

Step 6: The finishing touch

Although our reasoning was sound, we now need to refine the relationship between thisFrame and startAngle. We would like to have the object facing us at the nearest point on the circular path. Recall that the path starts out at 0 degrees along the x-axis. However, the first frame of the object movie clip shows it facing somewhat towards us as shown on the left side of Figure 8.7. But at 0 degrees, the object should be looking along the x-axis as it is in frame 32, and shown on the right side of Figure 8.7.

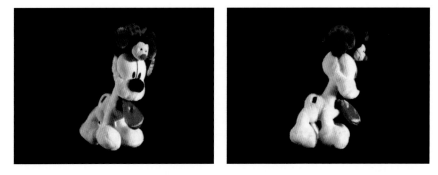

Figure 8.7 The object movie clip at frames 1 and 32

What we need is to start at frame 32 of the object movie clip rather than at frame 1. There is one other problem with the motion that you may discover if you look closely.

The problem is that the object is rotating about its own axis opposite to the circular path motion. We need to get these two movements consistent. Fortunately, all we have to do is to change the plus sign in line 76 to a minus sign. Make the change below, save your movie, and you are good to go. Notice that you also get aerial perspective with no extra work, since we had it in our original file.

```
75      // use the angle to set the frame position
76      thisFrame = 32 - Math.round(startAngle*totalFrames/360)%
                                                    totalFrames;
```

Tip: You may get smoother motion by changing speedfactor to a smaller number such as 20 or 25 in line 20 of the script.

Panoramas

Panoramic images can be created either photographically or in many 3D software programs. The basic idea is to stand in the middle of some environment of interest and take a number of partially overlapping photos around a full 360 degrees. There are a number of programs available such as REALVIZ Stitcher and VR Worx 2.6 that enable you to stitch the individual shots together into one single panoramic image that displays the whole scene. These are called cylindrical panoramas. The left side of the image aligns with the right side of the image. Fish-eye lenses are also used to capture a full 360-degree view of the scene both horizontally and vertically to create cubic or spherical panoramas. We will focus our attention on cylindrical panoramas.

Exercise 8.3: Simulating a Panorama

In this exercise, we will set up a simple navigational interface that will enable the user to continuously explore a panoramic background image that is larger than the Stage. Through ActionScript, the user controls the left and right movement of the background by placing the cursor to the left and right of the center of the Stage. To see the results of this exercise, locate and play 8_3_panoDONE.swf (Figure 8.8).

Step 1: Getting started

Open 8_3_pano.fla in the Chapter 8 folder. Set the Stage display size to be 25%. Select the pano layer in the Timeline. Locate LowerFalls.jpg in the Library. Drag the image onto the Stage, then center horizontally and vertically as shown in Figure 8.8.

Figure 8.8 Center the image on the Stage

Step 2: Create a movie clip

With the image selected, choose Modify > Convert to Symbol. Create a movie clip named `panoMC`. Set its registration point to be at the center of the image and click OK. Double-click on the image to edit the movie clip.

Choose Modify > Transform > Scale and Rotate. Set the scale factor to be 12.5% (1/8 scale) and then click OK. Set the Stage display size to be 50%. Because the image is so large, reducing the scale causes fewer problems in Flash. We will later scale back up to normal size.

Step 3: Create a duplicate

Even though we have a panorama image that spans a full 360-degree range, in order to pan continuously we need to duplicate at least part of the image. The question is how much? With either a little experimentation or some math, or blind luck, you will eventually discover that you need a minimum amount equal to the width of the Stage. The easiest way to do this in Flash is to create a copy of the image.

Select the image. In the Properties window, set its x-location to be at −672 so that the right side of the clip is at the registration point. Hold down the Option and Shift keys

(Alt and Shift in Windows) and drag the image to the right until the left side of the image is at the registration point. Use the Properties window to set the x-value of the duplicate to be 0 as shown in Figure 8.9.

Figure 8.9 Align the original and duplicated images

Step 4: Position the panorama

Return to Scene 1 and use *bg_mc* as the instance name of panoMC. Select the clip and choose Modify > Transform > Scale and Rotate. Set the scale factor to be 800% and then click OK. Hold down the Shift key and slide the clip to the right until the panorama is positioned roughly on the Stage as shown in Figure 8.10.

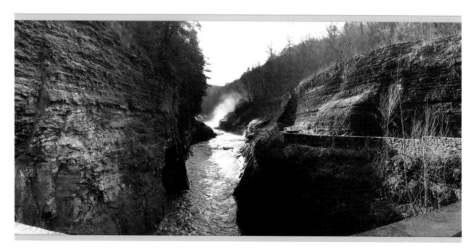

Figure 8.10 Position the panorama on the Stage

We needed to scale the image down initially to create the double panorama because of size limitations in Flash. By setting the size sufficiently small when creating the movie clip and then later scaling up, Flash can handle the large image size. It's a little strange, but it works.

Step 5: Add the beginning script

It's time to do a little scripting. We'll begin by initializing a few variables that we will need shortly.

```
1    // initialize variables
2    var moveAmount:Number = 10; // how fast the pano will move
3    var centerX:Number = Stage.width/2;// horiz. center of Stage
4    var xmax:Number = pano_mc._width/2;  // max position of pano
5    var xmin:Number = Stage.width - maxX;// min position of pano
6
```

The `moveAmount` variable controls how fast the pano moves left and right. The horizontal center of the Stage is placed in `centerX`. The variables `xmax` and `xmin` are restrictions that will be placed on the position of the panorama.

Step 6: Add the panorama onEnterFrame handler

As mentioned earlier, we want the image to move to the right or left when the user moves the mouse over the left or right side of the Stage; otherwise, nothing should happen. What we need to do, then, is to check the position of the cursor when it is over the panorama.

Since the panorama will be moving, we'll use an `onEnterFrame` handler to describe its behavior. Enter the lines shown below. The function simply says that for each frame, we should `checkTheMouse`. What we need to do next is to define what we mean by that.

```
7    // define the panorama actions
8    pano_mc.onEnterFrame = function()
9    {
10        checkTheMouse();
11   }
12
```

Step 7: Define the checkTheMouse function

There are three horizontal locations of the cursor that we need to address: the left side of the Stage, the right side of the Stage, and the center of the Stage. The function below deals with each of those cases. The function says that if the horizontal location of the cursor (_xmouse) is less than 10 pixels from the center of the Stage, then panLeft(). Otherwise, if the horizontal location of the cursor is greater than 10 pixels from the center of the Stage, then panRight(). Otherwise, dontPan() the image at all.

```
13    checkTheMouse = function ()
14    {
15        if (_xmouse < centerX - 10)         { panLeft()  }
16        else if (_xmouse > centerX + 10 )   { panRight() }
17        else dontPan();
18    }
19
```

Step 8: Define the panLeft() function

Add the lines below to your script. When the cursor is on the left side of the screen, we want to simulate a viewer turning left. The visual equivalent of that panning motion is to move the image to the right (line 22). If this were the only statement in the handler, the image would move as desired, but ultimately, we would run out of image, and it would proceed to keep on moving right off the Stage.

```
20    panLeft = function ()
21    {
22        pano_mc._x += moveAmount;
23        if (pano_mc._x > xmax) { pano_mc._x -= pano_mc._width/2 }
24    }
25
```

We have to put some restrictions on the movement of the panorama to prevent this from happening. At the same time, we need to remember our objective of having continuous motion of the panorama for a full 360-degree rotation. Also, recall that we made a duplicate of the image, so that we have two of them in our movie clip. It's time to find out the reason for it and why line 23 has the necessary restrictions on the movement of the panorama to the right. We'll discuss this in the next two steps.

Step 9: Find xmax and xmin

For the discussion that follows, it will be helpful to set the Stage display size to 50%. Select pano_mc and set its alpha value to 50% in the Properties window so that both the image and the Stage can be seen as shown in Figure 8.11.

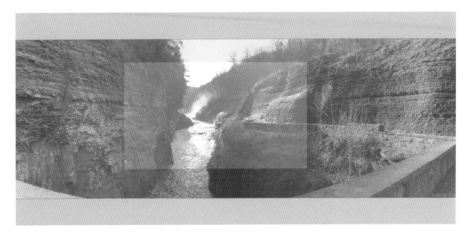

Figure 8.11 The panorama with alpha set to 50%

Use the Align window to horizontally align pano_mc with the left side of the Stage as shown in Figure 8.12. Referring to the Properties window, the left side is at x = 0. This is the maximum position that we can allow for the image to move right.

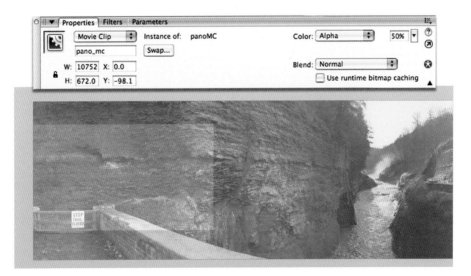

Figure 8.12 The maximum position for the panorama

Note, however, that the $_x$ position of a movie clip is the location of its registration point. By construction, the registration point is located at the middle of the movie clip, which is at a location half the width of the movie clip away. Thus, in this case, the value of xmax is

```
xmax = pano_mc._width/2
```

as provided in line 4 of the script. A similar analysis when the movie clip is aligned on the right shows that

```
xmin = Stage.width - pano_mc._width/2
```

or alternatively,

```
xmin = Stage.width - xmax
```

Step 10: Find the panorama jump point for panning left

What we want to do next is to be able to pan the image continuously rather than stopping at the edges of the background. The next few steps will enable us to carry this out. Let's consider the image at xmax (i.e., pano_mc._x = xmax) as shown in Figure 8.12.

By construction, pano_mc holds two copies of the entire panorama. We can see that if we suddenly shift the image left from xmax back to a location half the width of the panorama away, the image will look exactly the same on the Stage to the viewer. This is the key to continuous movement. The image will move to the right until it reaches xmax, then suddenly jump to its identical spot in the other half of the clip where there is room to continue moving to the right (Figure 8.13).

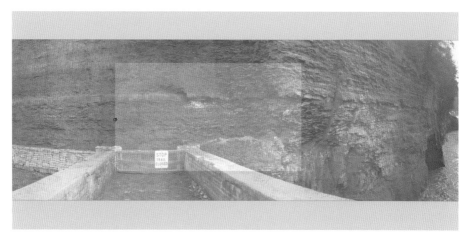

Figure 8.13 The same view as the maximum position for the panorama

Step 11: Define the panRight() function

Add the lines below to your script. When the cursor is on the right side of the screen, we want to simulate a viewer turning right. The visual equivalent of that panning motion is to move the image to the left (line 28).

```
26    panRight = function ()
27    {
28        pano_mc._x -= moveAmount;
29        if (pano_mc._x < xmin) { pano_mc._x += pano_mc._width/2 }
30    }
31
```

If we move the image all the way over to xmin and find its identical spot in the other half of the panorama movie clip, we again find that the jump is half the width of the panorama as before, only with a change of sign. Thus, the two panning functions have similar expressions as we would expect. They only differ in their plus and minus signs. Note that this process is essentially the same as we went through for parallax scrolling in Chapter 4.

Step 12: Define the dontPan() function

Here's a function you'll really like, one that does nothing at all. There are times when it's nice to do nothing.

```
32    dontPan = function ()
33    {
34
35    }
36
```

Save your file as 8_3_panoDONE.fla and check to make sure that it pans in both directions continuously. Is there a place where you do nothing?

Step 13: Add arrow cursors

Now that we have everything functioning, let's enhance the user interaction. It would be good to provide some visual feedback in the form of arrows whenever the cursor is in one of the hot spot areas. We can use the arrows like a cursor by hiding the regular mouse cursor and setting the arrows to have the same location as the cursor.

Rather than having separate clips for the arrows, let's create a single movie clip to house them. Choose Insert > New Symbol. Create a movie clip named `cursorMC` with three frames as shown in Figure 8.14.

Figure 8.14 Creating a cursor movie clip

In frame 1, drag `leftArrowMC` from the Library onto the Stage and center it.
In frame 2, drag `noMoveMC` from the Library onto the Stage and center it.
In frame 3, drag `rightArrowMC` from the Library onto the Stage and center it.

In the `cursors` layer of Scene 1, drag the `cursorMC` clip anywhere onto the Stage and name its instance `cursor_mc`.

Let's hide the cursor whenever the user enters the panorama and show it when the user leaves the panorama. Add the lines shown below.

```
 7    // define the panorama actions
 8    pano_mc.onRollOver = function() { Mouse.hide(); }
 9    pano_mc.onRollOut  = function() { Mouse.show(); }
10
11    pano_mc.onEnterFrame = function()
12    {
```

Step 14: Update the checkTheMouse handler

With the new *cursor_mc* clip, we can make some refinements in our script. The first thing we need to do is to set the coordinates of the `cursor_mc` to the coordinates of the cursor. That will guarantee that the arrows will track like the mouse.

295

```
16    checkTheMouse = function()
17    {
18        cursor_mc._x = _xmouse;
19        cursor_mc._y = _ymouse;
20
21        if (_xmouse < centerX-10) { panLeft() }
22        else if (_xmouse > centerX+10 )   { panRight() }
23        else dontPan();
24    }
```

Step 15: Update the pan handlers

The rest of our job is to make sure that the correct arrow is displayed when necessary. This can be done with simple additions to our pan handlers. Add the lines shown below.

```
26    panLeft = function()
27    {
28        cursor_mc.gotoAndStop(1);
29
30        pano_mc._x += moveAmount;
31        if (pano_mc._x > xmax) { pano_mc._x -= pano_mc._width/2 }
32    }
33
34    panRight = function()
35    {
36        cursor_mc.gotoAndStop(3);
37
38        pano_mc._x -= moveAmount;
39        if (pano_mc._x < xmin) { pano_mc._x += pano_mc._width/2 }
40    }
41
42    dontPan = function()
43    {
44        cursor_mc.gotoAndStop(2);
45    }
```

This completes the exercise. Save the movie and test it to make sure that everything works properly. All should be right with the world, well, at least as far as our cursors are concerned.

Exercise 8.4: Panning and Scrolling in Flash

In this exercise, you will set up a simple navigational interface that will more accurately simulate a QTVR panorama in Flash by enabling the user to do a continuous pan and a limited scroll of a panorama image. The user controls the movement of the background by dragging the cursor in any direction on the Stage. Cursors will change according to the direction of the drag movement.

Step 1: Getting started

Open the file 8_4_pano.fla in the Chapter 8 folder. The file is a duplicate of the completed version of the previous exercise. Although the movie works perfectly well just by passing the cursor over the background, some users feel uncomfortable with this and prefer to have the panning occur by pressing the mouse button down. This is, in fact, the way a QTVR panorama actually functions. Let's modify our movie to pan the background in the same fashion as a QTVR by panning only when the mouse button is down.

Step 2: Define a pressed variable

Let's define a variable called pressed that will be initially set to false. When the user presses down on the panorama, we will set pressed to true and hide the normal cursor. When the user lets up on the mouse, we will set pressed back to false. Also, replace the rollover and rollout handlers (which are no longer needed) with the lines below.

```
5    var xmin:Number = Stage.width-xmax; // min position of pano
6    var pressed:Boolean = false; // used for pressing mouse down
7
8    // define the panorama actions
9    pano_mc.onPress = function()
10   {
11       pressed = true;
12       Mouse.hide();
13   }
14   pano_mc.onRelease  = pano_mc.onReleaseOutside  = function()
15   {
16       pressed = false;
17       Mouse.show();
18   }
19
20   pano_mc.onEnterFrame = function()
```

Step 3: Modify the cursor movie clip

Now we have three cursors in `cursor_mc` indicating left movement, no movement, and right movement. Let's add one more frame showing no cursors at all. This will be the default when the user is not pressing the mouse button down. Double-click `cursor_mc` to go to editing mode. Insert a blank keyframe in frame 4 and then return to scene 1.

Step 4: Modify the panorama onEnterFrame handler

Let's add a test in `pano_mc.onEnterFrame` that goes to the `checkTheMouse` handler only if `pressed` is set to true. For convenience we will use the frame 4 of the cursor clip as the default cursor.

```
20    pano_mc.onEnterFrame = function()
21    {
22        if (pressed) { checkTheMouse(); }
23        else cursor_mc.gotoAndStop(4);
24    }
25
```

Save your movie as `8_4_panoDONE.fla` and test it. Rather than passing the cursor over the panorama, you will now need to press the mouse button down to move the image.

Step 5: Modify for variable speed panning

Rather than have our panning occur at a fixed rate, let's provide for variable-rate panning that speeds up as the cursor is moved farther from the center of the Stage. To make it easy to adjust the panning speed, let's define a variable, `speedFactor`, as shown below.

```
6     var pressed:Boolean = false; // used for pressing mouse down
7     var speedFactor:Number = 20; // used to control panning speed
8
9     // define the panorama actions
```

Using the variable `speedFactor`, let's make a one-line change to the `checkTheMouse` handler as shown. Rather than being a fixed quantity, the value of `moveAmount` is determined by the horizontal distance of the cursor from the center of the Stage divided by `speedFactor`. Note the use of the absolute value function to make all the values positive. The pan functions sort out the positive and negative directions. Save and test your movie. Drag the cursor to see variable-speed panning.

```
27   checkTheMouse = function()
28   {
29       cursor_mc._x = _xmouse;
30       cursor_mc._y = _ymouse;
31       moveAmount = Math.abs(_xmouse - centerX)/speedFactor;
32
33       if (_xmouse < centerX-10) { panLeft() }
34       else if (_xmouse > centerX+10 )  { panRight() }
35       else dontPan();
36   }
37
```

Step 6: Pan from anywhere on the Stage

What we have done so far is to create panning movement based on the center of the
Stage. We now want to be able to pan the background both left and right by pressing the
mouse button down and dragging from anywhere on the Stage. The way this will work is
to record the starting location of the cursor when the mouse button is first pressed down
as shown.

```
 7   var speedFactor:Number = 20; // used to control panning speed
 8   var startX:Number = 0; // initial dragging _xmouse position
 9   var startY:Number = 0; // initial dragging _ymouse position
10
11   // define the panorama actions
12   pano_mc.onPress = function()
13   {
14       pressed = true;
15       Mouse.hide();
16       startX = _xmouse;
17       startY = _ymouse;
18   }
```

Next, we will measure how far the cursor moves while it is held down so that we can
move the image in proportion to that amount. The only thing we need to do is to replace
centerX with startX in the checkTheMouse handler.

Save and test your movie. You should be able to start dragging the cursor from any-
where on the Stage. As you do, the movement of the panorama should start out slowly
and increase speed as you drag farther from the initial cursor location.

```
31    checkTheMouse = function()
32    {
33        cursor_mc._x = _xmouse;
34        cursor_mc._y = _ymouse;
35        moveAmount = Math.abs(_xmouse - startX)/speedFactor;
36
37        if (_xmouse < startX - 10) { panLeft() }
38        else if (_xmouse > startX + 10 )   { panRight() }
39        else dontPan();
40    }
41
```

Step 7: Define the panorama vertical limits

Now that we have a handle on panning, let's begin to look at vertical scrolling. The additional scripting that we will need is very similar to what you already have. We'll need some vertical limits on the panorama just as we have horizontal limits. At the same time, it might be helpful to clean up the beginning of the script for better readability. The determination of ymax and ymin is similar to xmax and xmin.

```
1    // initialize variables
2    var moveAmount:Number = 10;    // how fast the pano will move
3    var centerX:Number = Stage.width/2; // horiz. center of Stage
4
5    var xmax:Number = pano_mc._width/2; // max x-position of pano
6    var xmin:Number = Stage.width-xmax; // min x-position of pano
7    var ymax:Number = pano_mc._height/2;// max y-position of pano
8    var ymin:Number = Stage.height-ymax;// min y-position of pano
9
10   var pressed:Boolean = false; // used for pressing mouse down
11   var speedFactor:Number = 20; // used to control panning speed
```

Step 8: Test for vertical scrolling

We have to add a test for scrolling vertically in the checkTheMouse handler similar to that for panning horizontally. At this point, instead of simply defining a moveAmount, we will make a distinction between the horizontal move amount, xmoveAmount, and the vertical move amount, ymoveAmount.

```
36   checkTheMouse = function()
37   {
38       // set the cursor position to the mouse location
39       cursor_mc._x = _xmouse;
40       cursor_mc._y = _ymouse;
41
42       xmoveAmount = Math.abs(_xmouse - startX)/speedFactor;
43       if (_xmouse < startX - 10) { panLeft(); }
44       else if (_xmouse > startX + 10 ) { panRight(); }
45       //else dontPan();
46
47       ymoveAmount = Math.abs(_ymouse - startY)/speedFactor;
48       if (_ymouse < startY - 10) { scrollDown(); }
49       else if (_ymouse > startY + 10 ) { scrollUp(); }
50
51       // setCursor();
52   }
53
```

Note the commented lines in the `checkTheMouse` handler. The first one removes going to the `dontPan()` handler. This line can, in fact, be deleted. New cursors will be set in the `setCursor()` handler, which we will soon define.

Step 9: Create the panning functions

The functions for panning are provided below. They are the same as previously with the exception of having removed the lines that set the cursor and changing `moveAmount` to `xmoveAmount`. Modify your script to match that below.

```
54   panLeft = function()
55   {
56       pano_mc._x += xmoveAmount;
57       if (pano_mc._x > xmax) { pano_mc._x -= pano_mc._width/2 }
58   }
39
60   panRight = function()
61   {
62       pano_mc._x -= xmoveAmount;
63       if (pano_mc._x < xmin) { pano_mc._x += pano_mc._width/2 }
64   }
```

Step 10: Create the scrolling functions

The functions for scrolling are provided below. The scrolling functions are quite similar to panning except for setting the upper and lower bounds. These bounds prevent the panorama from scrolling off the Stage, either from above or from below. When the panorama reaches either of these limits, it can go no farther.

Add these functions after those for panning. You can delete the `dontMove()` handler, as we will be replacing its functionality with a new set of cursors.

```
66    scrollDown = function ()
67    {
68        pano_mc._y += ymoveAmount;
69        if (pano_mc._y > ymax) { pano_mc._y = ymax }
70    }
71
72    scrollUp = function ()
73    {
74        pano_mc._y -= ymoveAmount;
75        if (pano_mc._y < ymin) { pano_mc._y = ymin }
76    }
77
```

Save and test your movie. Although there are currently no cursors, you should be able to pan and scroll in all directions.

Step 11: Create additional cursors

Since we now have a wider range of motion, we should have cursors that include both vertical and diagonal movement. To do this we will actually need a set of nine cursors as shown in Figure 8.15.

Choose File > Import > Import to Library. Locate the folder named `CursorSet` in the Chapter 8 folder, Shift-select the cursors provided, and import them. The cursors represent the general directions in which we will want to move the mouse: the four primary movements of left, right, up, and down, plus the four diagonal movements, and one cursor for no movement.

Figure 8.15 Cursors for more generalized motion

Step 12: Update the cursor movie clip

We are now ready to deal with the cursors. Since we have created additional cursors to provide for more complicated panorama movement, we need to update the `cursorMC` movie clip.

Double-click on `cursorMC` in the Library window to bring it into editing mode. Update the movie clip as in Figure 8.16 so that it contains 10 frames with `cursor1.png` in frame 1, `cursor2.png` in frame 2, and so on. Frame 10 should be a blank keyframe.

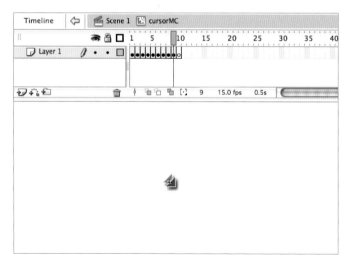

Figure 8.16 The updated cursor movie clip

Step 13: Directional movements of the mouse

We are soon going to define a `setCursor` handler, which will select a cursor based on the directional movements of the mouse. Referring to Figure 8.17, we will assume that when a user presses the mouse button down, the nine general movements indicated by the cursors are possible. The cursors are displayed in a matrix of rows and columns.

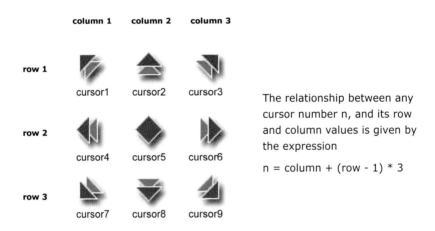

The relationship between any cursor number n, and its row and column values is given by the expression

$$n = column + (row - 1) * 3$$

Figure 8.17 The relationship between the cursor number and its matrix location

When a user holds the mouse button down and moves the mouse, we will test to see which column above describes the horizontal movement and which row describes the vertical movement. The intersection of the correct row and column is the cursor that needs to be used.

Step 14: Create the setCursor() handler

Using the expression above, we will relate the direction of the mouse movement to the correct frame in the `cursor_mc` movie clip with the `setCursor()` handler. Place the function shown below at the bottom of the other functions. Uncomment the `setCursor()` line in the `checkTheMouse` handler.

```
78    setCursor = function ()
79    {
80        if ( _xmouse < startX - 5) { column = 1;}
81        else if ( _xmouse > startX + 5) { column = 3;}
82        else column = 2;
83
```

```
84        if (_ymouse < startY - 5) { row = 1;}
85        else if (_ymouse > startY + 5) { row = 3;}
86        else row = 2;
87
88        n = column + (row - 1) * 3;
89        cursor_mc.gotoAndStop(n);
90    }
```

Step 15: Make the final adjustment

We have one small adjustment to make. When the user releases the mouse button, we need to go to the last frame of cursor_mc. Modify the line shown in the pano_mc.onEnterFrame handler.

```
30    pano_mc.onEnterFrame = function()
31    {
32        if (pressed) { checkTheMouse(); }
33        else cursor_mc.gotoAndStop(10);
34    }
35
```

Save your movie and test it to make sure that the panorama pans and scrolls properly. This completes the exercise.

Summary

This chapter focused on two types of QTVR movies and how to simulate them by incorporating ActionScript to create interactive object movies and panoramas. Now that you have finished reading the chapter, you should be able to

- Create a simulated simple object movie
- Extend object movies to include circular path motion
- Create simple panning movement in Flash
- Extend panorama movement to include scrolling with cursor feedback

The next chapter focuses on drawing three-dimensional objects.

have used the functionality of most of them already in some form or another, in earlier chapters. The first two buttons, shown at the top of Figure 9.2, control the distance of the camera to the picture plane. The effect of these buttons is to change the focal length of the camera.

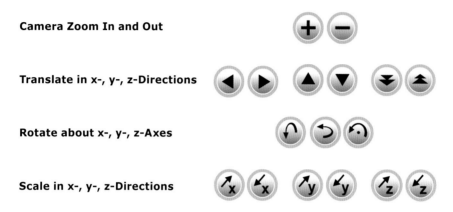

Figure 9.2 Object manipulation buttons defined

The remaining buttons control the object. The buttons in the second row of Figure 9.2 are the translation buttons, which enable you to move the object left and right, up and down, and in and out, respectively. The buttons shown in the third row will let you rotate the object about the x-axis, y-axis, and z-axis. The buttons in the bottom row of Figure 9.2 provide new functionality for transforming an object. With these buttons, you will be able to scale the object horizontally, vertically, and in depth.

Let's look at the script for the buttons. We begin by initializing the variables we will need to control the camera and object. We are changing only the focal length of the camera, since the other movements and rotations are equal but opposite to the

```
1   // initialize the incremental camera movement
2   var camdz:Number = 0;
3
4   // initialize the incremental object translation,
5   // rotation, and scale variables
6   var tx:Number = 0; var ty:Number = 0; var tz:Number = 0;
7   var rx:Number = 0; var ry:Number = 0; var rz:Number = 0;
8   var sx:Number = 1; var sy:Number = 1; var sz:Number = 1;
9
```

corresponding object movements and rotations. We have seen tx, ty, tz, and ry in previous chapters. The scale factors sx, sy, and sz are initially set to 1, or 100%.

The button actions follow the variable initialization, and are all simple one-line functions that set the appropriate variables. The camera and move amounts are in pixels, and although they are hard-coded here, it is easy to define additional variables such as camSpeed, xMoveAmount, and so forth. The rotation variables rx, ry, and rz are each measured in degrees.

```
10   //   ----------------------------------------------------------
11   //   define the button actions
12
13   camIn_btn.onPress    = function() { camdz = -5; }
14   camIn_btn.onRelease  = function() { camdz = 0;  }
15   camOut_btn.onPress   = function() { camdz = 5;  }
16   camOut_btn.onRelease = function() { camdz = 0;  }
17
18   moveLeft_btn.onPress    = function() { tx = -5; }
19   moveLeft_btn.onRelease  = function() { tx = 0;  }
20   moveRight_btn.onPress   = function() { tx = 5;  }
21   moveRight_btn.onRelease = function() { tx = 0;  }
22
23   moveUp_btn.onPress   = function() { ty = 5;  }
24   moveUp_btn.onRelease = function() { ty = 0;  }
25   moveDn_btn.onPress   = function() { ty = -5; }
26   moveDn_btn.onRelease = function() { ty = 0;  }
27
28   moveIn_btn.onPress    = function() { tz = -5; }
29   moveIn_btn.onRelease  = function() { tz = 0;  }
30   moveOut_btn.onPress   = function() { tz = 5;  }
31   moveOut_btn.onRelease = function() { tz = 0;  }
32
33   xRot_btn.onPress   = function() { rx = -5; }
34   xRot_btn.onRelease = function() { rx = 0; }
35   yRot_btn.onPress   = function() { ry = -5; }
36   yRot_btn.onRelease = function() { ry = 0; }
37   zRot_btn.onPress   = function() { rz = 5; }
38   zRot_btn.onRelease = function() { rz = 0; }
39
```

The scale variables sx, sy, and sz, are handled a little differently. Unlike the other variables, which are used to add or subtract values, the scale variables are used to multiply

```
40   sxUp_btn.onPress    = function() { sx = 1.05; }
41   sxUp_btn.onRelease  = function() { sx = 1;   }
42   sxDn_btn.onPress    = function() { sx = 0.95; }
43   sxDn_btn.onRelease  = function() { sx = 1;   }
44
45   syUp_btn.onPress    = function() { sy = 1.05; }
46   syUp_btn.onRelease  = function() { sy = 1;   }
47   syDn_btn.onPress    = function() { sy = 0.95; }
48   syDn_btn.onRelease  = function() { sy = 1;   }
49
50   szUp_btn.onPress    = function() { sz = 1.05; }
51   szUp_btn.onRelease  = function() { sz = 1;   }
52   szDn_btn.onPress    = function() { sz = 0.95; }
53   szDn_btn.onRelease  = function() { sz = 1;   }
```

values. We are familiar with this in real life. If we know the size of an object and we want to make it twice as big, we multiply the size by 2. Similarly, if we know the size of an object and we want to make it one quarter of the original size, we divide by 4, or equivalently, multiply by 0.25. The numbers we are using to scale up and down are only a little greater than 1 or a little less than 1, but you will discover that objects grow and shrink quite rapidly with the values used.

As you can see by the length of the button script, our scripts in this chapter will be longer than in previous chapters. Since we will be using this script in all of our examples and exercises, we are saving it as an ActionScript file named 3Dbuttons.as that we will include at the beginning of each of our remaining scripts. This modular approach makes it easy to reuse scripts and cuts down on development time and effort for new projects.

Simple Planar Object

Let's begin our journey into full 3D by starting off with a simple planar object. Although it is only a simple 2D object, by the time we're done, we'll have something that's fun to interact with. We need to define our object. This can be sketched out on a napkin or plotted out as shown in Figure 9.3. Also, programmers might choose to develop a separate utility program that plots and stores points.

Since we are using a planar object, we only need to worry about horizontal and vertical coordinates, but we need some way of getting them into Flash. A number of options are available, from hard-coding them into the program we are going to create, to loading

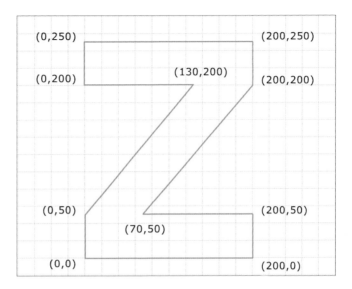

Figure 9.3 Plotting the coordinates of an object

them in as an XML file. We'll opt for a middle ground of saving them as an ActionScript file. That will make it easy to see what's happening, and we can use new objects with only a one-line change to our program.

Step 1: Create the data file

In Flash, choose File > New. The New Document dialog box appears as in Figure 9.4. Select the ActionScript file option, and then OK.

Figure 9.4 Creating a new ActionScript file

311

Step 2: Define the coordinates of the object

An Actions window will appear. We will create an array named `points` as shown in line 2, and then assign the x- and y-coordinates of the object to the elements of the array. The coordinates should be entered in order, preferably counterclockwise to be consistent with later programs we will be using. The file is saved as `planeDataZ.as`. It is critical that the .as suffix be used, as Flash requires it. Setting up the file in this manner makes it easy to access the coordinates of the object.

```
1    // define the coordinates of the plane shape
2    points = new Array();
3
4    points[0]= { x:   0, y:   0 }
5    points[1]= { x:200, y:   0 }
6    points[2]= { x:200, y:  50 }
7    points[3]= { x:  70, y:  50 }
8    points[4]= { x:200, y:200 }
9    points[5]= { x:200, y:250 }
10   points[6]= { x:   0, y:250 }
11   points[7]= { x:   0, y:200 }
12   points[8]= { x:130, y:200 }
13   points[9]= { x:   0, y:  50 }
14
```

Step 3: Include the ActionScript files and set viewer parameters

Now that we have the buttons and data out of the way, we're ready to look at the program. Open `planarLines3D.swf` for an example of where we are heading and open `planarLines3D.fla` to follow the discussion here. We'll start by including our object data (line 2) and the button actions (line 5). The syntax for the include is very specific and must begin with a # character and have the name of the ActionScript file in quotes.

```
1    // include the object data
2    #include "planeDataZ.as"
3
4    // include the button actions
5    #include "3Dbuttons.as"
6
7    // -----------------------------------------------------------
8    // set the viewer parameters
9    var d:Number = 200;// distance from viewer to picture plane
10
```

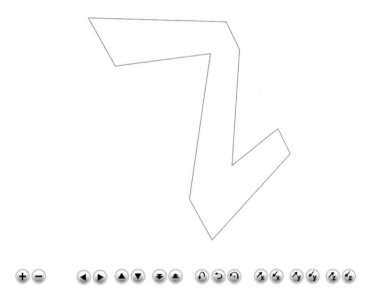

Figure 9.5 Sample screen from `planarLines3D.swf`

Note also that, unlike other ActionScript lines, you cannot have a semicolon (`;`) at the end of the line when using `#include`. Let's also set the distance from the viewer to the picture plane.

Step 4: Initialize object information

As we have done many times before, we'll create an empty movie clip named `scene3D` and set its location to be the center of the Stage (lines 17–19). We are also going to define five new arrays (lines 22–26). These arrays will be used to store the 3D coordinate data of the object and the equivalent 2D screen coordinates of the object.

```
11    // --------------------------------------------------------
12    // initialize object information
13
14    // create the picture plane: a movie clip named scene3D
15    // and position it in the center of the Stage
16    // the object will be drawn on scene3D
17    this.createEmptyMovieClip("scene3D", 100);
18    scene3D._x = Stage.width/2;
19    scene3D._y = Stage.height/2;
20
```

```
21   // define the 3D and screen coordinate arrays
22   x  = [];  // the x-coordinates of the shape
23   y  = [];  // the y-coordinates of the shape
24   z  = [];  // the z-coordinates of the shape
25   xs = [];  // the screen x-coordinates of the shape
26   ys = [];  // the screen y-coordinates of the shape
27
```

Step 5: Define the object in 3D space

Our next task is to define the planar object in 3D space. We'll first get the number of points, numPts, in the object. We can get this simply by setting it equal to the length of the points array that contains the 2D coordinates of the object (line 30). The object is then defined in 3D space by looping over the number of points and storing the coordinates of the points array into the x and y arrays. We can choose any value we wish for the z-coordinates, and setting the z-value of each point to 0 is convenient.

```
28   // ------------------------------------------------------------
29   // define the object in 3D space
30   var numPts:Number = points.length;
31
32   // get the coordinates of the object
33   for (var i:Number = 0; i < numPts; i++)
34   {
35       x[i] = points[i].x;
36       y[i] = points[i].y;
37       z[i] = 0;
38   }
39
```

Step 6: Determine the center point of the object

We are next going to do a calculation that we haven't had the occasion to use before, and that is to determine the center point of the object. The center point of an object provides a convenient point from which an object can be scaled and rotated. This way, no matter where the object is located, as long as it is visible in the picture plane, we can easily see any scaling and rotation.

To find the center point, we will find the maximum and minimum values of the object's coordinates along each axis. To do this, we start out with impossibly maximum numbers and impossibly large minimum numbers in each direction (lines 46–47). We then

```
40    // -----------------------------------------------------------
41    // this function finds the center point of the object
42    // which is used for scaling and rotation of the object
43
44    findTheCenterPoint = function()
45    {
46        xmax = ymax = zmax = -10000;
47        xmin = ymin = zmin =  10000;
48
49        // find the max and min points of the shape
50        for (c = 0; c < numPts; c++)
51        {
52            xmax = Math.max(xmax,x[c]);
53            xmin = Math.min(xmin,x[c]);
54
55            ymax = Math.max(ymax,y[c]);
56            ymin = Math.min(ymin,y[c]);
57
58            zmax = Math.max(zmax,z[c]);
59            zmin = Math.min(zmin,z[c]);
60        }
61        // take the average of max and min to find the center
62        xc = (xmax + xmin)/2;
63        yc = (ymax + ymin)/2;
64        zc = (zmax + zmin)/2;
65    }
66
```

loop over all of the points in the object and compare each point with the current maximum and minimum values using the `Math.max()` and `Math.min()` functions. For example, in line 52, the x-coordinate of a point is compared with the current value of `xmax`. If it is smaller than `xmax`, then nothing happens. If it is larger, then that x-coordinate becomes the new value of `xmax`. The other values are determined similarly. Once the loop is complete, the center point is just the average of the maximum and minimum values in each of the three directions (lines 62–64).

Step 7: Convert 3D coordinates to screen coordinates

The function `getScreenCoords()` is similar in function to the `displayObject()` function used in previous chapters. This key function performs several tasks and uses information passed to it by the buttons. First, the distance from the camera to the

```
67    // -------------------------------------------------------
68    // convert 3D coordinates to screen coordinates
69
70    getScreenCoords = function()
71    {
72        // update the camera distance position
73        d += camdz;
74
75        // update the object position
76        for ( var n:Number = 0; n < numPts; n++ )
77        {
78            x[n] += tx;
79            y[n] += ty;
80            z[n] += tz;
81        }
82
83        // update the object size
84        for ( var n:Number = 0; n < numPts; n++ )
85        {
86            x[n] = sx *(x[n]-xc) + xc;
87            y[n] = sy *(y[n]-yc) + yc;
88            z[n] = sz *(z[n]-zc) + zc;
89        }
90
91        // add changes due to rotating the shape
92        rotateObject(rx,ry,rz);
93
94        // convert to screen coordinates
95        for ( var n:Number = 0; n < numPts; n++ )
96        {
97            xs[n] =   x[n]*d/(d + z[n])
98            ys[n] = -y[n]*d/(d + z[n])
99        }
100   }
101
```

picture plane is updated (line 73). Next, the 3D coordinates of the object are updated as the result of any translation (lines 78–80).

The size of the object is adjusted based on the current vales of the scale factors sx, sy, and sz (lines 86–88). Any scale factors greater than 1 will stretch the object in that dimension, while any scale factor less than 1 will shrink the object in that dimension.

When we scale the object, we have to change its coordinates. Note that the scaling is done about the center point of the object. If the expression looks strange, it's a good idea to try a simple example like a square using pencil and paper. If a scale factor is 1, then the coordinates stay as they are. If a scale factor is 2, then the coordinates expand equally on either side of the center point.

The equations for the changes in the coordinates due to rotation are considerably more complicated than the others, and as a result, a separate function, rotateObject() has been defined to handle this situation (line 92).

Finally, once the 3D coordinates of the object have been updated in just about every conceivable way, we convert them to screen coordinates using the standard equations (lines 97–98).

Step 8: Rotate the object about its center point

The function to rotate the object about its center point is the most complicated in the program as it involves trigonometry and, frankly, isn't a whole lot of fun. To spare you as much pain, agony, and angst as possible, we'll focus on presenting the main ideas.

The rotation angles rx, ry, and rz are passed to the function through the button actions. Since they are in degrees, they need to be converted to radians in the usual way (lines 108–110). Once converted to radians, the sine and cosine of each of the angles is calculated (lines 113–115). These can be done outside of any loop since the rotations will be applied to all of the points of the object.

```
102    // -----------------------------------------------------------
103    // function to rotate the object about its center point
104
105    rotateObject = function(rx,ry,rz)
106    {
107        // convert degrees to radians for rotation angles
108        var a = Math.PI * rx/ 180;
109        var b = Math.PI * ry/ 180;
110        var c = Math.PI * rz/ 180;
111
112        // calculate sines and cosines of rotation angles
113        var sina = Math.sin(a);   var cosa = Math.cos(a);
114        var sinb = Math.sin(b);   var cosb = Math.cos(b);
115        var sinc = Math.sin(c);   var cosc = Math.cos(c);
116
```

```
117      // create intermediate coordinate arrays
118      x2 = []; y2 = []; z2 = [];
119      x3 = []; y3 = []; z3 = [];
120
121      for ( n = 0; n < numPts; n++ )
122      {
123          if (ar == 0)        // no x-axis rotation
124          {   x2[n] = x[n];
125              y2[n] = y[n];
126              z2[n] = z[n];
127          } else
128          {
129              // rotate about the x-axis
130              x2[n] =   x[n];
131              y2[n] = -(z[n]-zc)*sina + (y[n]-yc)*cosa + yc;
132              z2[n] =  (z[n]-zc)*cosa + (y[n]-yc)*sina + zc;
133          }
134
135          if (br == 0)        // no y-axis rotation
136          {   x3[n] = x2[n];
137              y3[n] = y2[n];
138              z3[n] = z2[n];
139          } else
140          {
141              // rotate about the y-axis
142              x3[n] =  (x2[n]-xc)*cosb + (z2[n]-zc)*sinb + xc;
143              y3[n] =   y2[n];
144              z3[n] = -(x2[n]-xc)*sinb + (z2[n]-zc)*cosb + zc;
145          }
146
147          if (cr == 0)        // no z-axis rotation
148          {   x[n] = x3[n];
149              y[n] = y3[n];
150              z[n] = z3[n];
151          } else
152          {
153              // rotate about the z-axis
154              x[n] = -(y3[n]-yc)*sinc + (x3[n]-xc)*cosc + xc;
155              y[n] =  (y3[n]-yc)*cosc + (x3[n]-xc)*sinc + yc;
156              z[n] =   z3[n];
157          }
158      }
159  }
```

Unlike translations and scaling, where rotations are concerned, the order of application is important. We will apply the x-rotation first, the y-rotation second, and the z-rotation third. To help keep the coordinates straight, we are creating some additional, temporary coordinate arrays (lines 118–119) that will be used during the rotation transformations. The rotation equations themselves are straight out of a math book.

Step 9: Draw the object

Whew! After wading through the `rotateObject()` function, you are rewarded here with the fun part of actually drawing the object. To do this, we will use the Drawing API. The Drawing API requires a movie clip onto which visual elements can be drawn at runtime. Hmm. We just happen to have a movie clip named `scene3D` that represents the picture plane. What better place to draw an object using its screen coordinates?

We'll call the function that draws the object `drawLines()`. We'll use a `with` statement to establish that all the actions appearing between the `{ }` braces that follow will operate on `scene3D` (line 166). One thing we need to do is issue a `clear()` method to erase the current drawing (line 169). This is necessary since we will be animating our object and need to clear the drawing from one frame before drawing in a new frame.

```
161   // -----------------------------------------------------------
162   // use the drawing API to draw the object
163
164   drawLines = function()
165   {
166       with ( scene3D )
167       {
168           // erase the previous drawing
169           clear();
170
171           // draw the shape
172           lineStyle(2, 0x0000ff, 100);
173
174           moveTo(xs[0], ys[0]);
175           for (i=1; i<numPts; i++)
176           {
177               lineTo(xs[i], ys[i]);
178           }
179           lineTo(xs[0], ys[0]);
180       }
181   }
```

Before we can actually draw, we need to tell Flash what we want the lines that we will be drawing to look like. The `lineStyle()` method serves this purpose (line 172). The first parameter is the line thickness and may be any integer between 0 and 255. The second parameter is the RGB color of the line value expressed as a hexadecimal color value. If nothing is specified, the default color is black. The third parameter is optional and specifies the alpha of the color using an integer between 0 (transparent) and 100 (opaque). Our values specify an opaque, pure blue line that is 2 pixels wide.

To begin drawing, we first issue a `moveTo(xs[0],ys[0])` method that moves to the first screen coordinate (line 174). Next, we set up a `for` loop that loops over the number of points in the screen coordinate arrays (line 175). For each point in the loop, a line is drawn from the previous location to the current location using the `lineTo(xs[n],ys[n])` method (line 177). After the loop is done, we draw a line to the first point with a `lineTo(xs[0],ys[0])` in line 179.

Step 10: Update the object

As a final step, we want an `onEnterFrame` handler to enable us to use the buttons to animate the object by moving, rotating, and scaling it. We just need to make calls to those functions that will enable us to carry that out. Each time we enter a frame, we need to find the new location of the center point, get new values for the screen coordinates, and draw the lines of the object.

```
183    // -----------------------------------------------------------
184    // update the object
185
186    this.onEnterFrame = function()
187    {
188        findTheCenterPoint();
189        getScreenCoords();
190        drawLines();
191    }
```

Tip: Make a one-line change to the program that will load the object data found in the file `planeDataF.as`. Get a sense of what each button does to transform the object. Note the difference between moving the camera distance to change the focal length and moving the object in and out along the z-axis.

Exercise 9.1: Creating a Filled Planar Object

In this exercise, we will extend the previous discussion to include filling a planar object with color. We will also consider more complicated shapes with holes. To view the finished results of this exercise, open 9_1_planarFillsDONE.swf in the Chapter 9 folder. You should be able to get results similar to Figure 9.6.

Figure 9.6 Sample screen from 9_1_planarFillsDONE.swf

Step 1: Getting started

We'll begin where we left off, so open 9_1_planarFills.fla in the Chapter 9 folder. This file contains the script that we just discussed.

To fill the interior of the shape, we just need to add two lines of code as shown. There are two parameters for the beginFill() method. The first parameter is a hexadecimal color value. The second parameter is an optional alpha value. In our case,

```
beginFill(0x00aaff,75)
```

specifies a blue (with some green) at a 75% opacity (line 173). You will also need to insert an endFill() method to tell Flash when to stop filling in the interior of the object (line 180). Save your movie as 9_1_planarFillsDONE.fla and check that the letter is filled as specified. Two lines of code. It doesn't get much easier than that!

```
171          // draw the shape
172          lineStyle(2, 0x0000ff, 100);
173          beginFill(0x00aaff,75);
174          moveTo(xs[0], ys[0]);
175          for (i=1; i<numPts; i++)
176          {
177              lineTo(xs[i], ys[i]);
178          }
179          lineTo(xs[0], ys[0]);
180          endFill();
181      }
182  }
183
```

Step 2: Dealing with more complicated shapes

The program we have works well with simple planar objects. Suppose we have a more complicated object like a logo or letterform with a hole in it, such as the left side of Figure 9.7. There are several ways in which the object could be modeled or constructed.

An engineering technique is finite element modeling, where the object is subdivided into smaller, simpler elements such as triangles. There are many advantages to this approach, particularly for very complex objects. Since we are dealing with planar objects and have a desire to keep the amount of data input relatively small, we will use an alternative approach as shown in the right side of Figure 9.7.

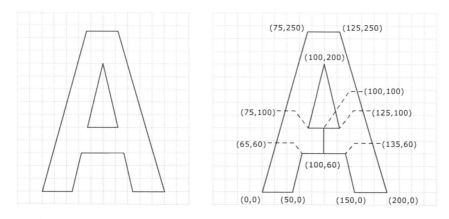

Figure 9.7 Constructing a shape with a hole

We will solve the problem by cutting the letter so that it no longer has a hole. Actually, we will make two cuts, one going from the outside of the letter into the counter area, and another going from the counter area back to the outside of the letter. The idea is to make the cuts in exactly the same place so that they are there but can't be seen. Kind of a cheap trick, but it works.

Step 3: Create the object data file

We need to create a data file for the letter. Choose File > New. The New Document dialog box appears as in Figure 9.8. Select the ActionScript file option, and then OK.

Figure 9.8 Setting up an ActionScript file

An Actions window will appear. Create an array named `points` as shown in line 2, and then assign the x- and y-coordinates of the letterform to the elements of the array. Enter the coordinates in counterclockwise order as shown below and on the next page.

```
1   // define the coordinates of the letter A
2   points = new Array();
3
4   points[0] = { x: 75, y:250  }
5   points[1] = { x:  0, y:  0  }
6   points[2] = { x: 50, y:  0  }
7   points[3] = { x: 65, y: 60  }
8   points[4] = { x:100, y: 60  }
9   points[5] = { x:100, y:100  }
10  points[6] = { x: 75, y:100  }
11  points[7] = { x:100, y:200  }
```

```
12    points[8] = { x:125, y:100  }
13    points[9] = { x:100, y:100  }
14    points[10]= { x:100, y: 60  }
15    points[11]= { x:135, y: 60  }
16    points[12]= { x:150, y:  0  }
17    points[13]= { x:200, y:  0  }
18    points[14]= { x:125, y:250  }
```

Save the file as `planeDataA.as` and then close it. As noted earlier, it is critical that the .as suffix be used, as Flash requires it.

Step 4: Load the object data

You just need to make a one-line change at the beginning of the program as shown.

```
1     // include the object data
2     #include "planeDataA.as"
3
```

Save and test your movie. Your results should look like the left side of Figure 9.9 with the cut line showing. Comment out the `lineStyle` setting as shown below, then save and test your movie again. You should get the right side of Figure 9.9 as advertised.

```
171        // draw the shape
172        //lineStyle(2, 0x0000ff, 100);
173        beginFill(0x00aaff,75);
```

Figure 9.9 The letterform with and without the border

Step 5: Make a final adjustment

If you've done any experimenting with zooming the object or moving near the camera, you will discover that things get a bit wacky. That's because we haven't put in any tests for checking when we are too close, and it's something that should be done.

In the `text` layer, create a message that alerts the user to being too close to the camera as shown in Figure 9.10. Choose Modify > Convert to Symbol. Create a movie clip whose instance name is `note_mc`.

Figure 9.10 Creating an alert message

Let's add the necessary code to the script. Define a variable `tooClose` as shown in line 10. We'll live dangerously and set the value to 5. Let's also start with the alert note turned off (line 11).

```
 7  // -----------------------------------------------------------
 8  // set the viewer parameters
 9  var d:Number = 200; // distance from viewer to picture plane
10  var tooClose:Number = 5; // too close to camera distance
11  note_mc._visible = false;
12
```

A convenient place to test for being too close is in the `findTheCenterPoint()` function. Inside this function, we are calculating the minimum and maximum z-values of the object. Since the minimum z-value is the one closest to the camera, `zmin` is the value to use with our test. If the object is too close, we will turn the alert note on and turn the scene off. When the object is at an acceptable distance, we will turn the note off and the scene on. Add the lines shown to the function.

```
63        // take the average of max and min to find the center
64        xc = (xmax + xmin)/2;
65        yc = (ymax + ymin)/2;
66        zc = (zmax + zmin)/2;
67
68        // check if the object is too close
69        if (d + zmin < tooClose )
70        {   note_mc._visible = true;
71            scene3D._visible = false;
72        }
73        else
74        {   note_mc._visible = false;
75            scene3D._visible = true;
76        }
77    }
```

Save and test your movie. Make sure that the alert note and scene turn on and off as they should. This completes the exercise.

Exercise 9.2: Extruded Objects with Lines

As a transition from planar objects to fully three-dimensional ones, let's look at line drawings of simple extruded objects. An extruded object is basically a 2D shape that extends along the object's z-axis to add thickness. In this exercise, we'll use the results of the previous exercise to create a simple extrusion program. To view the finished results of this exercise, open 9_2_extrusionDONE.swf in the Chapter 9 folder. You should be able to get results similar to Figure 9.11.

Step 1: Getting started

We'll begin where we left off, so open 9_2_extrusion.fla in the Chapter 9 folder. This file contains the script that we just discussed in Exercise 9.1. Let's load in a data file that we can use. Change line 2 to that shown here. We are going to make an

```
1     // include the object data
2     #include "extrudeDataV.as"
3
```

Figure 9.11 Sample screen from `9_2_extrusionDONE.swf`

```
1    // data for creating an extruded V shape
2
3    // define the thickness of the extrusion
4    var thickness:Number = 30;
5
6    // define the coordinates of the 2D shape
7    // the end point and starting point
8    // should not be the same
9
10   points = new Array();
11
12   points[0]= { x:-80, y:120  }
13   points[1]= { x:-20, y:-40  }
14   points[2]= { x: 20, y:-40  }
15   points[3]= { x: 80, y:120  }
16   points[4]= { x: 40, y:120  }
17   points[5]= { x:  0, y:  0  }
18   points[6]= { x:-40, y:120  }
```

extruded V letterform. The data has already been created for you and is shown here so that you can see what it looks like.

Step 2: Define the object in 3D space

The nice thing about simple extruded objects is that the back face of the object is the same as the front face except for the depth, so it is easy to define the coordinates of the back face. Since the extruded object will have twice as many points as the front face, we need to define the number of points accordingly (line 32). In setting up the `for` loop, we need to loop only over the values in the points array (line 35). Insert the lines that set the coordinates of the back face equal to the coordinates of the front face plus the thickness of the extrusion (lines 41–44).

```
30   // -------------------------------------------------------
31   // define the object in 3D space
32   var numPts:Number = points.length*2;
33
34   // set the coordinates of the object's front plane
35   for (var i:Number = 0; i < numPts/2; i++)
36   {
37       x[i] = points[i].x;
38       y[i] = points[i].y;
39       z[i] = 0;
40
41       // add the coordinates of the object's back plane
42       x[i+numPts/2] = x[i];
43       y[i+numPts/2] = y[i];
44       z[i+numPts/2] = z[i] + thickness;
45   }
46
```

Step 3: Modify the drawLines() function

We need to make a few changes to the `drawLines()` function. Rather than drawing continuously from one point to another, we need to break up our drawing into three parts. We must draw the front plane, the back plane, and then all of the lines that connect the front plane to the back plane.

Replace lines 188–197 with the lines shown here. Let's start with the front plane. Set the color of the line to blue in line 189. We must move to our first data point before drawing (line 190). To draw the front plane, we must loop over the first half of the total number of points, which is `numPts/2` (line 191). The `lineTo()` method connects the points of the front plane with the exception of the first point (line 193). We need a separate `lineTo()` to connect the last point of the front plane to the first point (line 195).

```
188          // draw the front plane
189          lineStyle (2, 0x0000ff, 100);
190          moveTo (xs[0], ys[0]);
191          for (i = 1; i < numPts/2; i++)
192          {
193               lineTo (xs[i], ys[i]);
194          }
195          lineTo (xs[0], ys[0]);
196
197          // draw the back plane
198          lineStyle (2, 0xcc0000, 100);
199          moveTo (xs[numPts/2], ys[numPts/2]);
200          for (i = numPts/2+1; i < numPts; i++)
201          {
202               lineTo (xs[i], ys[i]);
203          }
204          lineTo (xs[numPts/2], ys[numPts/2]);
205
206          // draw the connecting lines
207          lineStyle (2, 0xaa00aa, 100);
208          for ( n = 0; n < numPts/2; n++ )
209          {
210               moveTo (xs[n], ys[n]);
211               lineTo (xs[n+numPts/2], ys[n+numPts/2]);
212          }
```

The back plane is handled in a similar manner. Let's set the drawing color to red so that we can differentiate the back plane from the front plane (line 198). Next, we move to the first point of the back plane (line 199). To draw the back plane, we must loop over the second half of the total number of points (line 200). As before, the lineTo() method connects the points of the back plane with the exception of the initial point (line 202). A separate lineTo() connects the last point of the back plane to the first point (line 204).

We'll use a violet color to draw the connecting lines from the front plane to the back plane (line 207). Since each face has numPts/2 points, we can set up a loop that starts from each point on the front plane (line 210) and connects to its corresponding point on the back plane (line 211).

Save your movie as 9_2_extrusionDONE.fla. Make sure that all of the points are connected properly. This completes the exercise.

Tip: Make sure you understand how to use the `beginFill()` method by filling the front and back planes of your object as in Figure 9.12. Why can't the side planes be filled?

Figure 9.12 The front and back planes filled

Exercise 9.3: Modeling Solids with Lines

Let's move more fully into three-dimensional solids. As we have done before, we will need to specify the coordinates of the object, but now we will also need to supply the z-coordinates. Since the points of the object can be connected in many different ways, we will need to specify the starting point and ending point of each line that defines the solid. Open `9_3_3DlinesDONE.swf` to see where we are headed (Figure 9.13).

Step 1: Getting started

Open `9_3_3Dlines.fla` in the Chapter 9 folder. This file is a copy of the file we used in Exercise 9.1. We'll use it to convert from 2D planar to 3D solids with lines. Let's load in a data file that we can use. The data has already been created for you. Change line 2 to that shown here. The object we are using is a diamond shape with a hexagonal cross-section. A section of the data file has been included here so that you can see how it is set up with the points and lines arrays.

```
1    // include the object data
2    #include "diamondData.as"
3
```

Figure 9.13 Sample screen from Exercise 9.3

```
1    // data for creating a general shape
2    // consisting of points and lines
3
4    // define the coordinates of the 3D shape
5    points = new Array();
6
7    points[0]= { x:  0,   y: 100, z:   0 }
8    points[1]= { x:  0,   y:-100, z:   0 }
9    points[2]= { x:-100, y:   0, z:   0 }
10   points[3]= { x:-50,  y:   0, z: -87 }
11   points[4]= { x: 50,  y:   0, z: -87 }
12   points[5]= { x: 100, y:   0, z:   0 }
13   points[6]= { x:  50, y:   0, z:  87 }
14   points[7]= { x: -50, y:   0, z:  87 }
15
16   // define the start and end point of each line
17   lines = new Array();
18
19   lines[0]= { sp:0, ep:2 }
20   lines[1]= { sp:0, ep:3 }
21   lines[2]= { sp:0, ep:4 }
22   lines[3]= { sp:0, ep:5 }
```

Step 2: Define the object in 3D space

Only two minor changes are needed to define the object in 3D space. We will later need to know the number of lines, numLines, in the object, but it is convenient to set it where we are setting the number of points. Add line 31 as shown below.

Since we now also have specified z-coordinates, we can obtain them from the points array in the same way as the 2D coordinates (line 38).

```
28    // ---------------------------------------------------------
29    // define the object in 3D space
30    var numPts:Number = points.length;
31    var numLines:Number = lines.length;
32
33    // get the coordinates of the object
34    for (var i:Number = 0; i < numPts; i++)
35    {
36            x[i] = points[i].x;
37            y[i] = points[i].y;
38            z[i] = points[i].z;
39    }
```

Step 3: Modify the drawLines function

The only thing left to do is to adjust the drawLines function so that it can handle the data for the starting points and ending points of each line. If you wish, you can change the drawing color and weight (line 173). You will need to replace the code for the current drawing with lines 175–181 below. A for loop is set up to loop over the number of lines specified (line 175). For each line, we refer to the lines array and get the starting point and ending point (lines 177–178). We get the screen coordinates of the starting point

```
172            // draw the shape connecting lines
173            lineStyle(2, 0xff0000, 100);
174
175            for ( n = 0; n < numLines; n++ )
176            {
177                sp = lines[n].sp;
178                ep = lines[n].ep;
179                moveTo (xs[sp], ys[sp]);
180                lineTo (xs[ep], ys[ep]);
181            }
```

and `moveTo` that point (line 179). We then get the screen coordinates of the ending point and draw a line to that point (line 180). That's all there is to it. Save your movie as `9_3_3DlinesDONE.fla` and check to make sure that everything works as it should. With a few simple changes, we went from planar 2D shapes to 3D solids.

Exercise 9.4: Modeling Solids with Planes

One major drawback of the previous exercise is that we see lines that normally would not be visible in a solid object. We want to move toward removing those lines. To do this, we need to look at the object in terms of the planes that define the object rather than the lines.

Step 1: Getting started

Open `9_4_3Dplanes.fla` in the Chapter 9 folder. This file is a copy of the completed Exercise 9.3. We'll use it to convert from 3D solids with lines to 3D solids with planes.

The object in this exercise is a cube as shown in Figure 9.14. The data has already been created for you and saved as `cubeData.as`. The format of the data is a little different than in the previous exercise. We enter the coordinates of the object's corner points into the `x`, `y`, and `z` arrays at the outset. We are also defining a `planes` array. Each element of this array is an array that contains the corner points of one of the planes of the object, entered in a counterclockwise direction as you are facing the plane.

```
1    // initialize data
2    x  = [];  // the x-coordinates of the object
3    y  = [];  // the y-coordinates of the object
4    z  = [];  // the z-coordinates of the object
5    planes = [];  // planes that define the object
6
7    // define the corner points
8    x = [ -50,  50,  50, -50, -50, 50,  50, -50 ]
9    y = [  50,  50, -50, -50,  50, 50, -50, -50 ]
10   z = [-100,-100,-100,-100 ,  0,  0,   0,   0 ]
11
12   // points defining the planes of the object
13   planes = [ [0,1,2,3], [1,5,6,2], [5,4,7,6],
14              [4,0,3,7], [4,5,1,0], [3,2,6,7]
15            ]
```

Figure 9.14 The cube and its data points

Let's load the `cubeData.as` file into the program. Change line 2 to that shown here. Delete lines 24–26 since they are already defined as part of the data.

```
1    // include the object data
2    #include "cubeData.as"
3
```

Step 2: Define the object in 3D space

Only two minor changes are needed to define the object in 3D space. Change `numLines` to `numPlanes` in line 31 as shown below. Delete lines 32–39 since we already have the coordinates of the points.

```
27   // -----------------------------------------------------------
28   // define the object in 3D space
29   var numPts:Number = points.length;
30   var numPlanes:Number = planes.length;
31
```

Step 3: Modify the drawLines function

We need to modify the `drawLines` function so that it can handle the data for the planes. Since we are now dealing with planes rather than lines, it is a good idea to rename the function to `drawPlanes` (line 166).

```
163    // ---------------------------------------------------------------
164    // use the drawing API to draw the object
165
166    drawPlanes = function()
167    {
```

To draw the object in terms of its planes, replace lines 173–182 with the lines below. We first create a temporary array, `p`, that will hold the points of each plane of the object (line 174). We want to draw each plane so we set up a `for` loop to loop over the number of planes (line 177).

For each plane, we need to pick up the points that define the plane. For the sake of simplicity, we are assuming each plane consists of four points, and we are placing those points in the `p` array (line 180). Note that the `p` array is not necessary, but it sure simplifies the expressions since we are getting elements of an array that is inside of an array.

```
173            // draw the shape using its planes
174            p = []; // temp array to hold the points
175                    // of any plane
176
177            for ( n = 0; n < numPlanes; n++ )
178            {
179                // get the points p that define each plane
180                for ( k = 0; k < 4; k++) { p[k] = planes[n][k];}
181
182                lineStyle (2, 0x6600cc, 100);
183                beginFill (0x33aaff, 10);
184                // get screen coordinates and draw the plane
185                moveTo (xs[p[0]], ys[p[0]]);
186                lineTo (xs[p[1]], ys[p[1]]);
187                lineTo (xs[p[2]], ys[p[2]]);
188                lineTo (xs[p[3]], ys[p[3]]);
189                lineTo (xs[p[0]], ys[p[0]]);
190                endFill();
191            }
```

At this point, we are ready to begin drawing. The border of the planes is set to an opaque blue (line 182) while the interior will be filled with a 10% blue (line 183). For each plane, we will `moveTo()` the first point and then use `lineTo()` to draw the lines around the plane (lines 185–189) and finish the job with an `endFill()`.

Step 4: Update the object

The only thing left to do is make a one-line change inside the `onEnterFrame` handler to reflect the substitution of the `drawPlanes()` function for the `drawLines()` function.

```
198    this.onEnterFrame = function()
199    {
200        findTheCenterPoint();
201        getScreenCoords();
202        drawplanes();
203    }
```

This completes the exercise. Save your movie as 9_4_3DplanesDONE.fla and test it.

Removing Hidden Lines

Now that we have objects defined in terms of their planes, it is time to get rid of planes that can't be seen. This will require a little more coding and some geometry. If you want to see where the gory details are heading, open 9_4_3DsolidsDONE.swf in the Chapter 9 folder.

Step 1: Getting started

We'll use 9_4_3DplanesDONE.fla as our starting point. We will need an additional array, b, which we'll call the boundary matrix since it will be an array that holds other arrays within it. The data it will contain consists of vectors that are perpendicular to each of the planes of the object.

```
23    // define the 3D and screen coordinate arrays
24    xs = [];  // the screen x-coordinates of the shape
25    ys = [];  // the screen y-coordinates of the shape
26    b  = [];  // the boundary matrix of normal vectors
27
```

Step 2: Create the boundary matrix

Rather than getting bogged down with the specifics of the code in creating the boundary matrix, let's discuss what the code is doing. The general equation for each plane is given by

$$b1*x + b2*y + b3*z + b4 = 0$$

The createBoundaryMatrix function calculates the values for b1, b2, b3, b4 for each plane and stores them in the boundary matrix b in the following way. Two vectors v1 and v2 are created using three points on each plane where point 2 is between point 1 and point 3 as shown in Figure 9.15.

By performing a certain type of mathematical calculation called the cross product, we can take the cross product of **v1 x v2** to get a normal vector **N** that is perpendicular to the plane. If the coordinates have been entered in a counterclockwise direction, then the vector will be pointing up rather than down.

The coordinates of the normal vector provides b1, b2, and b3. By using the coordinates of point 1 in the plane equation, we can determine b4. The values b1, b2, b3, and b4 for each plane in the object are stored in the boundary matrix.

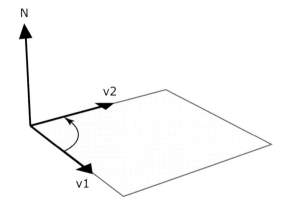

Figure 9.15 Construction of a normal vector to a plane

Step 3: Test the boundary matrix

The function testBoundaryMatrix tests to see whether the normal vector for each plane is pointing in the right direction by performing another type of calculation called the dot product. By taking the dot product of the normal vector and a vector to the center point, we can determine whether that value is positive or negative. If the test is negative, then the values in the boundary matrix for that plane are made negative.

The basic idea is that when the dot product is positive, the normal vector is pointing towards us and the plane is visible. If the dot product is negative, the normal vector is pointing away from us and the plane is invisible.

Step 4: Test for hidden planes

The function `hiddenPlaneTest` tests each plane to see whether it is hidden from the viewer. If it is, a flag is set to 1 so that the plane isn't drawn later. This test uses the values that have been stored in the boundary matrix.

Step 5: Modify the drawPlanes function

The only change needed in the `drawPlanes` function is to add a test that looks at the flags generated by the hidden plane test. If the flag for any given test is 1, the visibility for that plane is set to false, and it isn't drawn.

Step 6: Update the object

The last step is to update the object using the `onEnterFrame` handler. As before, calls to each of the functions are placed in order.

```
283    this.onEnterFrame = function()
284    {
285        findTheCenterPoint();
286        createBoundaryMatrix();
287        testBoundaryMatrix();
288        hiddenPlaneTest();
289        getScreenCoords();
290        drawPlanes();
291    }
```

Exercise 9.5: Planes of Different Colors

In this exercise, we will extend the capabilities of our hidden line program to include assigning different colors to the planes of an object. We will also see how we can substitute other kinds of user interaction for the buttons.

Step 1: Getting started

Open `9_4_3DsolidsDONE.fla` in the Chapter 9 `Completed_Exercises` folder. The first thing we need to do is to assign some colors to the planes of the object. Let's place the information in the same location as `numPts` and `numPlanes`. Since the `planes` array is

338

already defined, we can just add a color property to it and then specify the color we want for each plane.

```
28    // --------------------------------------------------------------
29    // define the object in 3D space
30    var numPts:Number = x.length;
31    var numPlanes:Number = planes.length;
32    planes.col = [ 0x6666cc,0x66cc66,0x66cccc,
33                       0xcc6666,0xcc66cc,0xcccc66
34                   ]
```

Step 2: Modify the drawPlanes function

The hard part of deciding the colors for each plane was in the last step. Here, we just need to change the `beginFill()` method as shown, and we're done.

```
267              for ( k = 0; k < 4; k++) { p[k] = planes[n][k]; }
268
269              lineStyle (2, 0x6600cc, 100);
270              beginFill (planes.col[n], 50);
271              // get screen coordinates and draw the plane
```

Save your movie as 9_5_colorsDONE.fla and check it out.

Step 3: Use mouse control to spin the cube

It is easy to use the button actions for other types of user interaction such as movement of the mouse. Add the two-line change below to put the y-axis angle of rotation and the x-axis angle of rotation under mouse control. The farther the cursor is from the center of the Stage, the faster the cube will spin.

```
286    this.onEnterFrame = function()
287    {
288         ry = (_xmouse - Stage.width/2)/100%360;
289         rx = (_ymouse - Stage.height/2)/100%360;
290
291         findTheCenterPoint();
```

Save your movie as 9_5_mouseDONE.fla. Test it and watch it spin.

339

Summary

This chapter focused on creating simple 3D objects in Flash. The exercises incorporated ActionScript to create objects that can be moved, rotated, and scaled interactively. Now that you have finished reading the chapter, you should be able to

- Create planar shapes with lines and fills
- Extend planar shapes to extruded objects
- Create 3D solids defined by lines
- Develop 3D solids defined by planes

The next chapter focuses on how you can integrate the more sophisticated 3D graphics available with other software into Flash.

Integrating 3D Graphics in Flash

Creating 3D graphics involves the modeling and rendering of 3D objects. Modeling is the creation of 3D objects. The rendered image includes visual depth cues found in the real world such as light and shadow, perspective, form and texture, and sometimes movement. Exercises throughout this book have incorporated rendered images from 3D software packages. There are many 3D software packages available to you. All include modeling techniques that are universal.

3D software enables you to create and view a model from many different views. This is a huge advantage over 2D drawing, where each new view has to be drawn individually. Let's explore two common modeling techniques.

Extruding and Revolving 3D Objects

There are two common modeling techniques: extrusion and revolving. An extruded 2D object extends along the object's z-axis to add depth. Figure 10.1 illustrates an extruded object. If you extrude a 2D ellipse along its z-axis, it becomes a cylinder.

z-axis

Figure 10.1 Extruding a 2D ellipse to create a cylinder

Revolving a 2D object sweeps a path in a circular direction around the y-axis to create a 3D object. Figure 10.2 illustrates a revolved object, a wine glass. We start with a profile that defines half the glass shape. The symmetrical wine glass is created by sweeping the profile path around the y-axis.

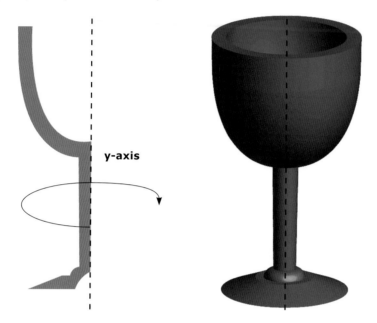

Figure 10.2 Revolving a 2D profile to create a symmetrical 3D object

Using Adobe Illustrator

Adobe Illustrator has tools that create 3D vector objects. These 3D graphics can be imported into Flash. Let's walk through a typical example, 3D extruded text. The text tool allows you to create the text. With the text selected, choose Effect > 3D > Extrude & Bevel to open the 3D tool's options dialog box. Options include Position, Extrude & Bevel, and Surface settings (Figure 10.3).

Position allows you to rotate and change the perspective of the 3D extrusion. There are several preset positions that can be selected from a drop-down menu. Click and drag on the 3D cube to rotate the object to any custom angle. The blue face of the cube represents the front of the 3D object. The light gray face is the top. Numerical adjustments can also be entered using the three rotation text boxes. Perspective can be adjusted from 0 and 160 in the Perspective text box. A small number illustrates the effects of a telephoto camera lens; a larger number simulates a wide-angle camera lens.

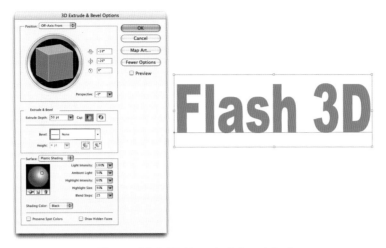

Figure 10.3 3D Extrude & Bevel Options

To see the 3D effect in the document window, select Preview. Extrude & Bevel controls the object's depth and any bevel applied. The extruded depth can be set between 0 and 2000. If you wish to have your object appear as a solid shape, select the Cap On button. Selecting the Cap Off button makes the object hollow.

Click More Options to view the complete list of options. Surface controls how the final rendered object appears. Surfaces can appear dull and unshaded or glossy with highlights that simulate plastic. Select a preset surface from the drop-down menu. Lighting can create dramatic effects. Click and drag the light around the sphere to adjust the lighting. Additional lights can be added by selecting the Add Light button.

When you are done, click OK (Figure 10.4).

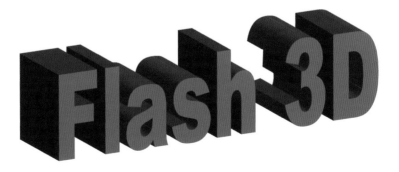

Figure 10.4 3D extruded text

Export the Illustrator file. Select File > Export. Set the format to Macromedia Flash (.swf). In the Macromedia Flash (SWF) Format Options dialog box, deselect the Generate HTML check box (Figure 10.5). Click OK to export the file.

Figure 10.5 Macromedia Flash (SWF) Format Options dialog box

Open a new document in Flash. Select File > Import > Import to Stage. Locate your saved .swf file and click Import. The 3D text appears on the Stage. Go to the Library and look at its contents. The Library contains graphic symbols that are used to create the 3D extruded text effect (Figure 10.6).

Figure 10.6 Extruded text in Flash made up of several graphic symbols

Adobe Illustrator can also create 3D objects by revolving a 2D shape around the y-axis. Let's take a look at building a simple 3D object—a pawn chess piece. When modeling a revolved 3D object, you need to create a profile for half of the object. Using the Pen tool in Illustrator, draw the profile shape of the chess piece. Do not use a stroke; create only a filled shape. This shape will be revolved around the y-axis to create a 3D object. With the shape selected, choose Effect > 3D > Revolve to open the 3D Revolve Options dialog box. Options include Position, Revolve, and Surface settings (Figure 10.7).

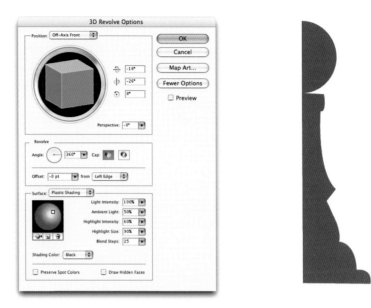

Figure 10.7 3D Revolve Options dialog box

To see the 3D effect in the document window, select Preview. The options are similar to Extrude & Bevel. Experiment with each set of options to achieve your desired results. When you are done, click OK. Export the Illustrator file as Macromedia Flash (.swf) file. Open a new document in Flash. Select File > Import > Import to Stage. Locate your saved .swf file and click Import. The chess piece appears on the Stage. The Library contains all the graphic symbols that are used to create the 3D chess piece (Figure 10.8).

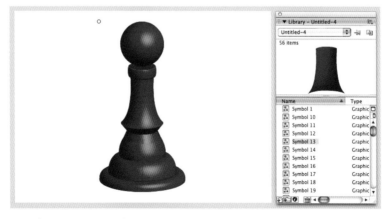

Figure 10.8 3D chess piece made up of several graphic symbols

Bitmap Caching

Illustrator created vector-based 3D graphics in the previous examples. Once imported into Flash, the rendered image consisted of several graphic symbols. This works fine for static-based imagery, but what happens if we want to animate the chess piece or 3D text? Flash has to keep track of a lot of information to move what appears to be a simple shape. In some cases, a raster graphic may be a better choice of file format. The creators of Flash thought of this and incorporated runtime bitmap caching.

Open 10_2_MoveChessPiece_DONE.fla in the Chapter 10 folder. The chess piece was converted into a movie clip symbol and motioned-tweened across the Stage. When published, it moves very slowly. This is a result of Flash updating all the vector shapes on each frame. Let's see what effect bitmap caching has on performance.

Select the movie clip on the Stage. Go to the Properties panel and select "Use runtime bitmap caching" (Figure 10.9). Publish the movie again. The image moves much faster across the Stage. Flash converted the contents of the movie clip into a bitmap image. As a result, the runtime engine doesn't have to process as much data. This works well when animating the same image over time. If the contents of the movie clip change, Flash regenerates the bitmap image.

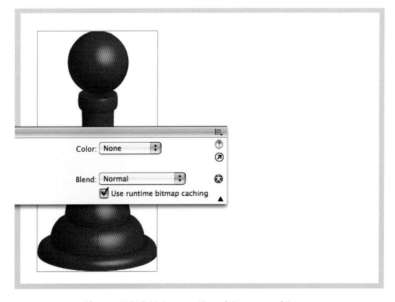

Figure 10.9 Using runtime bitmap caching

Electric Rain's Swift 3D

Electric Rain's Swift 3D was specifically designed to create 3D vector and raster anima-
tions for Flash. Swift 3D allows you to build models using primitives. All 3D software
packages come with a set of primitives, preset geometrical shapes. The most common
shapes include cube, sphere, cone, cylinder, pyramid, and torus. Primitives are used
as building blocks to create 3D models. In Swift 3D, primitives are located in the Main
toolbar (Figure 10.10).

Figure 10.10 Swift 3D primitives in Main toolbar

Click on a primitive to add the shape to the Viewport windows. The Viewport displays
the 3D space you are working in. Think of it as your camera. There are seven standard
views that can be selected from a drop-down menu. These are perspective, front, back,
top, bottom, left, and right (Figure 10.11).

Figure 10.11 Swift 3D viewports

Each primitive has properties such as width, height, and depth. These can be accessed
and altered through the Properties toolbar. Editing tools are also available that allow
you to scale and rotate each primitive in a scene. Combining these primitive shapes
together creates 3D models that you can export to Flash.

Let's walk through a basic Swift 3D project using the Text tool. Clicking on the Text but-
ton in the Main toolbar adds the default word "Text" to your 3D scene. You can change
the font type by choosing another font from the Font drop-down menu. To change the
word, type in your text in the Text entry box (Figure 10.12).

Figure 10.12 Creating 3D text in Swift 3D

To embellish the text, you can add a bevel by selecting the
Bevels option in the Properties toolbar. For this example,
Beveled was selected from the Style drop-down menu, and
the Depth was reduced from 0.050 to 0.020 (Figure 10.13).

Figure 10.13

The Sizing property allows you to control the width, height, and depth of your text.
Inter Character and Inter Line control the letter and line spacing. Experiment with these
options to create the desired results (Figure 10.14).

Figure 10.14 Adjusting the 3D text width and letter spacing properties

The Material property allows you to add color and textures to your 3D model. A Material Gallery holds several different types of materials that you can apply. To apply a material, click and drag it from the Gallery to the Material Display Ball in the Properties panel. Different materials can be applied to the face, bevels, and edges for dramatic effect. For this example, a glossy orange material was applied to the text (Figure 10.15).

Figure 10.15 Applying a material to the 3D text

Swift 3D includes animation presets that help speed up your work time. Toggle the Materials palette to the Animation palette by clicking the Show Animations button (Figure 10.16). The animation presets are divided into four categories: common spins, deformations, fly-bys, and regular spins. Single-click on each icon to see a thumbnail preview of the motion. To apply the animation preset, click and drag from the preview window to the 3D object in the Viewport.

Figure 10.16 Animation presets in Swift 3D

The Animation Timeline displays the results. All drag-and-drop animations are 20 frames in duration. You can change the length by dragging the Animation Scaling Bar to a new frame. Click the Play button to preview the animation.

To render the animation for Flash, select the Preview and Export Editor tab at the top of the Swift 3D interface. Here is where you choose your output options, render the scene, and finally export to file. The user interface is divided into these three areas—Output Options, Render Preview, and Export to File (Figure 10.17).

You have two output options—vector and raster. By default, the Vector button is selected. Since we will be importing the animation into Flash using the Swift 3D importer, the target file type is set to Swift 3D Flash Importer (SWFT). There are options available to fine-tune the optimization of each frame within the animation.

Once you have chosen the output options, click on the Generate All Frames button in the Render Preview area to start the rendering process. Swift 3D displays each separate frame as it is rendered. After the rendering is done, you can preview the animation in the preview area. Use the playback controls to view the animation.

To export the animation, click on the Export All Frames button in the Export to File area. A dialog box appears for you to name the file. To import the animation into Flash, open a new document and select Edit > Import > Import to Stage. Locate the .swft file and choose Import. The exported Swift 3D animation will appear as a frame-by-frame animation in the Flash Timeline.

Figure 10.17 Animation presets in Swift 3D

This basic example showcases the process of creating 3D graphics using Swift 3D. It was divided into four stages. The first stage was the creation of the 3D model. Here we created the "Flash 3D" extruded text and added a bevel. Next, materials were applied to the surface of the model. A spinning animation was applied next. Finally, the rendering process produced the animation that was imported into Flash. This just scratches the surface of Swift 3D's capabilities.

There is an Extrusion Editor that creates extruded objects (Figure 10.18). Select the Extrusion Editor tab to load its interface. You can use preset geometric shapes, create custom shapes, and import EPS files to be extruded. The completed path is automatically extruded for you. You can alter the extrusion through the Scene Editor.

Figure 10.18 Extrusion Editor in Swift 3D

The Lathe Editor allows you to create revolved 3D objects. A vertical green line in the Viewport represents the Axis of Rotation. Its position is offset from the center of the Viewport. Using the drawing tools, draw the profile shape of your object on the right side of this line. Once you have completed the path, Swift 3D spins it 360 degrees around the Axis of Rotation.

The strength of this 3D software is its ability to build 3D models and animation that can be optimized for Flash. For more information and tutorials regarding Electric Rain's Swift 3D, visit their website at www.erain.com/products/swift3d/. You can also download a trial version of the software.

Creating Animated 3D Characters with Poser

So far, we have focused on creating vector 3D objects for Flash. Let's turn our attention to one 3D software package that creates raster images. Poser allows you to sculpt and animate 3D figures for games, interactivity, or storytelling. You click and drag to pose body parts, create facial expressions, or change the environmental lighting.

Poser has a unique visual interface (Figure 10.19). A default male figure appears with each new file. Libraries of figures, props, and poses are located on the right edge of the screen. You have a wide variety of ethnic males and females to choose from. There are even 3D figures of animals, robots, and cartoon characters.

Figure 10.19 Poser's visual interface design

Camera controls are represented by hands pointing in different directions. These symbolize the x-, y-, and z-axes. A trackball rotates the camera view. A drop-down menu gives you quick access to the different camera views. These include left, right, top, bottom, front, and back. The camera's position can also be keyframed and animated over time.

Animators use Poser to create walk cycles for their characters. Drawing a walk cycle is very time consuming. Poser has preset walk cycles built in that help reduce the time. This is one of the 3D software's major strengths. Let's "walk" through an example used to describe a frame-by-frame animation in Chapter 3.

The boy in Figure 10.19 was selected from the Figure Library. The Poses Library contains several static and animated preset poses to choose from. Inside the Poses Library is a Walk Designer category. The number in the upper-right corner of each thumbnail indicates the number of frames required to complete the walk cycle (Figure 10.20). Most of the walk cycles are 30 frames. Double-click on the thumbnail image to apply the walk cycle to the character.

Figure 10.20

Change the camera view from Main Camera to the Left Camera using the Camera Controls drop-down menu. To play the animation, use the Animation Controls at the bottom of the Poser interface (Figure 10.21). Once the walk cycle is complete, it is time to render.

Figure 10.21 Previewing the walk cycle in Poser

Rendering the animation is done by choosing Animation > Make Movie. A dialog box appears that allows you to set options for the render engine. You can save the Sequence Type as a QuickTime movie, a series of bitmap images, or an SWF file.

You might think that the SWF format is the correct setting. Although Poser has the ability to export a Flash SWF file, the image quality is reduced significantly as a result of converting from raster to vector (Figure 10.22). To retain a more realistic look and feel, export the walk cycle as a sequence of bitmap images. For this example, the frame rate was set to 30 frames per second. As a result, Poser will render 30 raster image files.

SWF Sequence **Bitmap Sequence**

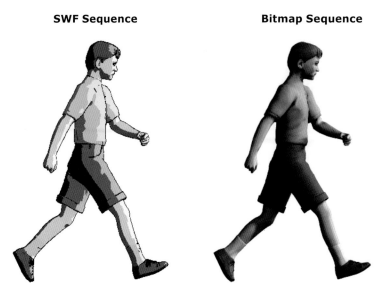

Figure 10.22 Poser rendering options

Open a new document in Flash. Choose Edit > Import > Import to Stage. Locate the first raster image in the walk cycle sequence. Click Import. A dialog box appears indicating that Flash recognizes this file to be part of a larger sequence (Figure 10.23). Click Yes to import the entire sequence into Flash as a frame-by-frame animation.

Figure 10.23 Importing walk cycle sequence into Flash

Alpha Channels

The previous example works well if you plan to keep the Flash Stage color white. When Poser rendered out each frame of the walk cycle, the white background color was merged with the boy's image. This is a result of the format in which it was saved, BMP. To see this, change the Stage color from white to black. You are left with the white bounding box surrounding the boy (Figure 10.24).

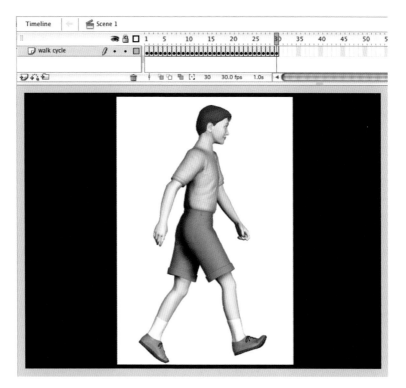

Figure 10.24 No alpha channel

Poser renderings are 32-bit color by default. This means they are 24-bit color with an 8-bit alpha channel. When rendering still images or animations in Poser, save the rendered images as PNG or PSD files. These file formats retain the alpha channel.

What is an alpha channel? An RGB image contains three color channels—red, green, and blue. When combined, these channels produce the full color image. The alpha channel is a fourth channel that contains an 8-bit grayscale image (Figure 10.25). This image determines the transparency of each pixel. Black pixels become transparent, and white pixels are opaque. Any value in between black and white has a certain degree of transparency.

Other 3D applications such as Autodesk Maya, 3ds Max, and CINEMA 4D save the rendered images with their alpha channels intact. Figure 10.26 shows the render settings in CINEMA 4D used to maintain an alpha channel and its results.

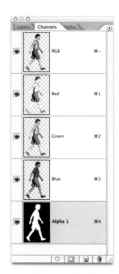

Figure 10.25

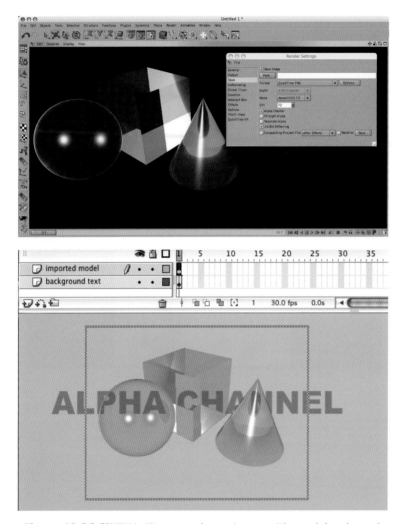

Figure 10.26 CINEMA 4D can render an image with an alpha channel

Summary

This chapter explored ways to integrate 3D-rendered models into Flash. There are many ways to import your 3D creations. The modeling techniques covered are universal to any 3D application. These are just a few examples to start your exploration.

The next chapter incorporates Flash 3D concepts from this book into reusable templates you can edit and expand upon.

11

Flash 3D Applications:
Putting It All Together

We have explored many concepts and techniques for creating and simulating 3D space in Flash. This chapter applies the key concepts to practical applications. These projects range from arcade-style games to interactive galleries. We give you the starting code for five different types of Flash 3D templates. Each template is complete in that it incorporates the basic 3D functionality.

Think of each project as a starting point for your own creative designs. Graphics and audio are provided, but feel free to modify them with your own. Most of the ideas used in these templates have been presented in previous chapters in this book. For each template, we provide suggestions for enhancement. These are meant to get you thinking about how to improve the interactivity and basic framework provided. Have fun!

Project 1: Space Blaster

One of the most popular arcade games is Asteroids. The user controls a rocket ship in space blasting away large asteroids. We take this concept and apply 3D space to it. A large part of this project has already been discussed in Chapter 6 (Figure 11.1). In Exercise 6.3 you created complex 3D movement using rocks in space. The finished code from that example will be the basis for the asteroid movement in this game.

Figure 11.1 Exercise 6.3 provides code for asteroid movement.

Open `01_spaceBlaster.fla` in the Chapter 11 folder. Publish the movie to see the game. The Flash file is divided into five frames in the main Timeline. The first frame is the title screen for the game. It contains two buttons that navigate the user either to an instructions screen or to play the game itself (Figure 11.2).

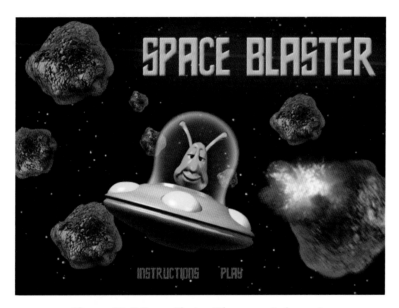

Figure 11.2 Space Blaster title screen is frame 1.

It is always a good idea to give the user instructions on how to play the game. Frame 2 of the Flash file contains the basic instructions for game play (Figure 11.3).

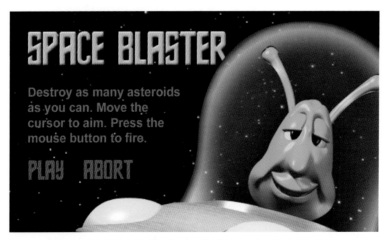

Figure 11.3 Space Blaster instructions screen is frame 2.

Frame 3 holds the game engine. It consists of an asteroid movie clip instance located just above the Stage. This instance will be duplicated many times to create the targets for the game. A target crosshair instance is located in the center of the Stage. This will follow the cursor's movement. Two laser movie clip instances are on either side of the Stage. They will animate towards the crosshair when the user presses the mouse button (Figure 11.4). Let's take a closer look at the asteroid movie clip.

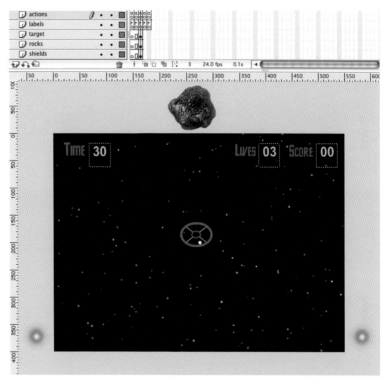

Figure 11.4 Space Blaster game components are on frame 3.

The asteroid was modeled and textured in CINEMA 4D. As discussed in Chapter 10, the 3D model was rendered and saved as a PNG file to maintain the alpha channel. Double-click on the asteroid to open its Timeline. This movie clip contains a frame-by-frame animation of the asteroid exploding.

The images that make up the explosion were created using Adobe After Effects. This software allows you to composite visual effects with digital video. After Effects was used to export footage of an explosion into a PNG sequence. Five frames from that sequence were imported into Flash. These images were placed one frame after another to create the animation of the asteroid blowing up when hit by the lasers (Figure 11.5).

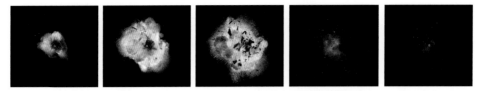

Figure 11.5 Explosion frame-by-frame animation

This provides visual feedback to players when they successfully destroy an asteroid, but what happens if an asteroid hits the ship? To provide visual feedback for this, another movie clip was created and placed on the `shields` layer in the Timeline. Go to the Library and double-click on `MC_shields` in the `Movieclips` folder.

The first frame of this movie clip was intentionally left blank. When an asteroid gets too close to the screen, the movie clip will play the animation. It consists of a flashing red graphic and the word *SHIELDS* (Figure 11.6). The red graphic's transparency is set to 50%. This allows the user to see the game playing underneath.

Figure 11.6 Shield damage frame-by-frame animation

The text at the top of frame 3 is a mixture of static and dynamic text. Dynamic text is used to keep track of the time left in the game and the player's lives and score. The last two frames of the Flash file provide feedback to the player at the end of the game. Frame 4 is displayed when the player shoots 30 or more asteroids in 30 seconds. Frame 5 is displayed when the player loses all lives or time runs out (Figure 11.7).

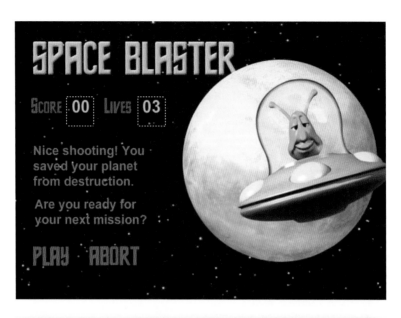

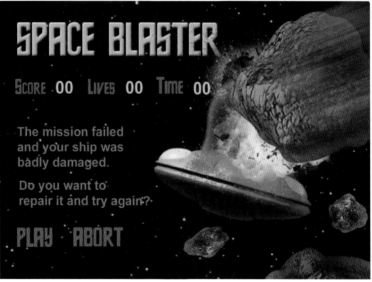

Figure 11.7 Space Blaster user feedback is on frames 4 and 5.

Let's focus on the coding that makes the game work. We recommend that you read the previous chapters before proceeding with this code. Some of the 3D concepts have already been covered, and we assume you have an understanding from reading this book, especially of 3D space.

We begin by initializing variables that will be needed by the game and can easily be modified to suit different tastes. For example, setting `winScore` to 29 means that the player must successfully shoot down 30 or more asteroids to win. The player is also given three lives. Each time an asteroid collides with the spaceship, the player loses a life. The player must reach the designated `winScore` without either running out of lives or out of time, which is set to 30 seconds. The variable `shoot` is used to tell the code whether the player has fired the lasers or not. Time is kept by making calls to the `newDate` object. The beginning of game play is stored in the variable `startTime`.

```
4     // initialize game variables
5     var winScore:Number = 29;
6     var score:Number = 0;
7     var lives:Number = 3;
8     var shoot:Boolean = false;
9     var hit:Number = 0;
10
11    var time:Number = 30;
12    var newDate:Date = new Date();
13    var mySecond:Number = newDate.getSeconds();
14    var startTime:Number = mySecond;
```

The target is a movie clip that has the cursor for aiming the lasers. It is important that it be on top of everything, so after storing its initial depth in `tdepth`, it is set to a depth of 1000. We make sure that the target cursor is visible and hide the mouse cursor.

```
16    //set the target to be on top
17    var tdepth:Number = target_mc.getDepth();
18    target_mc.swapDepths(1000);
19    target_mc._visible = true;
20    Mouse.hide();
21
22    // record the initial laser locations
23    laserLx = laserL_mc._x;
24    laserLy = laserL_mc._y;
25    laserRx = laserR_mc._x;
26    laserRy = laserR_mc._y;
27
28    // create a new Sound Object for laser firing
29    shootLaser = new Sound();
30    shootLaser.attachSound("laser");
```

The locations of the lasers are stored so that after firing, they can be reset to their original locations. We are also attaching a laser sound that will be played when the lasers are fired. Remember to go to the Sound Properties from the Library and make sure that the linkage has been established for all sounds used.

After the game initialization, we come to the code for firing lasers at a target. When the mouse is clicked, if the `shoot` variable is false meaning there are no lasers in motion, the laser sound is played and `shoot` is set to true. When the lasers are fired, they go from their starting positions to the target location in 8 steps. This is done by taking the difference between the target location and their initial positions and dividing by 8.

```
33    // fire lasers at an asteroid target
34    target_mc.onRelease = function()
35    {
36        if (shoot == false)
37        {
38            // shoot the laser
39            shootLaser.start();
40            shoot = true;
41
42            // record the click location
43            xloc = target_mc._x;
44            yloc = target_mc._y;
45
46            // define the incremental laser moves
47            // (distance to asteroid)/8
48            dxL = (xloc - laserLx)/8;   // left laser
49            dyL = (yloc - laserLy)/8;
50
51            dxR = (xloc - laserRx)/8;   //right laser
52            dyR = (yloc - laserRy)/8;
53        }
54    }
```

The asteroids are created and displayed using the `placeObj()` and `displayObj()` functions previously discussed.

The only new wrinkle is the recording of the asteroid color using the Color object in line 76. This is used to darken the tint of faraway asteroids rather than applying alpha transparency. A tint color value is determined based on the z-value of the asteroid, and the `setTransform` method carries out the color change in lines 123 and 124.

The play of the game is carried out with an `onEnterFrame` handler. The target cursor is set to have the same coordinates as the mouse. When the lasers have been fired, they incrementally move toward the target position. When they reach the target location, they are reset to their initial coordinates. The variable `hit` is set to `1` to indicate the lasers reached their destination, and `shoot` is reset to false.

```
158    this.onEnterFrame = function()
159    {
160        // set the cursor position to the mouse location
161        target_mc._x = _xmouse;
162        target_mc._y = _ymouse;
163
164        // check if the lasers have been fired
165        if ( shoot )
166        {
167            // move the lasers toward the target position
168            laserL_mc._x += dxL; laserL_mc._y += dyL;
169            laserR_mc._x += dxR; laserR_mc._y += dyR;
170
171            // reset the lasers when they reach the target
172            if ( Math.abs(laserL_mc._x - xloc) < 2)
173            {
174                laserL_mc._x = laserLx; laserL_mc._y = laserLy;
175                laserR_mc._x = laserRx; laserR_mc._y = laserRy;
176                hit = 1;
177                shoot = false;
178            }
179        }
```

After the test for shooting, a determination is made about the amount of time elapsed. The position of the asteroids is updated and then checked to see whether any have been hit before displaying them.

There are three ways in which the game can end. The player can shoot down enough asteroids, time can run out, or the player can run out of lives. When any of these happen, the `onEnterFrame` handler is deleted, and some necessary cleanup occurs. Depending on which way the game ends, the player will go either to a "win" frame or a "lose" frame.

```
181        getTime(); // update the amount of time elapsed
182
183        // loop over the objects
184        for (var i:Number=0; i<numObjects; i++)
185        {
186            thisObj = _root["object"+i];
187
188            // update the current position of each object
189            thisObj.x += thisObj.dx;
190            thisObj.y += thisObj.dy;
191            thisObj.z += thisObj.dz;
192
193            hitCheck();    // check if the object has been hit
194            displayObj(); // display the object
195        }
196
197        // check for game over
198        if ( score > winScore || time == 0 || lives < 1 )
199        {
200            delete this.onEnterFrame;
201            cleanUp(); // get rid of stuff
202
203            if ( score > winScore ) { gotoAndStop("win");  }
204            if ( time == 0 )        { gotoAndStop("lose"); }
205            if ( lives < 1 )        { gotoAndStop("lose"); }
206        }
207    }
208
```

The getTime() function extracts the current seconds using the Date() object. A test is made to see whether the second hand has passed 12 and a new minute has begun. If so, an adjustment to startTime is made, and then the elapsed time and time remaining are calculated.

The hitCheck() function checks to see whether an asteroid has been hit. To pass the test, an asteroid must be hit by both lasers. When hit, the asteroid plays its explosion sequence, and the score is incremented by 1. The asteroid goes to the placeObj() function, where it is placed back in deep space. A break command breaks out of the for loop.

```
209    function getTime()
210    {   // extract the seconds from the newDate object
211        newDate = new Date();
212        mySecond = newDate.getSeconds();
213
214        // adjustment for second hand going past 12
215        if ( mySecond== 0 && startTime > 0 ) {startTime -= 60 }
216
217        // find elapsed time and time remaining
218        elapsedTime = Math.abs(mySecond - startTime);
219        time = 30 - elapsedTime;
220
221        // display the time remaining
222        if (time < 10 ) { time_txt.text = "0" + time; }
223        else time_txt.text = time;
224    };
225
226    function hitCheck()
227    {   // check if both lasers hit the object
228        if ( thisObj.hitTest(xloc,yloc) && hit == 1)
229        {
230            thisObj.gotoAndPlay(2); // explode the asteroid
231            score++;                // update the score
232            if (score < 10 ) { score_txt.text = "0" + score;}
233            else score_txt.text = score;
234            hit = 2;
235            break;
236        }
237    }
238
239    function cleanUp()
240    {   // reset the cursor
241        Mouse.show();
242        target_mc.swapDepths(tdepth);
243        target_mc._x = target_mc._y = -100;
244
245        // get rid of the asteroids
246        for (var i:Number = 0; i < numObjects; i++)
247        {
248            removeMovieClip(_root["object"+i]);
249            _root["object"+i]._visible = false;
250        }
251    }
```

The purpose of the `cleanUp()` function is to clean up the `game` frame so that the `win` and `lose` frames can be displayed without any leftover artifacts like extra asteroids. Since the mouse has been hidden during game play, we need to bring it back at the end of the game. The target cursor is reset to its original depth. Most importantly, the asteroids need to be removed so they don't continue. As an extra precaution, the visibility of the asteroids is also set to false.

You can expand this game in any number of directions. Currently the game play is rather simple. Either you win or you die. Think about creating a multilevel game. Start with a beginner's level and gradually work up to an advanced level. For each level, the number of asteroids could change as well as the time limit. Instead of asteroids, think of adding other enemies to the game. You could also add ways to refuel or repair the ship. This could be accomplished through a keypress or other items floating in space. The possibilities are limited only by your creativity.

This completes one game. Let's take a look at another. Instead of objects moving at you, Project 2 will move a "camera" towards the objects in a driving game. We will also change the user interaction from mouse to keyboard input.

Project 2: Test Drive

This project uses vector shapes to create a driving game. It expands on the 3D camera concepts discussed in Chapter 7. The player will control a racing car's movement through an obstacle course. The obstacles are placed in 3D space, and a "camera" moves through this space using keypress events.

Open `02_testDrive.fla` in the Chapter 11 folder. Publish the movie to see the game. The Flash file is divided into three scenes—`intro`, `game`, and `score`. Scenes in Flash help organize content in the main Timeline. You can access each scene through the drop-down menu in the Timeline (Figure 11.8). There is also a Scene panel that can be opened by choosing Window > Other Panels > Scene. This panel allows you to add, duplicate, rearrange, and delete a scene.

Figure 11.8 Accessing different scenes in Flash

The first frame in the `intro` scene is the title screen for the game. It contains three buttons that navigate the player to the help screen, `game` scene, or quit. Frame 2 contains instructions on how to play the game (Figure 11.9).

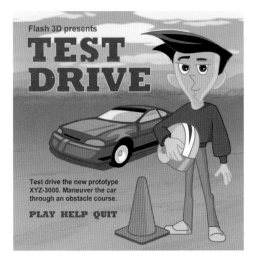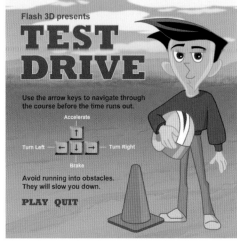

Figure 11.9 Test Drive title and help screen

The `intro` scene also contains a countdown animation starting on frame 3. When the player clicks on the play button, Flash navigates to this frame. The animation plays and leads into the next scene, which contains the game engine (Figure 11.10). This gives the player some time to get ready to interact with the game.

Figure 11.10 Animation leads into the game

The `game` scene holds all the components for the driving game (Figure 11.11). The graphics illustrate the inside of the car. The player is visually placed behind the steering wheel looking out the windshield at the desert environment.

The environment is made up of three layers. One layer contains a movie clip instance labeled `sky_mc`. A second layer contains a movie clip instance labeled `hills_mc`. These

Figure 11.11 Test Drive game components

two layers move at different speeds when the player presses the Left Arrow or Right Arrow keys. This illustrates parallax scrolling discussed in Chapters 3 and 4 and helps simulate turning the car in 3D space. The last layer of the desert environment is a simple rectangular shape. It contains a gradient fill that blends into the `hills_mc` instance.

Figure 11.12 Objects that are placed in 3D space

Double-click on the road cone to open its Timeline. It contains two frames. Frame 1 contains the cone, and frame 2 contains a cactus illustration. Both images are vector graphics created in Flash using the drawing tools. The `actions` layer holds a simple `stop()` action. Notice that the registration point is not in the center but at the bottom of the objects. This is done for placement in 3D space (Figure 11.12).

The text at the top of the interface is a mixture of static and dynamic text. Dynamic text is used to keep track of the time left in the game and the player's score (Figure 11.13). The last scene, `score`, provides dynamic feedback when the game is over.

Figure 11.13 Dynamic text displays the game time and user's score.

The concept of this game is to drive through an obstacle course. The obstacles are randomly placed in 3D space. A "camera" moves through the 3D space based on the arrow keys pressed. Figure 11.14 illustrates the game structure. Figure 11.15 shows what the player sees while playing the game.

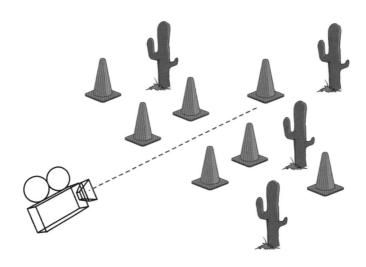

Figure 11.14 Test Drive concept

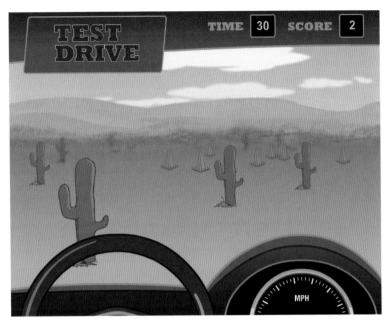

Figure 11.15 Test Drive game

Now that you have seen how the game is set up graphically, let's take a look at the code "driving" the action.

As in the first game, we begin by initializing variables that we will need for game play. They are similar to what we saw in the first game. In this case, we want both the dashboard and the roof to be on top of everything else and set them to a sufficiently high depth value.

Setting up the viewer (camera) information is straightforward with nothing new. Since we will be using the arrow keys to do our driving, we must make provision for camera moves in the x- and z-directions. Note that the vertical origin yo has been moved up from the center of the Stage to be consistent with the horizon line of our imagery.

To create the objects, a movie clip with instance name object_mc was made that had the cone in the first frame and the cactus in the second frame. The game objects were made by duplicating this movie clip. Since we wanted a mixture of cones and cacti, we randomly chose one of the two frames for each duplicate (line 63). The placeObj() function distributes the objects randomly in the x-direction, a constant value in the y-direction, and in equal increments in the z-direction. We saw this type of arrangement

```
51    // create the game objects
52    // set the number of objects to be created
53    var numberOfObjects:Number = 31;
54
55    // create the cones and cacti and place them in 3D space
56    for (var i:Number = 0; i < numberOfObjects; i++)
57    {
58        if ( i < numberOfObjects - 1)
59        {
60            duplicateMovieClip(object_mc,"object"+i,i);
61            thisObj = this["object"+i];
62            thisObj.id = i
63            thisObj.gotoAndStop(Math.round(Math.random()+1));
64            placeObj(thisObj,i);
65        } else
66        {   duplicateMovieClip(finish_mc,"object"+i,i);
67            this["object"+i].x = 0;
68            this["object"+i].y = -250;
69            this["object"+i].z = 30000;
70            this["object"+i].id = i;
71        }
72    }
73
```

previously with the Poser puppies. As a last object in 3D space, we added the finish line and placed it way back in the z-direction. For each object, an id number is assigned. This will be used to test for crossing the finish line.

This displayObj() function is pretty standard fare with a few new additions. A blur filter is applied to objects far away, again replicating the Poser puppies. Some additional coding was used to check whether the z-value of the object is too close to the player. There are two cases to consider. If we are too close to an object and that object is the finish line, then the game is over.

On the other hand, if the object is not the finish line, then the object is given new coordinates in the placeObj() function, and we check to see whether the x-value of the object is close to the viewer. If it is, then we have run over an obstacle. The score is increased by 1, and the camspeed of the car is reduced. Since the speed is reduced, the angle of rotation of the needle on the speedometer is also reduced.

```
96          // check if the object is too close to the viewer
97          var done:Number = numberOfObjects - 1;
98          // if it's the finish line, game is over
99          if ( thisObj.z <= -d + tooClose && thisObj.id == done )
                        {over = true;}
100         // if too close but not finish
101         if ( thisObj.z <= -d + tooClose && thisObj.id <  done )
102         {
103             // move it back in space
104             placeObj(thisObj,i)
105             // if object has been run over
106             if ( Math.abs( viewer.x - thisObj.x) < 300 )
107             {   score++;
108                 roof_mc.score_txt.text = score;
109                 camdz += camspeed;
110                 dash_mc.needle_mc._rotation = - camdz;
111             }
112         }
113
```

The game is played within an `onEnterFrame` handler. A call to the `getTime()` function is made to update the elapsed time, as in the last game. Since the game is played with the arrow keys, they must be checked.

If the Left Arrow key is pressed, the camera is panned in the direction of the arrow, which moves the player right and changes the view. In addition, since we are turning, we also use a call to the `parallax` function to move the hills and sky in the proper direction for additional visual feedback. Within the car, the steering wheel is turned in the direction of turning. The Right Arrow key is handled similarly.

```
142         // check the arrow keys
143         if (Key.isDown(Key.LEFT))
144         {
145             camdx +=  2 * camspeed; // adjust camera
146             parallax(hills_mc, 2);
147             parallax(sky_mc, 1);
148             if(dash_mc.wheel_mc._rotation >= -30)
149             {   dash_mc.wheel_mc._rotation -= 5;   }
150         }
151
```

When neither the Left Arrow nor Right Arrow keys are pressed, the steering wheel gradually returns to a normal position (lines 158–167, see file on CD).

If the Up Arrow key is pressed, the camera is accelerated in the z-direction, an accelerating sound is played, and the needle on the speedometer is rotated clockwise. Pressing the Down Arrow key produces a similar but opposite behavior.

```
168        if (Key.isDown(Key.UP))
169        {    camdz -= camspeed; // accelerate camera
170             accelerateFX.start();
171             dash_mc.needle_mc._rotation = - camdz;
172             if ( dash_mc.needle_mc._rotation < 0 && dash_mc
                                       .needle_mc._rotation > -60 )
173             { dash_mc.needle_mc._rotation = -60; }
174        } else if (Key.isDown(Key.DOWN))
175        {    camdz += camspeed; // decelerate camera
176             dash_mc.needle_mc._rotation = - camdz;
177        }
178
```

The remaining part of the onEnterFrame handler displays the objects, keeps the player from moving too far left or right, and checks for the end of the game. When the game is over, the handler is deleted, and general cleanup is performed like the last game before moving to the score frame.

The parallax function uses two parameters: a layer, which represents the movie clip to be moved, and a speed, which controls how fast the movie clip will move. The speed can be either positive or negative, depending on the desired direction. The sky and hills are designed for continuous movement and are used with different speeds to provide parallax motion.

Some possibilities to enhance this game include the following. Add more obstacles to the game. Each obstacle could impact your score differently. You could also add a fuel limit and ways to refuel the car. This could be accomplished through a keypress or other items randomly placed in the 3D space.

Project 3: Gargoyle Gallery

Let's shift gears from games to interactive galleries. In the Chapter 11 folder on the accompanying CD, open `03_gargoyleGallery.fla`. Publish the movie. This project expands on the 3D rotation concepts discussed in Chapter 6. Six gargoyles rotate around a circular path. When the user clicks on a gargoyle, it moves into position under the spotlight (Figure 11.16).

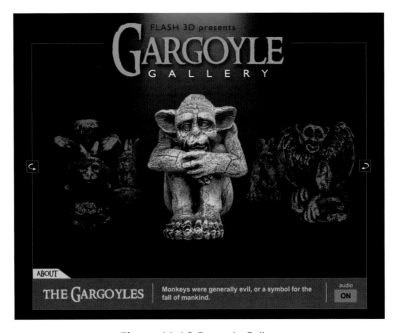

Figure 11.16 Gargoyle Gallery

The gargoyles are PNG files that are dynamically loaded into the Flash file. This helps keep the main Flash file small in file size and lets it be easily updated. Open the `asset` folders in the Chapter 11 folder. It contains each gargoyle PNG file (Figure 11.17).

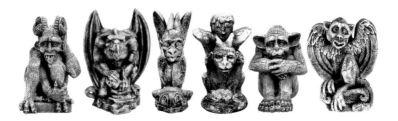

Figure 11.17 Gargoyle PNG files that are dynamically loaded into Flash

Arrow buttons control the rotation of the gargoyles. They can spin clockwise or counter-clockwise. The spotlight is an imported PNG file. The panel at the bottom of the Stage displays information unique to each gargoyle. It can also be hidden by clicking on the About tab (Figure 11.18).

Figure 11.18 Information panel can be hidden by clicking on About.

Double-click on the panel movie clip instance to open its Timeline (Figure 11.19). The animation that hides the panel is a motion tween. Using a Mask layer, the contents of another layer can be revealed or hidden. In this example, the information panel animates up or down within a mask shape.

Figure 11.19 Information panel Timeline

The mask also hides a button that turns the music on and off. The button is made up of two parts—a button symbol and dynamic text (Figure 11.20). The text changes to reflect the status of the music.

Figure 11.20 Audio button is made up of a button symbol and dynamic text.

Let's take a look at the code for this project. First, we define the variables. With the exception of one variable, this section is lifted from our discussion of objects rotating in the x-z plane in Chapter 6. The new variable `target`, represents the point on the circular path at which an object will be nearest to the viewer under the spotlight.

```
1    // Set the viewer distance d from the screen
2    var d:Number = 400;
3
4    // define the center of the screen coordinate system
5    var xo:Number = Stage.width/2;
6    var yo:Number = Stage.height/2;
7
8    // define the circular path characteristics
9    var xc:Number = -120;   // xc = horiz. center of the circle
10   var yc:Number = 160;    // yc = vert. center of the circle
11   var zc:Number = 475;    // zc = depth center of the circle
12   var r:Number  = 450;    // r  = radius of circle
13
14   // define the object characteristics
15   var numberOfObjects:Number = 6; // number of objects to orbit
16   var startAngle:Number = 30;     // starting rotation angle
17   var target:Number = zc - r;     // set the target area closest
                                     //      to the viewer
18
19   // calculate the angle between any two objects on the circle
20   var circleAngle:Number = 360/numberOfObjects;
21
```

The `placeObj()` and `displayObj()` functions are the same as in Chapter 6 with the inclusion of just a few new lines to better handle aerial perspective. Using the alpha value for aerial perspective works well on solid backgrounds and where there is no overlapping of objects. For general situations, another approach is called for.

When creating the objects, or in the `placeObj()` function, the color of the object is recorded by creating a new `Color` object as shown below.

```
51       // record the color of the object
52       thisObj.myColor = new Color(this["object"+i]);
53
```

The `displayObj()` function is where we need to apply aerial perspective. We'll define a color value variable `colval` that represents the tint that we want to apply to an object. In most cases, this value will be related to the z-coordinate of the object or its distance ratio. In this particular example, we are taking the larger of either –125 or the negative z-coordinate of the object. Once the value has been determined, the color `setTransform` method is called to modify the color of the object as shown below. The range of values can be from –255 (black) to +255 (white).

```
74     // set the tint based on the z-location of the shape
75     // to provide aerial perspective ( -255 to +255 )
76     colval =  Math.max(-125, -thisObj.z);
77     thisObj.myColor.setTransform({rb:colval, gb:colval,
                                       bb:colval})
78
```

We are using only three of eight properties available, `rb`, `gb`, and `bb`, which are offset values for the red, green, and blue components of a `Color` object. It is also possible to specify percentages of the components as well as alpha values. Note that in our example, we are applying equal values to the offsets, which uniformly affects the color. By increasing one while decreasing the others, we could make an object look as if it were under a red light, a blue light, and so forth. There is no one formula that works for all occasions, and some experimenting is usually required to get the effect you are after.

The movement of the objects on their circular path is carried out as usual with an `onEnterFrame` handler. There are several types of movement available. The user can press on the arrow buttons to rotate the objects clockwise or counterclockwise. This movement is continuous for as long as the user presses down on a button and will stop when the button is released. The button variables, `next` and `back`, control the motion.

The user can also click on an object to bring it to the foreground. When an object is selected, it becomes the target for movement (lines 100–105), and all objects will rotate either clockwise or counterclockwise until the selected object is under the spotlight. If the clicked object is to the right of center, the objects will rotate in a clockwise direction (line 111). If the clicked object is to the left of center, the objects will rotate in a counterclockwise direction (line 112).

In order to ensure that the buttons, title, and spotlight are never covered up, they are placed on top using `swapDepths()`, similar to what we have done in the games. Initially, the arrow buttons were defined as actual buttons, but `swapDepths()` cannot

be applied to buttons, so they were converted to three-frame movie clips that represented the up, over, and down states of a button.

The code for the arrow buttons is quite simple. The button variables, next for the clockwise rotation, and back for the counterclockwise rotation, are initially set to false. The onRollOver and onRollOut handlers simply replace the over state of a button. When the clockwise arrow is pressed, the down state of the movie clip is displayed, next is set to true, and blank text is placed in the info area of the pop-up window at the bottom of the screen. The counterclockwise arrow is handled in a similar manner.

```
132   // button-related scripts
133
134   var back = next = move = false;// initialize the button states
135
136   // script for the clockwise turn button
137   cw_mc.onRollOver = function() {this.gotoAndStop(2);}
138   cw_mc.onRollOut  = function() {this.gotoAndStop(1);}
139
140   cw_mc.onPress = function()
141   {    this.gotoAndStop(3);
142        next = true;
143        infoPop_mc.info_mc.gotoAndStop(7);
144   }
145   cw_mc.onRelease = cw_mc.onReleaseOutside = function()
146   {    this.gotoAndStop(1);
147        next = false;
148   }
149
```

The infoPop_mc movie clip will raise and lower the information area depending on the status of the toggle variable dropStatus. It is initially set to 1, hiding the panel. When the user clicks on the ABOUT button, the status changes. If it is a 1, it will be set to 0, and the panel will be opened. If it is a 0, it will be set to 1, and the panel will be closed. The audio button has a similar on/off toggle that will play the music or turn it off.

This project can be easily updated by changing the artwork in the assets folder. Flash can load JPEG, PNG, and other SWF files. As mentioned earlier, it is also easy to use the project as a template for creating totally different projects. Figure 11.21 shows a project with an entirely different look and feel, and apart from changing the graphics, it involved only a few changes in code. Open 03_glassGallery.swf in the Chapter 11

Figure 11.21 The Glass Gallery based on the Gargoyle Gallery

folder. The number of objects has changed from six to nine. In order to make it easy
to select the larger number of items, the scene was set to be viewed slightly above the
plane of motion by setting the vertical center of the plane yc to be 60 pixels below the
vertical origin of the coordinate system in line 10. The vertical origin yo was adjusted
to comfortably display the glasses on the Stage. The radius of the path of motion
remained the same, but the depth center of the circle was brought forward to bring
the glasses closer to the viewer.

An important thing to note is the value of the `startAngle`. Rather than using 30
degrees as we did in the Gargoyle Gallery, the value used is 30.1. This was necessary
to force all of the glasses to have different z-coordinates initially. When 30 degrees was
used and the `displayObj()` function was called, two glasses had identical z-coordi-
nates which in turn caused them both to attempt to `swapDepths()` to the same value,
which Flash doesn't allow. The visual result was that a small glass in the back over-
lapped a larger glass in the front and was on top of it. In most situations, the problem
doesn't arise, but when it does, a little tweaking of z-values usually solves the problem.

One other change to the code is worth mentioning. The treatment of the aerial perspec-
tive is somewhat different in this example. A dramatic falloff from the spotlight was
desired while, at the same time, making sure that the glasses in the back were clearly

```
1    // Set the viewer distance d from the screen
2    var d:Number = 300;
3
4    // define the origin of the screen coordinate system
5    var xo:Number = Stage.width/2;
6    var yo:Number = 100;
7
8    // define the circular path characteristics
9    var xc:Number = -120;    // xc = horiz. center of the circle
10   var yc:Number = -60;     // yc = vert location of the circle
11   var zc:Number = 420;     // zc = depth center of the circle
12   var r:Number  = 450;     // r  = radius of circle
13
14   // define the object characteristics
15   var numberOfObjects:Number = 9; // number of objects to orbit
16   var startAngle:Number = 30.1 //30; // starting rotation angle
17   var target:Number = zc - r; // closest point to the viewer
18
19   // calculate the angle between any two objects on the circle
20   var circleAngle:Number = 360/numberOfObjects;
21
22   // create the objects for the circular motion
23   for (var i:Number = 0; i < numberOfObjects; i++)
24   {
25       this.createEmptyMovieClip("object"+i, i);
26       this["object"+i].loadMovie("j_glasses/glass"+i+".png");
27   }
28
```

visible. Better results for colval were obtained with the distance ratio. In fact, using the square of the distance ratio as shown gave the results that we were after.

```
75       // to provide aerial perspective ( -255 to +255 )
76       colval = 100*dr*dr -140;
77       thisObj.myColor.setTransform({rb:colval, gb:colval,
78                                       bb:colval})
```

Although not done here, to make the project fully dynamic, the content could also be loaded dynamically through a text document or XML. The more dynamic the content is, the easier it is to update.

Project 4: Museum Trail

Let's take a look at another type of interactive gallery. Open `04_museumTrail.fla` in the Chapter 11 folder. Publish the movie. This project expands on the QTVR concepts discussed in Chapter 8. You can click and drag the magnifying glass over the map to locate one of four museums in Rochester, New York (Figure 11.22). Click on the museum to learn more. User interactivity includes QTVR panoramic images (Figure 11.23). Move the cursor to pan around the image.

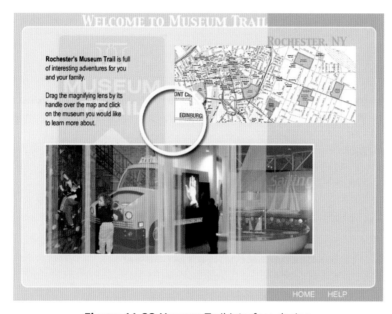

Figure 11.22 Museum Trail interface design

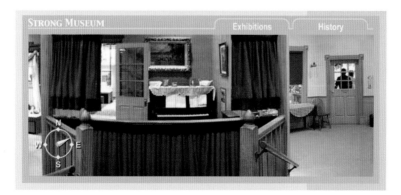

Figure 11.23 Panoramic image allows user to explore a selected museum.

Similar to the previous project, the imagery is loaded dynamically. The panoramic images are located in the `pano_swfs` folder. The static images of the museums are located in the `pic_folder`. Let's take a closer look at `04_museumTrail.fla` Timeline. It is divided into separate sections for each museum. The `labels` layer identifies each of these sections (Figure 11.24). When the user clicks on a museum button in the map, ActionScript navigates the playback head to the selected museum's frame label.

Figure 11.24 `04_museumTrail.fla` Timeline

Code at each museum's frame loads in the appropriate image and panoramic SWF file. Let's see how ActionScript pulls all the interactivity together. We start with the map. The user clicks and drags a magnifying glass over a map of Rochester, New York. Go to the Library and double-click on `magGlassMC` in the `magnifying glass` folder.

The magnifying glass in made up of two layers—`handle` and `artwork` (Figure 11.25). The artwork is a PNG file created in Photoshop with a drop shadow. The handle is a movie clip instance. The alpha color is set to 0%. This acts as an invisible hot spot.

It has an instance name of `handle_mc` and will be referenced through ActionScript to allow the magnifying glass to become draggable when clicked on. To create the illusion of a magnified image, we use two layers in the main Timeline. One layer is a mask that contains a circular shape that fits inside the magnifying glass. It is a movie clip with an instance name of `mask_mc` (Figure 11.26).

There are two map bitmap images used in this project. The large map is a movie clip with an instance name of `bigMap_mc`. The smaller map image is also a movie clip with an instance name of `smallMap_mc`. Both movie clips share a common registration point located in the bottom-left corner (Figure 11.27).

Figure 11.25 Magnifying glass

Figure 11.26 Mask movie clip

Figure 11.27 Both map movie clips' registration points are in the lower-left corner.

Now that we have examined the artwork, let's look at the code that makes it all work. The first thing to be done is to store the current location of all the components into separate variables. The code sets the location of the mask shape to the location of the magnifying glass.

```
3    bigMapStartX = bigMap_mc._x;
4    bigMapStartY = bigMap_mc._y;
5
6    mask_mc._x = magGlass_mc._x;
7    mask_mc._y = magGlass_mc._y;
8
9    startX = mask_mc._x;
10   startY = mask_mc._y;
11
12   dxHS1 = bigMapStartX - strongHS_mc._x;
13   dyHS1 = bigMapStartY - strongHS_mc._y;
```

Lines 12 through 22 record locations for movie clip hot spots that are over the four museums. The code records each hot spot's position based on the starting position of the larger map. As the larger map moves with the magnifying glass, the hot spots will follow, maintaining their correct position.

```
24    scaleFactor = bigMap_mc._width / smallMap_mc._width;
25
26    bottom = smallMap_mc._y;
27    left   = smallMap_mc._x;
28    top    = smallMap_mc._y - smallMap_mc._height;
29    right  = smallMap_mc._x + smallMap_mc._width;
30
31    magGlass_mc.handle.onPress = function() {
32        magGlass_mc.startDrag(false, left, top, right, bottom);
33    }
34
35    magGlass_mc.handle.onRelease = function() {
36        magGlass_mc.stopDrag();
37    }
```

The variable scaleFactor establishes the percentage of scale between the large and small map. By dividing the width of the larger map by the smaller map's width, you get the scale factor. Lines 26 through 29 define the bounding box of the smaller map and store that information into four variables. With that information, the magnifying glass can be restricted to this area (Lines 31 through 33).

```
68    bigMap_mc.onEnterFrame = function() {
69
70        mask_mc._x = magGlass_mc._x;
71        mask_mc._y = magGlass_mc._y;
72
73        dx = mask_mc._x - startX;
74        dy = mask_mc._y - startY;
75
76        bigMap_mc._x = bigMapStartX - (scaleFactor - 1) * dx;
77        bigMap_mc._y = bigMapStartY - (scaleFactor - 1) * dy;
```

Next we need to update the movie clips as the magnifying glass is being dragged. Using the onEnterFrame function for bigMap_mc will accomplish this. Every time the playback head enters the frame, the location of the mask shape is reset to the new location of the magnifying glass. The big map also resets its position based on the scale factor and the amount of distance the magnifying glass has moved.

The remaining code sets the navigation for each button when clicked on.

When the user clicks on a museum hot spot, the current time marker jumps to the designated frame label. A frame script loads in the dynamic content. First it clears any SWF movie that may be loaded into `pano1_mc`. This movie clip acts as a placeholder for each loaded movie. Let's now focus on a QTVR panoramic file.

```
1    stop();
2
3    pano1_mc.unloadMovie();
4
5    picLoc="pic_folder/pic4.jpg";
6    pic_mc.unloadMovie();
7    loadMovie(picLoc,pic_mc);
8
9    exhibits_mc.onRelease = function() {
10        gotoAndStop("exhibits")
11   }
12
13   history_mc.onRelease = function() {
14        gotoAndStop("history")
15   }
```

Open `adventurePano.fla` located in the `pano_swfs` folder. It contains a photographic panoramic image. The individual shots were stitched together into one single panoramic image using VR Worx 2.6 (Figure 11.28). For more information, refer to Chapter 8.

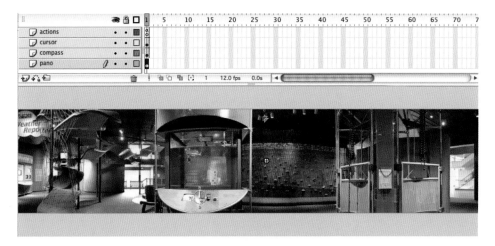

Figure 11.28 Panoramic image

The `actions` layer contains a simple command—`#include "pano.as"`. The script that controls the interactivity is contained in a separate ActionScript file. This allows the code to be reused by other files. For this project, each panoramic Flash file loads this ActionScript file to complete the interactivity.

Open `pano.as` and look at the code. First, we initialize the variables that will be used.

```
 9    // define the panorama display area
10    imageWidth = 580;
11    imageHeight = 228;
12
13    // define the horizontal & vertical pano limits
14    maxX = pano_mc._width/2;
15    minX = imageWidth - maxX;    // minX = Stage.width - maxX;
16    maxY = pano_mc._height/2;
17    minY = imageHeight - maxY;   // minY = Stage.height - maxY;
18
19    // define the movement defaults
20    speedFactor = 20; // lower numbers give faster speeds
21    pressed = false;
```

Next, we define the external events that trigger the panoramic movement.

```
23    // define the panorama event handlers
24    pano_mc.onPress = function() {
25        pressed = true;
26        xStart = _xmouse;   // store the initial
27        yStart = _ymouse;   // mouse location
28        Mouse.hide();
29        currentx = pano_mc._x; // store the current horizontal
30                               // location of the panorama
31    };
32
33    pano_mc.onRelease = pano_mc.onReleaseOutside = function() {
34        pressed = false;
35        Mouse.show();
36    };
```

Since the panorama will be moving, we'll use an `onEnterFrame` handler to describe its behavior. A custom cursor movie clip is repositioned to the cursor's current position. If the mouse button is pressed, a function `checkTheMouse` is called to load the correct cursor graphic (Figure 11.29). This reinforces the movement of the panoramic image. For more detail on this function refer to Chapter 8—specifically Exercise 8.4.

```
38    pano_mc.onEnterFrame = function() {
39
40        cursor_mc._x = _xmouse;   // set the cursor location
41        cursor_mc._y = _ymouse;   // to the mouse location
42
43        if (pressed) { checkTheMouse(); }
44        else cursor_mc.gotoAndStop(10);
45    };
```

Figure 11.29 Custom cursor

The last bit of code rotates the compass pointer to reflect the direction you are moving. The compass is a movie clip. Inside the movie clip is a pointer movie clip with the registration point set at the bottom (Figure 11.30).

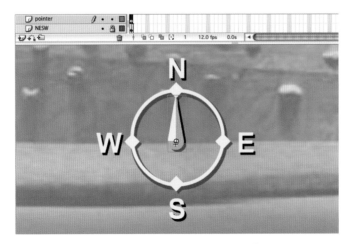

Figure 11.30 Compass movie clip

```
86      setCursor = function () {
87          if (_xmouse < xStart - 5) { column = 1; }
88              else if (_xmouse > xStart + 5) { column = 3; }
89              else column = 2;
90
91          if (_ymouse < yStart - 5) { row = 1; }
92              else if (_ymouse > yStart + 5) { row = 3; }
93              else row = 2;
94
95              n = column + (row - 1) * 3;
96              cursor_mc.gotoAndStop(n);
97      }
98
99      rotateCompass = function() {
100         // determine how much the pano has moved horizontally
101         dx = pano_mc._x - lastx;
102
103         // calculate the rotation of the compass point
104         // note that maxX == 1 full rotation of the panorama
105         // we need a negative rotation value because
106         // of the direction of Flash rotation
107         compass_mc.pointer_mc._rotation -= dx * 360 / maxX;
108
109         // update the current horizontal location of the pano
110         currentx = pano_mc._x;
111     }
```

To rotate the pointer, the distance from the panorama's last position, `lastx`, to its current position is set to `dx`. When the panorama moves a distance equal to `maxX`, the point at which it has had one full rotation, then there should be an equivalent full 360-degree rotation of the compass pointer. To convert the incremental distance `dx` to an incremental rotation angle, a simple proportional relationship is used

$$dx/maxX = rotation\ angle/360$$

from which

$$rotation\ angle = dx*360/maxX$$

A negative value must be used for this rotation angle because of the direction of Flash rotation. After the rotation is carried out, the panorama's current position is set to `lastx`, and the process repeats whenever the panorama is moved.

Project 5: A Walk in the Park

Our last project is a marketing Flash application for a fictional movie. It incorporates a parallax scrolling technique using the cast members in the movie. The scrolling is interactive based on cursor movement. Open 05_WalkinthePark.fla in the Chapter 11 folder. Publish the movie (Figure 11.31).

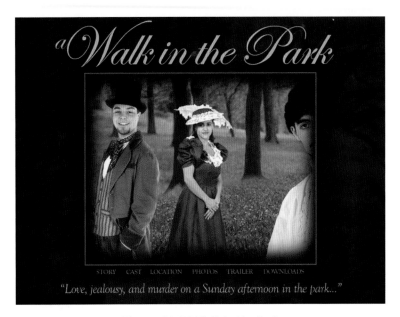

Figure 11.31 Walk in the Park

Open scroll.fla in the assets folder. It contains several layers in the Timeline. Each layer holds a character saved as a PNG file (Figure 11.32).

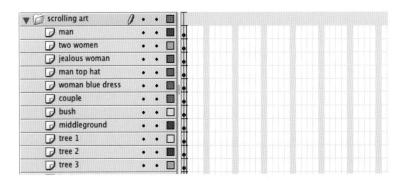

Figure 11.32 Scroll Timeline contains several layers, each holding a separate PNG file.

The project poses some interesting problems and has a solution that lies somewhere between 2D and 3D. Figure 11.33 shows the starting point. The two-dimensional image represents a projection of a three-dimensional space. The Stage is shown in the center, and the idea is to be able to pan the image left and right within the Stage area much like a panorama. As we pan, we want to move in such a way that we have a sense of a three-dimensional space through the movement of the individual layers.

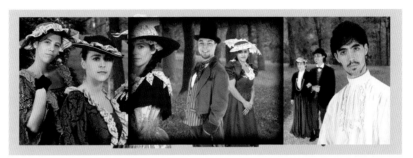

Figure 11.33 Initial layout for the project

To create the desired motion, each layer was constructed to be the same size as the background layer. Figure 11.34 shows the background layer and one of the topmost

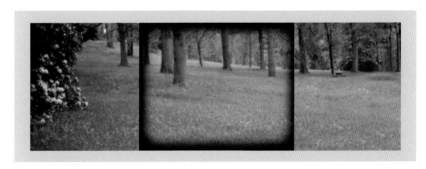

Figure 11.34 The background layer and a top layer

layers. Each element maintained its original position in the overall composition and was surrounded by a transparent marquee (shown as a black outline here) that had the same dimensions as the background layer.

To get the effect that we wanted, there were several problems that we had to solve. The first was strictly two-dimensional and dealt with the general movement of the image. We wanted the image to pan based on the position of the mouse on the Stage. For example, if the mouse is at the position represented by the yellow dot in the top half of Figure 11.35, then we want to move the image to its proportionally corresponding point on the Stage, as shown in the lower half of Figure 11.35.

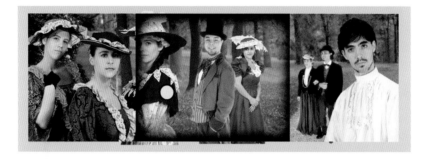

Figure 11.35 Proportional movement of the image

To get the corresponding point, we first have to calculate the scale factor involved in scaling up from the Stage width to the image width. Since everything was centered on the Stage, the target point in the image that corresponds to the x-position of the mouse is given by

```
target = xo - scale * (_xmouse - xo)
```

where xo is the horizontal center of the Stage and

```
scale = background width/stage width
```

By moving the cursor on the screen, we change the target point of the image, and we will be able to move the image around on the Stage. The same idea can be used to have the panning and scrolling of a rectangle in a small map control the movement and display of a larger map in a window.

With this as a foundation, let's start to look at some code. It was convenient, although not necessary, to define an object array that consists of all of the layer movie clips. The background served as the initial element and as a reminder that everything will move relative to it. Generally, the rest of the array was built from the foreground images to those closest to the background.

The horizontal center of the Stage is defined as xo. We are also defining a speed factor that will control how fast the background pans left and right. The scale variable is set to the background width divided by the Stage width as discussed.

The next task is a little trickier, and that is how to move the separate layers or planes in such a way as to create the effect of moving in a 3D space. The separate layers that comprise the total image can be thought of as separate planes along the z-axis in 3D

```
1   // define the array of object movie clips
2   // that are in the scene
3   obj = [];
4   obj[0] = this["background_mc"];
5   obj[1] = this["man_mc"];
6   obj[2] = this["twowomen_mc"];
7   obj[3] = this["jealouswoman_mc"];
8   obj[4] = this["bush_mc"];
9   obj[5] = this["mantophat_mc"];
10  obj[6] = this["tree1_mc"];
11  obj[7] = this["womanbluedress_mc"];
12  obj[8] = this["tree2_mc"];
13  obj[9] = this["middleground_mc"];
14  obj[10]= this["couple_mc"];
15
16  // define the center point and background speed
17  var xo:Number = Stage.width/2;
18  var speed:Number = 8;
19
20  // set scale to be the background width/Stage width
21  scale = obj[0]._width/Stage.width;
22
```

space. Viewed from above, we have the situation illustrated by the left side of Figure 11.36. Everything is aligned, and no movement of the planes will give us what we want.

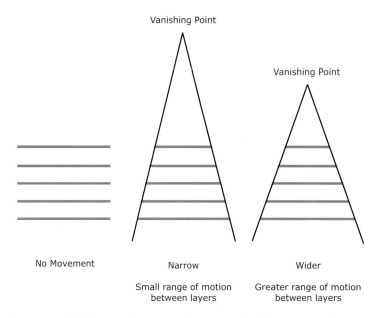

Figure 11.36 The vanishing point determines the layer range of motion.

We need to establish a vanishing point for the layers and then size the layers to be consistent with the vanishing point as shown in the center and right side of Figure 11.36. If the vanishing point is very far away, only a small amount of movement between the layers is possible. As the vanishing point is brought in, a greater range of motion is possible, but there must be a greater size difference between the individual layers.

In our case, the various layer images already reflect the scaling caused by perspective. We need to change the layer size horizontally, but we do not have to make any changes in size of the layer images. The marquees in the individual layers were increased in size using the background layer as the baseline as shown in Figure 11.37.

The next thing to be determined is the amount each layer could move to be consistent with the vanishing point. We know from our work with panoramas that the maximum value for movement of the background is the background width divided by 2, and the minimum value is the Stage width minus the maximum value.

Figure 11.37 The position of the layer elements after resizing the bounding rectangles

```
23    // set the background limits of movement
24    // all others are relative to it
25    var xmax:Number = obj[0]._width/2;
26    var xmin:Number = Stage.width - xmax;
```

A few quick experiments provide the information we need. When the background moves from the center of the Stage to align with the left edge, it moves 350 pixels as shown in Figure 11.38. When we do the same thing with one of the two nearest images, we find that the distance the image moves is 750 pixels as shown in Figure 11.39.

Figure 11.38 Movement of the background to its maximum location

Figure 11.39 Movement of the foreground to its maximum location

When the background moves, the foreground must move relative to it, and they both must end at the left edge of the Stage at the same time. The foreground must travel 750 pixels in the same time the background moves 350 pixels. In other words, the foreground must travel 750/350, or 15/7 (= 2.14) times as fast as the background. Going through a similar process for each of the layers shows how each must move relative to the background.

As it turns out, it is easy to get the information on how far each layer moves simply by reading its x-value in the Properties window. This value gives the distance from the object to the origin, which is all the information we need. Since we have objects moving around, we'll put everything inside an `onEnterFrame` handler. We let the mouse identify the target we want to move toward (line 7). If the background location is less than the target location, we just move the objects in unison according to their relative speed factors. If the background location is greater than the target location, we just move the objects by the same amount in the opposite direction.

There is just one piece of business to take care of. We don't want the background or other objects to run off the Stage, either on the left or right. If the background is at `xmax`, we just set it to remain at that location until the mouse is moved in the opposite

```
1    // create the movement under mouse control
2    this.onEnterFrame = function()
3    {
4        // when the mouse is at some location on the Stage,
5        // we want to move to the corresponding point
6        // on the background -- the target
7        target = xo - scale * (_xmouse - xo);
8
9        // if the background location
10       // is less than the target location
11       if ( obj[0]._x < target - 2)
12       {    obj[0]._x += speed;
13            obj[1]._x += 2.14 * speed;
14            obj[2]._x += 2.14 * speed;
15            obj[3]._x += 2.00 * speed;
16            obj[4]._x += 1.85 * speed;
17            obj[5]._x += 1.71 * speed;
18            obj[6]._x += 1.55 * speed;
19            obj[7]._x += 1.43 * speed;
20            obj[8]._x += 1.29 * speed;
21            obj[9]._x += 1.14 * speed;
22          obj[10]._x += 1.14 * speed;
23       }
24       //else if the background location
25       // is greater than the target location
26       if ( obj[0]._x > target + 2)
27       {    obj[0]._x -= speed;
```

direction. If we stop the background movement, then we must stop the movement of the rest of the objects. For each of them, they must stop at xmax plus one-half of the difference between the object's width and the background's width. For example, for a foreground object, its width was resized from the 1200 pixels of the background to 2000 pixels. The difference between the two widths is 800 pixels, so the foreground must stop at xmax plus 400.

A similar test must be performed to keep the background from sliding off the Stage in the other direction. The code is the same except for a minus sign.

```
69          if ( obj[0]._x > xmax )
70          {     obj[0]._x = xmax;
71                obj[1]._x = xmax + 400;
72                obj[2]._x = xmax + 400;
73                obj[3]._x = xmax + 350;
74                obj[4]._x = xmax + 300;
75                obj[5]._x = xmax + 250;
76                obj[6]._x = xmax + 200;
77                obj[7]._x = xmax + 150;
78                obj[8]._x = xmax + 100;
79                obj[9]._x = xmax +  50;
80               obj[10]._x = xmax + 50;
81          }
82
```

There you have it. When you have imagery that can be broken into some number of well-defined planes in 3D, the movement can be very realistic and really attests to the effectiveness of parallax motion in creating a strong sense of three-dimensional space. The most pleasant surprise is the simplicity and brevity of the code.

Summary

In this chapter, we have applied many of the concepts and techniques for creating and simulating 3D space used throughout the book to typical applications. The projects ranged from arcade-style games to interactive galleries and provide you with starting code for five different types of Flash 3D templates. Each template is complete in that it incorporates the basic 3D functionality and should provide a solid foundation for your own creative projects.

Index

Symbols

3D drawings 2, 3, 15, 16, 19, 161
3D rotation 177, 375
3ds Max 355
3D space xi, xii, 2, 33, 89, 114, 157, 158, 160, 161, 163, 164, 165, 166, 167, 168, 170, 172, 175, 179, 180, 181, 182, 183, 189, 214, 217, 218, 223, 224, 225, 226, 232, 233, 238, 240, 241, 248, 250, 255, 258, 264, 266, 267, 268, 271, 272, 276, 307, 314, 328, 332, 334, 339, 347, 357, 361, 367, 369, 370, 372, 374, 393, 398

A

ActionScript xi, 2, 90, 91, 92, 96, 98, 99, 102, 103, 104, 105, 106, 108, 109, 110, 111, 112, 114, 115, 119, 123, 125, 127, 128, 136, 151, 152, 158, 164, 166, 222, 225, 276, 278, 287, 305, 310, 311, 312, 313, 323, 340, 383, 387
acute triangle 116
Adobe Illustrator 16, 140, 342, 344, 345, 346
aerial perspective xi, 19, 22, 26, 27, 54, 55, 96, 176, 196, 208, 214, 222, 287, 377, 378, 380, 381
angles 3, 4, 5, 9, 11, 12, 14, 116, 118, 119, 120, 121, 124, 125, 131, 144, 155, 160, 185, 212, 277, 286, 317

animation xi, 28, 42, 55, 56, 57, 58, 59, 60, 61, 64, 67, 79, 80, 81, 88, 90, 91, 103, 228, 274, 275, 276, 349, 350, 351, 352, 353, 354, 359, 360, 368, 376
arctan 151
array 222, 223, 240, 242, 250, 251, 253, 261, 312, 314, 323, 328, 332, 333, 335, 336, 338, 393

B

bitmaps 25, 29, 80, 191, 196, 207, 215
Boolean 243, 245, 250, 297, 298, 300, 362

C

Cartesian coordinate system 116, 117
center of vision 160, 162, 178, 199, 201, 214, 307
CINEMA 4D 268, 355, 356, 359
circle radius 136
circular motion xii, 127, 129, 134, 135, 136, 159, 183, 185, 190, 192, 194, 205, 206, 207, 215, 283, 381
class 5, 91, 114
color depth
 24-bit 355
 32-bit 355
cone 347, 370, 371
coordinate systems 115, 116, 117
cos(angle) 124, 125
cosine waves 115, 143, 144